LEONARDO DA VINCI

THE ROYAL PALACE AT ROMORANTIN

LEONARDO DA VINCI

THE ROYAL PALACE AT ROMORANTIN

CARLO PEDRETTI

THE BELKNAP PRESS OF
HARVARD UNIVERSITY PRESS
Cambridge, Massachusetts

1972

Remorentin sa perte rémémore

PREFACE

In the last chapter of my *Chronology of Leonardo da Vinci's Architectural Studies after 1500* (Geneva, 1962) I assembled what I then called "a considerable number of unsolved problems." It is well known that the initial intention to write a chapter may develop in time into a book. This was the case with my chapter on Leonardo at Romorantin, which became a lecture in 1965 and is now a book in which many of the problems gathered in 1962 have found a solution.

My research was undertaken in 1963, with the assistance of M. Maurice Masson, former President of the Archaeological Society of the Sologne, Romorantin-Lanthenay. Resumed in 1965 with the generous support of the American Council of Learned Societies, it was completed in 1967 during my sabbatical leave while I was assisting Lord Clark (then Sir Kenneth Clark) with a new edition of his catalogue of Leonardo's drawings at Windsor Castle.

Several persons, over the years, have helped me with the project: the late Prince Igor de Baranowicz of Paris, to whom I am indebted for his assistance during my first visit to the libraries and archives in Paris; Mme Trainard-Vienne, Bibliothécaire de la Ville de Romorantin-Lanthenay; Mlle Rousselet, Conservatrice, and Mlle Souberbielle, Bibliothécaire, Musée de Blois; M. de Marcheville, President of the Archaeological Society of the Sologne, Château du Moulin; and M. Jacques Thyraud, Mayor of Romorantin-Lanthenay. I also should like to record the advice and encouragement that Professor André Chastel has given me since the beginning of my work.

During the final phase I had the pleasure of meeting four gentlemen who cherish with me the memory of our mutual friend Giorgio Nicodemi. They are MM. Paul Botte, J. F. Faure, Guy Darrieutort of Paris, and M. Francis Vanoverbecque of Amboise. They assisted me in every possible way during a thorough visit to the Loire region and made it possible for me to check all the original documents.

PREFACE

A first report on this study was the subject of a lecture in 1965 at the Institute of Fine Arts, New York, in the program of the Wrightsman Lecture Series. The same lecture was given at Stanford University, at the Warburg Institute in London, and, in Italian, at the University of Urbino. I owe to Mr. and Mrs. Charles B. Wrightsman the initial impulse to develop the lecture into a book. Before reaching the present form my work had the good fortune to be read by Professor James A. Ackerman, who has given me invaluable advice and has taken a personal interest in it equaled only by that taken by the readers whom the Press called upon for advice. As is well known, readers must remain anonymous, but my gratitude to each of them is the same as I would express to a true friend.

<div align="right">C. P.</div>

CONTENTS

ILLUSTRATIONS

All of Leonardo's drawings reproduced here have been newly photographed. Those in the Royal Collection at Windsor Castle are reproduced by gracious permission of Her Majesty Queen Elizabeth II (John R. Freeman & Co., Photographers, London). Those in the Codex Atlanticus, by permission of the Prefetto of the Ambrosian Library (Signor Walter Scansani, photographer). The folios of the Arundel MS, by permission of the Trustees of the British Museum. The folios of the Paris MSS, by permission of the Conservateur en chef of the Bibliothèque de l'Institut de France. The drawing on the cover of the Turin MS on the Flight of Birds, by permission of the Director of the Biblioteca Reale, Turin (Laboratorio Fotografico Rampazzi, Turin). Two sheets of the Trivulzian MS have also been newly photographed and are reproduced by permission of the Director of the Biblioteca Trivulziana, Castello Sforzesco, Milan.

ILLUSTRATIONS

ILLUSTRATIONS

xiii

ILLUSTRATIONS

ILLUSTRATIONS

ILLUSTRATIONS

ILLUSTRATIONS

INTRODUCTION

This book is about the last three years of Leonardo da Vinci's life, when the image of the man and the artist was fading away into the mist of legend. At the age of sixty-five, Leonardo left Italy to enter the service of the king of France, planning for him a royal residence envisaged as the nucleus of a new urban center at Romorantin. The project was the summation of a lifelong study of the problem of palatial architecture, and its background and development can be understood only after a survey of Leonardo's architectural career, as given in Part One below. Conversely, his final undertaking reflects new light on his earlier studies.

Our knowledge of the Romorantin project is based on curiously elusive evidence. No contemporary record of it has come down to us, but a number of Leonardo's notes and drawings pertaining to the canalization of the Sologne region include references to a project for a royal palace at Romorantin. Eighteenth-century French historians tell us that Francis I, who had become king of France in 1515, wanted to have a new court at Romorantin and undertook the enlargement of the old château. Romorantin was his mother's *douaire* (dowry) and the hometown of his wife, Claude de France. The work was interrupted in 1519 because of an epidemic in the area, and Francis I decided to build Chambord instead. In 1519 Leonardo died in Amboise. As evidence of the work undertaken at Romorantin, a document of 1515 records that Francis I granted a tax exemption on wine to the inhabitants of Romorantin in order to foster the urban development of the town. We are also told that walls of a new construction were still standing at the time of the French Revolution.

A document of 1512 and an eighteenth-century map (pages 70–71 below) of the area of the old château at Romorantin show that there must have been a project to enlarge the fifteenth-century building to make it a symmetrical structure, a project that may or may not have involved Leonardo. All one

can say is that the layout of the impressive park "smells of Leonardo" and may reflect a greater architectural plan known to us through a series of Leonardo's studies. His notes show that he had been at Romorantin to study the terrain and that he had planned the canalization of the whole region, which was in part financed in 1518. The architectural problem of a princely residence was not new to him but had developed out of a significant series of projects and ideas throughout his architectural career. A reconsideration of the historical events in the later part of his life may even suggest that the project of a royal palace at Romorantin motivated his decision to enter the service of the king of France, leaving behind whatever chance of employment he might have had at the papal court. Instead of retiring in his hometown, Vinci, where he owned land and could have lived a comfortable life with the money put aside over the years, Leonardo set out for France, accompanied by two pupils and two servants. He must have been aware of the perils of a long journey through the Alps, as described in Cellini's autobiography. And yet Leonardo left his country, an old man and probably sick, with little hope, if any, of ever returning to it.

It was for his mother, Louise of Savoy, that Francis I wanted to transform the Romorantin residence. In 1514 Louise's sister, Philiberta of Savoy, married Giuliano de' Medici, who later became duke of Nemours. Giuliano, brother of Pope Leo X, was Leonardo's last Italian patron. The relationship between the Medici family and the king of France was a close one. Lorenzo di Piero de' Medici, nephew of Leo X and of Giuliano, was to marry Madeleine de La Tour d'Auvergne in 1518. He went to France and was received with great festivities at Amboise. Louise and Philiberta were present. The celebrations included a performance of a *Paradiso* play that has been recognized from the descriptions as a replica of the one arranged by Leonardo in Milan thirty years before.[1] Leonardo was at Amboise at that time. He must have been in the service of Lorenzo di Piero de' Medici too, especially after Giuliano's death in March 1516, and there is in fact a document showing that he was in his pay.[2] In 1515 Lorenzo had become head of the Florentine government. Michelangelo Buonarroti the Younger, writing in 1600, speaks of a mechanical lion that Leonardo made for the city of Florence, which was sent to Lyons on the occasion of the triumphal entrance of Francis I into that city in July 1515.[3] Lorenzo di Piero in Florence and Leo X in Rome were reviving the prestige of the

INTRODUCTION

Medici family, and Lorenzo had adopted the emblem of his ancestor, Lorenzo the Magnificent, a cut trunk of laurel that generates new branches, symbol of a return to life and power. As governor, Lorenzo must have envisaged the replanning of the Medici quarter in Florence, including the construction of a new palace next to the old one. All that is left of the ambitious project is a sheet of Leonardo's architectural studies; this shows the two Medici Palaces at either side of the widest street of Florence, the Via Larga, which links the piazza of the cathedral to the Piazza San Marco. Leonardo suggests opening up a large piazza at the head of the two palaces, with one side extending all the way to the Medici church of San Lorenzo. Nothing else is known of the project, but it must be related to the pope's intention to have the façade of San Lorenzo completed by Michelangelo in 1515, and to Michelangelo's closing up the corner loggia of the old Medici Palace in 1517. And it was not long afterward that Michelangelo suggested (whether seriously or not it is hard to say) building the campanile of San Lorenzo in the form of a human colossus, from whose mouth was to issue the sound of bells crying out mercy.[4] It is hard to explain Vasari's celebrated passage ascribing Leonardo's leaving for France to rivalry with Michelangelo at the time of the competition for the façade of San Lorenzo;[5] still it can be taken as evidence of the existence of some project in which both Leonardo and Michelangelo were to participate, just as they had been associated with the decoration of the Council Hall ten years before. Michelangelo's idea of a colossus for San Lorenzo is another example of his attaching biological connotations to a building, as an organism conveying the tension and physical power of a human body in action.[6] In his design for the new Medici Palace, Leonardo reveals a similar concern for the organic, but with a stress on the generative powers of nature. He had shown this concern over twenty years before, in the decoration of the Sala delle Asse, and G. P. Lomazzo speaks of it as being congenial to Bramante's conceptions:

Negl'arbori altresì si è trovato una bella inventione da Leonardo di far che tutti i rami si facciano in diversi gruppi bizarri, la qual foggia usò canestrandoli tutti Bramante ancora. (As for trees, a beautiful motif has been invented by Leonardo, that of making their branches interlace in bizarre groups; this weaving together of branches was also used by Bramante.)[7]

Very little is known of Leonardo's last years in France. Apart from occa-

sional dates in his manuscripts, there remain only records of stipends paid to him and to his pupils Francesco Melzi and Andrea Salai and of the visit that Cardinal Louis of Aragon and his followers paid him in October 1517. There are also his last will, now known only in a copy; Melzi's moving letter to Leonardo's brothers soon after Leonardo's death (a document known only from an eighteenth-century publication); and finally the document of inhumation, which gives Leonardo's title as "Premier peintre et ingénieur et architect du Roy."

Antonio de Beatis, secretary to Cardinal Louis of Aragon, states in his diary that Leonardo was no longer painting "with the same sweetness as he used to," because his right hand was paralyzed, but that he was still able to produce drawings and to teach others. Leonardo's intellectual powers must have dominated whoever approached him, including the king. Cellini gives a spirited account of the high esteem in which Leonardo was held at the French court and reports what he had heard from the king himself over twenty years after Leonardo's death:

> I feel that I must not neglect to repeat the exact words that I heard from the king's own lips about him, which he told me in the presence of the cardinal of Ferrara, the cardinal of Lorena, and the king of Navarre. He said that he did not believe that there had ever been another man born into the world who had known so much as Leonardo, and this not only in matters concerning sculpture, painting, and architecture, but because he was a great philosopher.[8]

It is difficult to believe that Leonardo left no tangible evidence of his activity in France. Art historians now agree that his ideas inspired the conception of Chambord. And yet the palace he planned for Romorantin, as clearly visualized from his notes and sketches, has no relation to Chambord and would have looked romantically old-fashioned to a Roman architect of the High Renaissance. He wrote down suggestions for the patron and instructions for the builders as if he were compiling a treatise on architecture reminiscent of Alberti's and Francesco di Giorgio's.

An abandoned work of architecture can exercise little influence unless its conception is made known through drawings and writings. One can hardly expect any influence from the few extant notes on the Romorantin project.

They are little more than first ideas jotted down as a preliminary framework for a more complex and thorough development. Perhaps it is not too farfetched to surmise that there must have been a detailed report, probably neatly compiled by Francesco Melzi, to be submitted to the king. Probably, even a model of the palace was produced, since the maker of the model of Chambord, Domenico da Cortona, was frequently in Amboise at the same time as Leonardo. It is certain, at least, that around 1542 Cellini acquired from an impoverished nobleman a treatise on painting, sculpture, and architecture copied from one by "the great Leonardo da Vinci." Both the original and the copy are lost, and there is no other evidence that Leonardo ever intended to write a treatise on architecture. Cellini, however, had shown the copy to Sebastiano Serlio, and one cannot fail to note that the type of treatise introduced by Serlio, consisting of figures of buildings and architectural members accompanied by short annotations, reflects a system adopted by Leonardo in his anatomical studies of 1510.

The style of Leonardo's late drawings is even reflected in the bird's-eye views of castles and parks in the drawings of Jacques Androuet Du Cerceau. These remarkable architectural images, which appeared in France toward the middle of the sixteenth century, have hardly any precedent other than Leonardo's late drawings in pen and ink, which show landscapes from the same high point of view. The minutest details of architectural elements and landscape are revealed with calligraphic precision, and yet with an almost oriental daintiness of touch. As in Leonardo's drawings, the inessential is obliterated, and fields and vegetation fade away beyond the enclosing walls of parks and gardens. It is a style that recalls Leonardo's drawing of a mausoleum in the Louvre or the Adda landscapes at Windsor.

Leonardo's literary remains do not contain a theory of architecture comparable to the theories expressed in his notes on painting. One document, however, reveals some of his views about architecture. It is the letter, dating from about 1490 and preserved only in a draft,[9] with which he probably intended to accompany his wooden model for the tiburio (crossing tower) of Milan Cathedral, and in which he drew comparisons between an ailing body and a dilapidated building. It has been shown that similar comparisons occur in Alberti, Filarete, and Francesco di Giorgio, but recently M. A. Gukovskj

has pointed out that the whole letter was more probably inspired by Galen's *De constitutione artis medicae*.[10] The document leaves no doubt about Leonardo's knowledge of some basic principles of architecture:

It [a building in need of repair] also requires a doctor-architect who understands the edifice well and knows the rules of good building from their origin and knows into how many parts they are divided, what are the causes that keep together an edifice and make it endure, what is the nature of weight and of energy in force, and in what manner they should be combined and related to one another and what effect they will produce when combined. He who has true knowledge of these things will plan the work to your satisfaction. Therefore I shall try to convince you, partly by reasoning and partly by my works, sometimes showing the effects from their causes, sometimes sustaining my argument by experiment, and bringing in the authority of ancient architects and the proofs already afforded by edifices that have been constructed and show the cause of their ruin or their survival.

Finally, when Leonardo submitted his model, he clearly stated the principle of conformity that he followed:

I shall begin by explaining the plan of the first architect of the cathedral and show clearly what was his intention, as revealed by the edifice begun by him; and, having understood this, you will see clearly that the model that I have made embodies the symmetry, the correspondence, and the conformity appertaining to the edifice from the beginning.

Such a statement may appear to contrast with the solution he submitted. It has been surmised that Leonardo was forced to withdraw his model from the competition in 1490 because it was impossible to disregard the local crossing tower tradition in favor of the Tuscan tradition of Brunelleschi's cupola design.[11] The existing drawings show that at an early stage Leonardo may have considered the daring solution of an imposing cupola, but as he worked the project out in detail the structure became more restrained, conforming with that of the edifice.[12] Some of his sketches show that he meant only to suggest the Tuscan element of the cupola underneath the vertical accents of turrets, pinnacles, and flying buttresses that were to crown the late Gothic edifice.

The only other place in which Leonardo expresses an evaluation of architecture is the Treatise on Painting, in a section of the *Paragone* that contains a eulogy of the eye: "This [the eye] is the prince of mathematics, its sciences are

6

most certain . . . it has generated architecture, and perspective, and divine painting."[13] In fact, according to Leonardo, it is painting, with its basic principle, design, that "teaches the architect to make his edifice agreeable to the eye."[14] Finally, in a note dating from 1492, Leonardo recommends the painter's training in perspective, proportions of man and animals, and architecture, obviously a reference to his own training in Verrocchio's studio: "and see that you are also a good architect, that is, insofar as concerns the form of buildings and other things that rest on the earth, which are unlimited in form."[15]

The material by Leonardo presented in this book might well have found its way into a treatise on the form of buildings; yet there is always a practical motivation behind every one of his architectural drawings. Even the series of studies for ecclesiastical architecture in the early Manuscript B can no longer be regarded as a theoretical digression on the centralized church. A recent study by S. Lang[16] shows that they pertain to a project for the Sforza Mausoleum, which was to develop into Bramante's conception of Santa Maria delle Grazie in 1492. Like his technological production, Leonardo's architectural drawings should be considered for their "unlimited forms" reflecting the richness of man's thought and inventiveness in an epoch that Leonardo is rightly entitled to represent.

PART ONE

THE ARCHITECTURAL CAREER
OF LEONARDO

Leonardo di Ser Piero Vinci, architetto et pittore, 1500.

Cod. Magliabechiano XXV, 636 (Cod. Strozzi), fol. 73 v

I. EARLY STUDIES
AND PROJECTS

A contemporary of Leonardo, Sabba da Castiglione, who had witnessed in 1499 the destruction of the clay model of the horse for the equestrian statue of Francesco Sforza, spoke of Leonardo as follows:

> . . . pochi altri lavori si trovano di sua mano, perche quando doveva attendere alla pittura, nella quale senza dubbio un nuovo Appelle riuscito sarebbe, tutto si diede alla Geometria, all'Archittetura & Notomia (. . . only a few other of his works exist, because, while he was expected to profess painting, in which he would undoubtedly have become a new Apelles, he devoted himself entirely to geometry, architecture, and anatomy).[1]

And when Luca Pacioli acknowledged Leonardo as the author of the drawings of the geometrical bodies for the *Divina proportione* he referred to him as the "degnissimo pictore, prospectivo, architecto, musico e de tutte le virtù dotato" (most praiseworthy painter, perspectivist, architect, musician, endowed with all the virtues).[2]

Leonardo himself, upon offering his services to Lodovico Sforza around 1482, stated that "in time of peace I believe I can give perfect satisfaction to equal any other in architecture and the composition of buildings public and private."[3] And the memory of Leonardo's architectural activities in Milan was still alive when in 1584 G. P. Lomazzo significantly referred to Leonardo as a "tanto huomo filosofo, architetto, pittore e scultore, che non meno seppe fare che insegnare" (so great a man, a philosopher, an architect, a painter, and a sculptor, just as skillful in teaching as in producing).[4]

There is no evidence that Leonardo had any formal training as an architect. But when he entered Verrocchio's studio, about 1469, Verrocchio was engaged in a commission that was to crown the greatest architectural undertaking of the

time—the completion of the cupola of Florence Cathedral by placing a copper ball on top of the lantern.[5] The tradition of Brunelleschi's technological innovations was still sufficiently strong in Florence for Leonardo to record in his earliest drawings the machines devised by Brunelleschi for constructing the dome.[6] One can sense that the already legendary figure of the Florentine architect had a particular appeal to the young Leonardo, and in fact the examples of Brunelleschi in architecture, Masaccio in painting, and Donatello in sculpture are the ones that he took as models and inspiration.[7] Only later, in Milan, did Leonardo become familiar with Alberti's *De re aedificatoria*, perhaps first through the treatises of Filarete and Francesco di Giorgio, and then directly when he acquired a copy of it.[8] Alberti's influence can be sensed in the changed way in which Leonardo's notes are compiled. They are now gathered in notebooks, and Leonardo seems to be compiling treatises in emulation of Alberti's. The loose sheets dating from the first years in Milan are still much like those dating from the preceding years in Florence, but the roughness of technological sketches is gradually replaced by a more methodical and neat presentation of contrivances, and in fact drawings and notes of about 1482–1485 give the impression that Leonardo intended to make a corpus of illustrations to the statements in his letter to the duke.

Leonardo's architectural drawings dating from the early years of his Milanese period are very few, and nothing is known from the previous Florentine period, except for some "edifizi" designed to house hydraulic devices.[9] His earliest known architectural drawings are those on the sheet containing an inventory of the works that he was to take to Milan (fig. 1).[10] They are ground plans of a huge palace, with a complex arrangement of rooms and courtyards, of the type envisaged by Giuliano da Sangallo for the king of Naples; they are echoed in Leonardo's later projects for a palace in the area of the Porta Vercellina at Milan.

In the first decade of his Milanese sojourn, from about 1482 to 1492, Leonardo's architectural studies are best represented by the notes in the Paris Manuscript B, part of which may even date as early as 1482.[11] This manuscript contains a series of church studies, the purpose of which is not necessarily only theoretical,[12] and a series of studies of fortifications, probably related to some work on the Castello Sforzesco. In addition to notes and drawings on geometry,

botany, mechanics, and technology, there are notes on architecture for festivals, and the well-known series of studies of civil architecture and the planning of an "ideal city."[13] The style of the drawings and handwriting, and related folios at Windsor and in the Codex Atlanticus, suggest a date of around 1487. Throughout the series there is a wealth of ideas and details. Leonardo was developing his architectural idiom in a way that reflects his parallel concern for language in collecting word lists in the contemporaneous Codex Trivulzianus. From time to time Leonardo would resume an early model, modifying only the style of its representation, or making it the starting point for new conceptions. The roof tiles on folios 12 recto and 22 verso of Manuscript B appear again, practically identical, in a folio of the Codex Atlanticus dating from the last years of Leonardo's activity, about 1518.[14] This is also true of the windows and portals on folio 68 recto. Calvi mentions a related drawing in Codex Atlanticus 295 verso-a, which shows a bifora (mullioned window with two lights) most probably inspired by those of the Palazzo Strozzi in Florence.[15] There is no doubt that Leonardo's later drawings and projects pertaining to palace architecture can be understood and appreciated better when compared with his earlier studies in Manuscript B.[16]

Vasari writes that in 1492 Giuliano da Sangallo was called to Milan by Lodovico Sforza to design a palace, and that on that occasion Leonardo, speaking with him, received some excellent suggestions on the casting of the Sforza horse.[17] It is also documented that Leonardo was acquainted with Francesco di Giorgio, with whom he was in Pavia in 1490 to examine architectural problems in the construction of the cathedral.[18] (And it is well known that Leonardo owned and annotated a codex of Francesco di Giorgio.)[19] Finally, the competition for the tiburio of Milan Cathedral, which Leonardo entered in 1487 with a wooden model,[20] must have brought him into contact with Luca Fancelli, Alberti's assistant at Mantua. All these personal contacts, taken in conjunction with the tradition of Filarete and Michelozzo in Milan, resulted in Leonardo's projects for the urban replanning of Milan, studied from the theoretical point of view first (1487–1490), and then in a detailed, practical plan to be submitted to Lodovico Sforza in 1493–1494, and preserved in a draft in the Codex Atlanticus (fig. 2).[21] Leonardo planned to enlarge the city by adding, outside the city gates, a ring subdivided into ten sections, to which Leonardo refers as ten

cities. Each section was to have a regular arrangement of houses and piazzas around a marketplace as nucleus. Leonardo's financing plan, based on the idea of deriving contributions from the revenue paid by a wealthy industrial center of the dukedom, Lodi, includes the suggestion of taking one section of the projected new ring as the ground for a "pilot" urban unit. This is the section between the Porta Romana and the Porta Tosa, and one is reminded that in the eighteenth century a house near the Porta Romana was traditionally attributed to Leonardo.[22] Leonardo's detailed planning of this section is reminiscent of Sangallo's ideas, and there is a classical flavor in the general layout and especially in the design of the houses, which are placed back to back with end projections framing a space to serve as a garden or courtyard. The area is divided into two halves. In the center is a large square structure with an interior colonnade, which Leonardo inscribed "spesa" (marketplace). Outside the eastern boundary of the area Leonardo indicates an existing construction with a word, "giessa . . . ," which the editor of the codex failed to transcribe correctly and to explain. It is obviously a reference to the monastery of San Pietro in Gessate, which had two cloisters reported to be designed by Bramante.[23] What should increase interest in these designs, says Horst de la Croix, is the fact that an actual extension of the city was eventually carried out in the manner suggested by Leonardo.[24]

After 1494 Leonardo became engaged in a series of architectural decorations, the significance of which fully emerges when taken in conjunction with his later projects. Thus, the decoration of the Sala delle Asse in the Castello Sforzesco is not only a piece of pictorial virtuosity but belongs to the repertory of Leonardo's architectural ideas as well.[25] The painted pergola suggests the motif of archivolts made of intertwined branches springing from columns in the form of tree trunks, as in the much later project for the Medici Palace. Around 1494 Leonardo was in Vigevano, working at the Sforzesca, the Sforza residence on which Bramante was engaged at the same time.[26] The theory that Leonardo designed the piazza at Vigevano is put forward with much passion by Berghoef in a recent article,[27] but Leonardo's participation in the works at the Sforzesca at Vigevano has been well documented since the eighteenth century (B. Oltrocchi, J. B. Venturi, C. Amoretti), and there is no evidence that he was engaged in works other than decoration and hydraulics. Yet he may have

inspired Bramante's design for the replanning of the piazza. The detail of a drawing in Manuscript B, folio 39 recto, shows a building almost identical to those flanking the piazza at Vigevano, but the early date of Manuscript B makes the correlation doubtful.

It was above all in Milan that Leonardo was to perform as an architect. The history of Milan by his contemporary Bernardino Arluno, published in 1530, contains a detailed account of the vast program of urban improvements undertaken by Lodovico Sforza.[28] Leonardo, Bramante, and Caradosso are specifically mentioned as the court artists responsible for the realization of the duke's ambitions.[29] Reference is made to the opening of two new city gates, which were named after the duke and his wife (Porta Lodovica and Porta Beatrice); to the reorganization of the piazza in front of the castle, which created an urban center around the new court as the counterpart of the old center around the cathedral and the old court; and finally to the splendid growth of houses of prominent citizens in the area of San Vittore outside the Porta Vercellina, with the church of Santa Maria delle Grazie as the focus of the duke's patronage.

Leonardo's residence in Milan during the Sforza period was at the Corte Vecchia, next to the cathedral, where Isabella of Aragon, widow of Gian Galeazzo Sforza, also lived. It was there that Leonardo modeled the gigantic horse for the Sforza monument.[30] And it was on the roof of the Corte Vecchia that he intended to test a flying machine, around 1497.[31] Since Leonardo speaks of hiding behind the tower of San Gottardo in order not to be seen by those who were working on the tiburio of the cathedral, it can be assumed that his quarters were near that tower. A drawing in scale of the ground plan of a palace in Codex Atlanticus 80 recto-a (fig. 3), about 1487,[32] may refer to some work of rearrangement of rooms in a wing of the Corte Vecchia, but the eighteenth-century alterations of the palace make the identification impossible. A drawing of the identical edifice, in the identical scale, is in a sheet at Windsor, 12692 verso (fig. 4), which Leonardo subsequently filled with pictographs.[33] The huge building is designed in metal point, invisible in reproduction, and only part of it is inked in. No other scale drawings by Leonardo have survived.

II. THE GUISCARDI HOUSE

In 1498 Lodovico Sforza presented Leonardo with a vineyard in the area of San Vittore near the church of Santa Maria delle Grazie.[1] In the same area the duke had assigned land and houses to prominent citizens faithful to him, as for example the Atellani, whose house was located between Santa Maria delle Grazie and Leonardo's vineyard.[2] It was in the Atellani house that Luini painted a celebrated ceiling decoration reminiscent of Leonardo's motifs. At the return of the Sforzas in 1512, after the French intermission, the Atellani house was still looked on as one of the most distinguished intellectual circles in Milan, especially because of the presence of Barbara Stampa, wife of Carlo Atellani and a patroness of the arts, whom Leonardo mentions in a folio of about 1513.[3] The suburban area of the Porta Vercellina was enriched by the magnificent house of Galeazzo Sanseverino, who was a captain in the service of the Sforzas and the son-in-law of Lodovico Sforza. It is well known from a record in Leonardo's own hand that in 1490 Leonardo organized a festival in this house.[4] And it has been surmised that Leonardo's studies of stables in the 1490s were in fact for the stables added to the house, a hypothesis favored by Leonardo's reference to horses in Galeazzo's possession that he had used as models for his Sforza monument.[5] That one of the three manuscript copies of Pacioli's *Divina proportione* is dedicated to Galeazzo Sanseverino is further evidence of his role as a patron.[6] Pacioli, speaking of sixty geometrical bodies designed by Leonardo for that treatise, specifies that a set of them was done for Galeazzo.

It was in Galeazzo's house that Pacioli was accommodated around 1496, when he arrived in Milan to teach mathematics and architecture,[7] and it is significant that Sanseverino was among the distinguished citizens and scholars to whom Pacioli lectured in 1498 on Vitruvian principles related to the problems of Milan Cathedral.[8] Palace and stables were destroyed in 1499 at the collapse of the Sforza dynasty, as reported by Arluno in his history of Milan and *De bello Gallico*—two documents made known at the end of the eighteenth century.[9]

16

II. THE GUISCARDI HOUSE

With the discovery of the documents pertaining to Leonardo's vineyard, scholars came to realize that he must have participated in the urban planning of the area of Santa Maria delle Grazie. After a first tentative identification of the site of the vineyard suggested by G. Biscaro in 1909, Luca Beltrami in 1920 established its exact location, a strip of land still kept as a vineyard much as in Leonardo's time.[10] The location was identified on the basis of references given by the documents to neighboring properties, one of which belonged to a prominent member of the Sforza administration, Mariolo de' Guiscardi. The reports of the devastations of 1499 include a reference to a magnificent palace of Mariolo de' Guiscardi, which was not yet completed ("nuouamente fondata et non ancora coperta," says Corio)[11] and was badly damaged together with its park. The Guiscardi property is mentioned again in a document of 1540 concerning the sale of the land "super quibus alias aderat pallatium seu domus que nunc sunt diructe, salvis muris circumdantibus dicta bona. . ." (on which there used to be a palace or dwellings now in ruin, except for the enclosing walls. . .).[12]

In a notebook dating from the last years of the fifteenth century, the Paris Manuscript I, Leonardo compiled a schematic survey of lots of property shown to be located in the area of the Porta Vercellina by such specifications as "siluestre," "ponte tincone," "porta di vangelista," and above all by the note:

la strada di meser mariole he braccia $13\frac{1}{4}$
la casa di vangelista he braccia 75.[13]

In 1925 Gerolamo Calvi was able to relate the notes in Manuscript I to sheets of architectural projects in Codex Atlanticus 158 recto-a, verso-a (figs. 5 and 6) and to conclude that Leonardo was engaged around 1497–1498 in the design of a vast palace either for Galeazzo Sanseverino or Mariolo de' Guiscardi, both of whom had property in the area to which Leonardo refers.[14] Since Calvi left the problem open, it has become customary to refer to Leonardo's drawings on folio 158 of the Codex Atlanticus as pertaining to a house planned for Galeazzo Sanseverino;[15] yet there is no evidence that Galeazzo ever intended to build a new house in addition to the one that he already had. That Leonardo might have designed the stables for him does not prove that the projected palace was for him. Calvi rightly gives equal weight to the hypothesis that the house was for Mariolo de' Guiscardi, whom Leonardo specifically mentions in his

notes in Manuscript I. Furthermore, Leonardo once mentioned one of Mariolo's horses, just as he had mentioned horses belonging to Galeazzo.[16] Thus the presence of stables in the projected palace cannot be taken as evidence that the palace was for Galeazzo rather than for Mariolo de' Guiscardi.

The folio containing Leonardo's studies of the ground plan of a palace (figs. 5 and 6) is a sheet on which the patron himself had written a number of requirements, such as the reception hall, quarters for his wife and her maids, stables, quarters for retainers, and finally a "canzelaria," that is, a chancery, or study:

> Note that we want [one room with *deleted*] a parlor of 25 braccia; a guardroom for myself; a room with two attached rooms for my wife and her maids, with a small courtyard.
> Item, a double stable for 16 horses, with the room for the stable attendants.
> Item, a kitchen, with attached larder.
> [Item, two rooms, with a chancery *deleted*.]
> Item, a dining room of 20 braccia for the retainers.[17]
> Item, one room.
> Item, a chancery.[18]

In the remainder of the sheet Leonardo started outlining the ground plan of the palace, with a detailed study of the kitchen area, which is shown as a curiously elaborate exedra flanked by two circular rooms. On the verso he carried the project further, with computations and specifications, even referring to a design already submitted that had to be revised: "The drawing that I have made has a larger façade behind than in front, whereas it should be the opposite."[19]

The detailed explanation of the arrangement and function of the rooms forms an interesting document of the architectural planning of the time, illustrating the relationship between patron and architect. Leonardo is dealing primarily with the quarters of the master of the house, which are located in the left wing of the palace. As for the purpose of the right wing, which is drawn almost symmetrical, there is only one hint: the room at the right corner of the façade (second plan from above) is designated as stables. The apartments of the wife and her maids, as well as the quarters for the retainers, were probably to be located in this wing of the house.

II. THE GUISCARDI HOUSE

A plan (third from above, on the left) has rooms designated with letters, which are explained in the legend written next to it:

a. Large room for the Master.
d. Room.
b. Kitchen.
c. Larder.
n. Guardroom.
o. Large room for the retainers.[20]

Above the plan Leonardo wrote: "The large room for the retainers away from the kitchen, so that the master of the house may not hear their clatter; and let the kitchen be convenient for washing the pewter so that it may not be seen being carried through the house."[21]

The larger plan (fourth from above) is headed: "See that the retainers do not use the logs kept in the kitchen for the convenience of the kitchen"; and is inscribed, from top to bottom: "Hall. Larder. Kitchen. Cupboard. Hall of the retainers. Room for the retainers. 3 rooms for the guests."[22] On the left of the plan Leonardo explained:

Larder, logs, kitchen, and chicken coop, and hall and room [of the retainers] will be or ought to be adjoining for the convenience that ensues.

And the garden and stable, manure and garden, adjoining.

The large room for the master and that of the retainers should have the kitchen between them, and in both the food may be served through wide and low windows, or by tables that turn on swivels.[23]

The master's living quarters are located at the far end of the wing, overlooking the garden. The plan immediately below, to the right, specifies the alignment of his bedroom and hall ("camera del padro," "sala maestra del padroni," bedroom of the master, hall of the master) and introduces some variations in the arrangement of the retainers' quarters, which are now parallel to those of the master and in line with the kitchen. The logs are kept in a large room in line with the "cortesella," the small courtyard.

The plan below shows still more variations. The kitchen appears again between the master's large room and the retainers' quarters, but the small courtyard is moved to the left. Another set of notes on the left deals with the quarters of the master's wife:

As for the lady of the house, we should make her own room and hall apart from the retainers' hall, because her serving maids will eat at another table in the same hall.

She should have two rooms besides her own, one for the serving-maids, the other for the wet nurses; and several small rooms for their utensils.

I want one door to close the whole house.[24]

The last sentence recalls the postulate in the earlier Manuscript B, folio 12 verso: ". . . serra l'uscio m̲ e ha' serrato tutta la casa," thus stressing that Leonardo's plan is presented in the form of a treatise. No detailed plan illustrates the paragraph pertaining to the wife's quarters, but her apartment was probably in the right wing of the palace. Finally, the note at the bottom of the sheet suggests further refinements of the kitchen service: "He who is stationed in the buttery ought to have behind him the entrance to the kitchen, in order to be able to do his work expeditiously; and the window of the kitchen should be in the front of the buttery so that he may extract the wood."[25]

In addition to plans and notes, both the recto and the verso of the sheet contain calculations. Those on the recto (fig. 5) are accompanied by the note: "a width of a hundred braccia and a length of 294 are $15\frac{3}{4}$ pertiche."[26] It is known that the area of Leonardo's vineyard was 16 pertiche, and that its size (ca. 50 × 200 m.), as determined by Beltrami, was much narrower and longer than the area considered by Leonardo (ca. 60 × 150 m.). Similar annotations appear in Manuscript I, folio 50 verso: "If I take a width of 95 braccia and a length of 294, I have 15 pertiche. If I take a width of 100 braccia and a length of 194 [i.e. 294], I have $\frac{3}{4}$ of a pertica more than necessary, which is left in the back."[27]

Among the calculations in the folios gathered by Calvi the number 1855 appears frequently; this is explained by Leonardo himself in Manuscript I, folio 51 recto, as the number of quadretti which make up the pertica. Leonardo's note is an estimation of the value of an area of 15 pertiche: "at 4 soldi a quadretto (the pertica being 1855 quadretti), each pertica will cost 371 lire, i.e. $92\frac{3}{4}$ ducats, and so 15 pertiche will cost $1391\frac{1}{4}$ ducats."[28]

Calvi surmises that Leonardo's intention was to evaluate the property that Lodovico Sforza was to assign to him. Yet we know from documents that the Guiscardi Palace had a garden measuring 15 pertiche.[29] One of the computations in Codex Atlanticus 158 recto-a is 1855 × 15, which gives 27825, that is,

the number of quadretti corresponding to 15 pertiche—a computation repeated in Manuscript I, folio 51 recto.

There is no doubt that all these computations refer to the project of a house commissioned from Leonardo by a prominent citizen. It is known that the property acquired by Mariolo de' Guiscardi included a number of houses that he had to demolish in order to build his palace,[30] and it is therefore possible that the estimate of the cost of the land in Leonardo's notes refers to Mariolo's intention to purchase more land to be turned into garden. Calvi mentions another folio of the Codex Atlanticus, 393 recto-a (fig. 7), which contains two ground plans of edifices and calculations resulting in the figures 1936 and 1944, that is, the number of square braccia in each pertica, as explained in Manuscript I, folio 59 recto: "One pertica is 1936 square braccia, or 1944." This points to a correspondence between architectural drawings and the set of calculations in Manuscript I.[31]

Folio 393 recto-a contains the note: "90 in fronte e 330 illungo," which suggests an area somewhat in the proportions of those considered in the notes on folio 158 recto-a (294 × 100 braccia) and in Manuscript I (294 × 95 or 100 braccia). It may again be a reference to the area of the Guiscardi House, although the ground plans on folio 158 point to a façade far larger than 90 braccia.[32] Indeed, the general layout suggests the type of ground plans studied on folio 158 verso-a, but Leonardo seems to be concerned mainly with the organization of the garden at either side of an emphatically marked axis. The sketches are too slight to show Leonardo's intentions for the structure to be placed at the end of the garden; it has a circular area in line with the longitudinal axis and may have been intended as a nymphaeum similar to that of the Villa Giulia of fifty years later.[33]

Another sheet of the Codex Atlanticus, folio 377 recto-a, shows that the project for Mariolo de' Guiscardi must have been studied in conjunction with a broader plan of urban replanning for the area outside the Porta Vercellina. This folio contains drawings of the same textile machine and system of flyer spindle as shown in folio 393 recto-a. Furthermore, it contains the computations 45 × 45 = 2025 and 44 × 44 = 1936, the latter being repeated on folio 393 recto-a. On the verso of folio 377 (fig. 8) are architectural studies which must therefore relate to the same problem studied on folio 158. A note leaves

no doubt that Leonardo is dealing with the project of a building: "[la]ccinta . he braccia 18 dj vachuo overo 19 il tutto . lintrata braccia 6 . ellostudjo 11 e $\frac{1}{2}$ / . una sala lunga braccia 18 ellarga 12 e alta .8. ellalteza dello studjo braccia 7 e $\frac{1}{2}$ / la [chamera *deleted*] sala e chamere vn granaro alto braccia 4."[34] What can be understood of this note is the reference to a hall, whose dimensions are given as 18 by 12 by 8 braccia, and to a studio (study), which may well correspond to the "canzeleria" required by the patron of the palace studied on folio 158.

The architectural sketches on folio 377 verso-a echo the ones on folio 393 but seem to include an even wider area, as if the context were a general urban replanning of a quarter of the city. Leonardo seems to be studying a street arrangement aiming at more efficient communication between the properties in the area of San Vittore, the Porta Vercellina, and Sant' Ambrogio, and the nearby Sforza Castle. The large avenue flanking San Vittore is known to have been opened in the last years of Lodovico Sforza's government.[35] So also was the straight avenue perpendicular to it linking San Vittore to Santa Maria delle Grazie, that is, the present Via Zenale, on which lay the entrance to Leonardo's vineyard. A small, rough sketch in a corner of folio 377 verso-a, when compared with a detail of a later map of Milan, can be identified as the area outside the Porta Vercellina, showing the piazza of Santa Maria delle Grazie linked to the monastery of San Vittore by a straight avenue (figs. 9 and 10). Leonardo seems to have been planning a street that was to run along his own property and, crossing the newly opened avenue, reach the property of Mariolo de' Guiscardi.[36] The nearby area of the Sforza Castle is sketched in Manuscript I, folios 32 verso and 38 verso, in an equally vague way.

Leonardo's architectural activity in 1497–1498 is therefore hinted at in only three folios of the Codex Atlanticus and a few notes in the Paris Manuscript I. But the latter contains, in addition, some architectural sketches that may be related to the Guiscardi House. They are as follows:

(1) On folio 18 verso (fig. 11): red chalk sketch of the ground plan of a palace, with numbers in pen and ink to correspond to each side of the palace, that is, 75 for the façade, 55 for the rear façade, $136\frac{1}{3}$ for the right side, and $133\frac{1}{3}$ for the left side. Leonardo appears to have been studying the replanning of an existing irregular structure similar to the ground plans in Codex Atlanticus 158.

The dimension of the frontage, 75, may be related to the note quoted above from Manuscript I, folio 118 verso: "la strada di messer mariolo he braccia $13\frac{1}{4}$. La casa dj vangelista he braccia 75." Vangelista was probably a neighbor of Mariolo, and Leonardo must have had some reason to record the ground plan of his house.

(2) On folio 56 recto (fig. 12): ground plan and elevation of a country villa. If this is a study for the Guiscardi House, it shows that Leonardo was probably thinking of Brunelleschi's Pazzi Chapel as suitable for being turned into a secular building, which would have been sufficiently imposing to harmonize well with Bramante's apse of the nearby church of Santa Maria delle Grazie.[37]

(3) On folios 52 verso and 56 verso (figs. 13 and 14), which contain details of wall treatment: a window flanked by a set of paired columns and a study of the pilasters of a portico. They show the type of wall articulation, possibly inspired by Bramante, that was to become the main characteristic of Leonardo's secular architecture after 1500.

III. TUSCANY AND ROMAGNA

In 1499 Leonardo left Milan and went to Venice as a military architect, accompanied by his friend Luca Pacioli. One of his friends at the Sforza court who had remained faithful to the Sforzas—Giacomo Andrea da Ferrara, an architect and a commentator of Vitruvius—was killed, his body quartered and placed at the four points of the city.[1] Leonardo's celebrated meditation on the fall of the Sforza dynasty contains a reference to edifices by Bramante and to works for the duke that could not be carried out.[2]

On his way to Venice Leonardo stopped in Mantua as a guest of the Gonzagas, where he drew a charcoal study for a portrait of Isabella d'Este. Nothing is known of his brief visit to Venice, but a sheet of notes in the Codex Atlanticus shows that he intended to submit to the Venetian Republic a plan of defense against the threatened Turkish invasion. His plan consisted of a system of locks that were to turn the Isonzo River into a water barrier. A reference in one of his later studies for the Romorantin Palace shows that the project was actually carried out. (See pp. 95–96 below.) Soon after his arrival in Florence in 1500 he was consulted as an architect about the sliding foundations of the church of San Salvatore.[3] About one mile south of that church stood the villa of a Florentine merchant, Agnolo Tovaglia. In this villa Francesco Gonzaga, Isabella's husband, had been lodged when he was in Florence as a Condottiere sometime before 1500; the marquis decided to build a replica of it for himself near Mantua. In July 1500 he wrote to Agnolo asking for a drawing and the measurements of the villa.[4] On August 11, 1500, Francesco Malatesta, Gonzaga's agent in Florence, sent the drawing to Mantua, explaining how its author, Leonardo da Vinci, was ready to make one in color, or a model. Malatesta reports Leonardo's significant observation that in order to make a satisfactory replica of the villa one should move its typical Tuscan landscape to Mantua.[5] The Villa Tovaglia still exists. It overlooks the Ema valley on the way to Santa Maria a Montici, and is known today as "La Bugia" (The Lie, because of an eighteenth-century feigned façade that suggests a much larger edifice).[6] It has been restored

considerably, but the interior arrangement is still the same: a great hall some-what reminiscent of that of the Villa Medici at Poggio a Cajano, with stairs at one end and rooms at either side of it. A similar arrangement is seen in a series of ground plans in Codex Atlanticus 220 recto-c and verso-b (figs. 15 and 16), which I have already suggested might refer to the Villa Tovaglia.[7] Other drawings that I tentatively proposed as referring to that villa are those in Manuscript I, which are now identified as related to the projects for Mariolo de' Guiscardi's house in Milan, 1497–1498. I cannot reach a final verdict in dating the studies on folio 220 of the Codex Atlanticus. They are certainly later than 1500 because of the style of handwriting and their characteristic greenish ink, which Leonardo was using especially around 1507–1509.[8] A little elevation drawing on the recto shows that the house was to be built on some elevated point; at least there was to be a slope on one side, and the area in front of the arcaded loggia was to be arranged on two levels. An approaching path is shown as climbing considerably as if it were a flight of steps. It must be borne in mind that throughout these studies Leonardo shows only a part of the house, that is, the area corresponding to the side of the courtyard that faces the entrance. Everything else is shown as razed to ground level: what appears to be the shaded side of the house in the elevation drawing is in fact a side resulting from the section of the house along the line of the courtyard. Once visualized in its entirety the edifice would have more imposing proportions.

The main interest of the drawing lies in the studies for a triple-ramped stair hall.[9] In fact the studies on the verso, if taken in isolation, would appear to be a draft of notes for a treatise on stairs, but the tendency to theorize is characteristic of Leonardo, even when there is evidence that he is working on a commission. Thus he ends his careful instructions with the axiomatic sentence: "maj le teste delle sale deono esse/re rotte" (one should never have a hall wide open at its head).

Finally, the project includes a study for some machinery to be located in a room on the left side of the hall. It is impossible to explain its purpose, because it is not shown in elevation; but a few slight sketches on the recto might be interpreted as representing a waterwheel. I am tempted to relate them to the instrument that Leonardo made for Bernardo Rucellai around 1510, a water meter consisting of a hollow wheel with eight openings.[10] But a date around

1510 may be too late, just as the one around 1500 suggested before may be too
early. On the basis of style and handwriting I would date the drawing about
1507: a folio of such a date and style, Codex Atlanticus 282 recto-b, which
was originally joined to folio 282 verso-c (figs. 17 and 18), contains a similar
ground plan next to the sketch of a mechanism inscribed: "molino dalla doccia
di uincj."[11] But this is too slight evidence to suggest that the project refers to
some construction in Leonardo's hometown.

In 1502 Leonardo was in Romagna, in the service of Cesare Borgia, as engi-
neer and chief architect in charge of harbors and fortifications. In July of that
year he was in Urbino visiting the fabulous Ducal Palace, which was known to
him only through the descriptions of his friends and colleagues Bramante and
Francesco di Giorgio. He took note of the monumental staircase and of the
small Cappella del Perdono.[12] Then followed a period of intense activity in
Florence and Tuscany, from 1503 to 1506, which includes three projects per-
taining to the Arno: (1) to divert its course at a point near Pisa, for strategic
reasons, (2) to make it navigable by means of a canal from Florence to Prato,
Serravalle, and to the sea, and (3) to straighten its course east of Florence. All
the projects are known through a series of magnificent maps at Windsor and
in the second of the newly discovered manuscripts at Madrid. The latter brings
new evidence of Leonardo's architectural works in Tuscany in 1503–1504,
especially on the harbor and fortifications of Piombino. It was already known
that Leonardo had envisaged draining the marshes of Piombino, but the slight
evidence of his presence there was always associated with his task as an architect
in Cesare Borgia's service in 1502.[13] We know now that Leonardo was in
Piombino in the last two months of 1504, and in fact the sketch of the "padule
di piombino" in Codex Atlanticus 139 recto-a is drawn next to a series of
studies of a system of wing joints preliminary to the drawings in the Codex on
the Flight of Birds of 1505. In the Madrid Manuscript II there are several pages
of calculations and drawings pertaining to Piombino, which are discussed in
the following chapter; and, since they date from 1504, Leonardo must have
been in the service of Jacopo IV Appiani, the patron to whom he refers as the
"Signore di Piombino."[14] His notes contain a reference to the cost of architec-
tural work in Rome,[15] which can be taken as another hint that Leonardo made
his first visit to Rome at the beginning of the sixteenth century.[16]

III. TUSCANY AND ROMAGNA

At the time of his drawings of maps, about 1504, Leonardo frequently wrote in the ordinary way, from left to right. It has been shown that he did so also around 1479–1482, at the crucial period of his decision to move to Milan.[17] Both occurrences may be explained by Leonardo's need to show his work to other persons. This is the case with the map of the Pontine Marshes, about 1514, in which the notes are written by Leonardo's pupil Francesco Melzi.[18] In 1504, the year of his father's death (an event that Leonardo recorded in left-to-right handwriting),[19] Leonardo's intense field activity in Tuscany alternated with pauses of theoretical work that led him to the intention of resuming a treatise on architecture. The theoretical pages in the Arundel Manuscript, which have been singled out as a brief treatise on the causes of fissures in walls, date from about 1506 and are the result of Leonardo's investigation into the origin of the sliding movements threatening the church of San Salvatore and the nearby campanile of San Miniato in Florence.[20] There is also a sheet of notes on the shape and proportion of columns and capitals, Codex Atlanticus 325 recto-b,[21] which is written from left to right in the same handwriting as the note with the record of the death of Leonardo's father, 1504, and the notes to the maps of the Arno projects.

During the period 1503–1506 Leonardo was much occupied by studies for the great mural, the *Battle of Anghiari*, that was to decorate a portion of the Council Hall in the Palazzo Vecchio. He was accommodated in the monastery of Santa Maria Novella, in which a large room, the Sala del Papa, was turned into a suitable studio for him. It was there that he prepared the cartoon, testing a new color technique on a small-scale model. On June 6, 1505, he began painting on the wall in the Palace. About a year later he went to Milan on a three-month leave of absence, leaving behind what Gonfaloniere Soderini was to call bitterly "a small beginning of a great work he was supposed to do."[22]

We know that Michelangelo was commissioned to paint another portion of the same hall, but his composition, the *Battle of Cascina*, was not carried beyond the cartoon stage. The competition was highly significant, not only for the direct confrontation of the two major artists of the moment but also because their work would have concluded the architectural program of the construction of the Council Hall, a program undertaken in 1495 by a group of architects headed by Antonio da Sangallo the Elder.[23] Vasari speaks of long meetings held

27

before work on the building started and mentions the participation of Leonardo, Michelangelo, and Giuliano da Sangallo.[24] Finally, in addition to Antonio as designing architect, Cronaca and Baccio d'Agnolo were appointed as temporary builders. By 1498 at the end of the construction, Antonio's post was taken over by Baccio d'Agnolo, who, as "capomaestro del palazzo," was to carry out the important woodwork of the furnishing.

It has been argued that Leonardo could not have had any part in the preliminary discussions on the building of the Council Hall because he was in Milan at the time. In fact, his activity in Milan between 1495 and 1499 is well documented. By November 1494 he must have given up his hope of seeing the colossal horse cast in bronze; he was subsequently engaged in the decoration of rooms in the Sforza Castle and finally was commissioned to paint the *Last Supper*. His presence in Florence in 1495 would have been justified only during the period of preliminary discussions for the building of the new hall—that is, between May 23, when Antonio da Sangallo was appointed as architect in charge, and July 16, when Monciatto and Cronaca were appointed as builders after the plans for the building had been agreed upon. The work was carried out with incredible speed, and by 1498 the immense room was finished (figs. 19, 20, and 21). It was actually a freestanding building in the back of the Palazzo Vecchio, connected to the old palace only by a passage leading to the Sala dei Dugento. Stairs were built only later, around 1510 (either by Baccio or Cronaca), leading from the court of the palace to an independent entrance at the opposite end of the hall, approximately where the entrance to the studiolo of Francesco I is now. This arrangement was completely altered by Vasari in 1563.

Marie Herzfeld has shown that a sheet in the Codex Atlanticus contains a note, not by Leonardo, instructing "Maestro Lionardo" to find out how the "Reverend Father, called frate Jeronimo" (obviously Savonarola) had arranged the fortification system of Florence.[25] Unfortunately, since Leonardo only sketched the profile of a ditch on the sheet, there is no way to ascertain its date, which may be later than 1498, that is, after Savonarola's death. It is probable that Vasari's remark about Leonardo's participation in the plan of the Council Hall was intended to refer to a later phase of the work, that is, to the woodwork furnishing entrusted to Baccio d'Agnolo, with whom Leonardo must have been in touch soon after 1500. In fact, while Leonardo was preparing the cartoon

of the *Virgin and St. Anne* for the Servites, Baccio received the commission for the architecture of the high altar for the same church. A sixteenth-century source mentions the altar as having the form of a triumphal arch and as having been designed by Leonardo.[26]

Vasari describes the wooden furnishing of the Council Hall as a masterpiece taken apart and dispersed with the return of the Medici in 1512. And the chronicler Landucci states that the whole city regretted the loss of that masterpiece even more than the loss of liberty.[27] The hall was turned into lodging for mercenary soldiers and thus came to be called the "sala della guardia." There seems to have been some concern for the fragment of Leonardo's *Battle of Anghiari* painted on a wall, since in 1514 a carpenter was paid to make some kind of frame around it in order to protect it.[28]

At the center of the longer wall of the trapezoid-shaped room was the loggia for the Gonfaloniere and the Signori. On its entablature was to be placed a life-size marble statue of the Saviour commissioned from Andrea Sansovino in 1502. At either side of it stood a window and a large space, which was to be decorated by a mural. Leonardo was probably given the space on the right, and Michelangelo, who entered the competition about a year later, the one on the left. Facing the loggia, on the opposite wall, there was to be an altar with a monumental frame (sometimes referred to as cappella) designed by Filippino Lippi and carved by Baccio d'Agnolo. Filippino first and Fra Bartolomeo later (1510) were commissioned to paint the altarpiece for it. Fra Bartolomeo's unfinished altarpiece is now preserved in the museum of San Marco (fig. 22). It represents the Virgin and Child with St. Anne and the little St. John the Baptist (as in Leonardo's "Burlington House cartoon"), surrounded by the Florentine saints on whose days the city had its victories.[29] The central figures are set against a niche flanked by columns, with steps leading to their seat. The painted architecture may well have been a continuation of the architecture of the frame, which in turn may have been linked to that of the room. Unfortunately, we have no other evidence of the iconography of the room except Vasari's description of Cronaca's architecture and a glimpse of a corner of it in one of Vasari's octagonal paintings on the ceiling of the present room.[30]

While Leonardo was undertaking the decoration of the wall, Filippino and Baccio were busy with the wooden architecture of the room. Something of

the classical fantasies of Filippino's painted architecture in Santa Maria Novella —but restrained, as in a woodcut of Francesco Colonna's *Hypnerotomachia Poliphili*—must have gone into Baccio's woodwork, a spectacular, almost theatrical setting most suitable for the solemnity of the place. This wooden architecture must have set a model in Florence. It is echoed in Michelangelo's design for the furnishing of the Laurentian Library and may explain why Michelangelo intended to have the stairs of the vestibule built in wood.[31] There is no evidence for the design of the loggia for Gonfaloniere Soderini and the monumental frame for the facing altarpiece. Something of their appearance might have filtered down into Michelangelo's conception for the Tomb of Piero Soderini in San Silvestro in Capite, Rome, commissioned in 1518.[32] For one of Michelangelo's sketches (fig. 23) the Altoviti Tomb in Santissimi Apostoli has been suggested as a quattrocento precedent. From placing Michelangelo's sketch next to one of Leonardo's studies for the Trivulzio Monument of 1506–1508 (fig. 24) an obvious conclusion ensues: they appear to stem from a common source, which might have been the lost frame for Fra Bartolomeo's altarpiece. It is worth noting that next to Leonardo's sketch is a smaller sketch with an alternative solution resembling Sansovino's wall tombs in Santa Maria del Popolo, Rome, of 1505, again something that may be referred back to the decoration of the Council Hall of Florence. In Leonardo's sketches for the Trivulzio Monument (figs. 24 and 25) the architectural element of the base always has a wooden quality, even when it echoes Bramante's Tempietto or Michelangelo's first project of the tomb of Julius II. It is true that Leonardo's estimate of the cost of the monument specifies the use of marble and stone, but significantly enough he envisages bronze capitals,[33] as in the architecture in Botticelli's and Filippino's paintings. Therefore, when Leonardo sketched his first ideas for the Trivulzio Monument, the memory of the wooden architecture of the Council Hall in Florence must have been still fresh in his mind.

There is a sketch in Codex Atlanticus 264 recto-a (fig. 26), which I have tentatively referred to the Trivulzio Monument.[34] The folio contains geometrical studies of about 1508, and we know that in the first months of 1508 Leonardo was in Florence. Two sketches are ground plans of a square room, which I was inclined to interpret as a project for the Trivulzio chapel in San Nazaro. One elevation sketch, which resembles the Sansovino type of base for

the Trivulzio Monument, is probably meant to represent an altar. One of the ground plans shows an arrangement of benches within the square area that corresponds to what we know of the central portion of the Council Hall.[35] If these sketches refer to the Council Hall (unfortunately a larger drawing has been cut out of the sheet, mutilating one of the sketches), it may be that Leonardo was envisaging an ambulatory behind the altar, with a passage to link the Council Hall to the Palazzo Vecchio.

IV. THE FORTIFICATIONS
OF PIOMBINO

On April 2, 1504, Machiavelli was sent to Piombino on a diplomatic mission; the only records of this are the instructions that the Signoria gave him and the credentials with which he was to introduce himself to Jacopo IV Appiani, lord of Piombino. The editors of Machiavelli's *Legazioni e commissarie* reproduce the two documents and add that nothing else is known of the mission.[1] The sheet of instructions is therefore the only evidence left of the action that Florence was prepared to take in favor of the recently restated lord of Piombino.[2] It was the time of the war between Florence and Pisa, and Florence was well aware of the strategic importance of Piombino. Machiavelli's mission was to reestablish friendly relations between the Florentine republic and Jacopo IV Appiani, offering him assistance and protection. The instructions read as follows:

Nicolo, you will go to Piombino on horseback to see the lord of that town about the matters we have discussed here, which have seemed to be of some importance to us, both for that lord's interest, which is our main concern, and then for our own interest. And you will explain to him how we wish his state to be preserved as it is at the present time. And since we know about the gathering of people at the Sienese border, and also know that he may not be aware either of the ill feeling of his people toward him or of the several other circumstances about which we have been informed, we cannot help being curious and concerned about all this and actually determined to see to it that nobody enters his state and upsets it in any way. You will talk to him about these things in a tactful manner, making clear to him that we have sent you there in order to offer him all those favors that he may deem necessary, and also assure him of our intention to protect him against any menace. And so you will make this offer to him so that one of two effects may ensue, or both together; that is, one, that His Excellency becomes faithful to us again; the other, that in the event of any favor being requested by him we are ready to help him, satisfying at once his and our needs.

During your stay there you will observe him carefully, find out about his men's attitude, and what part the Sienese have in his policy and what part we have. And going through Campiglia, you can talk to our Podestà there, and obtain from him all the information that he may have to offer you.[3]

IV. PIOMBINO

Unfortunately, no report by Machiavelli has come down to us about the outcome of the mission, probably because his stay in Piombino was not long enough for him to have to write letters. He may have reported verbally when he returned to Florence and may have explained the need to strengthen the town's defense system. Piombino must have been sufficiently protected against an attack from the sea, but the fifteenth-century fortifications inland may have become inadequate, especially after 1500, with the increased power of guns. If Florence was to help reestablish the efficiency of its fortifications, an architect had to be sent to inspect the place and give advice about what was necessary. It is now known that, five months after Machiavelli's mission, Leonardo suddenly interrupted his work on the *Battle of Anghiari*, which the Signoria had commissioned from him, to enter the service of Jacopo IV Appiani, for whom he prepared a careful plan of fortification works at Piombino. In fact one of the newly discovered manuscripts by Leonardo at Madrid shows that at the beginning of November, 1504, Leonardo was in Piombino working on fortification projects.[4] Significantly enough, it was Machiavelli—as the Florentine Secretary—who signed the contract for the *Battle of Anghiari*,[5] and it was Machiavelli who backed Leonardo's plan to divert the Arno River in 1504, in an attempt to end the war against Pisa.[6] And finally it was Machiavelli as the Florentine envoy to Cesare Borgia who came to know Leonardo as Cesare's chief military architect. Machiavelli must have recommended Leonardo for the Piombino job since Leonardo may already have had a knowledge of the place from the time of the Borgia invasion in 1501. The task was important enough to detach Leonardo from his public commission to decorate the Council Hall. While in Florence, he worked on the cartoon of the *Battle of Anghiari* in the Sala del Papa in the monastery of Santa Maria Novella, the same monastery in which he was to leave some of his belongings and books during the Piombino intermission.[7] We do not know how long he was away, but by the end of December, 1504, he must have been back in Florence: his name appears again in documents showing the progress of his work on the *Battle of Anghiari*.[8] It appears that meanwhile Michelangelo was given the commission for a companion battlepiece, the *Battle of Cascina*.[9] We know now that on June 6, 1505, Leonardo began painting in the Council Hall.[10]

The notes in the Madrid Manuscript are mainly about the estimate of the

cost of a projected work of fortification at Piombino. Until the manuscript is published, one cannot ascertain whether Leonardo designed and superintended some architectural construction there.[11] As far as I recall, the manuscript contains only a few topographical sketches, which are difficult to identify as referring to some part of Piombino, and a series of theoretical writings on architecture, which have been identified as related to Francesco di Giorgio's treatise.[12] Curiously enough, our main evidence of Leonardo's activity at Piombino in 1504 comes from well-known sources, the Codex Atlanticus and Manuscript L, the latter being a notebook that Leonardo used while he was in the service of Cesare Borgia.

A report that I was asked to prepare for *Life* magazine after a quick examination of the contents of the Madrid Manuscripts[13] concludes with a section stressing the importance of an almost dramatic change of style in Leonardo's drawings as he moved from the neat compilation of technological drawings in the earlier manuscript to the dynamic quality of the fortification drawings in the later one. I had no doubt that the type and style of fortification drawings in the Madrid Manuscript could be associated with a whole series of fortification drawings in the Codex Atlanticus, which I always suspected (with no other evidence than that of their style)[14] dated from a time later than Leonardo's activity in Cesare Borgia's service in 1502. Since none of the published accounts of the Madrid Manuscripts has taken up the problem, it seems appropriate to quote here the concluding section of my mimeographed report:

A comparison with the neat compilation of a few years earlier as represented by the other manuscript at Madrid shows the rapid change that Leonardo's style was undergoing at the beginning of the sixteenth century, at the time of his activity in the service of Cesare Borgia. His activity as a military architect at that time is reflected in numerous notes and drawings that show how a curtain should be shaped to receive or divert hurtling missiles. As the theoretical principles are put into practice, his fortification drawings show a plasticity unknown to the early drawings in other manuscripts, and in fact they have a dynamic quality enhanced by the constantly shown trajectory of gunfire. He is now dealing with forms that can be rendered in sculptural terms to convey precise technical information. In addition to a more traditional type of drawing with the exactness of an illustration to a fifteenth-century treatise on architecture, we find here a type of drawing in which the pen flows at a great speed, with a power of expression only equalled by that of his later studies on the action of the heart. A comparison with the earlier drawings shows how Leonardo's style has

changed. Diagonal shading appears, but it no longer predominates; now the lines of shading are directed to indicate depth. Thus the lines used to make a shadow on a cylinder (a form that appears frequently in his fortification drawings), instead of being made up of graded diagonals, will be drawn to follow the curvature of the surface, thus conveying an effect of greater plasticity. Several drawings of fortifications in the Madrid Manuscript II are reminiscent of Bramante's or Sangallo's structures, and yet their dynamic quality is only comparable to that of Michelangelo's fortification drawings of twenty years later.

Closely related to architecture are the geometrical studies that fill a great part of the manuscript and especially the studies of stereometry, which deal with the problem of transforming one solid into another of equal volume, thus suggesting the manipulation of space that was the main concern of the architects of the High Renaissance. The diagrams of stereometry too have a dynamic quality underlying the process of changing one form into another.

One does not need to place the two Madrid manuscripts side by side to realize the profound difference of style from one to the other. Because of their highly refined execution the drawings of the first manuscript have a certain metallic coldness. Those in the second manuscript have an explosive and fluid line produced by a broad pen used as a dripping brush, often in conjunction with the dense, warm touch of the red chalk. Even the handwriting now expands into an untidiness reflecting the burst of the artist's mind at work. The sweeping lines of the huge waves of the sea, or waves splashing against the rocks, are symbols that sum up Leonardo's vision of a world in continuous motion and transformation.

It was not for literary effect that I ended my report with the drawing of sea waves splashing against rocks. This drawing was done at Piombino, and therefore its relation to the fortification series is not only one of style. It can be associated with a diagrammatic sketch in Manuscript L, folio 6 verso, inscribed "fatta al mare di piōbino," and with a note on a much later sheet at Windsor with instructions on how to represent a deluge: "honde del mare dj piōbino / tutte dacqᵃ sciumosa ———." [15]

There is no doubt that Manuscript L contains references to Piombino, but the newly discovered evidence raises the question whether they should be dated from the Borgia period, in 1502, or from the Appiani period, in 1504. The second possibility is supported by notes on painting written in the Madrid Manuscript at the time of Leonardo's visit to Piombino in 1504 that are closely related to notes on painting in Manuscript L.[16] As I have suggested already, Leonardo must have kept Manuscript L as a notebook over a longer period of

time than was previously believed. Consequently, it is probable that some of its notes and drawings of fortifications refer to his visit to Piombino in the last months of 1504. In a few instances one can actually show that this is true. For example, folios 81 verso–82 recto (fig. 28) contain an outline of the coast of the Piombino region inscribed "populonia," a reference to the Etruscan center Populonia, just north of Piombino. Similar references occur on folios 76 verso–77 recto and 78 verso–79 recto, the latter containing a note on painting related to one in the Madrid Manuscript. Other topographical sketches, not inscribed, on folios 82 verso–83 recto and 83 verso–84 recto may also refer to Piombino, in particular to its marshy land. From a note on folio 139 recto-c of the Codex Atlanticus, which can be dated about 1504–1505 because of drawings related to studies of mechanical wings in the Codex on the Flight of Birds, we know that Leonardo was thinking of a "modo dj sechare il padule / dj pionbino."[17]

The references to Piombino in Manuscript L are all grouped toward the end of the manuscript, except for the note on sea waves on folio 6 verso. Folio 81 recto, which faces a beautiful drawing of a draped figure on the verso of folio 80,[18] contains a sketch suggesting a large space enclosed by walls (fig. 27). The space is crossed longitudinally by a slightly inclined line identified as "tramontana," which indicates the north. A rectangular structure placed at an angle to this line is oriented toward "grecho," that is, northeast. The dimensions of the structure are given as 8 braccia wide and 80 long, approximately 4.8 × 48 m. A comparison with a map of Piombino shows that the sketch most probably represents the pier, which is in fact oriented northward and had at the far end a "rocchetta" of the same dimensions and orientations as those indicated by Leonardo.

There is an early map of Piombino (fig. 29) in a sixteenth-century collection of fortification drawings in a codex of the Biblioteca Nazionale at Florence attributed to the Bolognese Francesco de' Marchi, author of a celebrated treatise on fortifications published in 1599.[19] More accurate maps made in the eighteenth century (fig. 30) show that the fortified enceinte of the town, the citadel, and the castle had been modified considerably.[20] The early map shows the fortification system much as it must have been at the time of Leonardo's visit. It is interesting to note that the pier was considerably larger in the six-

teenth century, whereas the later maps show its profile almost in line with the retaining wall. The action of the "onde del mare di Piombino" over the centuries must account for the erosion of the rocks all around.

The town of Piombino stretches on a strip of rocky land at either side of the pier and is delimited on the west by the citadel and on the south by the fortress. On the north is the only gate of access to the town from the land. The gate, which is in line with the pier, was obviously the most vulnerable point of the town and had to be fortified accordingly. Drawings in Manuscript L, folios 50 recto and 51 recto (figs. 31 and 32), are studies of one such gate. The elaborate system of curved orillons and triangular projections anticipates the organic character of Michelangelo's fortification drawings, with a boldness of line and a plasticity of form that will appear again only later in the drawings of the valves of the heart. Although they are not inscribed in any way, there is little doubt that these two drawings are meant to represent a solution for the city gate of Piombino. The proof comes from a series of fortification drawings in the Codex Atlanticus, the greater part of which are gathered between folios 41 and 48.

A large drawing in Codex Atlanticus 41 recto (fig. 33) can be identified as a map of the fortifications of Piombino. It is apparently not by Leonardo: the measurements and the annotations are certainly not in his hand. It shows the project of a northwest enlargement of the citadel, apparently the same as the one mentioned in the Madrid Manuscript, folios 36 verso–37 recto (fig. 34), a strengthening of the city gate, and a system of new straight walls and a ditch outside the gate. The old walls (identified as "mura vechie") are hastily and somewhat inaccurately indicated, and yet the general appearance of the enceinte of the town is that of Piombino. The old wall includes the indication of a "revellino." The fortress is shown on the right, and half a pier is cut off. The measurements of the new walls and structures are given in "canne," and we know from Leonardo's notes in the Madrid Manuscript that a "canna" equals 4 braccia, that is, about 2.40 m.[21] The resulting overall dimensions of the town correspond well enough to those of Piombino. Judging from the inscriptions, the drawing was done with the south at the top as in the map by Francesco de' Marchi. The walls along the coastline and within the pier are not indicated. The city gate predominates as a massive revelin made up of three concentric

rings of wall. A frontal passage between orillons leads to side entrances. It is precisely this structure that Leonardo studied at length in Manuscript L and in a series of drawings in the Codex Atlanticus.

A drawing in Codex Atlanticus 45 verso-b is exceptional in that Leonardo uses brush and wash to sketch the ground plan of the projected gate. The colors he uses, red and green, recall those of the map of Imola at Windsor. The other sketches on the page, in pen and ink, show the gate as part of the wall system. The back of the drawing, folio 45 recto-b, contains a number of sketches showing details of a curtain wall with gun postings. Originally this folio was numbered 130 by an early collector of Leonardo's papers. A folio of the same size, style, and contents, Codex Atlanticus 343 recto-b, numbered 131 by the same collector, was originally joined to it (figs. 35 and 36).[22] Here again is a study of the city gate of Piombino, which also includes details of the curtain wall.[23] Its verso contains other studies for the wall, which should be taken in conjunction with the drawings on folio 45 verso-b, to which it was originally joined. A curious detail on folio 343 verso-b may suggest evidence for the date of the drawing. It is a sketch of a dodecahedron of a type shown in Pacioli's *Divina proportione*. It is known that in 1504–1505 Pacioli dedicated a manuscript copy of his book to Gonfaloniere Soderini and that he had models of the geometrical bodies reproduced in the book made for him. At the same time that Leonardo was being paid for his work on the *Battle of Anghiari*, at the end of August 1504, Pacioli was paid for his models.[24]

Studies of a curtain wall to be related to the ones already considered are found on folio 212 recto-b, which also has details of civil architecture, such as cornices, columns, and capitals, somewhat reminiscent of the architecture of Francesco di Giorgio.[25] There is a hint at one such architectural detail of cornices on folio 45 recto-b, which contains, as we have seen, studies related to Piombino. Folio 212 was originally joined to folio 355 recto-a and verso-a (figs. 37 and 38). The sheet thus recomposed shows drawings on one folio complemented by lines on the other. The early collector gave the folios the consecutive numbers 197 and 198. The drawing on folio 355 verso-a shows a stelliform structure that might have originated from an idea for the gate of Piombino, as shown in Codex Atlanticus 286 recto-b and verso-b (figs. 39 and 40). Similar structures appear on folios 48 verso-a and 48 verso-b (figs. 41 and 42), originally numbered

151 and 152, and therefore likewise once joined together. Leonardo seems to be moving into theoretical problems, as if he were taking a practical task as an excuse to collect data for a treatise on military architecture. On folio 48 verso-a he axiomatically states that the increase of gun power calls for a proportional increase of defense power in the fortification walls.[26] There is no doubt therefore that the celebrated drawings of a circular citadel on folios 48 recto-a and 48 recto-b should also date from the period of Leonardo's activity in the service of Appiani, at the end of 1504. Paper, style of drawing, and handwriting are the same as in the folios considered previously. It is again a case of two folios that were originally joined together (fig. 43). They were numbered 201 and 202, and their physical correlation is confirmed by scribbles not by Leonardo on their versos.[27]

We can detect reflections of the problem of organizing a citadel in other sheets of the series, e.g., folios 43 recto-b and verso-b (figs. 44 and 45) and 43 recto-a and verso-a (figs. 46 and 47). Each of these two folios was originally joined to a folio that is unfortunately now missing. In fact they were not numbered consecutively: 135 and 151.

Among the drawings of circular and square citadels on folio 43 verso-b (fig. 45) is an elevation sketch showing a detail of a detached corner tower, of a type that recalls certain drawings in the Madrid Manuscript (fig. 34). One of the notes in this folio provides a *terminus a quo* in dating the series:

chel sochorso non uadj nella rocha del
castellano acco nō sia piv potente dj luj
come fu in fossonbrone ——

The historical event to which Leonardo is referring took place on October 11, 1502, when both Leonardo and Machiavelli were in Imola.[28] Not only does Leonardo refer to it as already long past, but there is no reason to believe that he had much to do with fortification studies for Cesare Borgia after October 1502.

The studies of circular, square, or octagonal citadels developed into the beautiful drawing of turreted fortresses on folio 43 verso-a (fig. 47). (Notice at the bottom a light sketch of the octagonal citadel.) This brings back the

problem of style as a means of dating Leonardo's drawings. Heydenreich dates the drawing about 1495.[29] Popham dates it 1500–1505 and explains that its style, with the slightly untidy strokes curving to the outline of the buildings and the occasional cross-hatching, is in contrast to the drawings of Manuscript B with their neat parallel lines.[30] And, finally, Kenneth Clark places it among the latest drawings, at the time of Leonardo's projects for the Romorantin Castle in 1517.[31] Indeed, the drawing looks much later than 1504. It combines the explosive line of the horses for the *Battle of Anghiari* with the untidy, energetic penwork of the anatomical studies of 1513. Here, if nowhere else, one should realize that style is a dangerous weapon.

V. THE HOUSE OF
CHARLES D'AMBOISE

In 1506 Leonardo returned to Milan, entering the service of the French governor Charles d'Amboise. His activity as an architect is now documented. Writing to the Signoria of Florence to praise Leonardo's many virtues in fields other than painting, Charles specified that Leonardo had been employed for "certain designs and architecture."[1]

Leonardo left Florence at the end of May 1506 on a three-month leave of absence. Charles's letter dates from December 16. Extensions of the leave requested by the French governor were granted, but on October 8 the Signoria replied rather rudely to another request for an extension; his letter of December 16 was thus meant to accompany Leonardo on his way back to Florence and to convey to the Signoria his gratitude for the privilege of having had Leonardo in his service. Yet on January 12, 1507, Leonardo was still in Milan. The king himself, in France, had seen a painting by Leonardo and expressed a desire to meet him and to have him in his service. The Florentine ambassador Pandolfini was instructed to arrange for Leonardo to remain in Milan until the arrival of the king. But Leonardo is recorded back in Florence on March 5, and it is not known whether he went to Milan again shortly afterward to meet the king, who was to enter that city on May 24. Letters by Charles to the Signoria dating from July and August 1507 show that Leonardo was in Milan and needed a fast settlement of a litigation with his brothers in Florence, since he was very busy working on a painting for the king ("per essere obbligato a fare una tavola ad esso molto carissima"). And so Leonardo went to Florence again. His letter to Cardinal Ippolito d'Este, concerning the litigation, is dated from Florence September 18, 1507. He remained there through the first months of 1508. In fact, he began the manuscript now known as the Codex Arundel in the house of his friend Martelli on March 22, 1508.[2] At about the same time he was in touch

41

with his Milanese patrons, informing them of his intention of returning to Milan by Easter, that is, around April 23. The drafts of his letters refer to his two preceding stays in Milan as a guest of either Charles d'Amboise or Antonio Maria Pallavicino and mention two Madonna paintings for the king, which Leonardo was about to finish. The next date, September 8, 1508, records the day when Leonardo, in Milan, began the notebook known today as Manuscript F.

The often indirect evidence of Leonardo's journeys between Florence and Milan during the period usually termed his second Milanese period, goes to show that his activity as an architect in the service of Charles d'Amboise was probably confined to the seven months between May 30 and December 16, 1506. Probably Charles consulted him again as an architect during his subsequent visits, but his main occupation was no longer architecture. In the entries recording the stipend paid to him by the king, Leonardo is listed as a painter. On the other hand, in a letter of July 26, 1507, the king refers to him as "nostre chier et bien amé Léonard da Vincy, nostre paintre et ingénieur ordinaire."[3]

No Milanese building dating from the first decade of the sixteenth century is traditionally attributed to Leonardo. The attribution to him of the church of Santa Maria alla Fontana (fig. 48), which was commissioned by Charles d'Amboise in 1507, is a relatively recent one, based on stylistic elements that could apply as well to any Milanese follower of Bramante.[4] There is a problem not only of attribution but also of placing Leonardo's architectural studies in correct chronological sequence. The two studies by Leonardo believed to be for Santa Maria alla Fontana are either too early or too late.[5] A sheet of the Codex Atlanticus, folio 352 recto-b (fig. 49), dating from about 1507–1508, contains a sketch of a church that can be reasonably identified as an idea for Santa Maria alla Fontana. It shows two colonnaded courtyards flanking the square apse and two bell towers at either side of the apse.

As we have seen, by December 1506 Leonardo had produced "disegni et architectura" for Charles d'Amboise. This patron is reported to have been very fond of festivals, banquets, and comedies. Thus it has been assumed that Leonardo was employed to design costumes and stage sets. There is in fact a sheet in the Arundel Manuscript, folios 224–231, with studies of a revolving stage for the representation of a play that might have been inspired by Polizi-

ano's *Orfeo*.[6] The style of the sketches and the type of short annotations are identical to those of sketches and notes in Codex Atlanticus 231 recto-b, which are studies of the ground plan of a villa (fig. 50). Even the characteristic greenish ink that Leonardo had come to use around 1506–1509 is identical in both sheets. The sketches for a villa were identified by Gerolamo Calvi in 1925 as pertaining to the project of a house for Charles d'Amboise, who is in fact mentioned in one of the notes as the "gran maestro." Calvi further suggested the identification of the intended site for the construction: an area close to the church of Santa Babila in Milan, at the beginning of the present Corso Venezia. It was to be somewhere across the Bramantesque Casa Fontana-Silvestri and was to be bordered by two canals meeting at about a right angle and mentioned in Leonardo's notes as "Neron da Sancto Andrea" and "Fonte lunga." They ran along the streets known today as the Corso Monte Napoleone and the Corso Venezia. Finally, Calvi suggested that the long description of a garden and instructions for the arrangement of stairs within a house on folio 271 verso-a of the Codex Atlanticus were probably related to the project of a villa for Charles d'Amboise. His assumption was subsequently proven correct: in fact, the description of the garden and the fragment with ground plans were originally one single sheet (figs. 50 and 51).

In his letter of December 12, 1506, Charles speaks of "architectura," that is, buildings, not projects. Thus some construction must have been actually undertaken. Other folios of the Codex Atlanticus show how carefully he had studied the canal system around the area of the projected house. And yet there is no historical evidence that the project was undertaken. Charles died in 1511, and the properties confiscated by the French were subsequently restored to their owners. We do not even know whether the area chosen by Charles was bought or confiscated. The sketches in the Codex Atlanticus are the only evidence of Charles's intention to build a house. They are all ground plans, except for insignificant details of arcaded structures below. Even the orientation of the building is uncertain, and we cannot tell which side of it was intended as the main entrance. But a few characteristic details may help in interpreting what type of building Leonardo must have had in mind.

The fragment contains eleven sketches of ground plans, six of which are somewhat detailed. It is impossible to say which came first; yet only two indi-

43

cate the ground plan of the whole villa including the garden area. They are both inscribed and annotated. Regardless of which was done first, they both stem from a precise model, Giuliano da Maiano's Poggio Reale at Naples of 1487 (figs. 54 and 56), which is recorded in the ground plan placed about half-way up in the fragment (fig. 52): it shows four rooms placed at the corners of a court and connected by loggias. To its right is the derivation that may have come first to Leonardo's mind. It is inscribed "a, b, c, e," to which the note below refers:

> *a* is the court of the great master
> *b c* are his rooms *e* is his hall
> and this may be wide open at its head.[7]

Above the drawing is a slightly simplified sketch as if Leonardo intended to clarify the framework of the room arrangement. There is no doubt that Poggio Reale is the prototype. In turn, Leonardo's interpretation is reflected in a drawing by Peruzzi in the Uffizi that has been shown to be the prototype of a whole series of Serlio's very influential designs (fig. 55).[8] The court has become a great hall flanked by loggias. This is clearly shown in another sketch further above, which is inscribed: "portico / sala / portico." At one side of the hall and loggias (on the left of the drawing) are the living quarters.

My conjectural interpretation of the plan (fig. 53) shows that Leonardo may have taken the dimensions of the hall as his module. In the fragment originally joined to this folio he gives the measurements of the hall as being 21 braccia long and $10\frac{1}{2}$ braccia wide, a rectangle made up of two squares. The adjoining rooms are the result of combining the same squares and half-squares, so that it is possible to estimate what the overall area of the building was to be: $52\frac{1}{2}$ braccia on the longer side and $31\frac{1}{2}$ braccia on the shorter one (ca. 31.2 × 18.6 m.). The arrangement of the garden seems to follow the same principle. The area marked *a* is specified as the court of the "great master," that is, the courtyard corresponding to his living quarters. It is an enclosed space aligned with the walls of the edifice, both inner and outer walls. The central area corresponds even in size to the hall inside marked *e*. A passage in line with the longitudinal axis of the house leads to a bridge spanning a canal.

The principle of planning the garden as an extension of the house applies to the area facing one of the loggias. It is an area twice the surface of the loggia,

thus a square equal to the sum of the area of the loggia and that of the adjoining hall. The basin of a fountain is placed on the axis that marks the passage through the loggia.

The whole plan seems to be made up of two identical building blocks placed on opposite sides of a great hall flanked by loggias. One block, as we have seen, is taken up by the living quarters; the other contains the stairs, and in addition it must have been intended as the quarters for guests. There is no indication of rooms for retainers, kitchen, wardrobe, and so on. In these preliminary studies Leonardo was mainly concerned with the general layout of the construction, studying in particular the relationship between the house and the garden, with a careful consideration of the arrangement of the rooms for the master of the house. A sketch below is almost a duplication of the one just seen, but it contains some additional detail and some variation. The area of the courtyard is now inscribed "prato" (meadow) and is no longer enclosed. Its partitions still align with the walls of the edifice; they appear to be rows of columns with lintels and must have been meant to resemble a classical pergola. The three spaces are occupied by three long tables in a "horseshoe" arrangement, obviously for banquets in the open air. A note specifies that the area is next to the canal called "Fonte lunga" and that it should be covered with a net of copper to make it an aviary.[9] The passage across the canal is no longer there. The garden with the fountain in the middle (now in the form of a Greek cross) is no longer lined up with the loggia; its axis corresponds to the passage leading to the court of the "great master." Inside the house the living quarters show two bedrooms with a bed indicated in each one, and the hall termed in the preceding sketch "hall of the lord" shows two tables, one along each of its two longer sides. It is therefore conceivable that the hall of the "great master" was in fact his dining room, while the adjoining "sala" flanked by the loggias was to be a great hall for receptions and entertainment.

So far we have been considering two sides of the building, none of which can reasonably be taken as the main façade, that is, the entranceway. The passage that Leonardo once planned on the side facing the "Fonte lunga" could have been just a private way out through the courtyard. The loggia façade opposite the garden with the fountain was to run parallel to another canal, the "Neron da Sancto Andrea," from which it must have been somewhat separated by an

45

orchard, and therefore away from the street bordering the canal. There remains therefore the shorter side on the right, corresponding to the building block that contains the stairs. Since a façade would likely reflect the interior arrangement of the rooms, it would have to be tripartite. The ground plan we have considered first shows two pairs of columns on the far right corresponding to the width of what would be the central bay of the façade. These seem to flank a passage leading to the entranceway as well as to the side garden. It is tempting to identify a design of the façade of the villa in the drawing on the cover of the Codex on the Flight of Birds (fig. 60). It is a design that meets the structural requirements of the room arrangement as detected in the sketches of the ground plan of the villa.[10] One can imagine the entrance door opening into a vestibule that has doors leading into the rooms at either side of it and a central passage leading into the great hall. It was probably upon entering the hall that one could turn to the right or to the left and take one of the staircases to the upper floor.

We have seen that Leonardo had already considered this type of triple-ramped staircase in Codex Atlanticus 220 recto-a and verso-b (figs. 15 and 16), in which he proposes that one could enter the central ramp and take either one of the side ramps at the first landing and suggests the alternative of two ramps that lead to a landing and turn into a single central ramp. These solutions are studied in a number of elevation drawings on a sheet at Windsor (fig. 66). It has been shown recently that the wooden model of the Chambord Castle had the same system of triple-ramped staircases.[11]

Leonardo seems to attach great importance to the stairs for the House of Charles d'Amboise. They are so accurately described in the note preceding the description of the garden in Codex Atlanticus 271 verso-a (fig. 50) that an exact reconstruction in scale is possible.[12] Leonardo says that the width of each ramp should be one braccio and three quarters, but then he makes it two braccia. The wall in between has a thickness of half a braccio, and the one for the hall is ten and a half braccia. Leonardo does not specify that the latter was to open into three doors or passages, as in the ground plans. The space occupied by three doors of two braccia each, plus the half-braccio interval in between, would make a total of seven braccia out of the given ten and a half braccia of the wall. On the other hand, Leonardo speaks of a four-braccia landing, which

would account for only two ramps. Three ramps would require at least a seven-braccia landing, but there is a possibility that the term Leonardo uses for landing ("piano della rivolta") is meant to take into consideration only the portion of the landing that pertains to the two ramps under discussion.[13] Leonardo's instructions read as follows:

The staircase is one braccio and three quarters wide and is made of two ramps,[14] and altogether [i.e. both ramps] it is sixteen braccia with thirty-two steps half a braccio wide and a quarter high; and the landing where the staircase turns is two braccia wide and four long; but the breadth of the staircase should be two braccia, and make the hall half a braccio wider; so that this hall will come to be twenty-one braccia long and ten and a half braccia wide, and so it will serve well.[15]

Leonardo made a slight miscalculation. If the stairs were built according to these instructions the top step would be exactly in line with the ceiling of the lower room. At least two more steps would have to be added to compensate for the thickness of the floor between the two stories. The concluding sentence is about the proportions of the hall: "and let us make it eight braccia high, although it is usual to make the height equal to the width; such rooms, however, seem to me depressing, for they are always somewhat in shadow because of their great height, and the staircases would then be too steep because they would be straight."[16] Leonardo is not concerned with the rules of proportions (Alberti); he deliberately avoids making the height of the hall tally with the width, thus ensuring greater light to the room, and consequently a more cheerful atmosphere.[17]

It must be stressed that the sketches of ground plans in the fragment in the Codex Atlanticus represent preliminary ideas that must have been developed into a final project. Thus the diagram of paired columns placed in front of pilasters, fourth sketch from above (fig. 57), may be a first indication of wall treatment that shows a structural and stylistic affinity with the drawing on the cover of the Codex on the Flight of Birds. It may well be the study for a decorative framing of the entranceway.[18] If so, it is significant that the drawing in the Codex on the Flight of Birds shows indications of paired columns flanking the door.

None of the plans in the fragment seems to refer to the upper floor of the

building, with the exception, perhaps, of the first sketch at the top. This suggests the area of a loggia in the central bay of the façade and adjoining rooms, a detail pointing again to a relationship with the drawing in the Codex on the Flight of Birds. The system of the tripartite façade with central attic bay crowned by a triangular pediment could have been repeated on the side façades, which were to have in addition a ground-floor loggia. It is easy to imagine how influential such a conception could have been: it would have been reminiscent of the Brunelleschian building in the background of a well-known plaquette in the Louvre,[19] yet the garden façade would have combined the festive appearance of the Farnesina and the stage-like use of loggias in the courtyard of the Palazzo Massimi alle Colonne. No doubt Peruzzi was well informed of Leonardo's ideas, and Leonardo himself refers to him twice.[20]

The drawing in the Codex on the Flight of Birds has come to be regarded as an anticipation of Bramante's Palazzo Caprini, the so-called House of Raphael (fig. 62), and of Michelangelo's system of recessed columns in the vestibule of the Laurenziana.[21] One may even go so far as to see in it an anticipation of Palladio, but it is precisely because of the Palladian quality that one should look for an Albertian precedent. In fact, it can be considered as an illustration of one of Alberti's precepts: "A private house should never have such a pediment as to seem to rival the majesty of a temple. However, the front of the vestibule may be raised somewhat above the rest of the building and be adorned by a smaller pediment."[22]

The drawing is often considered as a prototype of the Roman palace of the "primo cinquecento," but it is really more quattrocento in character than one may be inclined to believe. The sketches of details of recessed columns are afterthoughts arising from the central theme of a façade conceived in the Florentine idiom, with a stress on wall surface. In fact, as Leonardo experiments with the Albertian idea that the column is "a certain strengthened part of the wall, carried up perpendicularly from the foundation to the top," and that "a row of columns is indeed nothing else but a wall, open and discontinued in several places,"[23] he comes to realize the potential expressiveness of the column as a sculptural element (note the sketch at the top left, which is the one closer to Bramante's House of Raphael)—and one may surmise that his brief visit to Venice in 1500 had acquainted him with Coducci's projects for the Vendramin-

48

Calergi Palace, in which the idea of expressive groups of columns was to be realized.[24] Above all, Leonardo's drawing does not show the rusticated base as in the Palazzo Caprini or the arched openings of the "botteghe" subdivided by an architrave, a feature found in the Trajan markets and in Caesar's forum that would have influenced only such archaeologically minded architects as Bramante, Peruzzi, and Raphael.[25] It is only in his 1515 project for a new Medici Palace that Leonardo "echoes" that feature by hinting at the presence of an architrave in the rusticated wall with which he closes the arched openings of a portico or loggia (fig. 83). This villa façade thus still retains some of the quattrocento flavor that must have come to Leonardo from Francesco di Giorgio and Il Cronaca. And yet the roof line heavily marked, the way of revealing the structure by stressing its cage-like quality especially in the central area, which opens into a dark loggia, and finally the vertical and horizontal accents of powerful bands counteracting one another as in a Greek cross pattern, are all symptoms of a style yet to come. The idea is carried further by Serlio in his façade "al modo di Venezia" (fig. 61), in which windows and loggias are multiplied in accordance with Leonardo's scheme—with the revealing comment that "all those things into which sight can penetrate are always the most satisfactory."[26]

If the drawing in the Codex on the Flight of Birds shows the gradual emergence of High Renaissance forms, some sketches in the Arundel Manuscript and the Codex Atlanticus dating from about the same time, about 1505, show how Leonardo has come to consider a palace façade for its strong contrast between recessed and projecting elements and how emphatic an effect of chiaroscuro could be achieved with the articulation of the wall. The small sketch of a palace façade in the Arundel Manuscript, folio 160 verso (fig. 63), omits every detail only to stress the interaction of negative and positive forces, by means of vertical projecting elements (either columns or pilasters), and dark recessed areas for the windows and the door, which are not shown. Each area is considered for its degree of recession and is thus significantly shaded with heavy, horizontal strokes of hatching, while an exceedingly projecting cornice stresses the building's squat quality. A sketch in Codex Atlanticus 322 recto-b (fig. 64) appears to be a detail of the window system in the same or a similar building.[27] The opening is shaded with slanting strokes, and the window takes

49

over almost the whole area in between twin columns, in a way that anticipates the window system of the Palazzo dei Conservatori. The drawing is probably cut at the bottom (there are traces indicating that the vertical members continue below), so the detail of the window system refers to a floor above a very much elaborate stringcourse. This course, with a classical tablet inscribed in the window parapet, is so tall and massive that it resembles a base course. Taken in conjunction with the stepped back entablature, this may account for the strong affinity with Raphael's Chigi stables in Rome.[28]

One of the anatomical sheets at Windsor (12592 recto), dating from after 1506, contains a number of studies of staircases and a sketch of a detail of wall decoration (fig. 66). The date of the drawing and the studies of stairs point to the project for the French governor. Here again is the familiar motif of the tree-trunk columns and *opus reticulatum* as in the later projects for the Medici Palace, but still pictorial in treatment, with an almost Gothic delicacy reminiscent of the Sala delle Asse and therefore recalling the façade of Filarete's "Palazzo in luogo palustre" (fig. 65).[29] Leonardo seems to be experimenting with motifs and ideas combining Bramante's severely classical idiom and the late Gothic fantasies of Filarete.

Two folios of the Codex Atlanticus, originally joined together, folios 260 verso-b and 87 verso-a (fig. 67), contain architectural studies that have been identified as related to the area of the projected Villa of Charles d'Amboise.[30] They are studies for a drawbridge probably meant to be placed at a side entrance to the villa and perhaps related to an earlier sketch derived from Bramante.[31] Once again the tree-trunk motif appears, this time in a gateway leading to a crossroad with porticoes and a Filaretesque tower.

As in the later project for Romorantin, Leonardo had in mind a type of "festive architecture" suitable for every sort of entertainment and festival. This must have been the intention of the patron, who was so fond of theatrical representations, banquets, and dances that he adopted the symbol of the "wild man" as his own emblem, to signify that a rugged appearance was one way to conceal tender feelings for the ladies.[32] In his description of a fantastic garden for the Villa of Charles d'Amboise, Leonardo refers to groves of oranges and lemons sending forth the scent of their blossoms and mentions a sprinkler system for the playful owner "to give a shower-bath from below to the ladies or others

who shall pass there," a joke quite fashionable at the time, but less atrocious than that of the architect of Poggio Reale, who planned to flood the entire court in the middle of a banquet.[33] Water was an important element in Leonardo's project also. He plans streamlets running through the garden and even through tables, to keep wine containers cool, and for the delight of seeing fish. A drawing of a "peschiera" in Codex Atlanticus 348 verso-a (fig. 58) can be dated from this time and again may be considered as inspired by Poggio Reale. This folio belongs to a series of studies for some hydraulic device, as does the folio with the drawing of a church considered above (fig. 49), which can be tentatively related to Santa Maria alla Fontana, about 1507–1508. A drawing on another folio of the same series, Codex Atlanticus 288 recto-b (fig. 59), shows the plan and elevation of a courtyard with loggia crowned by a sequence of decorative projections resembling a crenelation, a motif usually associated with late sixteenth-century villa architecture.

On the verso of the fragment with the project for the Villa for Charles d'Amboise, Codex Atlanticus 231 verso-a (fig. 51), there is a sketch of a mechanical bird descending along a rope, the wings beating by a system of wheels and cranks recalling the mechanical eagle in the sketchbook of Villard de Honnecourt. The sketch is inscribed "ocel de la comedia" (bird of the comedy), an unmistakable hint at the sort of entertainment for which the projected villa was designed.[34]

Finally, there is another fragment in the Codex Atlanticus (folio 214 recto-b, unfortunately without drawings) that explains further the function of the place and contains specifications of a room arrangement corresponding almost exactly to the ones in the sketches of ground plans in the fragment considered previously:

The hall of the festival should be situated so that you come first into the presence of the lord and then of the guests, and the passage should be so arranged that it enables you to enter the hall without passing in front of people more than one may wish; and over on the other side opposite the lord should be situated the entrance of the hall and convenient staircases, which should be wide, so that people in passing along them may not push against the masqueraders and damage their costumes, when going out . . . the crowd of men [together] with such masque[raders] . . . [The concluding sentence is fragmentary, but most of the words can be restored.] This room [requires] two rooms at either side [with] their privies subdivided in two: one with an exit into the dining room, the other for the convenience of the masqueraders.[35]

It is not clear which side of the building was intended as a façade. The guests seem to have been admitted to the hall of the festival through the master's quarters, as if they had entered the house coming from the passage in line with the bridge across the "Fonte lunga." Yet there is a reference to the "entrance of the hall" as being situated opposite the lord together with the stairs. It is tempting to think that the building was envisaged as having two entrances: one through gardens and pergolas for festive occasions and one from the opposite street through a dignified façade, more suitable for a governor's residence.

As a place of resort, the suburban Villa of Charles d'Amboise was to have a garden meant to appeal to all the senses. Leonardo speaks of the delight of seeing the clear, transparent water of the streamlets. Musical instruments played hydraulically and the birds in the aviary would have produced perpetual music, accompanying the pervading scents of orange and lemon blossoms. Perhaps it is not a coincidence that Leonardo's drawings of costumes for masqueraders from this time on include all sorts of vegetable motifs recalling the pattern of the interwined branches and ribbons of his architectural decorations (figs. 68 and 69). Architecture comes to glorify the symbols of the generative powers of nature and produces what would be a fitting background for one of Titian's reclining Venuses. Leonardo's description of the "Sito di Venere" in a folio at Windsor (fig. 95) dates from about the same time as his project of a garden for the Villa of Charles d'Amboise.[36] It is also the time of his *Leda*; of the anatomical studies with the fetus in the womb as an architectural diagram; and, finally, of his replica of the *Virgin of the Rocks*, in which the group in the grotto is reconsidered for the effect of plasticity it can convey, as in a building of the High Renaissance.[37]

VI. THE VILLA MELZI

After the death of Charles d'Amboise in 1511 and before he moved to Rome in September 1513, Leonardo was engaged in another architectural project, the enlargement of the Villa Melzi at Vaprio d'Adda. The commission is not documented, and one can only surmise that the architectural idea originated from conversations with members of the Melzi family while Leonardo was their guest in the villa at Vaprio. It was about 1508 that Francesco Melzi, aged 17, entered Leonardo's studio. His father, Gerolamo, was a member of the Milanese Senate and must have known Leonardo since the time of the Sforzas. The villa at Vaprio was built in 1482, as shown by the inscription on a tablet still in place. It is a curious fact that in the eighteenth century the style of its architecture was taken as evidence of Leonardo's authorship and therefore as proof of his presence in Lombardy as early as 1482.[1] Later evidence proved the date to be correct, but the attribution of the building to Leonardo was discarded.

Vaprio is located about twenty miles east of Milan, and the Villa Melzi stands on the left bank of the Adda River, with a canal running in between (fig. 77). A painting by Bernardo Bellotto from the second half of the eighteenth century shows that the landscape must have been much as in Leonardo's day, including the ferryboat between Vaprio and Canonica di Vaprio, which is the same as in one of Leonardo's drawings at Windsor dating from about 1513.[2] From after 1508 there is evidence of Leonardo's involvement with the canalization of the Adda River, and this probably brought him to Vaprio. In his manuscripts he mentions Vaprio twice, once for water experiments at its mill, and another time for the arrangement of rooms at the "chamera della torre da vaueri."[3] The latter is on an anatomical sheet at Windsor dated January 9, 1513 (fig. 70). The sheet contains a number of architectural sketches and the ground plan of a fortress indicating the fire trajectory of besieging artillery posted around it. The fortress can be identified as the Castle of Trezzo because of the characteristic S-shaped course of the Adda River, which provides a natural

53

moat, and because a few days before the date recorded by Leonardo the castle was actually taken by the Venetians.[4] Leonardo was then in the Villa Melzi, busy with the compilation of anatomical notes and studies on the motion of water. Some architectural sketches jotted down among those notes hint at the project for an enlargement of the villa.

The arrangement of rooms and stairs studied in the Windsor sheet appears again in a fragment in the Codex Atlanticus, folio 61 recto-b (fig. 71), which is of blue paper, as is the anatomical sheet at Windsor. Above is the ground plan of a building. A black chalk outline indicates a structure with a square court, but Leonardo has inked in only two sides of the building, shown as meeting at a corner—probably the only part of the villa that had been carried out, and in fact this is how the villa looks today (figs. 77 and 78). In spite of the alterations made in the eighteenth century, the stairs are still located approximately where Leonardo has them. A note explains the proposed replanning and speaks about a passage that was to lead to the garden.[5] There is no doubt that the sketches in the anatomical sheet are preliminary studies for this replanning and therefore that the project refers to the Villa Melzi.

Below the ground plan, drawn perpendicular to it, are sketches of a terraced slope with a system of stairs, a detail that can safely be referred to the side of the villa facing the Adda River. The Melzi had probably asked Leonardo to study the replanning of that slope as well as a more efficient arrangement of the stairs within the building. And Leonardo must have made this the excuse for envisaging the transformation of the villa into a princely residence, with a festive rear façade facing the river. His conception can be followed through a sequence of studies.

The ground plan in the Codex Atlanticus fragment shows that the rear façade could have been extended with a wing at each side. This detail does not yet appear in the preliminary sketches in the anatomical sheet. The wings originate from new quarters attached at either side of the block, each of which includes a spiral staircase (indicated by a circle with a central dot). This feature is clarified in a sketch on another fragment in the Codex Atlanticus, folio 153 recto-d (fig. 73). This is again the ground plan of the corner of the villa, but now Leonardo seems concerned with the proposed addition of rooms. The appendage appears to be divided into three equal parts, two of which are

taken up by rooms (note the indication of a table in one of them), and one by the spiral staircase. The appendage is emphatically marked so as to suggest that it is structurally related to the main block of the building and not merely a detail of the proposed wing. Here it is brought in line with the façade. A companion fragment, Codex Atlanticus 153 recto-e (fig. 72), which must originally have been part of the same sheet, gives a bird's-eye view of the proposed replanning of the villa. The façade facing the river is placed at the top of the terraced slope (an arcaded retaining wall is shown below), the corner rooms are towers crowned by cupolas, and at either side is shown the appendage from which was to spring the arcaded wing, which was probably meant to terminate in a pavilion (only the one on the left being shown).

The ground plan of the appendage appears again, with slight variations, in two sketches on another anatomical sheet at Windsor, also dating from about 1513 (fig. 74). The paper is not blue like the other anatomical sheet, but yellowish and quite heavy and strong, exactly like that of the fragments in Codex Atlanticus 153 recto-e and recto-d. This is the paper that Leonardo used for some of the latest studies for the Trivulzio Monument as well as for one drawing of water vortexes at Windsor.[6] The anatomical sheet shows a bird's wing associated with the drawings of birds' wings and notes on the flight of birds in two Windsor sheets that are again of the identical type of yellowish paper[7] and have already been dated about 1513 by comparison with the contents of the Paris Manuscript E. Finally, the anatomical sheet contains other architectural sketches. They are in red chalk partly gone over with pen and ink: two sketches of an elegant well and two details of an arcade. But most important of all is a fifth sketch in red chalk almost entirely covered by a note on mechanics in pen and ink. To make the drawing more easily understandable I have provided a tracing of it in isolation (fig. 75). There is no doubt that it represents the elevation of one corner of the Villa Melzi according to the projected enlargement. We can see the end bay turned into a tower with the side appendage and the beginning of the arcaded wing. This is the characteristic feature hinted at in the fragment in Codex Atlanticus 153 recto-e (fig. 72) and fully and clearly shown in a series of beautiful drawings in another sheet of the Codex Atlanticus, folio 395 recto-b (figs. 76 and 79).

This sheet is undoubtedly one of Leonardo's most impressive architec-

tural drawings. It is on exactly the same type of yellowish paper as the other sheets of the series of studies for the Villa Melzi. Below are five elevations, showing the proposed new quarters of the villa. Above are drawings of water vortexes, some of which resemble plaited hair, and notes on water currents and the flight of birds—a compendium of Leonardo's occupations around 1513, the only exception being anatomy. The sheet, however, must originally have been larger.[8]

Leonardo's intention is now evident: to enlarge the villa with the kind of wings and pavilions that were to appear shortly afterward in Raphael's Villa Madama at Rome and were to be fully exploited in Vignola's and Palladio's villa designs some fifty years later.[9] The corner tower has a tent-like roof and lantern, next to which appears the hemispherical dome and lantern of a tempietto placed on top of the central bay of the terraced appendage. It recalls Vignola's original project for the casino of the Villa Giulia, and it probably served as the terminal of a spiral staircase, which therefore gave access to the terrace. The cluster of flaming pinnacles, the large windows, and the general articulation of the walls convey a French flavor that well justifies Heydenreich's suggestion that the bird's-eye view in Codex Atlanticus 153 recto-e (fig. 72) was to be related to Chambord and therefore to be dated after 1517.[10] Indeed, there is a series of studies for windows, portals, and porticoes in the Codex Atlanticus apparently related to a study of windows for the palace at Romorantin, which might have originated instead from the Villa Melzi project. These will be considered in Part Two below.

There is finally a red chalk drawing of an elegant narrow bay of a two-story building flanked by two superimposed columns (or pilasters?) somewhat reminiscent of Peruzzi's Farnesina (fig. 80).[11] There is no way to link the drawing to the studies for the Villa Melzi (a sketch of the ground plan of a building on the left is not sufficiently detailed), but the recto contains the celebrated drawing of an old man sitting, in right profile, by what appears to be the bank of a river, and, on the right, four sketches of water vortexes and a note to them.[12] The style and subject of the drawing point to a date around 1513, at the time of Leonardo's sojourn in the Villa Melzi at Vaprio.

The replanning of the slope with terraces and stairs was probably the only part of Leonardo's project to be carried out. The idea of arcaded wings and

pavilions was abandoned and never again appears in his projects. Never again was the spirit of French architecture to affect his artistic conceptions so profoundly, and this makes a first visit by Leonardo to France around 1509 a strong probability.

VII. THE NEW MEDICI PALACE

The period from September 1513 to the end of 1516 is usually referred to as the Roman period of Leonardo's activity. It is true that Leonardo went to Rome, in the service of Giuliano de' Medici, brother of Leo X, but there are reasons to believe that most of the time he was away from that city. His living and working quarters in the Vatican were in the villa of Innocent VIII at the far end of Bramante's Belvedere.[1] There are records of works in his quarters carried out under the direction of the architect Giuliano Leno in December 1513.[2] On July 7, 1514, Leonardo records the solution of a geometrical problem as having been reached in the Belvedere, "in the study given to me by the Magnifico."[3] When Leonardo arrived in Rome, at the end of 1513, Bramante was still alive: he died there on April 11, 1514. Thus Leonardo must have had first-hand information about Bramante's latest architectural works in Rome. And yet there is no evidence that he ever entertained the idea of becoming his associate or successor. In folios of the Codex Atlanticus dating from Leonardo's Roman period there are several drawings of systems of scaffolding (figs. 81 and 82) possibly motivated by Bramante's studies for the vaulting of the new St. Peter's.[4] Into one of them (fig. 82) is inset a large fragment of the same paper and date, with a drawing of the recumbent Ariadne, a celebrated statue that was displayed among the antiquities collected in the Belvedere.[5] In 1514 Leonardo was in Civitavecchia to study the remains of the ancient harbor, and afterward he was in North Italy again, in Parma, probably as a military architect in the service of Lorenzo di Piero de' Medici.[6] A sketch of the map of Florence at Windsor dates from this time.[7] In Florence Lorenzo di Piero de' Medici had his headquarters, and it was in Florence that Giuliano died in 1516. One of Leonardo's notes from that time gives the measurements of the Medici stables, which were built behind San Marco and the Florentine Studio, probably as part of Leonardo's project for a new Medici palace.[8] All we know of the project is a sheet in the Codex Atlanticus, but in addition there is contemporary evidence of Leonardo's reputation as an architect in Florence.

VII. THE NEW MEDICI PALACE

The earliest biographical record, by an anonymous Florentine, reproduced at the beginning of Part One above, mentions Leonardo first as an architect and then as a painter. And in 1564, in a speech delivered on the occasion of Michelangelo's funeral, Benedetto Varchi refers to Leonardo as follows: "Haveva oltra l'Architettura, oltra la Scultura, per sua principale arte o professione, dirò, o solazzo e intertenimento la Pittura" (Besides architecture and sculpture he had painting as his main art or profession, or should I say as his pleasure).[9] Cellini too was well acquainted with Leonardo as an architect. Not only did he own a copy of a compilation of Leonardo's notes on painting, sculpture, and architecture, but he reported that the king of France had spoken of Leonardo as very learned in matters concerning sculpture, painting, and architecture.[10]

Finally, in 1550 first and again in 1568, Vasari published a few statements about Leonardo's proficiency in architecture, as manifested in many drawings and models as well as in plans for the canalization of the Arno River. Although Vasari's statements are sometimes inaccurate, his remarks always have a basis of truth. He certainly could not have mentioned Leonardo's project of placing steps under the Baptistery of Florence Cathedral were this not something still much talked about in his day. There might be some truth also in his remark about Leonardo's having contributed to the design of the Council Hall for the Palazzo Vecchio, a work by Antonio da Sangallo and Il Cronaca, although there is no documentary evidence as yet of Leonardo's having been in Florence in 1495.[11] Again, there must be some truth in Vasari's obscure reference to Leonardo's departure for France as a consequence of rivalry with Michelangelo, in 1515, at the time of the projects for the façade of San Lorenzo in Florence.[12]

Vasari's statement makes sense, considering that Leonardo was not always in Rome between 1513 and 1516. In fact there is evidence that he was away from that city in September 1514 (when he was in Parma),[13] and in 1515 he was probably in Florence with his two patrons, Giuliano de' Medici and Lorenzo di Piero de' Medici, respectively the brother and the nephew of the pope. In December 1515 the pope himself was in Florence on his way to Bologna to meet Francis I, and his hometown had arranged great festivities for his arrival, with triumphal arches and a festive apparatus to which all the leading Florentine artists contributed.[14] Antonio da Sangallo the Elder built an "arcus quadrifrons"

in the Piazza della Signoria; Andrea del Sarto and Jacopo Sansovino worked together on a temporary façade in wood and canvas for Santa Maria del Fiore; Il Rosso, Pontormo, and others were engaged in similar tasks. It was at that time that the pope decided to have the Medici church of San Lorenzo completed by a façade, and opened a competition in which Michelangelo, Baccio d'Agnolo, Giuliano da Sangallo, and Raphael participated. The task was entrusted to Michelangelo. Meanwhile, the Medici family must have been entertaining the idea of a greater architectural project, that is, the replanning of the Medici quarter around San Lorenzo, with a large piazza in front of the church all the way to their palace, the corner loggia of which was to be closed by Michel-angelo at about that time. The only evidence left for such a plan is a sheet of Leonardo's studies, Codex Atlanticus 315 recto-b (fig. 83), which includes the project of a new Medici Palace facing the old one, on the other side of the Via Larga (fig. 84).[15] Leonardo suggests opening the Piazza San Lorenzo all the way to the Via Ricasoli, so that as one entered the piazza from the Via Martelli coming from the cathedral, the two Medici Palaces would have appeared at the head of two blocks flanking the Via Larga, and the façade of San Lorenzo, on the left, would have provided the proper background as in a theatrical setting. The church of San Giovannino was to be recessed in the block facing the side of the old Medici Palace, as shown in a companion sheet, Codex Atlanticus 315 recto-a (fig. 85). The motif of the large piazza was to be repeated at the end of the two blocks, corresponding with another religious center of the Medici patronage, the convent of San Marco.

The sheet was reproduced as early as 1883 by Richter and Geymüller,[16] who even transcribed the names of the establishments ("cosimo," "giovannino," "san marcho"), which make the identification of the area indisputable. But Geymüller was mainly concerned with the details of wall decoration, and this made him suggest that Leonardo "may have had in mind either some festive decoration, or perhaps a pavillion for some hunting place or park." The style of the drawing, the handwriting, and the type of rough paper point to a late period, about 1515, and one may think at first of some Roman project, espe-cially because of a note that can be taken as a reference to the Castel Sant' Angelo: "Le molina di castel si possan torre."[17] But by "castel" Leonardo meant what the Florentines called "Castellaccio," that is, the unfinished Santa Maria degli

VII. THE NEW MEDICI PALACE

Angioli, next to which was a fulling mill of the wool guild. The removal of the "molina di castel" would have resulted in the opening of a piazza in front of Brunelleschi's rotonda. The vast urban replanning of the area north of the cathedral, as shown in Leonardo's sketch, would have included not only an extensive program of demolition but also the building of a huge palace whose ground plan and elevation are indicated in sketches to the left of the topographical plan (figs. 88 and 93). A number of details of the elevation display a boldness of form and richness of decorative elements that may have appeared uncongenial to Florentine architecture. Even the static mass of the old Medici Palace would have been contrasted by the energetic growth conveyed by tree-shaped columns with archivolts formed by twisted branches, apparently recessed into a wall heavily rusticated, and thus suggesting an organic element breaking through stones.

The symbolism is obvious. The cut tree trunk sprouting new branches as a symbol of hope in a return to life and power was the emblem adopted by Lorenzo de' Medici, and again by his nephew Lorenzo di Piero, who in 1515 had become the governor of Florence. As the head of the Florentine government, Lorenzo di Piero must have envisaged a family glorification through a majestic architectural program that was to symbolize past deeds and present, in a piazza open as a stage set for which Michelangelo's façade of San Lorenzo was to provide the proper backdrop.

One is also prepared to understand why the idea should have originated in the festive atmosphere of Leo X's triumphal entrance into Florence in 1515. In the upper part of the sheet are sketches of a truss and bracing device apparently unrelated to the architectural plan below. And yet the sketches can be interpreted as a reference to temporary buildings of a kind used in festivals. They are in fact explained by drawings on another sheet of the Codex Atlanticus, folio 3 recto-b and verso-b (figs. 86 and 87), in which such a device is shown as pertaining to a centralized building somewhat like Palladio's Villa Rotonda.[18] The sheet contains a number of hints that point to a date around 1515. Leonardo shows the device in detail and explains that the walls of the building are kept firmly upright because the cables are twisted around at their intersection by a "menatoio," that is, a short tube with a longer staff thrust through it. (Once the tube is set in position at the intersection of the cables, it

is turned around with the help of the staff until the desired stretching of the cables is obtained, and then the staff is pulled up and stopped against the upper horizontal pole of the structure.) It is revealing that details of such a device appear on the sheet with the project for a new Medici Palace at Florence. Leonardo was probably advising the architects and the painters preparing the festive apparatus for the entrance of Leo X into Florence in December 1515, and it is even probable that his designs were related to the temporary structure that Antonio da Sangallo the Elder was to erect in the Piazza della Signoria. Vasari mentions it as a "temple with eight faces," and the chronicler Landucci specifies that it was a quadrangular structure with four triumphal arches.[19] A reconstruction of it based on Landucci's description shows that the projection of the arches may have suggested the octagonal form of the "temple."[20] Furthermore, one may surmise that it had an octagonal base and a wooden frame roof on a square or polygonal base, as suggested by Leonardo's sketches. Be that as it may, one may well wonder whether it is a coincidence that one of the personages present at the ceremonies of 1515, Cardinal Giulio de' Medici, the future Pope Clement VII, was to suggest to Michelangelo a few years later the motif of the "arcus quadrifrons" for the Medici Tombs in San Lorenzo.[21]

Nothing is left of the Medici project of 1515 except the sheet of Leonardo's studies.[22] But in addition to Michelangelo's closing up the corner loggia of the old palace, we have the record that the Medici stables were being built in 1515 next to the convent of San Marco, an event recorded by Leonardo himself. Furthermore, dating from the same time is Sangallo's idea of a new Medici Palace on the adjacent area east of the Annunziata, planned as a sumptuous residence echoing the imperial ambitions expressed in the design of a palace for King Ferrante thirty years before.[23]

Much of Leonardo's architectural project for the Medici anticipates Romorantin; and in fact, if it were not for the specific reference to Florentine buildings, Leonardo's plan could have been taken as one of his French projects of twin palaces in a regular setting of streets, piazzas, and canals, with a dominant longitudinal axis.

The tiny sketch of the elevation of the palace (fig. 88), with octagonal corner towers, heavy base, terraced roof with turrets, and galleries, shows how far

VII. THE NEW MEDICI PALACE

Leonardo had moved away from the Florentine architecture of the quattrocento toward the monumentality of Bramante's Roman period. It even recalls the entrance pavilion of the Castle of Gaillon (figs. 89 and 90). The details of wall treatment show how profitably Bramante's single touch of the rustic in the Cortile della Canonica of Sant' Ambrogio (figs. 91 and 92) could be expanded to take over a whole wall. The intricate wall articulation is reminiscent of the Gothic implications of the Sala delle Asse, but with a boldness that anticipates Giulio Romano. The rich overlay of vegetable motifs is a garden wall decoration applied onto the severe surface of a public façade. The Medici emblem of the dry laurel tree turned into a column sprouting intertwined branches to form archivolts recalls Leonardo's early drawing of a garden wall, "muri d'orti" (fig. 94). This aptly illustrates a passage of Alberti[24] and evokes the fabulous world of the garden cult of antiquity. Similarly, Poliziano's description of the "Sito di Venere" at Cyprus came to Leonardo's mind when he was planning a suburban villa for the French governor of Milan in 1506–1508.[25] The sheet on which he wrote his own description of the mythical garden of Venus (fig. 95) contains a sketch of Michelangelo's *David* turned into a Neptune fountain and the project of a palace with corner towers, terrace, turrets, and galleries, which was to develop, through his Florentine project for a new Medici Palace, into the design of a royal residence at Romorantin.

63

PART TWO

THE ROMORANTIN PALACE

M.^e *Lionard de Vincy, noble millanois* I.^er
peinctre et ingénieur et architecte du Roy,
meschanischien d'estat, etc.

Act of inhumation, August 12, 1519

I. THE OLD CHATEAU

The historians of Romorantin speak of two castles built on either bank of the Saudre River at different times. One was the medieval fortress located on the Ile-Marine, the island formed by the "Petit bras de la Saudre," on which still stands the Romanesque church of Romorantin. The château was besieged by the English in 1356. There are records of its restoration dating from 1463, 1464, and 1510.[1] No trace of it is left, and there is not even a record of what it looked like. The other château, which was to replace the medieval fortress, was to be more suitable as a residence. Its appearance before the early nineteenth-century alterations is preserved in a map of the town dating from about 1775 (fig. 128): it was square in plan, slightly irregular, with four corner towers, and stood in line with the west portion of the fortified wall. No park is shown.

There is some evidence that the more recent château was built around 1450 by Jean d'Angoulême, grandfather of Francis I. A detailed account of its construction, as given by Alexandre Dupré,[2] a historian of Romorantin, was published in part in 1875. The first record, dated 1451, pertains to work inside the castle. In 1454 Jean Bernardot, a local mason, was paid for eight days of work on the chapel inside the castle. Then a "glass master" was paid for the image of a St. Madaleine to be placed in the chapel. Another local mason, Pierre Marteau, was paid for the carving of the coat of arms of Charles d'Orléans and Jean d'Angoulême to be placed above one of the doors of the stairs of the château. Finally, again in 1454, there are records of purchases of fabrics for the decoration of the new apartments. Dupré refers to such evidence as being preserved in the "Archives de l'Empire, Etat manuscrit des dépenses de la maison de Jean d'Angoulême, pour les mois de Mai, Juin et Août 1454."[3]

There should be no reason to doubt Dupré's conclusions. Yet a document published by Henri Stein in 1898[4] suggests that the construction of the new château was undertaken only around 1512 under the direction of Pierre Nepveu called Trinqueau, a master mason of Amboise, and by order of Louise of Savoy,

mother of Francis I. Curiously enough, Stein ignores not only Dupré's publication but also the article by Paty published in 1843 in the same journal[5] and dismisses what seems to have been the accepted opinion—as expressed by Charles Vasseur in 1868[6]—that Jean d'Angoulême had undertaken the construction of the new château and that his son Charles had carried it out. "Cette opinion," concludes Stein "ne peut être admise, puisque Charles d'Angoulême décéda en 1496" (This opinion cannot be accepted, since Charles d'Angoulême died in 1496). According to the document published by Stein, it was Louise of Savoy who had the construction of the second château undertaken, but the evidence is not necessarily conclusive. In fact the document may refer just to the enlargement of the château, not to its construction (Appendix A, document 1). It may be paraphrased as follows:

> A visit to the foundations of a part of the Château of Romorantin.
> To all who will read this letter, Jean Gallus, licensed in law, "chastellain" of Romorantin, greetings. We make it known that today, date of the present letter, the nobleman Nycollas Foyal, esquire, seigneur de Herbault, adviser, etc., of Princess Madame la Comtesse d'Angoulême, has requested that Pierre Nepveu, called Trinqueau, a resident of Amboise, master mason in charge of the architectural work undertaken by order of the said Madame at the château of Romorantin be summoned to our presence and the presence of our notaries etc., and with him Macé Olivier, Loys Grasserreille, and Jehan Rousseau, also master masons, resident at Romorantin, in order to report about the conditions of the newly established foundations of the château to be built on the bank of the Sauldre River. After their visit to the site, they all report that the foundations, at their present level, are eleven feet, or more, lower than those of the old château, and that they have a thickness of seven feet over a layer of thick gravel. It is therefore suitable to carry the weight and the height of the said edifice according to the plans that have been shown and explained to them. So far as they can judge, no inconvenience or damage to the building should ensue during its construction on account of its foundations . . . Done on September 27, 1512. P. Meignen. S. De Launay.[7]

For several years, between the end of the fifteenth century and the beginning of the sixteenth, the French court alternated its residence between Blois and Romorantin. It was in Romorantin, in 1499, that Anne de Bretagne, wife of Louis XII, gave birth to Claude de France, who was to marry Francis I in 1514. Louise of Savoy, mother of Francis I, also lived there, since it belonged to her by dowry; and one of the first deeds of Francis I as the new king of France in

1515 was to promote the urban development of Romorantin by granting a tax exemption on wine to its inhabitants (Appendix A, document 2). The document explains that Romorantin is "le lieu où nostre très-chère et très-amée compaigne la royne a prins sa nativité, génération et nourriture" and states that to enlarge the city and keep it at an equal level of splendor and efficiency would greatly please the king and the queen. Finally, it is said that the royal favors bestowed upon the town are a homage to the ancestors and to "nostre très-chère et très-amée dame et mère," that is, Louise of Savoy, who "la pluspart du temps, a fait son séjour et résidence en la dite ville, et encore a voulloir et intention de ce faire, et nous pareillement." In the following years, the king's intentions were reflected in intense architectural activity at Romorantin. This, however, came to a halt around 1519–1520, at the time of some plague in the town, and the king decided to build the Castle of Chambord. But Francis I continued to visit Romorantin. It was there that he had an accident during a festival on January 6, 1521. He was seriously wounded in the jaw by a fire-cracker and had to grow a beard to cover the scar—with the curious consequence that beards became immediately fashionable in France, *regis ad exemplar*. Whatever architectural project was undertaken at Romorantin was abandoned; yet remains of walls were still standing in the eighteenth century. In 1682 the historian of Blois, J. Bernier, recorded the château as practically intact; however, he found it insignificant: "Ce bâtiment est encore presque tout entier, mais il n'a rien de singuler."[8] About a century later, in 1770, M. Leconte de Bièvre bore witness to the gradual demolition of its walls: "Il ne reste plus du château de Romorantin que quatre tours, une a chaque angle de la cour, une partie de l'aile orientale, et la chapelle à l'occident."[9] The story of its later alterations is told by the sous-préfet of Romorantin, M. Lambot de Fougères, in a report of 1818 (Appendix A, document 3b): after the revolution, in 1806, extensive demolition was carried out to provide space for the construction of the tribunal, the prisons, and the police station. A print by Lockhart, dated 1822 but obviously based on a considerably earlier drawing, shows what was still standing of the château around 1800 (fig. 99). Nothing of the new constructions is shown, and a wall in ruinous condition extends beyond the fragment of a corner tower on the left, an important detail that we shall meet again.

By the end of the eighteenth century there was little more left of the original

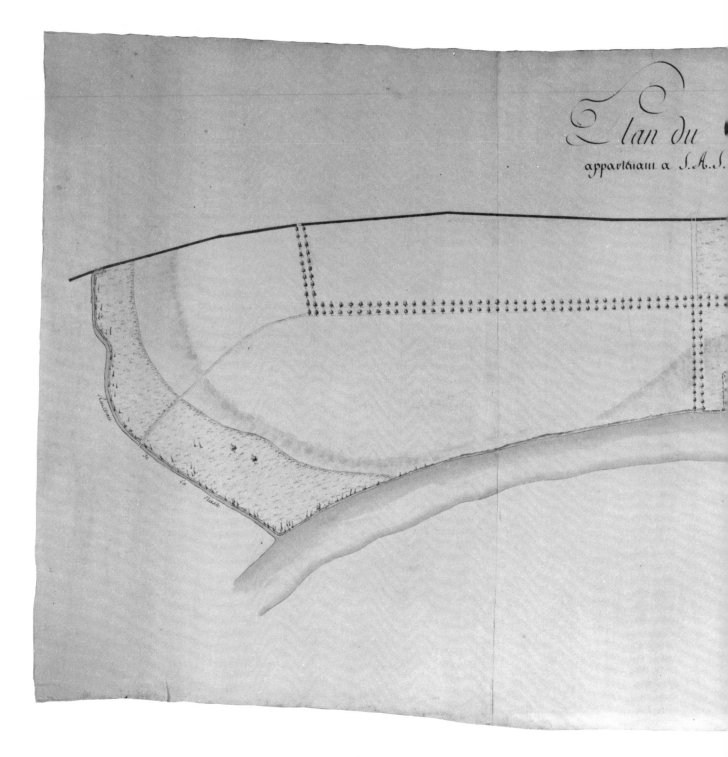

Eighteenth–century map of the Château of Romorantin and its park.

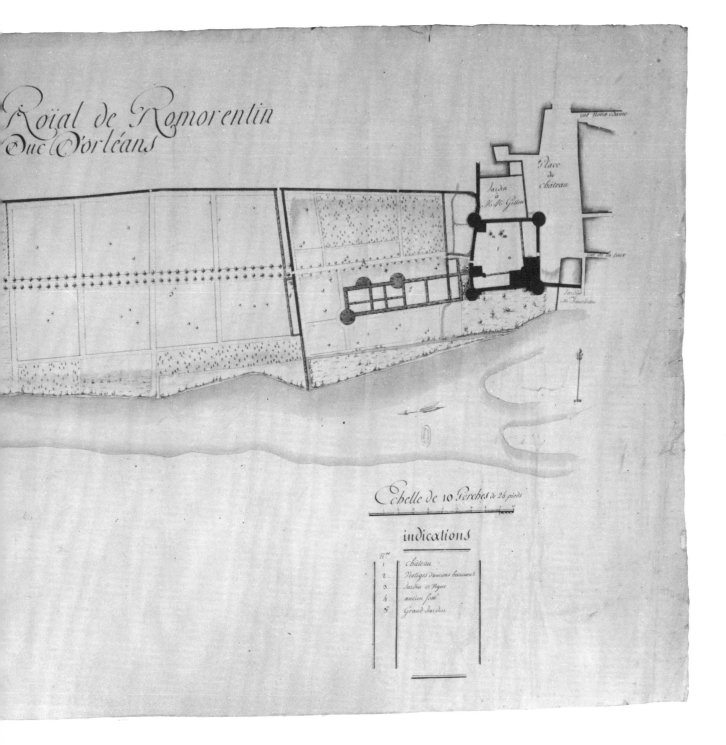

Roïal de Romorentin
Duc d'Orléans

Échelle de 10 Perches de 24 pieds

indications

n.°	
1	Château
2	Vestiges d'anciens bâtiments
3	Jardin et Digue
4	ancien fossé
5	Grand Jardin

Paris, Archives Nationales, cat. 1322, N III, *Loire et Cher 2*.

château than two of the corner towers. But at least the tower facing the Saudre River was at the same time restored to preserve the sixteenth-century decoration of its vertical sequence of windows crowned by the elegant round pediment with a shell (figs. 100 and 168). Since this is all that remains of the original château, the possibility of locating traces of any work of enlargement is negligible. As seen below, however, several reports from the eighteenth century speak of the walls of a new construction as standing to a height of ten feet. Recently Heydenreich, unaware of the 1512 document published in 1898, has combined three such reports in a single "composite document" and presented it as evidence that the project of a new palace was actually undertaken and that it was probably conceived by Leonardo da Vinci.[10] His abridgment of the historical accounts results in the omission of important elements pertaining to the location and type of the new construction. Since the site had not been identified with certainty, one was left with the impression that there was to be a new palace built in the park of the fifteenth-century château, somewhere along the river further down in a westerly direction.

The earliest of the historical accounts is by Jean François Bidaults, dated May 25, 1710 (not 1770, as given by Heydenreich). Three short chapters (62–64; see Appendix A, document 3a) pertain to the work undertaken under Francis I and include topographical indications:

62. Of the Romorantin Castle.

The Castle of Romorantin was built of bricks and cut stones by the princes of the Angoulême house. Francis I wanted to enlarge it, as is shown by the foundations made at the castle in the place called Les Lisses. But his design was hindered by the plague. This king, in 1515, also conceived the design of making navigable the river that flows alongside of the château.

63. Of the "grand jardin."

This castle, which we have just mentioned, has a park enclosed by brick walls, and at the entrance of the park, on the right, coming from Les Lisses, there is a deep passage with brick revetment, which served as the place for the bull game at the time of the sojourn of the princes, the seigneurs of Romorantin: and this passage is still called today the "fosse aux lions."

64. Of the old "seigneurie" of Monceaux.

This "jardin" of which we have just spoken leads to the garden of an old "seigneurie" called Monceaux, where Francis II, king of France, had grown up to the age of seven years. Between the two gardens there is an area flanked by tall elms, which was the place where the ambassadors were received when Francis I was staying at Romorantin.

72

I. THE OLD CHATEAU

This document, which is the source of a later compilation, the *Étude sur Romorantin* by an anonymous author, about 1800 (document 3c), explains that the foundations of the new construction were located next to the old château in the place called Les Lisses and that the park of the château extended all the way to the Mousseau Manor with two characteristic features: a deep pit for the bull game, that is, the "fosse aux lions" located on the right upon entering the park from Les Lisses, and the area flanked by tall trees that was used by Francis I as a natural audience hall to meet the ambassadors.

The other document on which the greater part of Heydenreich's "composite document" is based is the report of Lambot de Fougères, 1818, a somewhat lengthier account of Francis I's project, but less specific about the location of the new construction (Appendix A, document 3b). Its wording is somewhat ambiguous, since it states that the king intended to enlarge the old château and that he ordered the construction of a "véritable palais," leaving it unclear whether the enlargement and the "véritable palais" were one and the same undertaking. The pertinent passage of the whole section on the château can be paraphrased as follows:

This prince [Francis I] had much affection for Romorantin, as one has for the place of one's ancestors. Having become a king, he wanted to enlarge the castle, and in accordance with his orders the foundations of a majestic palace were laid, which was to be surrounded by a huge park crossed by the Saudre. The Romorantin Castle would then have become a royal residence that would have brought a great many advantages to Romorantin, but the town was not to have this good fortune. The project was abandoned at the death of the prince's beloved mother. This sad event and the prince's feelings, rather than an epidemic as someone has suggested, must have been the reason for the interruption of the work at Romorantin and for the king's decision to build the Castle of Chambord on the banks of the Cosson—a castle that the king, whom Mézerey called "le grand bâtisseur," wanted to have constructed to replace the one that he had planned on the banks of the Saudre. The foundations of the latter were still existing before the revolution, and they were used as a quarry until they were exhausted, as they are in fact today, for no trace of them is left. There is every reason to believe that the brick walls that enclose on one side the terrain bordered by the Saudre on the other side and extend down to the small Château of Mouceau are a work of that prince.

These historical accounts dating from 1710 to 1818 are not verified by first-hand documents concerning the king's intentions and the reasons for the abandonment of the work at Romorantin. They contain no reference to the fact

73

that in 1512 the foundations of the "new château" had already been laid. But they are certainly reliable insofar as the remains are concerned, remains of walls built to a height of ten feet and still standing at the time the accounts were written.

Similar accounts are preserved in the Municipal Library at Romorantin in a volume compiled in 1888, *Recuil de documents pour servir à une histoire de Romorantin, recuillis par M. Berge*, which consists of seven essays written between 1790 and 1879.[11] These are preceded by the map mentioned above representing Romorantin in 1775 (fig. 128) and are followed by a number of illustrations, including a photograph of a drawing of the Porte d'Orléans (fig. 127), which was the last of the city gates to be demolished (1849). On pages 65–93 is an essay written around 1800, *Notice sur la ville de Romorantin* by Nicolas Millot, director of the Collège de Romorantin at the time of the French Revolution. He was then in the position of describing the château and its park with the accuracy of an eyewitness (Appendix A, document 4a). But the title of his compilation, *Notice*, is a warning that his work cannot be taken as a systematic presentation of facts and records and that his notes are not always related to each other in a logical sequence as in a guidebook. On folio 75 are three notes concerning the garden of the Château de Mousseau, the park of the Château de Romorantin, and the project of a new palace in that park. The Mousseau Manor, which is opposite the castle at the west end of the park, was originally a hunting lodge, inhabited on occasions by Françoise de Foix, comtesse de Châteaubriant, the first mistress of Francis I; it was considerably enlarged in the sixteenth century, but the area has not been much affected by new constructions (figs. 101, 109, and 110).

"The garden of this château," writes Millot, "is adjacent to the park of the Château de Romorantin, or rather it is only separated from it by a small brook called La Nasse, which is also the boundary of the two communes [Romorantin and Lanthenay]." The next two sentences say that it was in the Mousseau Manor that Francis II (son of Henry II and Catherine de' Medici) had spent his first seven years, that during his reign he often went back to Romorantin to visit the place of his childhood, and finally that it was during one of those visits that he signed the famous *édit de Romorantin*, in 1560. This insertion prevents us from establishing a relation between the note on the Mousseau Manor and

the note in the next paragraph, which deals with the park of the Castle of Romorantin and with the "fosse aux lions":

Upon leaving the garden of the castle to enter the park, one finds on the left a "fosse" with brick revetment, 8 to 10 feet deep, about 30 toises long and 2 toises wide. This is where the bullfight took place when the seigneurs de Romorantin were living in the château, and it is still called today "la fosse aux lions." They have just removed the walls of this fosse and are working to fill it up. The park has been sold to a "particulier" [private individual] as national property, the trees have been cut down and the land put to cultivation.

The opening sentence is somewhat ambiguous, and one is tempted to interpret it as referring to the preceding paragraph concerning the garden of the Mousseau Manor—which was referred to as a château—and to deduce that the "fosse aux lions" was located on the way out of that garden, on the left, in the area of the park of the Château of Romorantin. The interpretation of the passage is further complicated by the reference to the "fosse aux lions" in the document of 1710: as we have seen, the earlier account mentions the fosse as being located on the right-hand side of the park at the exit of an area (Les Lisses) related to the old château. The documents do not specify whether the fosse was parallel to the longitudinal axis of the park or at a right angle to it. But before considering other evidence we must go on to the next paragraph of Millot's account:

Francis I . . . had had the foundations laid which are still visible several feet above the ground, of a considerable extension of the castle on the banks of the Saudre River, but he abandoned his project and moved his plans to Chambord.

There is no way to ascertain the accuracy of this important information. But at least the Millot account is more specific than those at Blois: whereas the other documents state that Francis I intended to enlarge the château and to have a "véritable palais" built, Millot says that what was still visible were the remains of a "prolongement considérable" of the old château. The extension of such a "prolongement" is still uncertain, because the location of the "fosse aux lions" is not specified.

The short account by an anonymous author, *Antiquités de la ville de Romorantin*, dated May 1, 1790, the seventh essay in the Miscellanea Berge (Appendix A,

document 4b), is another document dating from the time when the ruins were still standing. It is apparently based on the document of 1710. A paragraph on the Château of Romorantin reads as follows:

The castle of the city was built of bricks and cut stones by the princes of Angoulême. Francis I wanted to have it enlarged, as is seen by the foundations made in the area of the château known as Les Lisses; but his design was hindered by the plague. The king also wished to make the river navigable. There is a park enclosed by a brick wall, and at the entrance of the said park there is a deep area revetted with brick walls; this was the place where the bullfight was performed when the seigneurs were at Romorantin. It has come to be called the "fosse aux lions." In this park there was a considerable garden with beautiful allées, leading to the garden of an old house called "la Seigneurie de Monceaux," etc.

Here again is the reference to the "fosse aux lions" as located at the entrance of the park of the Castle of Romorantin, but without any specification whether it was on the left or on the right. There is no mention of the park as being adjacent to the garden of the Mousseau Manor. It can be deduced, however, that if the location of the fosse were the one implied in Millot's description, the reference would be not to the "entrance" of the park but to its exit, or at least to its end. The ambiguous language of the historical accounts would leave the problem unsolved were it not for a different kind of evidence: an accurate map of the whole area (pages 70–71), drawn in the first half of the eighteenth century, and recording the ground plan of the abandoned construction, shown as an extension of the old château.[12] The legend is explicit and helps to interpret the documents considered previously:

No. 1 indicates the fifteenth-century château, a somewhat irregular square structure with corner towers.
No. 2 records the "vestiges d'anciens bâtiments."
No. 3 refers to a "Jardin et vigne," that is, "Les Lisses," the area in which the enlargement of the palace was to be carried out.
No. 4 is designated as "ancien fosse," undoubtedly the "fosse aux lions" mentioned in the documents.
No. 5 is the "Grand-Jardin," that is, the park of the castle.

The puzzling paragraph of Millot's document becomes clear. The statement "upon leaving the garden to enter the park" does not refer to the garden of

the Mousseau Manor but to the "Jardin et vigne" of the Romorantin Castle and to its "Grand-Jardin," that is, nos. 3 and 5 in the map. The scale of the map ("Echellede 10 Perches de 24 pieds") makes it possible to ascertain that the space enclosed between the two parallel walls of the "ancien fosse" measures about 68 by 4 meters, very close therefore to the measurements of the "fosse aux lions" as given by Millot, that is, 4 meters wide and 60 meters long. This map may also help to explain an apparent anomaly in the accounts: in 1210 the fosse was recorded as located on the right of the entrance to the park, whereas Millot, around 1300, speaks of it as located on the left. It is conceivable that the right portion of the fosse had already been filled up at the time Millot was writing (he says: "they have just removed the walls of this fosse, and they are working to fill it up"), and that, although the original dimensions of it were still recognizable, the area still open was on the left.

It is impossible to say how closely the original sixteenth-century arrangement of the terrain is reflected in this map, and it is also impossible to say whether the remains of the ancient walls are all that was carried out of the project of enlargement. What is visible along the Saudre River is probably only one wing of the palace, which was to terminate with a corner tower as in the old château. The castle was to become three times bigger, a complex over 75 meters long. The area that includes the western end of the new construction and the "fosse aux lions" is still open space, with vegetation and some allées that reflect the original design. Most probably, some of the foundations recorded in the map still exist below the surface of the terrain, but excavations would only confirm their presence without adding anything to our knowledge of the structure. The same applies to the walls of the "fosse aux lions," part of which is still standing. Compare the air view (fig. 106) and the ground views (figs. 107 and 108).

It is interesting to note in the map that two walls at right angles shown inside the court of the old château suggest the intention of incorporating the old château in a plan as symmetrical as possible. Perhaps two wings were to be attached to the old château at either side of an allée, and probably joined at one extremity by a screen wall.[13] Two towers were planned inside the court, with or without a facing pendant, to be used as independent stairs. They were probably to be open structures as in the Blois Castle, wing of Francis I. Apart

from the hint at geometrical regularity, there is too little to suggest that the plan was conceived by an Italian architect. We know that the foundations of the projected enlargement were already laid in 1512. The builders in charge of the construction judged that they were suitable to support the huge edifice "according to the plans that have been shown and explained to them."

Who had made the plans? From 1506 to 1511 Leonardo was in the service of the French governor of Milan. It has been surmised that during that period he made a first trip to France.[14] It is doubtful that he had anything to do with the project to enlarge the Château of Romorantin; yet his advice might have been sought in Milan, and then his presence in France might have become necessary when the new king decided to transform the Romorantin Château into a great residence for his mother and himself. Indeed, the presence of a fosse at the entrance of the park implies that a greater architectural project was to be developed in the park itself. What is in fact most striking in the park's design is the geometrical arrangement of its partitions along an impressive longitudinal axis. One may conclude, therefore, that there was a first project to enlarge the château dating from the first decade of the sixteenth century and that after 1515 the project developed into the idea of a royal residence as part of a new city. Leonardo might have inspired both conceptions. It is certain, however, that in 1517 he was in Amboise, the hometown of Pierre Nepveu, the builder who worked on several projects: first at Romorantin, then at Blois and Chenonceaux, and finally at Chambord (fig. 96).[15]

II. THE PLANS OF A NEW PALACE

A sheet in the Codex Atlanticus, folio 76 verso-b (fig. 111), contains a project for a palace by a river. The style of drawing and handwriting and the type of brownish rough paper point to a late period of Leonardo's activity, probably around 1517. The palace is represented only in ground plan and is shown as a castle with four corner towers, one side of which is flanked by a road and the other side by a river. The road is inscribed "strada dābosa," route to Amboise,[1] and can be identified with the present rue des Capucins at Romorantin, which runs for a considerable length almost parallel to the river, that is, the Saudre River. The building is therefore oriented from west to east (figs. 112 and 113), and thus the drawing cannot represent a project to change the old château into a new structure. In fact it is unlikely that its park was meant to stretch into the urban center of Romorantin. The plan is strictly organized along a longitudinal axis. It is just conceivable that it was intended as a building to be erected ex novo somewhere in the vast park of the fifteenth-century château and to be linked to that château by a geometrical sequence of gardens. It is also conceivable that the old château was to be conveniently modified to fit the program of a great royal residence. The emphatic axis would have become the invitation to a glorious promenade through architectural marvels.

The drawing gives the measurement of the court: 120 braccia long and 80 braccia wide, that is, about 240 by 160 feet. Although it is not a drawing in scale, it must convey some of the relationships between the various parts of the building that Leonardo might have intended to achieve in the final project. A note below the drawing says that the frontage of the palace should be twice the width of the court, thus 160 braccia, that is, about 320 feet.[2] The width of the court measured from one corner column to the other is in fact exactly half the width of the front, excluding the projection of the corner towers. We know

that this front crossed nearly the whole width of the area under consideration. The river and the road are shown as almost parallel, only slightly converging at the rear of the palace, in the area of the park. This suggests an area approximately halfway between the Nasse Brook and the old château (fig. 110), an area which is now delimited by the "abattoirs" and the railroad tracks. Its width is about 340 feet, and we have seen that the width of the palace façade was to be about 320 feet. The eighteenth-century map (pages 70–71) shows an enclosing wall parallel to the route to Amboise. This would correspond roughly to the outer wall of the new palace, the space left to reach the road being taken up, in Leonardo's plan, by a moat.

The drawing shows only the projected new construction. In the upper part of the sheet are general instructions headed by a deleted sentence: "The palace of the prince ought to have a piazza in front."[3] Below this Leonardo advises how the halls for festivals should be arranged:

Dwellings in which provision is made for dancing or for any kind of jumping or any other movement with a multitude of people must be on the ground level; for I have already witnessed the destruction of some, causing the death of many persons. And above all let every wall, be it ever so thin, rest in the ground or on arches with a good foundation.[4]

The remainder of the notes, top left, deal with the type of roofing to be adopted and with the proper location of privies:

Let the mezzanines of the dwellings be divided by walls made of very thin bricks, and without wood on account of fire.

Let all the privies have ventilation [by shafts] through the thickness of the walls, so as to exhale through the roofs.

The mezzanines should be vaulted, and the smaller the vaults are, the stronger they will be.

The ties of oak must be enclosed in the walls in order not to be damaged by fire.

The rooms leading to the privies must be numerous and leading one into the other so that the stench may not penetrate into the dwellings, and all their doors must shut themselves by means of counterweights.[5]

Below are four sketches possibly related to the notes on the system of privies. One of them shows the plan of a central octagonal area with four projecting

arms. In the middle of the area a small rectangle is drawn. The words "cocine" and "dispensa" (kitchens and pantry) written below the sketch may be unrelated to it. Since no such cross-like structure is identifiable within the general plan of the palace, its purpose cannot be ascertained, and it may in fact refer to an independent building or to an alternative solution of the problem of a royal residence.[6]

The larger drawing in the lower part of the sheet represents the schematic ground plan of a palace with an apparently square courtyard; the two rooms at either side of the entrance are inscribed "ca," that is, "camera," a probable reference to bedrooms for guests. Stairs are placed at one corner of the courtyard, under the entrance loggia. There are no corner towers or projecting end bays in the façade. Three slight sketches are on the right and below. Next to it, on the left, is the plan already mentioned—smaller but more detailed—which includes the indication of a river, that is, the Saudre. Because of the reference to the route to Amboise, we know that the river flows from top to bottom. Its left bank happens to correspond to the outer wall of the palace shown in the larger plan, but there is no doubt that the two plans are unrelated.

It is impossible to say which drawing came first, but perhaps the more detailed one represents Leonardo's final intentions. In addition to four corner towers, the building was to have towers flanking the entrance as well as the exit, which leads into the garden. On the left is a detail of a corner tower, apparently with a square room, three sides of which have recesses corresponding to the opening of three windows. On the left side is a moat bordering the route to Amboise and making a right-angle turn to delimit the area of the second courtyard. All along the right side of the palace, and even extending the whole length of the second court, is a portico, with columns indicated by dots. Facing the portico, an area slopes down in steps into a basin formed by the river, in which the shapes of boats are indicated. This is inscribed: "giosstre colle nave cioe li giosstrāti stieno sopra le naue" (jousting in boats, that is, the jousters are to be on the boats).

The second courtyard was designed as stables and quarters for the retainers. The lateral wings are in fact inscribed "stalla" (stables). The end wing, to the right, is inscribed "famigli" (retainers),[7] and the corner room to the left is inscribed "a" to which the note on the left refers: "in a angholo stia la guardja

della stalla" (in a, corner, let the guard of the stable be). A large round fountain basin is placed in the center of each half of the court, accompanied by a small rectangle that may represent either a bench or another basin for the horses.

The drawing gives the proportions of the overall structure fairly accurately, so that we can tentatively transfer it onto a map of the area (fig. 113) and even attempt a conjectural rendering to scale (fig. 114). If the façade of the new palace was to span the area as suggested, the whole architectural complex would have had to be extended over about 1,000 feet of land to reach the old château. Leonardo's drawing shows a complex about three times longer than wide, thus suggesting that it was to cover an area about 1,000 feet long. It is probable that the longitudinal axis was to be further extended in a westerly direction to pass by the Mousseau Manor and to reach the route to Amboise.

There is still some doubt about what Leonardo intended to refer to with his measurements of the main court: whether he meant the open space delimited by the columns of the loggia or running from wall to wall, thus including the loggias. The note reads as follows: interre/no —— / b[raccia] 80e / lūgha b[raccia] / 120 —— (At ground level the court is 80 braccia wide and 120 braccia long).

If the measurements of the court were taken from wall to wall, the façade would extend far beyond the limit of the towers. In fact, as Leonardo says, the façade should be twice the width of the court. Thus he must have intended the dimensions of the court to refer to the area open to the sky. But why the apparently unnecessary specification "in terreno"? The theoretical sketches in a drawing at Windsor (fig. 141), dating from about 1508, probably provide the answer: the elevation of the court of a three-story building shows a two-story loggia, so that the court is actually wider at roof level—hence the need to specify that the measurements were taken at ground level rather than at roof level. The Palazzo Strozzi at Florence and several other palaces of the time have this type of court.

The note "fosso braccia 40," which refers to the moat, raises another question. This is a dimension of about 24.48 meters, which equals almost half the width of the court, whereas the drawing shows that it should be about one fourth of the court. But after examining the original I am convinced that Leonardo wrote "fosso braccia 10": the "4" of what appears to be "40" is only an illusion pro-

duced by a line of the hatching used to indicate water. Ten braccia, corresponding to 6.12 meters, would be in the right proportion.

In the proportions of the court Leonardo adopts the ratio 3 : 2, based on the "sesquialter" musical interval, which Alberti considers as fitted for small rooms.[8] The alternative solution, which omits corner towers, shows the court as a square, just as common in Renaissance architecture as the square and a half.[9] The 3 : 2 proportion is that of a rectangle containing two intersecting circles with a common radius. This recalls a geometrical figure that seems to have obsessed Leonardo in the last years of his life, a stelliform lunula with which he fills scores of folios in the Codex Atlanticus and at Windsor, all dating from 1518.[10] As he investigates the endless combinations of the simple motif, he repeats time and again the sentence: "The greatest perfection in the division of the circle into equal parts is in the use of the number six."[11] And in fact he shows that to carry out the construction of the hexagon all one needs is a fixed setting of the compass, which implies the design of the stelliform lunula. Sebastiano Serlio explains that it is because of this property that Italians call the compass the "seste."[12] Since the stelliform lunulae can be repeated to infinity in every direction, the sequence of intersections of the circles may well suggest the path corresponding to the longitudinal axis of an architectural complex. This would aptly illustrate Leonardo's definition of geometry as a science that deals with "continuous quantity,"[13] but there is no evidence that he ever visualized an architectural structure as generated by such a framework of lunulae. Such lunulae are found all over the folios containing notes on the Romorantin project, but the notes show that he is concerned with practical considerations only.[14]

Once again Leonardo was involved with the project of an architectural complex in which entertainment was to play a major role. The ballrooms were to be built at ground level for safety; the boat tournaments required the terraced slope for the spectators; and finally the sport of hunting required much space for the stables. Leonardo's projects for stables date as far back as 1487–1490, at the time of his drawings in the Codex Trivulzianus and Manuscript B (figs. 116 and 117). Stables were included in his projects for the Palace of Mariolo de' Guiscardi, about 1498, and it seems that at about the same time Leonardo had designed the stables for Galeazzo Sanseverino in Milan and that he was still

involved with the "stalla di ghaleazzo" around 1510.[15] Nothing is left of those buildings, but it must have been one or the other of them that Vasari mentioned in his life of Piero della Francesca as being decorated with paintings by Bramantino.[16]

Leonardo had probably planned the stables at Romorantin as a replica of his early project of stables for Galeazzo Sanseverino, just as he had made a replica of his early stage setting of the *Paradiso* play at Amboise in 1518. Furthermore, Galeazzo Sanseverino himself was then in France in the service of Francis I as the supervisor of the king's stables at Blois.[17] Finally, in Codex Atlanticus 174 verso-c (fig. 118) there is a record of a payment to Leonardo in France, with reference to horses from the king's stables:

A monsieur le Ventie tollez des chevaux de l'escuyerie du Roy en comt xv frs. Caissez payment ou envoyez à Monsieur Lyonard Florentin paintre du Roy xv frs. à franchisment dudi S[eigneu]ʳ

This is followed by the word "Amboyze" written four times. Leonardo used this folio for geometrical studies of lunulae, as he did with folio 177 recto-a, which contains a line in the same writing as the order of payment:

Monsieur, je me recommande à votre bone grace.

From Leonardo's early drawings of stables one can derive some idea of the wall treatment of the second courtyard of the Romorantin Palace. A sketch in the Codex Trivulzianus, folio 22 recto (fig. 116), which Geymüller describes as a "sketch of a palace with battlements and decorations, most likely graffiti," and Firpo as a portal or triumphal arch, perhaps for festivals,[18] is a detail of wall decoration for the stables designed on the facing page, folio 21 verso. The decorative overlay, not graffiti, is similar to that of the later project for a new Medici Palace (fig. 83). It is exquisitely quattrocento in character, and shows that Giulio Romano's Cavallerizza in the Ducal Palace at Mantua ultimately derived from this type of "stable decoration."

There are other references to the project of a royal residence at Romorantin in a series of Leonardo's studies for the canalization of the Sologne region. These must be handled separately. The drawing considered in this chapter is the only

evidence for the intended site of the construction, that is, the park of the fifteenth-century Château of Romorantin. It is impossible to say how close this drawing is to the final intentions of Leonardo and the king. Indeed, it looks considerably earlier than the other studies of the series, not only because it does not show the "palace of the prince" as part of a new urban complex, but above all because of the style of the drawing and handwriting. And I must confess that I have been looking into the possibility that the sheet may date as early as 1512–1513, Leonardo used this type of brownish rough paper for many of his geometrical studies in the Codex Atlanticus from about 1513 to 1516,[19] and also in some of the *Deluge* series, one of which contains a reference to Lyons and to Francis I's Italian campaign in 1515.[20] All the other studies for the Romorantin project, which can be dated with certainty to 1517–1518, are on a paper of better quality, on which Leonardo's handwriting has a firmness and a neatness that account for its characteristic boldness. Notes dating from the preceding years have a rather untidy look produced by the absorbent quality of the rough paper, as do the notes on this folio. Furthermore, their ductus is close to that of the anatomical notes at Windsor of 1513[21] and that of notes on blue sheets in the Codex Atlanticus dating from 1513 to 1515. The touch of the pen and the format and quality of the paper recall such folios of the Codex Atlanticus as 95 recto-a, from which originated two anatomical fragments now at Windsor and which contains architectural sketches probably related to the Castello Sforzesco in Milan.[22] Many are the folios of this type in the Codex Atlanticus, and several of them have a characteristic water stain around the margins, as does the folio with the project for the Romorantin Palace. Its possible earlier date does not necessarily suggest a relationship with the 1512 plans for an enlargement of the Romorantin Palace. Leonardo might have met Francis I in Italy sometime around 1515[23] and, having been told of the project, might have obtained enough information about the site to have some preliminary ideas for the projected new palace. Of course he could have become involved in it soon after his arrival in France, between 1516 and 1517, thus immediately before his visit to Romorantin. This would account for the preliminary character of the studies in the folio of the Codex Atlanticus and explain why their style appears so close to that of drawings and notes dating from his Roman period.

In his Amboise residence Leonardo might have discussed the project not only with the king but also with his builders, preparing scale drawings for them. It was certainly not a new experience for him, and we have at least evidence for a similar occurrence a few years before in Rome. In his Belvedere residence Leonardo was planning certain machines and was having them constructed by a German craftsman in his service. While reporting to his patron about the disastrous relationship with his collaborator, he explains a working procedure that may be applied to architectural planning as well:

> . . . I invited him to take up his abode and have meals with me, so that I could always see what work he was doing and could easily correct his errors, and moreover he would acquire Italian and so be able to speak it easily without an interpreter, and most important of all the money owed to him could always be paid before the time, as it always has been. Then he asked that he might have the models finished in wood just as they were to be in iron, and wished to carry them away to his own country. But this I refused, telling him that I would give him a drawing of the width, length, thickness, and outline of what he had to do, and so we remained at enmity.[24]

It is most probable that the Romorantin project was carried to the stage of a wooden model. One of the architects in charge of the construction of Chambord, Domenico da Cortona, was the author of a wooden model known only in an engraving by Felibien (fig. 119). Domenico was probably acquainted with Leonardo and therefore with his architectural ideas, a reflection of which in Codex Atlanticus 242 verso-a, about 1515, shows a type of building very like Chambord (fig. 120). In 1530 Domenico received payments for wooden models that Francis I had commissioned from him during the preceding fifteen years, one of which was that of Chambord. According to other documents,[25] Domenico was in the service of the king of France after 1515 and often went to Amboise, where Leonardo lived from 1517 to 1519. In a folio dating from Leonardo's French period, Codex Atlanticus 174 verso-a (fig. 121), which contains geometrical studies, is a note not by Leonardo, written in a corner next to four figures of the familiar type of stelliform lunulae:

memoria a noi
 Mastro Domenico.

Since no person by such a name is known to have followed Leonardo to France, this may well be a reference to Domenico da Cortona, one of the builders of Chambord.

86

III. THE PLANS OF A NEW CITY

The Romorantin project was abandoned in or about 1519, at the time of Leonardo's death. We do not know why Francis I changed his mind and decided to build Chambord instead. The historian of Romorantin Alexandre Dupré speaks of the affection that the king's mother had for Romorantin, the town in which she wanted to die.[1] In fact when she fell sick at Fontainebleau she asked to be taken to Romorantin; but she died during the trip, in Grez, on September 22, 1531. The story is told by the poet Clément Marot, who makes towns and provinces express their sorrow as in a funeral procession. Among them is of course Romorantin, brought in with a naive pun: "Remorentin sa perte rémémore."[2]

Dupré surmises that both the death of Louise of Savoy and an epidemic in the area caused the king's decision to abandon the project. Modern scholars have taken a different view. Heydenreich states: "We know that Francis I had to renounce the Romorantin project for very simple reasons: the marshy ground was not suitable to its execution." And again: "The Romorantin plan had to be abandoned after a thorough testing of the site, for the soil was too swampy to support such an edifice."[3]

This explanation is groundless: it is based not on documents but on the assumption that Leonardo and the French builders had the construction started without a preliminary study of the terrain. Indeed, the site was thoroughly tested as early as 1512, when the newly established foundations of an enlargement of the fifteenth-century château were found perfectly suitable to support a great edifice.

There is evidence for an epidemic at Romorantin in 1518,[4] but it seems unlikely that a temporary epidemic would be sufficient to account for the abandonment of a work that had already reached the height of ten feet above the ground. Thus the explanation given by Dupré, aside from its romantic touch, remains the most satisfactory, especially when one considers the vaster program

of amelioration of the Sologne region connected with the project of a new royal residence. The death in 1519 of the "premier painctre et ingénieur et architect du Roy" meant the end of the canal project.[5] There might be some truth in the assumption that no one else could have carried it out, not for technical reasons but for lack of faith and drive, and one is reminded of Vasari's celebrated remarks about another of Leonardo's architectural projects, the lifting of the Baptistery of Florence to place marble steps underneath it: "He argued with so much eloquence that it was not until after his departure that they recognized the impossibility of such a feat."

Leonardo's notes on the canalization of the Sologne occur in a series of studies in which the project of the royal palace develops into the project of a new city. One of these studies, Codex Atlanticus 336 verso-b (fig. 122) contains a record of one of Leonardo's visits to Romorantin: "The eve of St. Anthony's Day I returned from Romorantin to Amboise, and the king had left Romorantin two days before."[6] No day, month, or year of the event is given. But it has been possible to ascertain that this was January 16, 1517, because the king had left Romorantin for Paris on January 14, and St. Anthony's Day is January 17.[7] The first record of Leonardo's presence in France is in a sheet of the Codex Atlanticus, folio 103 recto-b, which contains geometrical studies and the note: "Ascension Day at Amboise, in the Cloux, May 1517."[8]

A sheet of identical size and style, Codex Atlanticus 106 recto-b (fig. 115), contains, in addition to geometrical studies, a number of architectural details (ground plans of a palace with corner towers, studies of archivolts and windows with round pediments), including what appears to be either the cross-section of a hill with horizontal stratification, or, if it is to be looked at upside down, the cross-section of a river with water shown at different levels. On the verso there are black chalk sketches of some mechanical device, perhaps for a stage set.[9] It is certain, then, that in May 1517 Leonardo was studying a project for a palace and that in January of the same year, shortly after his arrival in France, he had already visited together with the king the region in which the palace was to be built. At first, he seems to have been thinking of the usual square plan of a castle on the bank of a river, with four octagonal towers whose outer walls are enlivened by semicircular projections similar to the chapels shown in the ground plans of churches in the early Manuscript B, for example, folio 25

verso. The plan was obviously meant to be carried out geometrically, and, as often in Leonardo's late studies, it appears to be part of a series of geometrical studies of lunulae. Next to the motif of the octagonal court as in the preceding project for the Medici Palace at Florence is an unusual solution of the circular court, reflected in a number of Serlio's designs. The sketches are hastily done, but the important fragment at the margin of the folio can be easily reconstructed (fig. 155). Because of the centralized structure there is no need for a longitudinal axis, but the axes connecting the corner towers seem to project beyond the towers and across the river, thus suggesting their relation with a road running along the river and possibly with a set of bridges. This may well be related to the transformation of the fifteenth-century château, but a more ambitious plan was to develop out of it.

The topographical studies on folio 336 verso-b (fig. 122) show a project for a canal from Lyons to Blois (sketch on the right) and one for a canal from Villefranche to Romorantin (larger sketch in the center). The two drawings were done with the right side of the sheet kept as a base, and this is also the way they were interpreted by the early collector who numbered the sheet 185. This is the way the region would be considered by someone approaching it from Amboise; the normal way to look at it, that is, with the north above, would have the left side as base.

In the note next to the smaller sketch Leonardo informs us that a trial of the canal from Lyons to Blois was to take place between Blois and Romorantin: "Make a channel one braccio wide and one braccio deep to test the level of that channel which is to lead from the Loire to Romorantin."[10] The canal was to spring from somewhere northwest of Romorantin, an area where we know the new palace was to be built. The smaller sketch includes references to Tours, Amboise, Blois, Monrichard, Romorantin, and Lyons. It is easy to see their correspondence in a map of the region (fig. 123).

The larger sketch shows in detail the course of the Saudre River from Romorantin to its immission into the Loire. Its tributary, the Cher River, is shown as flowing from Villefranche to the point indicated as "ponte a Sodro," that is, the Saudre bridge. The course of water linking Villefranche to Romorantin is the projected canal. This would have presented a particularly difficult problem because of the mountainous region that the canal was to cross—hence its

wandering course, like that of a natural river.[11] It was to enter the Saudre at a point east of the town, so that water could be regulated for such conveniences as drainage, as well as used for irrigation and commerce. The town is an oval area. Its west side has a small rectangle along the course of the river on the outskirts of the town, which must indicate the new palace. And in fact it is at the head of an immense park outlined in the form of a rectangle stretching in a westerly direction on both sides of the river. The area is inscribed "barcho," the old Tuscan spelling for "parcho."[12]

At the top of the sheet Leonardo has written a few observations about the necessary slope of the canal:

A trabocco is four braccia, and one mile is three thousand of the said braccia. Each braccio is divided into 12 inches; and the water in the canals has in every hundred trabocchi a fall of two of these inches; therefore 14 inches of fall are necessary in two thousand eight hundred braccia of flow in these canals; it follows that 15 inches of fall give the required momentum to the currents of the waters in the said canals, that is, one braccio and a half to the mile. And from this it may be concluded that the water taken from the river of Villefranche and lent to the river of Romorantin will have to have . . . [*sic*] Where one river by reason of its low level cannot flow into the other, it will be necessary to dam it up, so that it may acquire a fall into the other, which was previously the higher.[13]

The concluding sentence alludes to a technical problem that Leonardo had already faced in his studies for the Arno canal some fifteen years before. Undoubtedly, any urban development at Romorantin depended upon the regulation of its river and an efficient canal system.

The folio contains notes not in Leonardo's handwriting, but in Francesco Melzi's.[14] One note is about the nomenclature of the Romorantin river: "From Romorantin as far as the bridge at Saudre it is called the Saudre, and from that bridge as far as Tours it is called the Cher."[15] The other note is a quotation from St. Augustine's *De civitate Dei*.[16]

Leonardo must have drawn a map of Romorantin of the same type as his famous map of Imola.[17] As he did with the streets of Imola, he collected data on the measurements and orientations of Romorantin's streets. These are found on two folios of the Arundel Manuscript originally joined together, so that a topographical sketch can be recomposed (fig. 124), the upper part being

III. THE NEW CITY

folio 270 recto, and the lower part folio 263 verso. On the verso of the sheet thus recomposed (fig. 126) we find, on folio 270 verso, the well-known sketches and notes of the Romorantin project and, on folio 263 recto, a few numbers of a calculation in pen and ink and a black chalk sketch, visible only in the original, of a plan of buildings and canals as in folio 270 verso. In the topographical sketch of Romorantin and notes to it we again recognize Melzi's hand. Leonardo only entered the word "porta" in his "mirror" writing, as a reference to one of the city gates. This sketch becomes clear when transferred onto a modern map of Romorantin (fig. 125). It indicates the roads north and south of the town, that is, the "Strada d'Orliens," as specified in the legend, and the road to Villefranche. The word "porta" refers to a city gate belonging to the first enceinte of the town, that is, the Porte de la Montre (fig. 127), which was still shown in a 1775 map of Romorantin (fig. 128) and was demolished in the first half of the nineteenth century. Just above the word "porta" in the diagram is a straight horizontal line in light black chalk, which can be interpreted as the fortification walls. The word "ponte" written by Melzi refers to the bridge on the Saudre River. A rectangle south of this bridge indicates the Romanesque church of Romorantin. North of the river is a slight indication of the fifteenth-century Château of Romorantin, and a straight line represents the beginning of the route to Amboise.

Notes and drawings were done in black chalk first during the surveying of the area, then the drawing was inked in and the notes neatly transcribed in pen and ink below. The transcription, however, omits the numbers in front of each orientation, which are shown in the first three entries in the upper part of the sheet and which correspond to the road sections of the topographical scheme of the "Strada d'Orliens," considered from top to bottom. In the following transcription the distances are given within square brackets:

strada dorliens	The Road to Orléans
[330] alla quarta de mezo di verso syrocccho	[330] At $\frac{1}{4}$ from the south to the southeast
[120] alla terza de mezo di verso syrocccho	[120] At $\frac{1}{3}$ from the south to the southeast
[80] alla quarta de mezo di verso syrocco	[80] At $\frac{1}{4}$ from the south to the southeast
[160] alla quinta de mezo di verso syrocco	[160] At $\frac{1}{5}$ from the south to the southeast
[116]	[116]
[34] Tra lybeccio e mezo di	[34] Between the southwest and south
[24] A Leuante participando de mezo di	[24] To the east moving to the south
[40] Da mezo giorno verso Leuante $\frac{1}{8}$	[40] From the south toward the east $\frac{1}{8}$

91

[80] Da poi verso ponte	[80] Thence to the west (or: straight to the bridge?)
[198] Tra mezo di e lybeccio	[198] Between the south and southwest
[90] A mezo di.	[90] At the south.

The notes and drawings on the verso of the upper part of the sheet thus re-composed are well known, and have been most frequently reproduced as Leonardo's plans for a royal residence at Romorantin and an illustration of his ideas on city planning (fig. 126). There has been much interpretation, and also misinterpretation, of these notes. Since it is a key sheet in the whole series of Leonardo's studies for Romorantin, a reconsideration of it is necessary. It is here reproduced with the folio that is joined to it, folio 263 recto. The latter shows the impression of Melzi's lines coming through from the other side of the sheet. Corresponding with the area of these lines is a black chalk drawing by Leonardo too slight to be interpreted with certainty, but likely representing an arrangement of palaces and gardens on either side of a river as in the plan on the facing folio 270 verso. On the upper left corner, also in black chalk and hardly visible in reproduction, are the words "80 e 120." As seen above, these are the dimensions that Leonardo intended for the courtyard of the Romorantin Palace. Other calculations, in pen and ink, are at the bottom left-hand corner.

When the left side of the sheet was compiled (folio 270 verso), the sheet was kept folded in half. In handwriting, color of the ink, and type of pen, it is related to Codex Atlanticus 336 verso-b (fig. 122), which contains Leonardo's record of his visit to Romorantin in January 1517; other similarities are a topographical sketch and notes on the Romorantin canal. On the upper part, to the right, is the urban complex of twin palaces and gardens placed at either side of a river, a vast rectangular area with water flowing through canals around it. To the right is a profile of an old man of the same type and style as a fragment at Windsor extracted from Codex Atlanticus 103 recto-b, dated May 1517.[18] To the left are two drawings of a temple with an octagonal central area around which are arranged, in alternation, square and octagonal chapels. The motif is echoed in two other sketches at the bottom, which seem to reflect some classical prototype. In the center of the sheet is a topographical sketch of the region, inscribed "Tours, Cher, Loire, Saudre, Romorantin." The notes begin at the

top right and move down through the drawings, which were obviously done first. In the lower part of the folio the notes are arranged in blocks; their sequence is indicated by Leonardo's connecting lines. The paper is torn off and carefully repaired at the bottom left-hand corner, but the missing writing can be safely restored.

The first note is headed "mutatione di case," that is, "on moving houses." It reads as follows: "Let the houses be moved and arranged in order; and it is easy to do so because such houses are first made in pieces on the open piazzas and then are assembled together with their timbers in the site where they are to be set."[19]

Below is the drawing of the plan for twin palaces and the note: "Let us have fountains on every piazza";[20] and to the left, written within the central area of the octagonal temple: "Let the country folk inhabit the new houses in part when the court is absent."[21]

Out of this set of notes has arisen the conviction (Pica, Heydenreich, Maltese, Rosci, and others) that Leonardo had devised a system of prefabricated houses and that the drawings of temples are schemes of temporary lodgings. This is mistaken. The structures clearly show masonry work (note the spiral staircase inserted at the junction of two chapels, the projection of pilasters, and so forth), and there is nothing that can be taken as indicating an assembly of wooden elements. Heydenreich quotes the passage "mutazione di case . . . le case sieno trasmutate e messe per ordine . . ." and comments as follows: "Leonardo proposes to organize a kind of provisional habitat composed of wooden octagonal lodges that can be taken to pieces when required."[22] But the passage contains a key word, "trasmutare," that explains Leonardo's intentions. One of the meanings of "trasmutare" is "to move from one place to another," and as such it is used by Dante and Boccaccio.[23] "Trasmutare" also means, of course, "to transform" (as in Ovid's *Metamorphoses*), but this would not apply to the prefabrication of houses: in prefabrication things are not transformed, but only put together. Leonardo even gives a heading to the note, "mutatione di case," thus showing that he is concerned about transporting, not building, the houses. When he specifies that it is easy to transport them because one can do it in pieces, he is obviously referring to a local practice of construction: wooden houses were made of pieces first (on the open piazzas simply because of the

93

convenience of the available space to work) and then assembled where they were to be set. There is nothing extravagant in his idea. He suggests bringing houses to Romorantin (that is, prefabricated elements easily transported by boats) and arranging them "in order," so as to fit a rationalized urban plan. The plan, not the prefabrication of houses, is the novelty. His plan of twin palaces includes twin parks with subdivisions of the land, but it is impossible to tell where in the area he intended to have the wooden houses set. It is easy to recognize the river crossing the plan and the canals running around the complex, the system of streets and the open space of the piazzas; but there is no way to know whether the remaining area, which is shaded with horizontal lines of hatching, was intended for garden or for houses—or for both.

As Firpo has correctly shown, Leonardo was referring to an urban development of Romorantin based on encouraging the inhabitants of the nearby Villefranche to move to Romorantin with their houses, that is, with the timber with which their houses were made. Such are still visible today, and one of them is shown in a sketch in the Codex Atlanticus (fig. 130).[24] Leonardo's program is clearly explained in the note on the left of the folio:

The water may be dammed up above the level of Romorantin at such a height that it will work many mills in its descent.

The river at Villefranche may be led to Romorantin, and also the people who live there; and the timber that forms their houses may be taken on boats to Romorantin, and the river may be dammed up at such a height that the water can be led down to Romorantin by an easy slope.[25]

The note in between the three plans in the upper part of the sheet refers to the system of canals for the projected complex of twin palaces and gardens, which is now thought of as a new urban nucleus crossed longitudinally by a river:

The river in the middle should not receive the turbid water, but the water should go by through ditches on the outside of the town, with four mills at the entrance and four at the exit; this can be done by damming up the water at Romorantin.[26]

All the notes in the lower half of the sheet are about the canal system. The one illustrating the topographical sketch proposes an alternative solution—a

canal from the Beuvron River at the north, instead of the Chier canal from Villefranche at the south:

> If the river *m n* [the Beuvron River], a tributary of the Loire River, were turned into the river of Romorantin [the Saudre], with its turbid waters it would enrich the lands that it irrigates and make the country fertile, so that it would supply food for the inhabitants and would also serve as a navigable canal for purposes of commerce.[27]

The remaining notes deal with the system of regulating the course of the rivers:

> How the river in its course scours the bed of the stream.
>
> By the ninth of the third: that which is swifter consumes its own bed more, and conversely the water that is slower leaves behind more of that which causes it to be turbid.
>
> Therefore when the rivers are in spate you ought to open the floodgates of the mills so that the whole course of the river is cleaned up. There should be many floodgates for each mill, so that they may be opened at once and produce a greater impetus and thus the whole bed will be scoured.
>
> And let the sluice be made movable like the one that I devised in Friuli, where when the floodgate was open the water that issued forth from it hollowed out the bottom.
>
> And below the two sites of the mills there should be one of these floodgates, one with movable sluices being placed below each of the mills.[28]

The reference to the "serraglio mobile che io ordinai nel frigholi" helps to establish a link between the system of canals in the Romorantin project and in Venice. Leonardo was in Venice in the first months of 1500. He had stopped in Mantua as a guest of the Gonzagas, and it was in fact to Isabella d'Este that Gusnasco da Pavia wrote from Venice on March 13, 1500, informing her of Leonardo's presence there.[29] By April 24, 1500, Leonardo was back in Florence. His brief visit to Venice has been the subject of much speculation and has been taken as evidence to support Vasari's statement about the impact of Leonardo's style on Giorgione. It is more probable, however, that Leonardo went to Venice in his capacity of architect and engineer, and in fact a folio in the Codex Atlanticus (234 verso-c) has a fragment of a report addressed to the Serenissima, with a strategic plan of defense on the Isonzo River against the Turkish threat. It is in this report that the floodgate device mentioned in the Romorantin

project is described as "il mio sostegnjo dentato." The document consists of a few sketches showing the course of rivers, sketches of an artificial obstacle ("pescaia"), and several notes all crossed through, evidence that they had been transcribed elsewhere—most probably in the final report submitted to the Signori, which may still exist in some Venetian archives.[30]

A sheet of the same series of architectural studies at Romorantin can be recomposed with two other folios of the Arundel Manuscript, that is, folios 264 and 269. One side of the sheet thus recomposed (fig. 131) contains studies for a wooden staircase in the upper part and for the mechanism of a fountain in the lower part. On the other side (fig. 132) is a map of the island of Amboise and, below, a series of plans of buildings and canals including a square structure with corner towers, a detail of a system of locks to make a canal navigable (drawing in the upper part of the folio, that is, lower left corner of the sheet), and next to it a small sketch of the island of Amboise as in the facing page. It is possible that some of these studies refer to Romorantin, although they were done in conjunction with others pertaining to Amboise. The large topographical drawing is in fact inscribed: "isola dove vna parte danbuosa" (island where there is a part of Amboise). To the right are the notes:

Loire, river of Amboise.
The river is higher within the bank *b d* than outside said bank.[31]

And, at the bottom:

The Loire River which passes through Amboise passes through *a b c d*, and after having passed the bridge *c d e* it turns around going upstream through the canal *d e b f* along the bank *d b*, which is interposed between the two contrary motions [currents] of the said river, that is, *a b c d* and *d e b f*; afterward it turns around again going down through the canal *f l g h n m* to rejoin the main current of the river . . .[32]

Since there is a similar arrangement of islands at Romorantin, Leonardo might have considered their problems of water currents by examining those at Amboise. The verso of the sheet now recomposed is occupied almost entirely by studies for a fountain, the only exception being three drawings for a wooden spiral staircase with the following notes:

The hollow *a b* receives inside itself the fingers of the hand.

As one descends the spiral staircase, the hollow *a b* receives the fingers of the hand inside itself, that is, *a* canal receives four fingers inside itself, and *b* receives the thumb. And the hollows *c d* serve the same purpose as one ascends the stairs, four fingers being received by the concavity *c* and the thumb by *d*; the projection *n m* receives in itself the board *f o*, which is the front of the step.

The stairwell of this staircase is square in plan because it is located at a corner of the house.[33]

There is no indication of the purpose of the design and thus no way to tell whether such stairs were envisaged for the new houses at Romorantin. The shape of the handrail recalls that of the staircase of the Castle of Blois, wing of Francis I, which is also a left-handed helix.[34]

The studies on the syphonic action of a fountain and details of its mechanism are related to a series in the Codex Atlanticus, e.g. folios 22 recto-b, 214 verso-f, 290 verso-a, and 296 recto-a. They all have a curious affinity with the ground plans of the Romorantin Palace. Folio 296 recto-a (fig. 133) shows details of the mechanism with notes to them, to which Leonardo adds the inscription: "anbosa a vna fonte reale sanza acqua" (Amboise has a royal fountain without water). Since the Romorantin project included fountains on every piazza, it is not certain that all these studies for a fountain refer to a "fonte reale" in Amboise that was temporarily out of order. Possibly, however, Leonardo considered for Romorantin some of the hydraulic devices that he had planned for the garden of Charles d'Amboise's villa ten years before at Milan, a re-creation perhaps of what a Roman villa or palace was believed to have been equipped with: water organs and water clocks as described by Vitruvius.[35] There are extensive and elaborate studies by Leonardo for a clepsydra with a bell-ringer (figs. 134 and 135) dating from the time of his projects for the house of Charles d'Amboise. And one of these studies shows the huge device set into the structure of a palace wing.[36] The efforts put into the conception of such an archaic device, when the most advanced and accurate mechanical clocks were common,[37] can only be explained as an intention to re-create an architectural feature of antiquity; this was to become fashionable in the later part of the sixteenth century, with Bernardino Baldi's editions of the works of Heron,[38] and was already adumbrated in Alberti's report on the uses of water in antiquity. "The architects," says Alberti, "also added some ingenious invention to show

the hours of the day to the great recreation of the beholders, by the contrivances of some little moving statue of brass, placed in the front of the head of the aqueducts . . . At the same time, the sound of musical instruments and sweet voices was heard, which were caused by the motion of the water."[39] "With the help of the mill," says Leonardo in his description of the garden for Charles d'Amboise, "I will make unending sounds from all sorts of instruments . . ."[40]

The last drawing of the series, Codex Atlanticus 217 verso-b and c (figs. 136 and 137), shows that the projects for a canal and a royal residence have developed into the idea of a new city. It is hard to say whether this represents the king's intention or is Leonardo's digression into his favorite subject of the theoretical project of an ideal city. The note on top of the larger fragment (fig. 136) shows the same type of careful and practical instructions as found in the other sheets:

> The course of the river shall not pass through the ditches that are within the city, so that when the river becomes turbid it shall not unload soil at the bottom of the said ditches. Water, then, shall be given to these ditches by means of floodgates, so that it shall be used for the mills, as well as to sweep away the mud of the city and any other filth.[41]

The area delimited by the "strada dambosa" and the Saudre River is an oblong strip of land (figs. 97, 98, and 113). Leonardo must have envisaged a new city being developed in this district, with the river as the axis of a symmetrical arrangement of buildings and gardens; and he must have thought of complementing the new palace with a replica on the opposite river bank. Such is the solution in the Arundel Manuscript, folio 270 verso (fig. 126). As we have seen, in the notes to that drawing Leonardo considered the prospective urban development of the new center. Since the vast undertaking required an increase of the population, he thought of asking the people of the nearby Villefranche to move to Romorantin with their wooden houses. Leonardo also suggested that the country folk occupy the new buildings (obviously those of the retainers) when the court was absent. Indeed, the king may have entertained the idea of an urban development of Romorantin around the nucleus of the projected royal residence. Already in 1515 he had granted tax exemptions on wine to promote the urban development of Romorantin, and then on January 17, 1518, he had ordered the issue of "4000 livres d'or, pour fair la rivière de Sauldre navigable depuis Romorantin jusqu'au lieu, où elle tombe en la rivière

du Cher."[42] The royal order was for the replanning of the river west of Romo-rantin, where the new center was to be developed, a project possibly suggested by Leonardo but not to be identified with the Villefranche or Beuvron canals that he had planned.

The layout of the new city appears again in the form of a rectangle (fig. 136), a shape suggested by the arrangement of the twin palaces, gardens, and quarters for the retainers, but it is also shown as an oblong area to allow for easier flow of the water into the canals at either side of the complex, obviously for greater drainage efficiency. The plan, bottom left, is inscribed: "a. merchatura" (market place), "b. botteghe" (shops), "c. p[. . .]," perhaps "parochia" (parish church), the word being obliterated by smudged ink. The letters *a*, *b*, and *c* refer to three blocks within the plan. Below, to the right, is a smaller diagram in which the oblong shape of the city is inscribed in a circle and a rectangle, probably suggesting alternative solutions of the arrangement of canals. A note explains: "figura dj fiume / eddj citta" (figure of river and city).

Heydenreich states that it is hardly possible to make these projects agree with the actual topography of Romorantin and that Leonardo's city was a completely new plan, which did not take into consideration the existing layout of the area.[43] We have seen that Leonardo's project was based on practical considerations, and in fact it could have been carried out with minimal demolition of existing constructions.

The folio must have been of a larger size originally, for at least a fragment of the missing portion has been preserved (fig. 137) and is now superimposed in part on the upper right-hand corner of the folio. It again shows the plan of the twin palace, but the arrangement is more compact and more feasible. The canal system, clearly shown, is explained by a note written above the drawing:

> The numerous canals keep numerous toilets clean.
> The numerous canals clean numerous streets, as water is dammed up at mills in the upper part of the city.[44]

To the right, as if a reminder of the type of entertainments to be considered in planning the architectural complex, are the words "al balone / giosstre / battaglie nauali" (ball game, jousting, naval battles).

This establishes an undeniable relation with the drawing examined first,

99

Codex Atlanticus 76 verso-b (fig. 111), in which Leonardo had shown a large basin flanking the palace to be used for boat tournaments.[45] The basin is a section of the river that was to become the axis of the twin palace complex. The plan in the fragment shows the palace inscribed "corte reale" leading to a second court inscribed "offiziali," that is, retainers. The opposite block on the other side of the river is inscribed "stalle," thus implying that a greater space was to be taken up by the stables. Finally, each block leads to a large space made up of two piazzas. The two piazzas are actually joined, as shown in a plan in the larger fragment, but a center passage or tunnel underneath corresponds to the course of the river. A note explains: "qui sotto staño le barche . elle due piaze stano vnite inuna" (here underneath are the boats; and the two piazzas are united into one). These are the boats shown in action in the drawing in Codex Atlanticus 76 verso-b (fig. 111).

The larger fragment (fig. 136) contains other sketches of secondary importance: a cross section of a floodgate and three studies for the roofing of an octagonal cupola. There is also a beautiful drawing of a portal (or window of a dormer) in a fragment stuck onto the sheet; though it may come from another sheet, it is done with the same pen and ink and is probably another fragment of the missing portion of the present sheet. Finally, there are two extraordinary sketches at the lower right-hand corner, showing the elevation of a palace. But these must be considered apart.

IV. THE ELEVATION OF THE NEW PALACE

All Leonardo's studies for the Romorantin Palace are ground plans, the only exception being the slight sketches in Codex Atlanticus 217 verso-b (figs. 136 and 149), which show details of a façade.

The plans, however, show clearly the type of structure that Leonardo had chosen, so that the elevation is easy to visualize: a castle-like building with towers at the corners and flanking the entranceway. These no longer have a military function, but the ground plans retain the appearance of a fortress somewhat like the Castello Sforzesco at Milan, a building that must have left a deep impression in Leonardo's mind. Not only had he come to know it at a moment of great splendor, when it could easily have suggested to him the elegant solution of corner towers in the famous drawing at Windsor with the study for an Apostle for the *Last Supper*, but he must have had something to do with it shortly before he left Italy for France, in 1515–1516. In fact, plans of the Castle of Milan are recognizable in two sheets of the Codex Atlanticus, folios 95 recto-a and 99 verso-b, both containing geometrical studies of lunulae.[1]

The military character of the structure would certainly have given way to a more festive appearance once the palace was seen in elevation. The entranceway flanked by towers could well have been turned into a triumphal arch reminiscent of Luciano Laurana's delicate classicism. The corner towers were probably meant to have rows of windows, and all the walls to have tiers of galleries as at Chambord. The final touch of a fabulous architecture fitted for a colorful pageantry was to be achieved by the side facing the river, with the long portico framing a platform opening onto a slope of steps for the spectators.

Leonardo's building would have looked deliberately archaic, and would have resembled Bramante's Palazzo dei Tribunali (fig. 138) only in certain details of the ground plan and elevation. The round towers that Leonardo seems to

prefer throughout his projects were militarily obsolete by about 1500, when bastions came to be accepted; thus Leonardo must have retained them for only decorative or symbolic purposes. He would have produced an Italian version of a French château, stressing the geometrical organization of its urban setting. The idea might have been suggested by the immediately preceding project for the replanning of the Medici quarter in Florence. A folio of the Codex Atlanticus, 294 verso-b (fig. 139), which has not been identified yet as pertaining to any of the projects discussed thus far, contains a number of sketches of a palace or castle shown as part of an urban setting. One is a sketch of the elevation of one side of the palace, showing a detail of the terraced roof that links two of the corner towers. These are of the same type as those in the palace on the Windsor drawing of the Neptune fountain (fig. 95). The folio is a fragment, and much must be missing. At the top are three lines of a proposition of mechanics in Melzi's handwriting. Immediately below are two lines written by Leonardo in black chalk, and therefore almost invisible, only the initial letter, M, being inked in. Two sketches show a device resembling a stretcher or a movable bed.[2] Below are five architectural sketches. A comparison with the ground plan of the Romorantin Palace in Codex Atlanticus 76 verso-b (fig. 111) leaves little doubt that these, too, are for Romorantin. The style of the drawing also points to a very late period of Leonardo's activity. One plan shows the palace linked to a basilica by a series of parallel avenues and perhaps canals, a majestic complex that can hardly be identified with the Medici project. True, the latter consisted of linking the new palace to the church of San Marco according to an identical principle of axiality, but the palace is given a strong military character not found in the Medici project. Furthermore, one of the sketches shows what appears to be an octagonal scheme of a town with a complex of twin palaces and churches crossed by a river. This seems to exclude both Florence and Rome and to point to a new town in France.

Unfortunately, only hints are left of Leonardo's ideas for the elevation of the Romorantin Palace. It is impossible to say how closely it was to reflect such imposing Italian buildings of the Renaissance as the Ducal Palace at Urbino or Bramante's Palazzo dei Tribunali. It is also impossible to say to what an extent Leonardo would have incorporated French decorative elements.

The ground plans in Codex Atlanticus 76 verso-b (fig. 111) show that Leo-

nardo was considering two solutions: a building with corner towers in which the Bramantesque principles of axiality could be successfully combined with the traditional type of French château, and a building without corner towers, hinting at a clear geometrical subdivision of its parts, unmistakably derived from the examples of Laurana and Francesco di Giorgio. There is one such plan in the Windsor folio 12585 (fig. 141) with a note explaining the proportional relationships of the parts:

The court must have its walls of a height equal to half the width of the court, that is, if the court is 40 braccia the house must be 20 braccia high in the walls of the said court, and such a court must be half the width of the whole façade.[3]

Below the ground plan are three sketches of elevations illustrating the architectural principle explained in the note, and showing how the loggias should be arranged to allow for a more efficient lighting of the court. Such is the similarity of these plans to the drawing in Codex Atlanticus 76 verso-b that Heydenreich ascribed them to the Romorantin project, although later on he agreed with Kenneth Clark's suggestion to date them earlier, about 1508.[4] Finally, he has suggested that another drawing at Windsor, no. 12292, is a bird's-eye view of the Romorantin Palace, again dated by Clark to about 1508 (fig. 143).

The latter drawing has become the symbol of Leonardo's last years in France, a dreamlike image emerging from the river mist with an evocative touch of the black chalk as in the celebrated Pointing Lady in a Windsor drawing. The elevation is made up of three tiers of arcades. The corner towers appear more like projecting corner bays surmounted by pavilions. Pavilions are also placed halfway back along each side of the building. (A slight indication of the pavilion at the end of the right side of the palace is visible near the right margin of the drawing.) The considerable extent of such sides obviously needed some sort of interruption to relieve the overwhelming sequence of arcades. Furthermore, these sides were meant to be looked at as façades, at least the one bordering the river, which could have been observed from the other bank. Indeed, the building corresponds quite well to the ground plan of the Romorantin Palace in Codex Atlanticus 76 verso-b (fig. 111): it shows the canal for the boat tournaments, the slope with steps for the spectators (but no platform separates it from

the side of the building), and the bridge in line with the façade. True, there are no markedly projecting round towers or towers flanking the entranceway; but the major difference is not one of decorative details, but one already pointed out by Clark: the palace is on an island rather than a river bank, for it is approached by two bridges, one on either side. The bridge visible on the left cannot be one spanning the "fosso" separating the palace from the route to Amboise. No such bridge is indicated in the plan. Moreover, it has at least three arcades. We have seen such an arrangement of an island with bridges at either side somewhat resembling the Isola Tiberina at Rome, in a drawing in the Arundel Manuscript representing the island of Amboise (fig. 132). The reference would still favor a dating of the perspective view at Windsor in the French period of Leonardo's activity, after 1517. But there is still a detail to be considered: the drawing is on the verso of one of Leonardo's studies for the Trivulzio Monument, about 1508–1511 (fig. 142).[5]

The palace, undoubtedly of greater importance to Leonardo than the detail of a horse's leg, must have been the first to be drawn on the sheet. The black chalk sketch was certainly meant to be inked in, but when the intention to do so was abandoned the other side could be used for the study of the horse's leg, which therefore assumed the appearance of having been drawn first. Finally, in the lower left-hand corner of the sheet, on the side with the palace, there is a slight geometrical figure which at first may appear irrelevant: an arc of a circle inside a semicircle. We know that around 1508–1509 Leonardo was carrying out such geometrical researches on the equation of curved surfaces with great intensity, and that quite often his diagrams were done in black chalk first and then inked in. Since such diagrams appear on folios recording his presence in Switzerland around 1508–1509 (fig. 144), it should not be surprising if evidence were someday to emerge that Leonardo followed Charles d'Amboise on one of his trips to France at that time.[6] We know from the *Diarii* of Marino Sanuto that Charles d'Amboise, together with Trivulzio and Antonio Maria Pallavicino (two other of Leonardo's patrons), was in Blois and Amboise between 1508 and 1509.[7] In a pocket notebook used at that time Leonardo sketched a palace with corner towers (fig. 145) and a diagram of the water conduit built by Fra Giocondo in the garden of the castle of Blois (fig. 146). Furthermore, two drawings at Windsor again dating from this period show

IV. THE ELEVATION

the familiar scheme of the oblong urban setting (fig. 148) and the ground plan of a palace (fig. 147), which resembles the earlier ground plans of the palace for Mariolo de' Guiscardi, with its rooms, halls, kitchen, stables, staircases, and court. Unfortunately, all these hints are not enough to explain Leonardo's intention in planning such a huge palace ten years earlier than his Romorantin project, and it would be too fanciful to suggest that it is related to the plan of enlarging the fifteenth-century château as recorded in 1512.

The two sketches of elevation in the lower right-hand corner of Codex Atlanticus 217 verso-b (figs. 136 and 149) are the only ones that can be ascribed to the Romorantin project with certainty. Yet they are difficult to interpret. Their relation to the bird's-eye view at Windsor, as suggested by Heydenreich, is based only on the apparent similarity of the system of arcades; there is no suggestion of projecting end bays or corner towers, nor is there any stress on the entranceway. The elevation on the left may be interpreted as a partial view of the façade, with only the central and left bays shown. A certain emphasis on the central bay suggests that it was intended to be projecting, as later in the Villa Giulia. There is apparently no exact proportional relationship between the two bays, but the middle vertical line seems to correspond with the right side of the pilaster separating the two bays. The proportional relationship in the other sketch is only hinted at and is somewhat changed, with a stress on verticality, but the change may be due simply to the lesser space available. The left bay now appears to be crowned by a semicircular cupola, but this detail—which would otherwise be important—is only accidental: as seen from an examination of the original, the lines of the cupola are the impression of a geometrical scribble coming through from the verso. Unfortunately, the drawing is pasted down and there is no way to ascertain what else might be concealed on the verso.

Aside from the degree of projection of the central bay (the following chapter presents the theory that the building might have been intended as a Greek cross structure), the elevation can be read as a continuous façade echoing the majestic gravity of the original façade of the Pitti Palace. Here again, however, as in most of Leonardo's architectural ideas, the quattrocento flavor is retained only as a background to a powerful articulation of High Renaissance forms.

The lower floor, probably a plain ashlar wall with square openings reminis-

105

cent of the Urbino Palace, is crowned by a balustrade; the two upper floors have the usual sequence of arcades. Between arcades there were probably flat pilasters with half columns superimposed. This system would require an equal number of arcades in both tiers, but in the projecting bay Leonardo seems to be building up a crescendo of tensions by gradually increasing the number of windows (two in the lower floor flanking the entranceway, three in the *piano nobile*, and five in the upper floor) undoubtedly followed by an even greater number of square openings in the attic (only the first two or three seem to be indicated on the left).[8] Tall pilasters determine each bay and support a massive cornice, which is actually made up of two large moldings framing the attic, in such a way that the attic itself becomes part of the cornice. The pilaster at the left corner has a Corinthian capital that takes up the whole height of the attic, thus conveying the impression of a colossal order.

The stress on horizontality resulting from the emphasis given to the attic as well as to the courses between stories does indeed produce the same effect of monumentality as such Roman buildings as the Palazzo Vidoni-Caffarelli, Bramante's House of Raphael, or even the bolder Palazzo Tarugi at Montepulciano (fig. 150). This is already apparent in Leonardo's earlier projects, such as the villa on the cover of his Codex on the Flight of Birds, about 1505, perhaps a first idea for the Villa of Charles d'Amboise (fig. 151). And I think that Leonardo had this type of building in mind when he sketched the mysterious allegory in the Windsor drawing 12497 (fig. 152), which may have been an idea for a stage set like those in the Arundel Manuscript. The drawing dates from after 1506, later than the drawing in the Codex on the Flight of Birds,[9] when Leonardo was in the service of Charles d'Amboise. Again the stress is on the courses between stories, and the Romorantin type of attic is prefigured in the huge cornice. The emphasis on structure rather than on surface is underlined comically by the presence of a monster breaking out of the building, as if out of a cage, through the loggia of the central bay.

It would be wrong to conclude that Leonardo was anticipating the manneristic love for the bizarre. In spite of the monster, the building is not "fantastic." Although it cannot be identified with any of the palaces built or projected in his day, it may be taken as symbolic of state power or government. Its imposing presence is somewhat reminiscent of what was to be realized in the Louvre and

IV. THE ELEVATION

may correspond to an idea that Italian architects of the Renaissance had of the Palace of Justice or the Palace of the Emperor in ancient Roman architecture. It is true that in his use of decorative details Leonardo may appear sometimes to be more in sympathy with French architectural forms. But what we know of his ideas for the House of Charles d'Amboise, the enlargement of the Villa Melzi at Vaprio, and to a certain extent his studies for the new Medici Palace at Florence is still basically Tuscan and shows a direct knowledge of the theories and works of Alberti and Francesco di Giorgio. Like Filarete, Leonardo might conform to the fastidiousness and fanciness of a type of decoration suitable to the taste of a court in northern Italy, but like Bramante he made the presence of the structure emphatically felt. He may have been aware of the curious mixture of Renaissance and medieval forms in the fabulous Château of Gaillon,[10] but it is doubtful that he would have liked it. Once he was in France he seems to have been thinking back to pure Roman forms, those that haunted the imagination of his friend Bramante. In the two elevations of the Romorantin Palace, Leonardo departed completely from any reminiscence of French or medieval architecture. Even the idea of corner towers is abandoned. It is replaced by a truly majestic example of what an Italian architect of the High Renaissance would have conceived as a revival of Roman grandeur. Only Michelangelo's design of the Palazzo dei Conservatori can be compared to it.

V. THE OCTAGONAL BUILDINGS

The ground plans of octagonal structures on folio 270 verso of the Arundel Manuscript (fig. 153) are still a mystery. They were drawn at the same time as the plan of twin palaces for Romorantin; and yet they have nothing to do with the notes on the Romorantin project. The drawing at the top is inscribed with the note:

> li omjnj del pae
> se abitino le nuo
> ve chase jn parte
> quando nove la cor
> te

This has been taken as a reference to "wooden octagonal lodges that can be taken to pieces when required."[1] It should not be difficult to realize that Leonardo wrote the note inside the drawing of the octagonal structure only because he was running out of space. As we have seen, the structure cannot be interpreted as wooden lodges, because the upper sketch clearly shows masonry work, with passages and even stairwells within the thickness of the walls (fig. 154). Similar plans are found in the early Manuscript B and can be traced back to the treatises of Filarete and Francesco di Giorgio.[2] The two sketches at the bottom are definitely ground plans of a classical tempietto. The more detailed one shows the octagonal central area framed by a row of eight niches, each of which is flanked by detached columns. Inside the niches are the altars. All the sketches have elements echoed in Michelangelo's designs for San Giovanni dei Fiorentini; and it is possible that both Leonardo's and Michelangelo's drawings have a common source, perhaps Sansovino's lost projects for the same San Giovanni dei Fiorentini or, better still, the Baptistery of San Giovanni in Laterano, about 465 (destroyed in 1629), drawings of which are found in Sangallo's Codex Barberinus (fig. 156).[3]

Recently, Rosci has put forward the ingenious theory that the "octagonal plans" in the Arundel Manuscript may be studies for a pavilion to be placed in

the garden of the Romorantin Palace and to be used as a bath, a construction
analogous to the one that Francis I intended to build on a bridge in the "grand
jardin" at Fontainebleau.[4] The project submitted by Serlio (figs. 157 and 158)
for that construction[5] does indeed echo the ground plans in the Arundel Manu-
script. Rosci, however, insists on interpreting Leonardo's plans as wooden
constructions in order to link them with his earlier drawings of a "padiglione"
(pavilion) in Manuscript B, folio 12 recto (fig. 159), which is also composed
of eight units around an octagonal area. Even though they are not wooden,
they may still be interpreted as pavilions. Serlio's too is a solid brickwork con-
struction. But the considerable size of Leonardo's construction, as shown by
the dimension of the round stairwell, makes this interpretation questionable.
Furthermore, one of the plans shows square elements placed at the center of
each of the four octagonal rooms and in the center of the whole construction.
We know this to be Leonardo's convention for altars.[6] Whether the plan was
meant to represent a temple or a pavilion must remain a matter of speculation;
and it can be shown, in addition, that it could have been an alternative idea for
the palace, since throughout the Romorantin projects there appears an oc-
tagonal or cruciform structure that is never inserted in the general plan of the
palace and gardens. As seen above, one of the Codex Atlanticus sheets with
studies related to Romorantin (fig. 115) contains a fragment of the ground
plan of a castle that can be interpreted as a square structure with four octagonal
towers (fig. 155). And one of the sketches above the ground plan of the Romo-
rantin Palace in Codex Atlanticus 76 verso-b (fig. 111) shows a Greek cross
structure with an octagonal central area, at the center of which is a small rec-
tangle. (Next to the drawing are the words "cucine / djspēsa," which may be
unrelated to it.) The "octagonal building" also appears more clearly in another
sheet of the Romorantin series, Codex Atlanticus 217 verso-b (fig. 136).

We have already considered the two sketches of elevation at the bottom of
this folio. Just below the elevation on the left is the ground plan of an octagonal
structure, resembling an "arcus quadrifrons" (one is reminded of one of
Michelangelo's first projects for the Medici Tombs)[7]; because it is so close to
one of the elevation drawings—to the point of being partly inserted into it—
the relation of the two is a strong probability. It is true that just above in the
folio are details of a tent-like covering for an octagonal structure—and a hint

at such a structure is found also on folio 264 verso of the Arundel Manuscript (fig. 132)—but the plan at the bottom may be interpreted as a Greek cross structure, the arms of which are connected by lines so as to make an octagonal plan. The motif of a circle inserted at the meeting of two arms is shown only twice and does not necessarily indicate spiral stairwells. (In fact they would be as large as a room.) The possibility of reading the geometrical pattern as the ground plan of an edifice is not to be overlooked. My hypothetical interpretation of the sketch (fig. 160) should be compared to Pietro Cataneo's suggestion of turning a Greek cross structure into an octagonal building (fig. 161).[8]

It is, then, conceivable that the elevation drawings above the ground plan represent a Greek cross structure inserted in an octagon (something like the block of Santa Maria delle Carceri with an octagonal base), so that each drawing combines the front view of one arm and the side view of the other.

This is obviously a suitable form for a villa. In Serlio's Seventh Book, published posthumously in 1575, there are several ground plans of villas that are variations of this theme and may reflect Leonardo's ideas.[9] What increases interest in them is that they were taken over by baroque architects. In fact, the destroyed Villa Contarini at Mira (Venice) by Longhena[10] owes much to Serlio's pattern; and, while rejecting Serlio's dry classicism in the elevation, it approaches the spirit of Leonardo's elevation drawing on Codex Atlanticus 217 verso-b in a way that would almost imply a knowledge of Leonardo's ideas. It has pilasters and attic windows that echo Leonardo's and introduces the central octagonal superelevation with tent covering that Leonardo seems to have envisaged for his Romorantin structure. All these affinities are probably coincidental, but one cannot fail to sense a kinship between the "octagonal structure" for Romorantin and the Villa Contarini, which was erected on the bank of a canal. My hypothetical interpretation of Leonardo's sketch shows what might have been the window system in the wall at the head of each arm. The upper row of five windows corresponding to the three windows below seems to include the Serlian device that Leonardo had already introduced in an early villa façade (fig. 12) and that was to become so popular with Palladio.

Since there is no place in any of the plans of the Romorantin Palace for such a villa or pavilion, one can surmise that it may have been an idea for the transformation of the Mousseau Manor at the far end of the palace park (fig. 110,

no. 9). The building would have been on the longitudinal axis of the palace, close to the river as the Villa Contarini was close to a canal. Traces of sixteenth-century brickwork in the area (figs. 101 and 102) seem to indicate that the project was actually undertaken. We know that the Mousseau Manor was used as a hunting lodge in the sixteenth century.[11] Such was the function of the little château of La Muette that Philibert de l'Orme was to build in the forest of Saint-Germain-en-Laye, and whose relation to Leonardo's designs has been stressed recently.[12] The view of the area of Saint-Germain-en-Laye in the drawing by Du Cerceau includes a "chappelle" in the same forest,[13] again a centralized structure that may suggest an interpretation for some of Leonardo's designs of centralized buildings planned for Romorantin. Finally, the "Château Neuf" by the river, built toward the end of the sixteenth century and destroyed in 1776, must have carried out some of Leonardo's ideas for Romorantin.

In a series of drawings in the Codex Atlanticus, which can be dated from after 1510 and most probably in Leonardo's French period, there are studies of palaces with corner towers and details of towers with spiral staircases (figs. 120 and 162), a detail of the corner of a palace with three octagonal rooms (fig. 163), and the plan of a building made up of eight octagonal rooms placed within a square area (fig. 164). Most important of all is the last, Codex Atlanticus 348 verso-c, which is unfortunately a fragment without any note and thus very difficult to date. Next to it are thirteen small fragments cut out of other sheets of a different date and laid down by the collector who put the Codex Atlanticus together. One of these small fragments has the same type of paper and ink as the larger one and represents the familiar plan of a two-courtyard palace of the Romorantin type. Thus the drawing in the larger fragment probably pertains to Leonardo's French period. If so, one might conceivably relate it to the ground plans of palaces that Sebastiano Serlio seems to have developed in France out of the pattern of the octagonal temple (fig. 165) and used in his design for the Louvre.[14] Characteristics of the construction prove that Leonardo was planning a palace rather than a church like the one in the Arundel Manuscript (fig. 153). The central octagonal courtyard has a gallery with columns. As in the Florentine project for the Medici Palace, spiral staircases were to be placed at the corners of the courtyard. The construction must have been envisaged in colossal proportions: each "corner tower" has its own court and galleries. The plan is

important also for its architectural representation. Since it combines plan and elevation, it is certainly one of the earliest examples of an axonometric drawing.[15]

A plan of a building with eight octagonal rooms, Codex Atlanticus 114 verso–a (fig. 166), is constructed geometrically, with lines carefully drawn with a stylus and freely gone over with pen and ink. The paper is of a type used by Leonardo in the last years of his activity, and in fact it is lightly tinted with black chalk, as is a series of folios in the Codex Atlanticus, in the Arundel Manuscript, and at Windsor, dating from 1518.[16] Thus, the drawing may well refer to a French project. A sketch on the lower left-hand corner shows a different solution to the problem of placing eight units around a central area. At the bottom, to the right, is a detail of the elevation of the structure shown above: it is in fact the exact projection of part of the two corresponding units represented in the plan just above. In the center of the cruciform courtyard is a fountain basin with four arms corresponding to the axes of the cross-like space. The purpose of the building is less easy to understand. Apparently it was meant to be of considerable size, as can be surmised from the detail of elevation, which indicates that it was to be a two-story building. Curiously enough, the plan does not show any stairs. It is possible, however, that stairs were to be placed outside, as suggested by the small circle drawn next to the outer wall of the unit on the lower left. Such stairs would have required a number of turrets, which would have had the decorative function of articulating the wall. This may appear exceptional with Leonardo, who seems to prefer to place stairwells at the corners of a court, so as to hide them behind a screen wall. But it might be that the example of Blois had shown him that a classical structure could be enlivened by inclined courses of spiral stairs within the open structure of a tower. The adjacent wall would appear to be too thick—so thick, in fact, that it could easily contain the outside stairwell; but in other parts of the drawing the wall is half as thick. In one point (upper right) Leonardo shows the wall at only one corner at the junction of two units, where it looks like a pilaster.

The design has a certain French character (even the slight sketch of the elevation recalls the linearity of Serlio's dry classicism), which justifies the late date suggested by paper and style. Not only is the drawing related to the mysterious octagonal structures in the Romorantin series, but the style of Leonardo's latest period is seen in his stress on geometry.

VI. THE WINDOWS

The fragment stuck onto the sheet of studies for the Romorantin Palace in Codex Atlanticus 217 verso-b (figs. 136 and 167) is the only study of a decorative detail in the whole series. It represents a window (probably for a dormer) crowned by a round pediment with a shell inside and a finial on top, the flanking pilasters being surmounted by flaming vases. There is a somewhat similar window, although far less spirited, at the top of the tower of the old château at Romorantin (fig. 168), obviously a sixteenth-century addition showing Italian influence in the classical shell and palmettes. It is impossible to say whether this influence originated from Leonardo's drawings, but it must have been precisely such decorative elements that French architects and masons were more inclined to assimilate. Their strong building tradition was embodied in the type of château shown in the illuminations of the *Très Riches Heures du Duc de Berry*, and Italian models and ideas could be absorbed only gradually, first with the works of Fra Giocondo, then with the circulation of Leonardo's ideas.[1] But Leonardo's decorative motifs were certainly congenial to them, and it is regrettable that the compilation of Leonardo's architectural studies circulating in France around 1550 has not come down to us. It belonged to Cellini and was known to Serlio,[2] who must have taken from it at least the idea of presenting architectural members and decorative details in illustrations accompanied by brief explanations, according to a system that Leonardo had recommended in his anatomical studies.

There is a series of studies of windows and doors in folios of the Codex Atlanticus dating from a late period, certainly after 1513 (figs. 169 to 172), which are very close in style to the drawing in the small fragment of the Romorantin series. They are on folios occupied by geometrical studies of lunulae and cannot be fully appreciated if considered in isolation. Those on folio 281 verso-a (fig. 169) show how Leonardo's mind moved from absorption in a geometrical problem to the conception of an architectural member. He is projecting the

rhythm of a play of curvilinear areas into the arch of a bifora with the abstract, almost quivering, beauty of a kaleidoscopic image. In the powerful frame is a distant echo of the central niche of Or San Michele, and the bifora is simply inserted into it as a fragile tracery, with the evocative touch of a Moorish motif common to both Florence and Venice—a deliberate rejection of High Renaissance classicism in favor of the mysterious language of a geometrical arabesque.

The series, which includes the famous and beautiful drawing of a portal on folio 279 verso-a (fig. 170), is difficult to date with certainty. All the drawings have in common the geometrical studies and the style of handwriting. They also have in common a characteristic, possibly too slight as evidence of their interrelationship, but indirectly suggesting that they originated from the same impulse of Leonardo's hand: either their vertical axis is inclined to the left, or the horizontal lines, instead of running parallel, diverge toward the left. This can be seen in the drawing of a window for Romorantin. It may be suggested that such characteristics are to be expected from one who draws with the left hand, but they are found in some of Michelangelo's sketches as well, for example those for the façade of San Lorenzo and some of the studies for the Medici Tombs. Yet I cannot think of any of Leonardo's earlier architectural drawings with such characteristics. His celebrated Venice drawing of a church has horizontal lines slightly diverging toward the right, but this is late, about 1513–1515, and his studies for the Villa Melzi (fig. 79) are also somewhat distorted. In fact, I would be inclined to refer this series of studies for windows and doors to the Villa Melzi project. Compare the study on folio 281 verso-a (fig. 169) with the details of a structure crowned by a cupola and pinnacles on folio 395 recto-b (fig. 79). The possible date 1513, however, is a warning that the series may belong to the following visit to Florence, or even to Rome. Folio 114 recto-b (fig. 171) has on its verso a sketch of a scaffolding related to a series in the Codex Atlanticus pertaining to Leonardo's Roman period (figs. 81 and 82).[3] But we have seen that there was a Florentine period within the Roman one; thus any architectural sketch from the Roman period may well pertain to the project of a new Medici Palace in Florence, 1515, and the studies of scaffoldings may be tentatively related to the vaulting of the Medici stables alla Sapienza, again 1515.[4]

There is indeed much in these drawings that points to Florence. The two

sketches on folio 114 recto-b (fig. 171) recall the double columns with niche and balustrade in Giuliano da Sangallo's projects for the façade of San Lorenzo, and the motif of a triumphal arch in Baccio d'Agnolo's altar for the Santissima Annunziata of 1501, the design of which is attributed to Leonardo by a sixteenth-century source.[5] A drawing stylistically identical is on a folio with notes on painting and the flight of birds in addition to the usual studies of lunulae, that is, Codex Atlanticus 184 verso-c (fig. 172). This points more clearly to the period of Manuscript E, about 1513–1514, the content of which is in fact re-flected in the notes on painting and the flight of birds. This drawing is sometimes adduced as evidence that Santa Maria alla Fontana in Milan, about 1507 (fig. 48), should be attributed to Leonardo. But the evidence based on style is contra-dicted by the chronology.

As for the portal in 279 verso-a (fig. 170) and the others in black chalk in the same folio, I suggested above that they might possibly be reflections of ideas for the project of closing up the corner loggia of the old Medici Palace (a project carried out by Michelangelo around 1517),[6] but it is probably safer to consider them as models with no precise purpose. And as such they could have been reconsidered in the project for the Romorantin Palace.

VII. CONCLUSION

The Romorantin project epitomizes the Renaissance dream of an ideal city that could be regarded as a reflection of ancient Roman planning. Alberti's project for the Borgo Leonino in the Vatican and Bramante's great undertaking, the Cortile del Belvedere, had paved the way. But projects for a whole city were still on paper in the treatises of Filarete and Francesco di Giorgio and in the drawings of the Sangalli. It is significant that an ideal reconstruction of an ancient Roman plan was about to be realized in France under the sponsorship of Francis I, the king who was to be greeted by Serlio as "most learned and fond of architecture," and "whose shadow alone would frighten any one who would dare to question the true doctrines of the great Vitruvius."[1]

Even the name of the town, Romorantin, may have had something to do with Leonardo's idea of building a new well-organized place that could be taken as a small version of a Roman city. Dupré states that the French name Remorantin, a literal version of the Latin Remorantinum, was generally used until the middle of the sixteenth century. Then the town came to be called Romorantin because it was thought that it had a Roman origin on account of a sojourn of Julius Caesar. In fact it was believed that the name had come from the Latin Roma Minor, and such was the pride of the inhabitants of Romorantin that they wanted to have those words carved on their city gates. Dupré points out that one of the gates, Lambin, had been believed for some time to have been named after Labienus, one of Caesar's lieutenants in France. Dupré, however, was not able to find any evidence that the name Romorantin was actually derived from Roma Minor and concludes: "L'engoûment de la Renaissance pour les souvenirs de l'antiquité classique aura contribué, sans doute, à introduire cette nouvelle dénomination."[2] It might well be that Leonardo, if not himself responsible for this interpretation of the name Romorantin, was at least so aware of its potential symbolism as to think of his planned architectural complex as a "Roma Minor." In fact, throughout his Romorantin

VII. CONCLUSION

project he writes "Romolontino" and "Remolontino" interchangeably, thus connecting the name of the town with the founders of Rome. At times, within his square plan he places transverse blocks at the head of longitudinal ones, as if deliberately to suggest the geometrical arrangement of a Roman military camp: compare, for example, the plan in Codex Atlanticus 217 verso-c (fig. 173) with any of Caesar's camps as represented in Palladio's edition of the *De bello Gallico*, 1575 (fig. 174).[3] Francis I, who certainly would have liked the pun, referred to Leonardo in a conversation with Cellini as a man with "some knowledge of Latin and Greek literature."[4] Puns were undoubtedly a fashionable game, not only in Renaissance painting and literature, but also in Renaissance architecture: the Castle of Gaglianico in Italy was dedicated to Charles d'Amboise in 1510 as an ideal replica of the Castle of Gaillon—the time-honored idea of *imitatio*, but it just happens that Gaglianico echoes the Italian pronunciation of Gaillon.[5]

About seventy years before the Romorantin project, Leon Battista Alberti wrote how the palace of a king should differ from the castle of a tyrant:

The palace of a king should stand in the heart of a city; it should be easy of access, beautifully adorned, and delicate and polite rather than proud or stately. But a tyrant should have a castle rather than a palace, and it should stand so that it is out of the city and in it at the same time. It looks noble to have a king's palace near the theater, the temple, and some noblemen's handsome houses. The tyrant must have his castle entirely separated from all other buildings. Both should be built in a handsome and noble manner, but yet in such a way that the palace is not so large and rambling as to be not easily defended against any insult; nor the castle so close and so cramped as to look more like a jail than like the residence of a great prince.[6]

Many Albertian ideas went into the Romorantin project. And more than a century after Alberti, architects were still planning royal palaces and cities basically following his suggestions, as was the case with Bartolomeo Ammanati.[7]

Heydenreich considers Chambord as linked to Leonardo's plans for the Romorantin Palace, but Firpo is probably correct in linking Chambord to Leonardo's earlier projects (fig. 95) or in general to a type of castle that appears in France soon after 1500, following the French occupation of Italy; for example, the castles of Le Verger and Bury, respectively the residences of Marshal de

117

Gié and Florimond Robertet, the latter known to have commissioned a painting from Leonardo.[8] The military character of such residences was indeed appropriate to their owners, although it is no longer identifiable with that of Alberti's castle of the tyrant.[9] A somewhat similar aspect recognizable in monumental fortress-like palaces built in Italy toward the middle of the sixteenth century has already been explained as a possible derivation from this type of French palatial architecture, in particular from Chambord.[10] The indirect relationship Leonardo–Serlio–Vignola, which can be reasonably suspected in the field of perspective, is still somewhat elusive in that of architecture.[11] There is no evidence whatsoever that Leonardo's plans for the Romorantin Palace were known to either Serlio or Vignola. And the equally elusive compilation of a book by Leonardo on painting, sculpture, and architecture, owned by Cellini and used by Serlio, probably included in the section on architecture much more material than what is known from Leonardo's extant manuscripts.

One cannot expect the hypothetical existence of Leonardo's plans for the Romorantin Palace to have had any effect on French Renaissance architecture. Yet in a recent publication François Gebelin suggested that the abandoned project for Romorantin may have been taken over and realized at La Rochefoucauld.[12] This was built by Francis II de La Rochefoucauld, who died in 1533. The date 1528 is carved on the entranceway leading to the monumental stairs, but the construction was apparently begun in 1520. It replaced a medieval fortress, from which it incorporated a Roman donjon and much of the fifteenth-century towers. The curtain walls of the eastern and southern wings were built in the newly introduced style of the châteaux of the Loire. What is extraordinary and unique in France, concludes Gebelin, is the decoration of the court (fig. 175): three stories of superimposed arcades in the fashion of the Italian palaces. The architectural elements are carefully considered: here the stories are not separated by a system of double molding as in the Loire châteaux or at Nantouillet, but rather, in accordance with Bramante's formula, each order carries a complete entablature above which runs a straight stylobate serving as a balustrade to the gallery above. The ornamentation is sober, with no trace of flamboyancy. As Gebelin surmises, the obviously foreign inspiration must have come from some of Leonardo's designs for Romorantin; he justifies the assumption by pointing out that Francis I de La Rochefoucauld, the father

118

of the builder of the château, was the godfather of Francis I and a friend and neighbor of Louise of Savoy when she was living at Cognac.

The architectural project that Leonardo was carrying out in the last years of his life was in many respects his way of looking back at his earliest experiences in Florence, when he was first introduced to the Brunelleschian ideal as expressed by Alberti: "I find it delightful to see in this temple a fragile charm combined with strength and fullness of forms, so that every member seems to have been made to display beauty, and yet one comes to understand that everything here is conceived and established to last forever."[13] Leonardo's architectural style grew out of this ideal and was subsequently enriched by the tradition of Filarete in Milan, when he came into contact with Francesco di Giorgio, Giuliano da Sangallo, and finally Bramante.

We can juxtapose his Romorantin project with Filarete's designs, which show similar systems of canals; we can find analogies with the Ducal Palace in Urbino, or with Sangallo's project for a majestic palace for King Ferrante of Naples; and finally we might compare it with Bramante's work, from the Palazzo Apostolico at Loreto to the Palazzo dei Tribunali in Rome.[14] But what keeps all these elements together in a unity that seems to prepare the way for the Louvre, or even for Versailles, is Leonardo's fantastic vision of an architecture growing out of analogies with man and the vegetable world and shaped after geometrical symbols into which he is attempting to reduce all the energies of nature.

APPENDICES

APPENDIX A. DOCUMENTS

The eighteenth-century records of an enlargement of the Romorantin Castle can be considered as documents only insofar as they refer to the actual remains of the building. Except for documents 1, 2, and 5, the entries gathered in this section are historical accounts often related to one another, the sources of which are either obvious or no longer available.

DOCUMENT I

Visite des Fondations d'une partie du Château de Romorantin. September 27, 1512. Paris, *Archives Nationales*, R⁴ 496, no. 2. Cf. H. Stein, *Bulletin Monumental*, LXIII (1898), pp. 335–340.

A tous ceulx qui ces présentes lettres verront, Jehan Gallus, licencié ès droiz, chastellain de Romorantin, salut. Savoir faisons que aujourd'huy date de ces présentes lettres, par devant nous et ès présences de Phelippon Meignen et Simon de Launay, notaires juréz du seel de la chastellenie dudit lieu de Romorantin, par l'ordonnance et commandement de noble homme Nycollas Foyal, escuier, seigneur de Herbault, conseiller et maistre d'ostel de très haulte et puyssante princesse Madame la comtesse d'Angoulesme, vicontesse d'Aulnay, dame de Romorantin et Millansay, ont esté convocquéz et assembléz maistres Pierre Nepveu, dit Trinqueau, demourant à Emboyse, maistre maçon, conditeur et entrepreneur de l'ouvraige et édiffice encommancé à faire pour madite dame ou chasteau dudict Romorantin, et avecques luy Macé Olivier, Loys Grasserreille et Jehan Rousseau, aussi maistres maçons juréz demourans audit lieu de Romorantin, pour veoir et visiter la proffondeur, largeur et lieu pour asseoir les fondemens dudit édiffice et ouvraige encommancé du cousté de la rivière de Sauldre; tous lesquelz, aprèz qu'ilz ont bien et deuement faicte ladite visitacion, ont dit et rapporté en leurs loyaultéz et consiences que ladicte assiette, à la profondeur qu'elle a de présent, est plus bas que celle du chasteau encien de ung pied et plus, et de largeur de sept piedz sur gros gravier, bon et convenable, pour porter la pesanteur et haulteur dudit édiffice selon le deviz qui leur a esté déclairé et monstré, et que pour raison desdits fondemens, ainsi pris que dit est, ne pourra venir ne ensuyvir aucun inconvéniant ne dommage audit édiffice, ainsi qu'ilz ont peu veoir et congnoistre; et

123

à ce veoir faire ont esté prins honnorable homme et saige maistre Michel Le Clerc, licencié en loix, proucureur, et Andry Corrien, receveur desdictes chastellenies de Romorantin et Millansay, dont et desquelles choses ledit escuyer nous a requis et demandé lettres testimonialles pour servir et valloir à madite dame et à luy en temps et lieu ce que de raison, ce que luy avons octroyé. En tesmoing de ce, nous, à la relacion des dictz juréz, avons scellés ces lettre dudict seel.

Ce fut fait l'an de grâce mil cinq cens et douze, le vingt septiesme jour de septembre.

P. Meignen. S. De Launay.

DOCUMENT 2

Exemption from the tax on wine granted to the inhabitants of Romorantin by Francis I. March 1, 1514 (i.e. 1515). On vellum. Romorantin-Lanthenay, Archives de la Ville. Cf. Dupré, *Société Archéologique et Historique d'Orléans*, XIV (1875), pp. 54–56. The following transcription includes Dupré's notes, printed below at the end of this document.

Françoys, nous, etc., désirant nostre ville de Romorantin, qui est de toute ancienneté et de si longtemps qu'il n'est quasi mémoire du contraire construite et édiffiée, et que néantmoins, pour ce qui est de la cloustture ancienne, est de si petite estendue que les bourgeois et habitans d'icelle ne se peuvent bonnement loger ne trouver lieux et places pour eulx y habiter, tellement que les anciens et principaulx d'iceulx ont esté et sont contraincts de faire maisons et édiffices hors la dite cloustture, où ils ne peuvent bonnement et seurement commencer et résider sans danger de leurs personnes et biens, et que, en ceste cause, iceulx bourgeois et les gouverneurs[1] et habitans de la dite ville, congnoissans que icelle ville estoit le lieu où nostre très-chère et très-amée compaigne la royne a prins sa nativité, génération et nourriture,[2] et que ce soit chouse à nous et à nostre dicte compaigne très-agréable de icelle ville faire croistre et augmenter et entretenir en bonne grandeur et réparation, ad ce que, le temps advenir, elle et les dits habitans puissent estre deffensables contre les ennemis de nostre royaulme, si besoing en estoit; que, depuis dix ou douze ans en ça, par le congé, license et permission de nos prédécesseurs a délibéré et jà commencé icelle ville à croistre et augmenter et prandre de la cloustture d'icelle les forsbourgs qui jà estoient et sont grandement édiffiés de maisons et peuplés de personnes notables; et jà ont fait commencer le principal portail de la dite nouvelle closture et grand quantité de murs où ils ont tousjours mis et employé les deniers qui par cy devant leur ont esté octroiez pour ce faire . . . En faveur des chouses dessus dictes et de la grant amour, loyaulté et vraie obéissance

124

qu'ils ont tousjours eue et portée envers nous et nos prédécesseurs et nostre très-chère et très-amée dame et mère, laquelle, par cy devant, la pluspart du temps, a fait son séjour et résidence en la dite ville, et encore a voulloir et intention de ce faire, et nous pareillement; pour ces causes et autres à ce nous mouvans, aux dits bourgeois, manans et habitans d'icelle ville et paroisse de Romorantin avons donné et octroié de grâce espéciale, par ces présentes, jusques au terme de dix ans, à compter du jour Sain-Remy prochain, l'aide du huitième denier du vin vendu en détail en la dite ville et paroisse de Romorantin, que nos prédécesseurs et nous y avons prins et levé par cy-devant.[3]

Donné à Paris, le premier jour de mars, l'an de grâce mil cinq cens et quatorze,[4] et de nostre règne le premier.

<div align="right">François</div>

[1] Officiers municipaux, appelés aussi échevins.

[2] Claude de France, fille de Louis XII, née à Romorantin.

[3] Une charte semblable fut expédiée à la même date, pour l'exemption des *tailles, octrois, impôts et emprunts* quelconques. (Rapport de M. Martonne, p. XLIII.)

[4] 1515 *nouveau style*. François Ier monta sur le trône le Ier janvier de cette même année.

DOCUMENT 3

Historical accounts in the Bibliothèque de Blois, excerpted by Heydenreich, *Burlington Magazine*, XCIV (1952), p. 278:

(a) MS no. 269. *Histoire et antiquitez de la ville de Romorantin ... par moy Jean François Bidavlts, borgeois de cette ville, le 25 Mai 1710* (not 1770 as given by Heydenreich). This is the source of (c). Compare also document 5.

(b) MS no. 107 (not 207 as given by Heydenreich). *Rapport de M. Lambot de Fougères, sous-préfet de Romorantin, sur l'histoire et les antiquités de son arrondissement, adressé au Ministère de l'Intérieur en 1818.*

(c) MS no. 270. *Étude sur Romorantin. Fragment anonyme du commencement du 19e siècle.* Based on (a), and the source of document 4b.

(a) MS no. 269 (Bidaults, 1710), no pagination; chapters 62–64

62. Du château de Romorantin.

Le chateau de Romorantin a été bâti / de briques et pierres de taille par les princes / de la maison d'Angoulême. François I avait / voulu l'augmenter[†] (*on the margin:* [†]ce qui se / voit par des / fondemens / faits au lieu / du château / qui se nomme / les Lisses.) mais la maladie contagieux / survenue empêcha son dessin. Ce Roy avait / aussi formé le dessin de rendre la rivière qui / coule le long du chateau navigable en 1515.

63. Du grand Jardin.

De ce château dont nous venons de parlèr il / y a un parc entouré de murs de briques / et a l'entrée du dit parc à main droite sortant / du lieu des lisses, il y a un endroit profond / revêtu de murs de briques qui était le lieu ou se / faisait le jeu du taureau pendant le séjour des / princes seigneurs de Romorantin, le quel / endroit s'appelle encore aujourd'hui la fosse aux / lions.

64. De l'ancienne seigneurie / de Monceaux.

Ce jardin dont nous venons de parler conduit / aussi au jardin d'une ancienne seigneurie / appellée Monceaux ou François II roy de France / a été elevé jusqu'à l'age de 7 ans. / Entre ces deux jardins il y a un endroit / grani de grands ormes. qui ètait le lieu ou / les ambassadeurs avaient audiance dans le / temps qui le Roy François I faisait son séjour à Romorantin.

(b) MS no. 107 (de Fougères, 1818), fols. 11 r–12 r

Château de Romorantin

pendant que cette église paroissiale s'élevait sur la rive gauche / de la Sauldre, le Prince Jean d'Orlèans, Comte d'Angoulême et / seigneur de Romorantin, construisait sur la rive droit, le Château / dont on voit encore aujourd'huy quelques dépendances— une preuve que les / deux édifices furent construits à la même époque, c'est qu'il existe / au frontespice de la fenêtre la plus élevée de l'une des tourettes du /château, une coquille sculptée d'environ un demi mètre sur tous / sens, absolument pareille et dans les mêmes dimensions que celles qui / audessous des colonnes tronquèn du choeur de l'èglise paroissiale dont / on a parlé plus haut.

La destruction opéré depuis la rèvolution de la plus grande / partie de ce Château sur l'emplacement de la quelle on a construit vers 1806 / les dépendances du tribunal, la prison et la caserne de la gendarmerie / ne permettent plus aujourd'huy d'y retrouver les appartemens dans les quels se / sont passés les differens faits historiques que l'on va rapporter, et que / au moins rendent intéressant l'emplacement et le reste du Château ou ils / ont eu lieu.

Aprés la mort du Roy Charles VIII, la maison d'Orlèans aient / succédé à la Couronne dans la personne de Louis XII. La branche / d'Orlèans Angoulême, se trouva la famille la plus raprochée du / trône et vêent plus intimement à la Cour qu'elle n'avait pu le faire / du vivent de Charles VIII, dont la Soeur, la dame de Beaujeu qui était / d'un caractère jaloux et ombrageaux, avait toujours en pendant le règne / de son frère la principale part au Gouvernment.

[fol. 11 v]

Aussi la Réine Anne de Brètagne femme de Louis XII, qui résidait / à Blois (où elle mourut depuis) étant devenue enceinte, et se croiant en / danger dans cette ville,

à cause d'une épidemie qui y règnait, / vent, par suite de cette intimité se réfugier chez le Comte d'Angoulême / au Château de Romorantin et y donna le jour en 1499 a Claude de France / qui èpousa par la suite François Ier—Louis XII qui faisait alors la guerre / en Italie, accourut aussitôt à Romorantin, pour embrasser le premier / enfant que lui donnait une épouse dont il avait été amoreaux idés avant le / mariage de cette princesse avec Charles VIII.

François Ier avant et depuis son avènement à la Couronne habita / frèquemment le Château de Romorantin, et sa mere Louise de Savoye / duchesse d'Angoulême, après y avoit séjourné à plusieurs époques, y / termina sa vie en 1531 à l'âge de 55 ans.

Ce Prince affectionnait Romorantin, comme on affectionne le lieu / des ses pères. Devenu Roi, il voulut aggrandir le Château, et, d'après ses / ordres, on jetta les fondemens d'un véritable palais qui devait être entouré / d'un vaste parc traversé par la Sauldre. Le Château de Romorantin fut alors devenu une maison Royale qui eût procuré à la ville / de Romorantin une multitude d'avantages; mais ce bonheur ne lui ètait / pas reservé. La mort de sa mère que ce Prince avait toujour estrêmement / respectée et chérie étant arrivée dans ce lieu, les souvenirs douleureux qu'obligé / lui retraçair lui en renderent le séjour pénible, et c'est probablement / à cet évènement et à ce sentiment, plutôt qu'à une maladie épidémique / comme quelques-uns le prétendant qu'est due l'interruption des travaux / commençés à Romorantin, et la construction sur les rives du Cosson, du Château / de Chambord, que ce Roy, que Mezeray appelle grand bâtisseur, fit élever / pour remplacer celui qu'il avait projetté sur les bords de la Sauldre. Les / fondemens de celui cy subsistaient encore peu de tems avant la révolution, / et ont servi de carrière jusqu'à leur épuisement qui est totalment opéré / ajourd'huy, sans qu'il ne reste de traces. Il y a tout lieu de croire que les murs de / briques entourant d'un côté un terrain que la Sauldre baign de l'autre / et que s'étend jusqu'au petit Château de Monceaux, sont un ouvrage de / ce prince.

Françoise de Foix Comtesse de Chateaubriant, maitresse de ce Roy / galant, demurait dans le petit Château de Moncezux, lorsque la Cour / séjournait a Romorantin.

Après la mort de François Ier les deux Rois qui lui succèderent / habiterent encore quelques fois le Château de Romorantin . on dit même / (mais rien ne l'assure aultrenti querment) que le Roy François II y fût / élevé jusqu'à l'âge de sept ans. Un fait certain, c'est le séjour / que ce même Roy François Ier, y fit en 1560 avec le Chancellier de / l'hopital, puisqu'il y signa le fameux *édit de Romorantin* [fol. 12 r] qui attribuait aux évêques la connaissance du crime d'hèrèsie et / l'interdisait aux parlemens. Le président Hesnault, dit que le Chancelier / de l'hopitale n'avait fait rendre cet édit que pour éviter un plus grand / mal qui était l'établissement de l'inquisition.

Tels sont les principaux événemens historiques qui ont eu lieu au / Château de Romorantin et les souvenirs que rappelle ce qui en reste. On / peut calculer que les bâtimens conservés n'en sont pas la 8.eme partie. / L'intérieur de les bâtimens est occupé

aujourd'huy par les salles d'audience / des tribunaux et quelques unes des leurs dépen-
dances . quant aux jardins qui / formaient les promenades de ce Château, au lieu
d'être conservés pour / l'agrément des habitans de Romorantin, tout, jusqu'à la
petite terrasse / qui régnoit entre le Château et la rivière, a été vendu dans la révolution.
/ On si abstiendra de toute reflexion sur la conduite des Autorités qui / provoquerent
ou tolerènt, sans s'y opposer cette aliénation, si / inconcevible, et qui cependant né en
lieu que bien longtems après la / régime de la terreur.

(c) MS no. 270 (anonymous, ca. 1800), fols. 9 v–10 r

.

Le Chateau de la dite / ville est bâti de briques et de pierres de taille par les soins / des
Princes de la maison d'Angoulême; François / Premier avait commencé à le vouloir
augmenter / ce qui vois par des fondements faits au lieu du [fol. 10 r] Chateau qui se
nomme Les Lisses, mais la maladie / contagieuse survenue in la dite ville empêcha son /
dessein, le tout est demeuré en l'état quel était; ce / Roi avait aussi formé le dessein de
rendre la rivière / qui coule le long du dit Château navigable; de ce / chateau il y a un
parc entourné d'un mur de briques / et à l'entrée dudit parc à main droite sortant du
dit / lieu des lisses il y a un endroit profond revêtu aussi / de murailles de briques qui
était le lieu ou se faisait / le jeu du Taureau, pendant le temps que les princes / Seigneurs
de Romorantin faisaient leur séjour audit / château le quel endroit s'appelle encore
aujourd'hui la / fosse aux Lions, et dans ce parc il y a un Jardin / considérable par de
belles allées de Charmes qui / vent se rendre aussi au jardin d'une ancienne seigneu- /
rie appelée Monceaux où François Second, Roi / de France a eté élevé jusq'à l'age de
sept ans de / ses tendres années, entre les deux jardins il y a un / droit où il y a de grands
ormes qui ètait le lieu où (les ambassadeurs avaient audience dans le temps / que le
Roi François Premier faisait son séjour à / Romorantin.

.

DOCUMENT 4

Historical accounts in the Bibliothèque Municipal de Romorantin-Lanthenay,
Miscellanea Berge, MS compiled in 1888. Unpublished.

(a) *Notice sur la ville de Romorantin par Nicolas Millot, ancien principal du College*, ca.
1800. (No. 3, pp. 65–93.)

(b) *Antiquités de la ville de Romorantin. Le manuscrit donné à la ville par M^r Pestel
port cette mention : Fait sur une copie du I^er Mai 1790, non signée.* (No. 7, pp. 263–
289.) Based on document 3c.

DOCUMENTS

(a) Millot, pp. 74–76

Ce château bâti de pierres de taille et de / brique est situé sur la rive droite de la Sauldre [p. 75] au chouchant de la ville. Il fut construit par les princes d'Angoulême qui, étant entrés en possession / de la seigneurie de Romorantin, trouvèrent l'ancien / Château suite des siègès qu'il avait soutenus contre les / Anglais et en firent construire un nouveau où ils sejournèrent souvent. De ce chateau on se renduit / à celui de Monceaux en suivant un parc borné / d'un côtè par la rivière et de l'autre par un mur / en briques.

Le Château de Monceaux situé dans la com- / mune de Lanthenay est une ancienne seigneurie / tantôt reunie à celle de Romorantin, tantôt / séparée par des concessions et des échanges, elle fut / définitivement cedée par Henri IV avec le four / canal à la branche cadette de Béttiune qui possédait Selles et Chabris, en échange des droits de haute / Justre dans le fauburg de Vienne à Blois.

Le jardin de ce château est contigu au parc de / celui de Romorantin ou plutôt n'en est séparé / que par un petit ruisseau appelé La Nasse, qui / fait la limite des deux communes; sur le bord de ce ruisseau était une salle de verdure ombragée / par de grands ornes sous lesquels François I se / plaisait beaucoup et donnait audience aux ambas- / sadeurs. Ce fut dans ce château de Monceaux / que François II fut élevé jusqu'à l'âge de sept ans, / et pendant son année de règne il revènt à / Romorantin revoir les lieux où il avait passé son enfance.

Ce fût pendant ce court séjour qu'il rendit ce / fameux édit qui attribue aux juges ecclésiastiques / la conaissance des crimes d'hérésie et l'interdit / aux parlements.

En sortant du jardin du château pour entrer / dans le parc on trouve à main gauche une fosse / revetue de briques, profonde de 8 à 10 pieds, longue de 30 et large de 2 toises. Ce lieu était / destiné au combat du taureau lorsque les seigneurs / de Romorantin habitaient le château et il s'est / appelé jusq'à présent la fosse aux Lions. On vient / d'arracher les murs de cette fosse et on travaille / à la combler. Le parc est vendu à un particulier [p. 76] comme domaine national, les arbres son abattus / et le terrain mis en culture. Ainsi disparaissent les / traces de l'antiquité, mais il serait à désirer que / les temps orageaux n'eussent jamais anéanti de / plus précieux.

François I qui avait passé une partie de sa / jeunesse dans cette ville y fit dans la suite de / fréquent séjours et travaillait à son embellissement. / Il avait fait jeter les fondements qui existent encore / à plusieurs pieds hors de terre d'un prolongement / considérable au château sur les bords de la Sauldre, / mais il abandonna son projet et transporta ses / plans à Chambord. On tient par tradition qu'il / fût engagé à ce changement par une peste qui régna / dans le pays vers l'an 1520 et qui fut occasionné / par le dessèchment d'un étang appelé l'étang / du Marché qui existait le long des murs à / l'orient de la ville.

129

APPENDIX A

(b) Anonymous Pestel, pp. 275–276

Le Château de la ville est bâti de briques et de / pierres de taille par les soins de princes d'Angou- / lême. François I avait commencée de vouloir / l'augmenter, ce qui se vois par des fondements / faits au lieu du Chateau qui s'apelle les Lisses; / mais le maladie contagieuse survenue empêcha / son dessein; le roi avait aussi envie de rendre / la rivière navigable. Il y a un parc entouré / d'un mur de briques et à l'entrée dudit parc / il y a un endroit profond revetu de murs de / briques qui était le lieu ou se faisait le combat du / taureau quand le seigneur faisaient leur séjour / à Romorantin; cette endroit a reçu le nom de / fosse aux lions. Dans ce parc était un jardin / considé- rable avec de belles allées de charmes qui / vent se rendre au Jardin d'une anciène maison / appelée la Seigneurie de Monceaux où François II [p. 276] Roi de France fut élevé jusqu'à l'âge de sept ans. / Entre cet deux jardins sont de grands ornes / sous les quels les ambassadeurs avaient audience.

DOCUMENT 5

Recette Générale des Finances en Languedoil et en Guienne. Paris, Archives Nationales, K. K. 389, fols. 260 and 273. Cf. Heydenreich (above, document 3 *ad init.*), p. 278, n. 1.

1518, January 17.
Francis I issues "4000 livre d'or: pour fair la rivière de Sauldre navigable depuis Romorantin jusq'au lieu, où elle tombe en la rivière du Cher."

APPENDIX B. THE LITERATURE ON LEONARDO AS AN ARCHITECT

The earliest study of Leonardo as an architect dates from the beginning of the nineteenth century and is still unpublished. Its author, Giuseppe Bossi (1777–1815), was the painter commissioned to copy the *Last Supper*; his studies on the subject resulted in the celebrated book *Del Cenacolo di Leonardo da Vinci, Libri quattro*, published in Milan in 1810. Bossi had planned to add a "fifth book" to his work, and he did in fact write a draft of it, to which he gave the title *Dell' Architettura del Cenacolo e delle Opinioni di Leonardo intorno all' Architettura in generale*. Unfortunately, the project was not carried out, and nothing else besides the draft recently located in the Ambrosian Library points to his intention of studying Leonardo as an architect. Bossi must have realized that it was virtually impossible to do so without the Leonardo manuscripts that had been removed from the Ambrosian Library and taken away to Paris in 1797. He died in 1815, the year when the Codex Atlanticus alone was brought back to Milan.

Bossi owned Leonardo's original drawings now in the Venice Academy; he had acquired them from the heirs of Venanzio de Pagave in Milan.[2] Together with Leonardo's drawings in the Ambrosiana they were the first to be published in Italy; in fact they appeared in the volume of prints by Carlo Giuseppe Gerli, in 1784, with a preface and a catalogue by Carlo Amoretti, a scholar of the Ambrosian Library who was to publish in 1804 the first biography of Leonardo based on documents.[3] One of the drawings in Bossi's possession was a well-known church façade (included in every study on Leonardo's architecture), which has received various dates and interpretations.[4] It was only natural that Bossi should have included a long discussion of that

1. See *Raccolta Vinciana*, XIX (1962), pp. 294–295.

2. Formerly in the collection of Cardinal Cesare Monti, Milan. Cf. Uzielli, *Ricerche* (1884), pp. 296–298. All the drawings are reproduced in facsimile in L. H. Heydenreich, *I disegni di Leonardo da Vinci e della sua Scuola conservati nella Galleria dell'Accademia di Venezia* (Florence, 1949). See also

L. Cogliati Arano, *Disegni di Leonardo e della sua scuola alle Gallerie dell' Accademia* (Venice, 1966).

3. Carlo Giuseppe Gerli, *Disegni di Leonardo da Vinci . . .* (Milan, 1784). Amoretti (below, Part One, sec. VII, n. 18).

4. See Firpo, p. 62. Cogliati Arano (above, n. 2), p. 25, states that I refer the drawing to S. Lorenzo in Florence, and quotes Brizio's

drawing in his unpublished essay. In his analysis of Leonardo's architectural style, he establishes parallels with the projects for Pavia Cathedral and detects the presence of forms that were to be introduced by Bramante. The fact that Leonardo worked on the *Last Supper* at the time of Bramante's project for the apse of Santa Maria delle Grazie led him to look for any possible evidence of a collaboration between the two in the field of architecture in general and in the building of Santa Maria delle Grazie in particular. A long note on Bramante published in his book on the *Last Supper* shows how much documentary material was available to him.[5] He was the first to point out the existence of that curious and extravagant satire, the *Simia* by Andrea Guarna da Salerno, published in 1517 in Milan by Gottardo da Ponte, the publisher of the Cesariano edition of Vitruvius. Bossi, who possessed this, as well as nearly every book to which he referred, gave a translation of the long section in which Bramante is made to talk with St. Peter about his work in the Vatican. He kept up an assiduous correspondence with the most erudite scholars of the time and was often their guest.[6] In Milan he had access to the library of his friend Prince Trivulzio, who owned the only manuscript by Leonardo left in Milan. Bossi's unpublished essay includes a thorough analysis of the architectural drawings in that codex, which he identified correctly as pertaining to the construction of the tiburio over the crossing of Milan Cathedral. That was all the material by Leonardo available to him. The scholars of the Ambrosiana had some record of the architectural studies in the manuscripts that were no longer there—some such records as those published by Amoretti in 1804 concerning drawings of Santa Maria della Pertica at Pavia, cupola studies for Milan Cathedral, the ground plan of Santo Sepolcro, and the projects for the stables of Galeazzo Sanseverino.[7] In addition to scanty material and recollection of material no longer available, there was in Milan a tradition that Leonardo had been the architect of some building there. Bossi mentions one such tradition referring to a house in the neighborhood of the Porta Romana. It is usually safe to discard an old attribution of a painting to Leonardo as based on some proud owner's fancy notion or lack of critical judgment, but it is less safe to discard the attribution of a building to him, when it might be the result of hearsay filtered down from Leonardo's time. It was Venanzio de Pagave, for example, who in the notes published in the 1792 edition of Vasari mentioned Leonardo's participation in the building of the Villa Melzi at Vaprio d'Adda in 1482, a date that was

rejection of my theory. But in my *Chronology*, pp. 136–137, I show that the drawing cannot be for S. Lorenzo, and I suggest S. Marco!

5. Bossi, *Del Cenacolo*, pp. 246–249.

6. Cf. G. Galbiati, *Il Cenacolo di Leonardo da Vinci del pittore Giuseppe Bossi nel giudizio di illustri contemporanei* (Milan, 1919), pp. 8–9.

7. Amoretti (below, Part One, sec. VII, n. 18), pp. 73, 150–151.

taken as evidence of Leonardo's presence in Milan as early as that year.[8] Later research confirmed that the date of Leonardo's arrival in Milan was correct, but the traditional attribution of the design of the Villa Melzi to him lost credit and soon was dismissed. Only recently was it possible to find some truth in the tradition reported by de Pagave. The evidence came from Leonardo's own notes and drawings, which show that he was in fact engaged in some project to enlarge the Villa Melzi, but during a later period, about 1513.[9]

Apart from the pioneering work of Bossi and his contemporaries, there was no further study on Leonardo's architectural drawings until the appearance in 1883 of J. P. Richter's *Literary Works of Leonardo da Vinci*. The section on architecture in the second volume of Richter's anthology was compiled by Heinrich von Geymüller and includes the most comprehensive selection of Leonardo's architectural drawings ever attempted. It was an impressive corpus of magnificent facsimiles, the quality of which was not surpassed even in the second edition of 1939. The material was arranged in two sections: A. Architectural Designs, and B. Writings on Architecture. The first section was subdivided into (I) Plans for Towns, (II) Plans for Canals and Streets of a Town, (III) Castles and Villas, (IV) Ecclesiastical Architecture, (V) Palace Architecture, and (VI) Studies of Architectural Details. The second section included the notes from the so-called Treatise on Fissures in Walls and notes on foundations, arches, and beams. In the introductory observations the author mentioned that he had undertaken his research in Milan in 1869, working on the Codex Atlanticus "for the purpose of finding out, if possible, the original plans and sketches of the church of S. Maria delle Grazie at Milan, and of the Cathedral at Pavia, which buildings have been supposed to be the work both of Bramante and of Leonardo."[10] Geymüller's work was therefore motivated by the persistence of opinions and traditions about Leonardo's association

8. Venanzio de Pagave carried out a thorough investigation in the libraries and archives of Milan to collect all possible information about the activities of Leonardo and Bramante in Lombardy. Unfortunately, his work was left unpublished, and all we know of it is what he had communicated to his contemporaries Rezzonico, Oltrocchi, della Valle, and Amoretti. A collection of his letters to Luigi Crespi, dating from 1777 to 1778 (Biblioteca dell'Archiginnasio, Bologna, MS B 12), shows with what passion and deliberation he intended to accomplish and publish his research. It was he who urged the librarians of the Ambrosian Library to study the material by Leonardo in their possession, and it was he who owned Leonardo's drawings that went to Bossi and are now in the Venice Academy. Some of the documentation on Leonardo that he had collected (e.g. the letter of Cesare Borgia in the Melzi archives) was included in della Valle's commentary in the fifth volume (1792) of the Siena edition of Vasari's *Lives*, 1791–1794.

9. See my article in *L'arte*, LXII (1963), pp. 229–239. See also *Raccolta Vinciana*, XX (1964), pp. 220–221, and above, Part One, sec. VI.

10. Vol. II, p. 26 (2nd ed., 1939, vol. II, pp. 19–20).

with Bramante in architectural works in Lombardy. Geymüller's deep understanding of Renaissance architecture and his thorough knowledge of Leonardo's manuscripts in Italy, France, and England enabled him to clarify to a great extent the significance of Leonardo's studies. In 1875 Geymüller published some of Leonardo's designs of centrally planned churches as anticipations of Bramante's design for St. Peter's,[11] thus establishing the view that has been adopted ever since: that Bramante's work reflected Leonardo's ideas. It is revealing that the first comprehensive study of Leonardo's architecture after Geymüller, that of L. H. Heydenreich of 1929 on Leonardo's *Sakralbauten*, concludes with the suggestion of turning the problem of "Bramante oder Leonardo" into the problem of "Bramante und Leonardo."[12]

Shortly before Richter's anthology, there appeared in Italy in 1872 the *Saggio sulle opere di Leonardo da Vinci* by Gilberto Govi, a publication that was meant to give a comprehensive summary of Leonardo's achievements as an artist and a scientist; it was published on the occasion of the unveiling of a monument to Leonardo in Milan. Govi's knowledge of the history of science in general and of Leonardo's manuscripts in particular enabled him to produce a valuable work of synthesis, in which he introduced material never before discussed. Unfortunately, he did not indicate the source of each of the texts he reproduced, and thus his work could not become a reference tool as Richter's did. Yet one may be surprised today at recognizing how many details were known to Govi, and a recent account of his scholarship on Leonardo has shown that he had transcribed nearly every one of Leonardo's manuscripts in the Bibliothèque de l'Institut de France, besides a great part of the folios of the Codex Atlanticus, to the publication of which he contributed until his death.[13] The chapter on architecture in his *Saggio* includes references to drawings pertaining to the Milan and Pavia Cathedrals, and so Govi could state that Leonardo was to be considered a practicing architect. He even mentioned Leonardo's design of a house for Galeazzo Sanseverino, referring to drawings in the Codex Atlanticus as possible plans for it. Although no specific reference is given, it appears that he meant folio 158 (figs. 5 and 6), the sheet of studies for the house of Mariolo de' Guiscardi.

Contemporary with Govi was Gustavo Uzielli, an equally influential scholar, author of a thorough series of *Ricerche intorno a Leonardo da Vinci*, published in 1872, 1884, and 1896. Uzielli's meticulous scholarship was dominated by a persistent positivistic approach to history, which might account for his lack of understanding of problems of style.[14] In his volume of 1884 he gave the first account of the Codex on

11. H. de Geymüller, *Les projets primitifs pour la Basilique de Saint-Pierre de Rome* (Paris and Vienna, 1875), pp. 37–38, 48, and pl. 43.

12. Heydenreich, *Sakralbau*, p. 91.

13. A. Favaro, *Gilberto Govi ed i suoi scritti intorno a Leonardo da Vinci* (Rome, 1923), pp. 20ff. Govi's transcriptions are preserved in the archives of the Accademia dei Lincei, Rome.

14. Cf. A. Venturi, *Memorie autobiografiche* (Milan, n.d.), p. 79.

the Flight of Birds, which was then the property of Count Giacomo Manzoni of Lugo, and he took the drawing of a villa on the cover of the codex as the excuse for a few remarks on the style of Leonardo's architectural drawings as a whole. He concludes by saying that "the architectural drawings of Leonardo are relatively few; and some of them appear to be researches of a new style, which in truth is not always beautiful." [15]

The publication of Richter's anthology first and the subsequent facsimile editions of Leonardo's manuscripts provoked an intense investigation into special problems of his architectural activity, such as the problems of Milan Cathedral, the Sforza Castle, and the canalization of the Adda River. A patient, learned work of exegesis was carried out by Luca Beltrami, himself an architect and the editor of the first of Leonardo's manuscripts to be published in Italy (1881), the Codex Trivulzianus, which contains some of Leonardo's studies for the tiburio of Milan Cathedral. [16]

Leonardo as an architect was the subject of a lecture that Vittorio Spinazzola delivered in 1906 at a cultural society in Florence in a series of *Conferenze Fiorentine* dedicated to Leonardo, to which such scholars as Solmi, Beltrami, Favaro, and Croce contributed. [17] It was published in 1910. Valuable as it was as a synthesis, it was nevertheless the first of a series of papers that aimed at popularizing the "universality" of Leonardo da Vinci. Such a presentation—which still has many adherents today—provoked two types of reaction: one, immediate, violent, and with a certain undisguised aim at sensationalism, was to be termed that of the "disfattisti," the detractors of Leonardo. (One of them, Francesco Malaguzzi-Valeri, plainly stated that Leonardo's role in the development of Renaissance architecture was negligible.) [18] The other type of reaction to the popular glorification of Leonardo's genius was that of scholars who carried out their patient and laborious research on his manuscripts and documents, building up in silence—so to speak—the solid foundation for a better understanding of the subject. I need only mention the fundamental work of Gerolamo Calvi on the chronology of the manuscripts, published in 1925 as a result of twenty-five years of research during which Calvi published a few papers and the monumental edition of the Codex Leicester (1909). [19] Calvi's work immediately became a model for all subsequent scholars; and its effect was soon manifested with the appearance of Kenneth Clark's catalogue

15. Uzielli, *Ricerche* (1884), pp. 394–395.

16. L. Beltrami, *Leonardo da Vinci negli studi per il tiburio della cattedrale di Milano* (Milan, 1903). For a complete bibliography of Beltrami's studies on Leonardo as an architect see E. Verga, *Bibliografia Vinciana* (Bologna, 1931).

17. *Leonardo da Vinci: Conferenze Fiorentine* (Milan, 1910), pp. 107–136.

18. F. Malaguzzi-Valeri, *La corte di Lodovico il Moro*, vol. II: *Bramante e Leonardo* (Milan, 1915). Malaguzzi-Valeri's drastic judgment provoked the violent and sharp reaction of L. Beltrami's *Leonardo e i disfattisti suoi* (Milan, 1919). which contains an appendix on *Leonardo architetto*.

19. For a bibliography of Calvi's studies on Leonardo see his *Leonardo da Vinci* (Brescia, 1936), pp. 229–230.

of Leonardo's drawings at Windsor Castle (1935). Yet the only new contributions to the chronology of Leonardo's architectural studies were those by Heydenreich on the drawings of the harbor of Civitavecchia (1934)[20] and the drawings for the royal residence at Romorantin, the latter having been identified in 1938 when Baroni still thought that they referred to Milan and dated therefore some twenty-five years earlier.[21]

In an article published in 1952, on the occasion of the quincentennial of Leonardo's birth, Heydenreich put forward the theory that Leonardo designed the new palace that Francis I had planned to build at Romorantin.[22] The subsequent publications on Leonardo as an architect are only compilations (with a few exceptions), and as such they repeat Heydenreich's conclusions.[23] The romantic touch in the story of a mag-

20. L. H. Heydenreich, "Studi archeologici di Leonardo da Vinci a Civitavecchia," *Raccolta Vinciana*, XIV (1934), pp. 39–53.

21. Baroni (below, Part Two, sec. V, n. 3), pp. 69–70. Heydenreich's identification of Leonardo's studies for Romorantin was announced in the catalogue of the Leonardo exhibition (Milan, 1939), p. 109. See also the article by C. Baroni, "Leonardo architetto," in the volume *Leonardo da Vinci a cura della mostra* (Novara, 1939), pp. 239–259 (reproduction on p. 254). Heydenreich published his finding fourteen years later (cf. *BM*, p. 278, n. 7: "Already in 1939 at my suggestion a plaster model of the Romorantin Castle was made and shown at the Leonardo exhibition at Milan").

22. *Burlington Magazine*, XCIV (1952), pp. 277–285.

23. The publications after 1952 on Leonardo as an architect are as follows:

A. Sartoris, *Léonard architecte*, Paris, 1952. (Beautifully printed, but worthless.)

G. U. Arata, *Leonardo architetto e urbanista*, Milan, 1953. (No. 11 in the publication series of the Museo Nazionale della Scienza e della Tecnica. A wordy compilation, whose only contribution is the redrawing of some of the plans of centralized churches in MS B and the Codex Atlanticus.)

E. Sisi, *L'urbanistica negli studi di Leonardo da Vinci*, Florence, 1953. (Worthless.)

C. Maltese, "Il pensiero architettonico e urbanistico di Leonardo," in *Leonardo: Saggi e ricerche*, Rome, 1954, pp. 333–358. (A learned and accurate account of Leonardo's architectural career, but premature as a synthesis; with inaccuracies in the chronology, e.g. p. 352, the project for Mariolo de' Guiscardi dated ca. 1506, p. 340, the plan of the enlargement of Milan referred to ca. 1507, etc.)

L. H. Heydenreich, *Leonardo architetto*, II Lettura Vinciana, Florence, 1963. (A lecture.)

L. Firpo, *Leonardo architetto e urbanista*, Turin, 1963. (The best work of synthesis, carefully brought up to date, very learned but with no trace of pedantry. With full bibliography.)

L. H. Heydenreich, "Leonardo and Bramante: Genius in Architecture," in *Leonardo's Legacy* (Berkeley and Los Angeles, 1969), pp. 125–148. (An excellent synthesis, but with a disturbing editorial mistake in the caption of fig. 3: Leonardo's drawings after the Cappella del Perdono at Urbino are designated as "Bramante. Sketches of details.")

S. Lang (below, Introduction, n. 16). (A perceptive interpretation of Leonardo's early church plans as studies for a Sforza Mausoleum.)

Other contributions, including my own, are discussed by A. M. Brizio in *L'arte*, LXXI (1968), pp. 107ff.

I must also mention the book by A. Bruschi,

nificent palace envisaged for the mother of the king, the construction of which was to be abandoned for unspecified reasons, was to be stressed all too often. It was much too easy to see a connection between the abandonment of work at Romorantin and the king's decision to build Chambord in 1519, the year of Leonardo's death. And it was easy to resume the old theory that the conception of Chambord was based on Leonardo's ideas.[24]

Bramante architetto (Bari, 1969), which is a masterpiece of scholarship and interpretation, with all the necessary data for a definitive assessment of the problem of the relationship between Bramante and Leonardo. See also the earlier perceptive essay by P. Murray, "Leonardo and Bramante," *Architectural Review,* CXXXIV (1963), pp. 346–351.

24. M. Raymond, "Léonard de Vinci archi-tecte du Château de Chambord," *Gazette des Beaux-Arts,* IX (1913). Gebelin, *Les châteaux de la Renaissance* (below, Part Two, sec. III, n. 34), p. 73, n. 33, and *Les châteaux de France* (below, Part Two, sec. VII, n. 12), pp. 91ff. F. Lesueur, "Léonard de Vinci et Chambord," *Études d'art,* 8–10 (1953–1954), pp. 225ff. See also *Chronology,* pp. 139ff, Firpo, pp. 119ff, and Guillaume (below, Part One, sec. III, n. 9), pp. 93ff.

APPENDIX C.
NOTE ON THE MANUSCRIPTS

Our knowledge of Leonardo's activity as an architect is based almost exclusively on his manuscripts. These are extraordinary documents that contain a wealth of information on Leonardo and his time. Yet their bulk (about eight thousand sheets and fragments) is only a fraction of what Leonardo had produced, and there are in fact indications that at least twice as much is lost. In the last decade the study of Leonardo's manuscripts has been increasingly directed to evidence pertaining to such missing material, making possible even the reconstruction of one of the lost notebooks.[1] The chance discovery of two manuscripts in the National Library at Madrid in 1967 was indeed timely.

Several of Leonardo's contemporaries must have compiled similar notebooks, but only insignificant fragments have survived.[2] L. B. Alberti, A. Filarete, Francesco di Giorgio, B. Peruzzi, S. Serlio, and others wrote treatises on architecture inspired by the classical model of Vitruvius, some of which were even published in their time. As for their architectural work, the evidence is often confined to the actual buildings, building accounts, and an occasional scale drawing; there are no preliminary sketches showing the gradual shaping of any of their architectural ideas. The only exceptions are Michelangelo's drawings, which have much in common with Leonardo's. Of

1. In my edition of the lost *Libro A*, I give in an appendix a general history of the manuscripts, including a chart of their vicissitudes. This is supplemented by my article on the *Libro F* (the present Codex Trivulzianus) in the *Journal of the Warburg and Courtauld Institutes*, XXXI (1968), pp. 197–217. The study of the original manuscript and of the changes in the numbering of its folios (a consequence of the removal of several folios at different times) has enabled me to add considerably to the history of the manuscript and of related folios in other collections.

2. An exception is the manuscript of Benvenuto di Lorenzo della Golpaja in the Biblioteca Marciana, Venice, a codex that I mention in Part One, sec. VII, n. 17 below. Because of its technological contents and format, it is very similar to some of Leonardo's notebooks. It has 96 folios (i.e. twelve signatures of eight folios each), exactly as Leonardo's MSS E, F, and G have. It also includes some of the machines and instruments invented by Leonardo, which are described as such, with important biographical information. In 1951 I made a transcription of the whole codex with a view to publication. I have recently turned over my material to Silvio A. Bedini of the Smithsonian Institution, who is preparing an English edition of the codex.

THE MANUSCRIPTS

Bramante, who is reported to have compiled treatises on architecture and must have produced a great many drawings, practically nothing is left. Raphael's drawings of the remains of antique buildings are also lost.

Leonardo's architectural studies are often considered as purely theoretical, with no bearing on practical applications. Recent studies have shown that all his architectural drawings were done in view of some project or commission and that the construction of some of the buildings designed by him was actually undertaken. Unfortunately, not only have such buildings vanished, but all that we know of them comes from preliminary sketches, each seldom larger than one square inch. As with his lost mural, the *Battle of Anghiari*, for which he produced a cartoon of well over a thousand square feet (and a few small preliminary sketches are all we know of it), there must have been large scale drawings for his projects of houses and palaces, and even towns.

Throughout this book I have made references to several of Leonardo's manuscripts, citing them according to a standard system, and always giving their dates or the date of an individual entry. A few manuscripts that do not contain architectural studies may still have some bearing on architectural theories, e.g. MS D, which is on optics, and the Codex Leicester, which is on water and canalization. The following List of the Manuscripts therefore includes also those manuscripts not cited in my study.

LIST OF THE MANUSCRIPTS

The manuscripts are grouped in two categories: (a) Miscellaneous collections, i.e. volumes put together after Leonardo's death, and (b) Notebooks, i.e. manuscripts preserved in their original form. Those in category (a) are given in order of size; those in (b) are given in chronological order.

In my descriptions of the manuscripts I have chosen not to repeat bibliographical specifications that are available in such standard works as Uzielli, *Ricerche* (1884), pp. 292–347, and A. Marinoni, "I manoscritti di Leonardo da Vinci e le loro edizioni," in *Leonardo: Saggi e ricerche* (Rome, 1954), pp. 231–273. See also V. P. Zubov, *Leonardo da Vinci* (Harvard University Press, 1968), pp. 283–292. Individual folios of Leonardo's manuscripts are located at present in various public collections, and some include architecture, e.g. the drawing in the Venice Academy, no. 238 v (church façade), ca. 1515. A complete list of such folios is given in the third volume (my commentary) of J. P. Richter's *Literary Works of Leonardo da Vinci*, third edition (in preparation: Phaidon Press, London).

(a) *Miscellaneous Collections*

Codex Atlanticus. Manuscript in the Ambrosian Library, Milan. Its name derives from its size, Atlas format, a designation introduced for the first time by Baldassare

Oltrocchi in his *Memorie* compiled around 1780 ("Codice delle sue carte in forma Atlantica," and even "Codice Atlantico").[3] It is incorrect to call it a codex. In fact it is a large album of 401 white sheets on which are mounted about 1,750 folios or fragments of Leonardo's notes and drawings, collected by the sculptor Pompeo Leoni toward the end of the sixteenth century. Such folios were originally the pages of notebooks, or sheets kept in unbound files pending their definitive arrangement. By placing them in a spectacular volume Leoni secured their preservation but destroyed their original order. Furthermore, about one third of the material is in fragmentary form, many drawings having been removed to form other miscellaneous collections. Thus the drawings now at Windsor come from one such volume; two other volumes of similar size and contents are listed among Leoni's possessions left at his death in 1608 and now lost.[4] Apparently Leoni arranged Leonardo's folios only as curiosity items, making no attempt to classify them according to their contents.[5] Thus different parts of one single sheet may have been mounted on different pages of the Codex Atlanticus (e.g. the sheet with the studies for the house of Charles d'Amboise and a sheet of archaeological studies at Civitavecchia).

Each of Leoni's mounts or pages in the Codex Atlanticus may contain up to ten of Leonardo's fragments. These are therefore designated with the letters *a*, *b*, *c*, etc., so that the tenth fragment would be *k* (the *j* is not used), as is the case with fol. 349 v-k quoted in Part Two, sec. V, n. 6.

Whenever a Leonardo folio has notes on its verso, it is placed against a "window" in the Leoni page, that is, it is glued around its edges and placed against the edges of a "window," with the result that the verso appears somewhat smaller than the recto. But this system was not used consistently. At times it is the recto that is seen through the "window"; at times the folio is placed only in part against the "window," while the remainder is made to slip under it through cuts in the paper of the mount. This

3. Cf. S. Ritter, *Baldassare Oltrocchi e le sue Memorie storiche su la vita di Leonardo da Vinci* (Rome, 1925), pp. 56, 69.

4. See Windsor Catalogue, p. x. See also *Raccolta Vinciana*, XX (1964), p. 315.

5. Nearly every one of the Leonardo folios in the Codex Atlanticus bears a number in a sixteenth-century hand, usually written in the middle of the folio. K. Clark (*Windsor Catalogue*, p. lxvi) speaks of similar numbers on the Windsor drawings as Leoni's, and as representing an earlier, unsuccessful attempt to arrange the drawings. Those in the Codex Atlanticus are probably earlier—if not by Melzi, by one of his assistants. See my note in *Bibliothèque d'Humanisme et Renaissance*, XXII (1960), pp. 526–528. In fact when two folios are reassembled as they were originally, their early numbers are always consecutive, e.g. the fortification studies for Piombino in Part One, sec. IV, or the archaeological studies at Civitavecchia, *Chronology*, fig. 48. There must have been several sets of Leonardo's papers numbered individually, since one number may occur several times in the Codex Atlanticus. Cf. G. Galbiati, *Dizionario leonardesco* (Milan, 1939), pp. 165–171.

Recto-a Verso-a

Recto-a Verso-b

Recto-a, b, c Verso-a
Recto-d, Recto-e Verso-b, Verso-c

makes it difficult in reproduction to recognize the verso of a folio by its shape alone. At times, especially in the case of a large folio, only part of the sheet is mounted, a smaller part of it being left to hang out of the "window" as a flap that can be folded back.[6]

The designation "recto-a," "recto-b," "recto-c," etc., was introduced shortly before the publication of the manuscript (1894–1904). Though accepted ever since, it has often proved unsatisfactory and has caused many mistakes. The verso of a "recto-a" is not necessarily a "verso-a," but can be a "verso-b" or even a "verso-c," depending upon the arrangement of the folios on the mount. The accompanying diagrams show when a "recto-a" has a "verso-a" or a "verso-b." In the case of a flap there is a further complication: both sides of the flap are considered as belonging to the recto (or the verso) of the Leoni mount and are lettered accordingly, as if the verso of the flap were the recto of another folio!

Pompeo Leoni adopted the same system in mounting the drawings now at Windsor. These were removed from their mounts toward the end of the last century. Only recently the Codex Atlanticus has been taken apart to reveal the versos that Leoni might have concealed in the process of mounting (he often placed one folio against the other, with or without a window in between, whenever a verso seemed to him insignificant). The detached folios, however, have been mounted again in volumes, disregarding the student's needs that I have been pointing out with my publications on the Codex Atlanticus since 1957. To my knowledge there is no record (not even a microfilm) of the physical structure of the Codex Atlanticus before the "restoration": the edition reproduces only the Leonardo folios, not their mounts.[7]

The Codex Atlanticus includes folios dating from 1478 to 1518. A tentative chronology of its folios is given in an appendix to my *Studi Vinciani*, pp. 264–289.

Windsor Collection. The drawings and anatomical manuscripts in the Royal Collection at Windsor Castle were originally kept together in a miscellaneous volume similar to the Codex Atlanticus. They are now designated by inventory numbers, as

6. Some of the "flaps" were torn off sometime before the publication of the manuscript. One of them has recently been identified in the Municipal Library at Nantes and published by R. Cianchi in *Bibliothèque d'Humanisme et Renaissance*, XIX (1957), pp. 161–169. See also my note in *Raccolta Vinciana*, XIX (1962), pp. 275–278.

7. In 1961, before the Codex Atlanticus was taken apart, I made such an inventory of the folios, giving a detailed description of the way they were mounted and revising my previous chronology. Unfortunately, my notes disappeared in 1965 as a consequence of a car theft in Los Angeles, and I could never replace them. My request in 1968 to work on the original manuscript in order to prepare another chronological list of the folios was rejected. While I was denied permission to study the Codex Atlanticus, a library attendant was stealing some of its folios, trying to sell them for about twenty dollars each in a bar next to the library! Cf. *La Nazione*, November 13, 1968.

shown in the catalogue by Kenneth Clark (published in 1935; the second edition, 1968, revised and enlarged by the author with my assistance). Several of the drawings, especially small fragments, were extracted from the sheets now in the Codex Atlanticus, as shown in my *Windsor Fragments*.

The Windsor collection includes material dating from the same time as the Codex Atlanticus, ca. 1487–1518.

Arundel MS 263, in the British Museum. This is again a miscellaneous collection put together after Leonardo's death, but the folios are not mounted as in the Codex Atlanticus. They are bound in signatures, and to some extent each signature retains its original structure. Some of the folios, however, have been shuffled about, so that a signature may contain sheets of different dates; this is the case with signature 68, which contains the Romorantin studies and two folios of about 1490. The first thirty folios are dated by the record on fol. 1 r (March 22, 1508); the dates of the remainder vary from about 1480 to 1518. See my "Saggio di una cronologia dei fogli del Codice Arundel di Leonardo da Vinci," *Bibliothèque d'Humanisme et Renaissance*, XXII (1960), pp. 172–177.

(b) *Notebooks*
1487–1490

MS B, in the Bibliothèque de l'Institut de France, formerly in the Ambrosian Library, Milan, together with the other Leonardo manuscripts in the Institut de France. They were brought to France by Napoleon as a war booty and were designated A to M by J. B. Venturi shortly before 1797, the date of his *Essai* in which the system was adopted for the first time. The Codex Atlanticus was indicated as N, but this designation was soon abandoned.

MS B (to be considered together with Ashburnham MS 2037, also in the Institut de France, corresponding to a section [fols. 91–100] stolen from the manuscript in the 1830s) contains the famous series of centralized churches, as well as fortification drawings.

Trivulzian MS or *Codex Trivulzianus*, in the Biblioteca Trivulziana, Castello Sforzesco, Milan, formerly in the Ambrosian Library, Milan (replaced by MS D some time before the donor's death in 1648). Almost entirely occupied by word lists, but with a few architectural sketches pertaining to Leonardo's studies for the tiburio of Milan Cathedral. See my article quoted in note 1 above.

Forster MS I², in the Victoria and Albert Museum, London. A notebook on hydraulic machines bound together with a notebook on stereometry of 1505 (I¹). See also under 1495–1497.

APPENDIX C

MS C, in the Bibliothèque de l'Institut de France. On light and shade, with a few notes on water and mechanics. It was the first to enter the Ambrosian Library (1609) as a gift of Cardinal Federico Borromeo, who, however, kept for himself a manuscript that was bound together with MS C and is known in early records as *Libro W*, also on light and shade. (Cf. *Libro A*, p. 147, n. 110.) On the leather binding that enclosed both MS C (formerly *Libro G*) and *Libro W* is an inscription recording Guido Mazenta's gift to the cardinal in 1603. This does not specify the contents of the binding, but the back flyleaf is torn off, and the thickness of the spine indicates that a manuscript of at least thirty folios has been removed. Recently I had information about a manuscript by Leonardo seen in one of the libraries of the Princes Borromeo, but my search for it has been unsuccessful.

MS C is dated 1490 and 1491.

MS A, in the Bibliothèque de l'Institut de France, to be considered together with Ashburnham MS 2038 (also in the Institut de France) which corresponds to a section (folios 81–114) stolen from the manuscript in the 1830s. It contains notes on painting, perspective, mechanics, water, and architecture (statics). Dated 1492, but certain sections (e.g. notes on weights) are in the minute script of about 1489–1490.

Madrid MS II, in the Biblioteca Nacional, Madrid (MS 8936). A signature at the end of the manuscript (folios 141–157) to be designated as Codex on Casting the Sforza Horse, dated 1491 and 1493. The remainder is later. See under 1503–1505.

MS H, in the Bibliothèque de l'Institut de France. This is made up of three pocket-size notebooks designated as H[1] (1494), H[2] (1494), H[3] (1493, 1494). Several references to architecture, especially pertaining to work at the Sforza residence at Vigevano.

At the same time Leonardo may have begun Forster MS III; see under 1495–1497.

Forster MSS II–III, in the Victoria and Albert Museum, London. Two pocket-size notebooks, II[1,2] (1495–1497), III (1493–1496). MS III contains notes on architecture, with reference to the project of enlarging Milan, thus indicating a date about 1493. A ground plan of Milan Cathedral on fol. 55 v (Firpo, p. 22) has suggested a date even earlier, 1487–1490, but this is not supported by the style. A date about 1493 is confirmed by drafts of tales developed in folios of the Codex Atlanticus, by studies for the casting of the Sforza horse, and by anatomical notes. It is possible, however, that Leonardo added to the notebook up to about 1496.

THE MANUSCRIPTS

1497–1499

MS I, in the Bibliothèque de l'Institut de France. Two pocket-size notebooks bound together: I^1 (1497–1499), I^2 (1497). Note on architecture, the house of Mariolo de' Guiscardi, etc.

MS M, in the Bibliothèque de l'Institut de France. A pocket-size notebook, probably begun around 1495 but added to considerably in 1499–1500. A few notes on architecture (resistance of beams), and the record of Bramante's drawbridge on fol. 53 v.

Madrid MS I, in the Biblioteca Nacional, Madrid (MS 8937). A collection of technological studies developed from notes in MSS H, I, M, and the Codex Atlanticus, with an earlier section (1490–1493) of notes on mechanics, statics, geometry, etc. To the compilation of 1497–1499 Leonardo added a few notes well after 1500, possibly around 1508.

1497–1502 (and 1504)

MS L, in the Bibliothèque de l'Institut de France. A pocket-size notebook with a few notes dating from 1497–1498, and the remainder from about 1500 and, above all, 1502 (architecture and fortifications pertaining to the Borgia period). Some of the fortification drawings possibly later, 1504 (Piombino period).

1503–1505

MS $K^{1,2}$, in the Bibliothèque de l'Institut de France. Two pocket-size notebooks dating from the time of the *Battle of Anghiari*, bound together with a third notebook dating from 1506–1507 (see below). Geometry, water, flight of birds, etc., some notes possibly earlier, 1502–1503.

Codex on the Flight of Birds, in the Biblioteca Reale, Turin. Dated March and April 1505. Drawing of a villa on the rear cover, inside, probably a study for the House of Charles d'Amboise in Milan (after 1506).

Madrid MS II, in the Biblioteca Nacional, Madrid (MS 8936). Two (or possibly three) notebooks of the same format as the Codex on the Flight of Birds, which dates from the time of the *Battle of Anghiari* and the canalization of the Arno River. Fortification studies at Piombino (October–November 1504). At the end is a manuscript of 1491–1493 on the casting of the Sforza horse. A note dated June 6, 1505, refers to work on the *Battle of Anghiari*.

Forster MS I^1, in the Victoria and Albert Museum, London. Notebook on stereometry dated July 12, 1505. Bound together with a notebook of 1487–1490 (I^2).

APPENDIX C

1506–1507

MS K³, in the Bibliothèque de l'Institut de France. A pocket-size notebook bound together with two notebooks of 1504–1505 (K¹, ²). Geometry, anatomy, water, canalization (with references to Lombardy), optics, architecture (Charles d'Amboise period, with a reference to the conduit built by Fra Giocondo in the garden of the Castle of Blois). A reference to Cassano on the Adda River (fol. 99 v) has been related to a visit of Louis XII in 1509.

Codex Leicester, in the library of Lord Leicester at Holkham Hall. A large-size compilation of notes on water, hydraulics, and cosmology. A later date, closer to 1509, is sometimes suggested.

1508–1509

MS F, in the Bibliothèque de l'Institut de France. Dated 1508. This is the first of a series of notebooks of an intermediate size, i.e., between the pocket-size and the regular book size. (Bibliographically an in-16mo size, which is in fact between the 24mo of the pocket-size book and the 8vo of the regular-size book.) Such notebooks have (or had) consistently 96 folios (twelve signatures of eight folios each). Other manuscripts of the same category are G (1510–1511, 1515), E (1513–1514), and the lost *Libro A* (1508–1510, or later).

MS F contains notes on water, cosmology, light and shade, optics, etc. No architectural studies, but references to Alberti and Vitruvius.

MS D, in the Bibliothèque de l'Institut de France. A notebook on optics and the eye, apparently compiled between 1508 and 1509 from notes in MSS K³ and F, and from folios in the Codex Atlanticus and at Windsor.

1510–1511

MS G, in the Bibliothèque de l'Institut de France. A notebook of the same format as F (see under 1508–1509). Notes on painting (plants and landscape) for the greater part in red chalk. Anatomy, water, geometry, etc. It was resumed in 1515 in Rome (see below).

1513–1514

MS E, in the Bibliothèque de l'Institut de France (designated in the sixteenth century as *Libro B*). A notebook of the same format as F and G. Notes on painting, light and shade, water, hydraulics, anatomy, geometry, mechanics, etc. Records of Leonardo's journey to Rome, September 24, 1513, and of his visit to Parma. September 25, 1514.

146

1515

Notes in MS G (see 1510–1511 above) pertaining to technological work in the Vatican, the last in notebook form. Also notes on mechanics and geometry and, on the inside of the front cover, the dated record: "Il Magnifico Giuliano de' Medici set out on the ninth day of January 1515 at daybreak from Rome, to go and marry a wife in Savoy. And on that day came the news of the death of the King of France."[8]

8. MacCurdy. *Dated Notes*. Louis XII died on the first of January 1515.

ILLUSTRATIONS

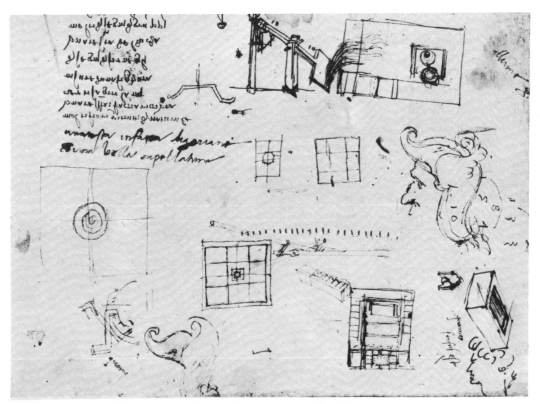

1. Ground plans of a palace. Codex Atlanticus 324 r (detail), ca. 1482.

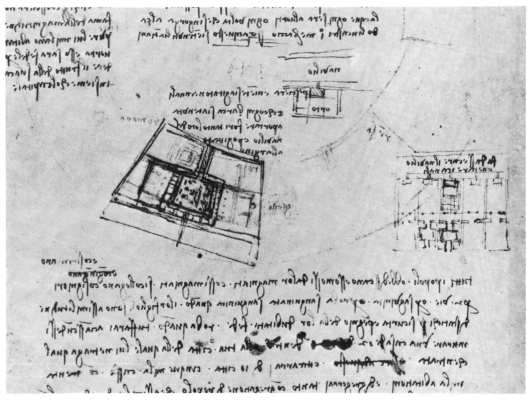

2. Plan of the projected enlargement of Milan. Codex Atlanticus 65 v–b (detail), ca. 1493.

3. Scale drawing of the plan of a palace. Codex Atlanticus 80 r-a, ca. 1487.

4. Sheet of pictographs and scale drawing of the plan of a palace. Windsor, Royal Library, no. 12692 v, ca. 1487.

5. Plans of a palace in Milan, probably for Mariolo de' Guiscardi. Codex Atlanticus 158 r-a, ca. 1497.

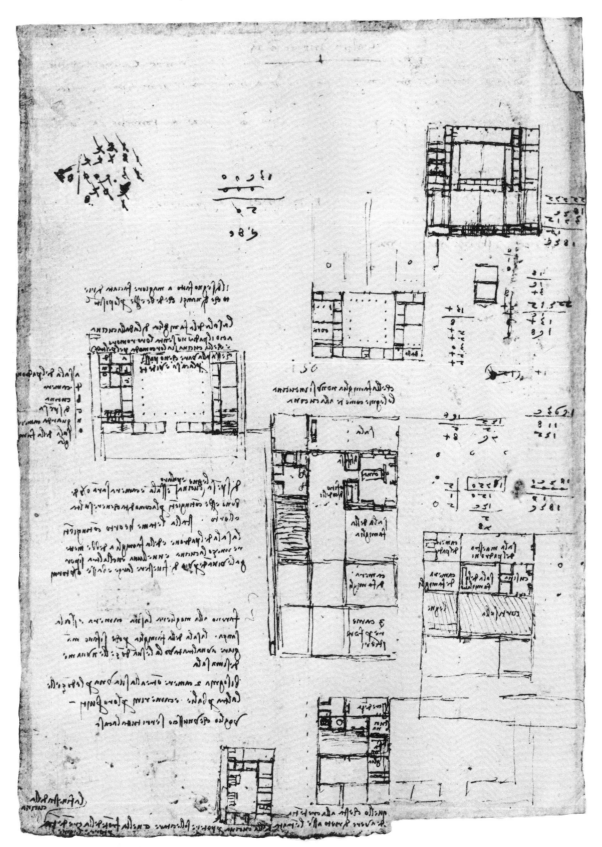

6. Verso of fig. 5. Codex Atlanticus 158 v–a.

7. Two plans of a palace with garden. Codex Atlanticus 393 r-a (detail), ca. 1497.

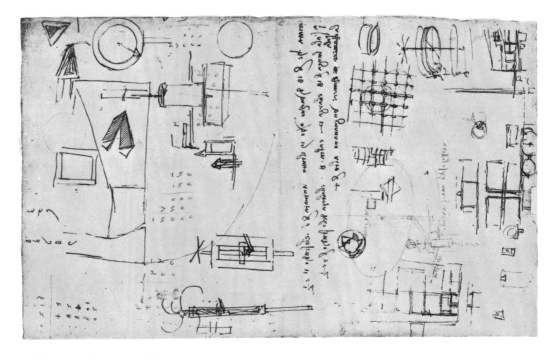

8. Urban replanning of the area of the Porta Vercellina, Milan. Codex Atlanticus 377 v-a, ca. 1497.

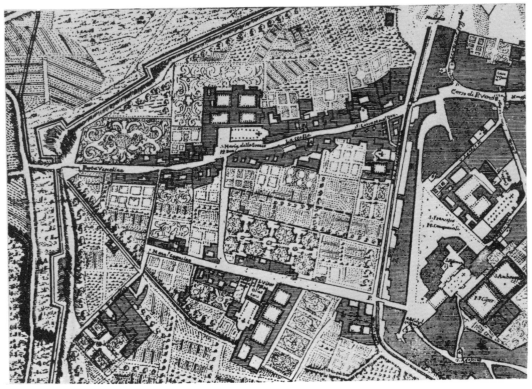

9. Detail of an eighteenth-century map of Milan, showing the area of the Porta Vercellina.

10. Detail of fig. 8.

12. Plan and elevation of a palace. MS I, fol. 56 r, ca. 1497.

11. Plan of a palace. MS I, fol. 18 v, ca. 1497.

14. Study of a window. MS I, fol. 52 v, ca. 1497.

13. Detail of an entrance portico. MS I, fol. 56 v, ca. 1497.

15. Study of a country house. Codex Atlanticus 220 r-c, ca. 1507 (?).

16. Studies of a system of stairs for a country house. Codex Atlanticus 220 v–b, ca. 1507 (?).

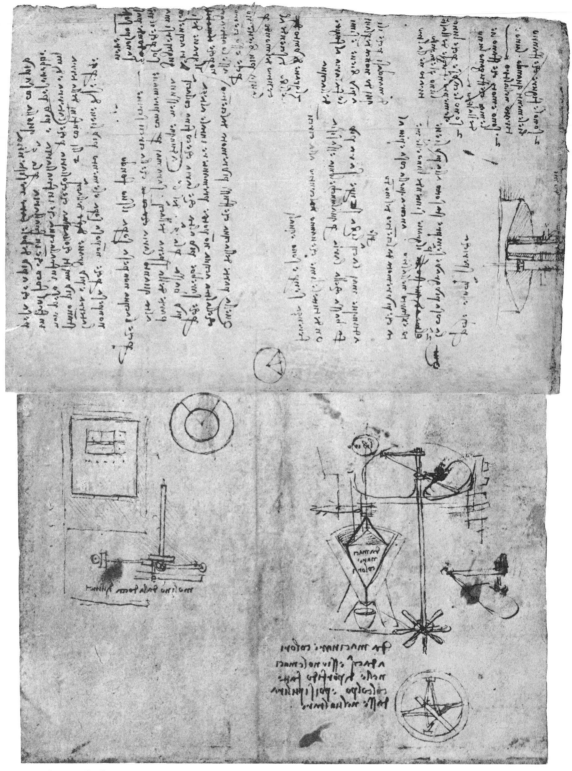

17. Ground plan of a country house and notes on mills, including the note on the "Mill of the Doccia at Vinci." Codex Atlanticus 282 r–b, v–c, ca. 1507 (?).

18. Bird's-eye view of Vinci and notes on waterwheels. Verso of fig. 17. Codex Atlanticus 282 v-b, r-c.

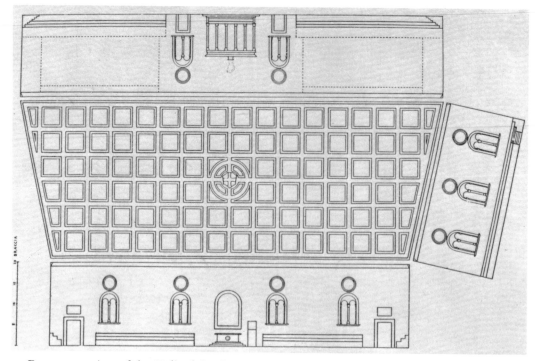

19. Reconstruction of the Hall of the Great Council, Florence (before 1512).

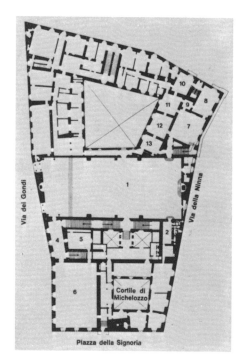

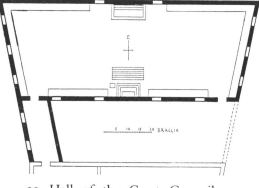

20. Hall of the Great Council, Florence. Ground plan.

21. Palazzo Vecchio, Florence. Ground plan of the first floor: (1) Salone dei Cinquecento (2) Studiolo di Francesco I (3) Tesoretto (4) Ricetto (5) Sala dei Signori Otto (6) Salone dei Dugento (7–13) New Medici quarters.

22. Fra Bartolomeo. Unfinished altarpiece for the Council Hall, 1510. Florence, Museo di S. Marco.

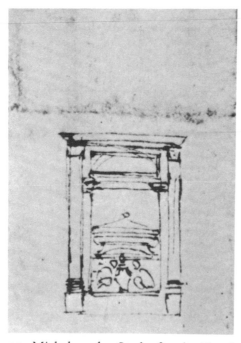

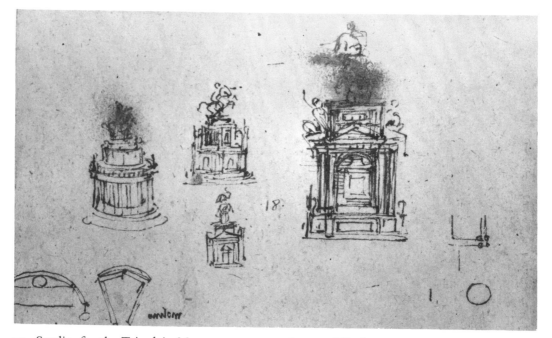

23. Michelangelo. Study for the Tomb of Pier Soderini, ca. 1518. Florence, Casa Buonarroti, no. 114 A (detail).

24. Study for the Trivulzio Monument, ca. 1506–1508. Windsor, Royal Library, no. 12355 (detail).

25. Studies for the Trivulzio Monument, ca. 1506–1508. Windsor, Royal Library, no. 12353 (detail).

26. Studies for an altar or a chapel, ca. 1508. Codex Atlanticus 264 r-a (detail).

27. Topographical sketch of the pier of Piombino, 1504. MS L, fols. 80 v–81 r.

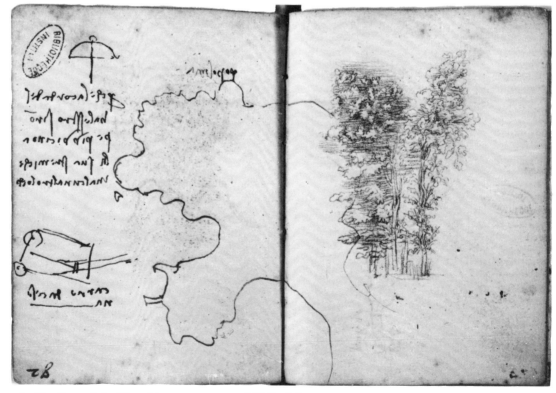

28. Outline of the Piombino coast, 1504. MS L, fols. 81 v–82 r.

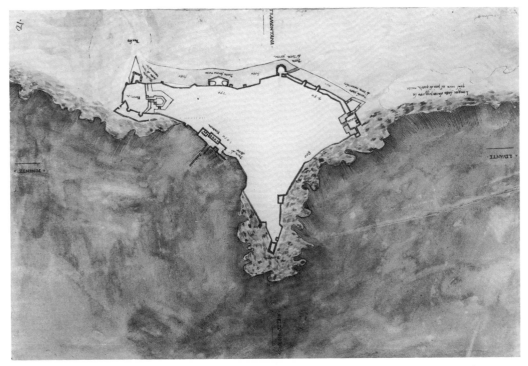

29. Francesco de' Marchi. Map of the fortifications of Piombino, ca. 1580. Florence, Biblioteca Nazionale, Cod. Magl. II. I. 280, fol. 21.

30. Eighteenth-century map of Piombino. Piombino, Municipal Library.

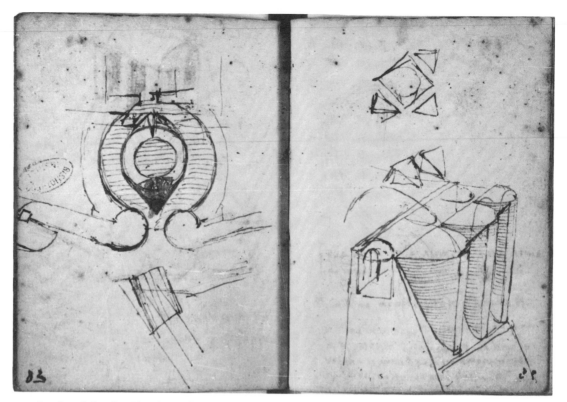

31. Study of the fortification of a city gate, perhaps for Piombino, 1504. MS L, fol. 50 r.

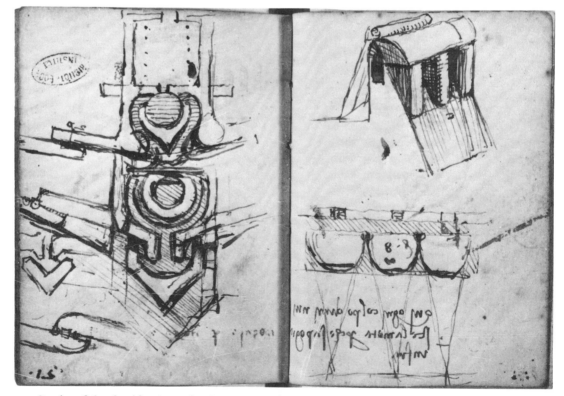

32. Study of the fortification of a city gate, perhaps for Piombino, 1504. MS L, fol. 51 r.

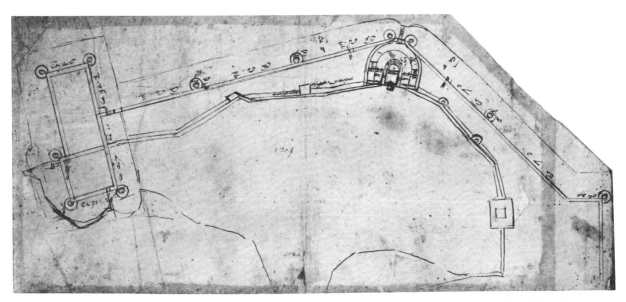

33. Antonio da Sangallo the Elder (?). Plan of the fortifications of Piombino, ca. 1504. Codex Atlanticus 41 r.

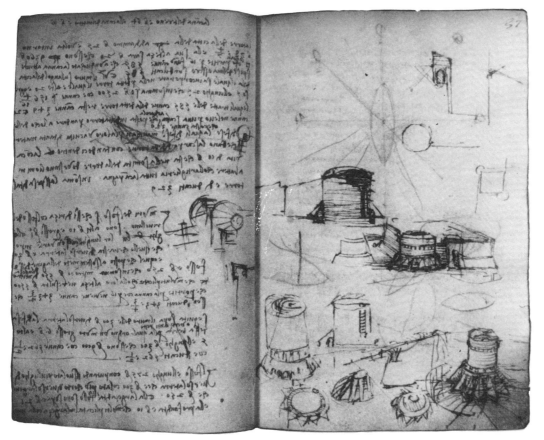

34. Studies of the fortifications of Piombino, 1504. Madrid, Biblioteca Nacional, MS 8936, fols. 36 v–37 r.

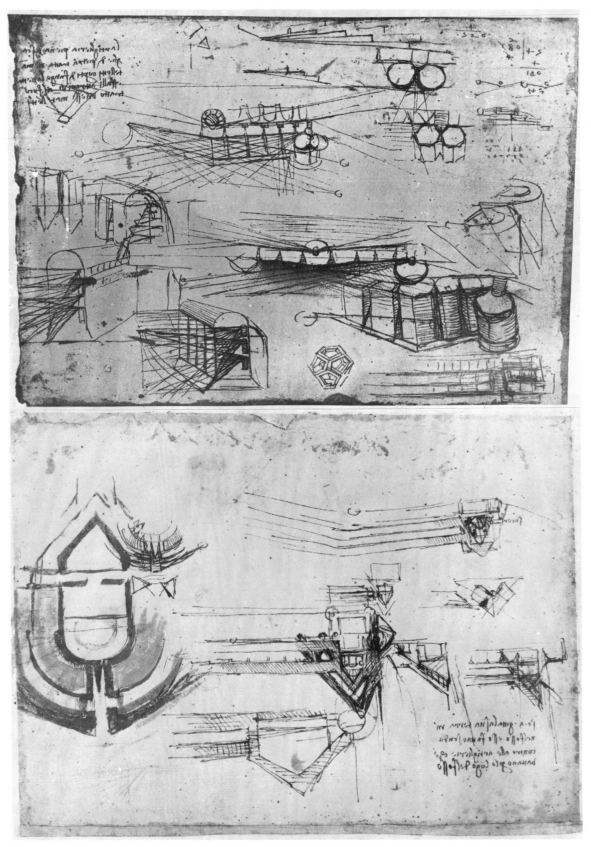

35. Studies of fortifications, probably for Piombino. A sheet recomposed with two folios of the Codex Atlanticus: 343 v-b (above) and 45 v-b (below).

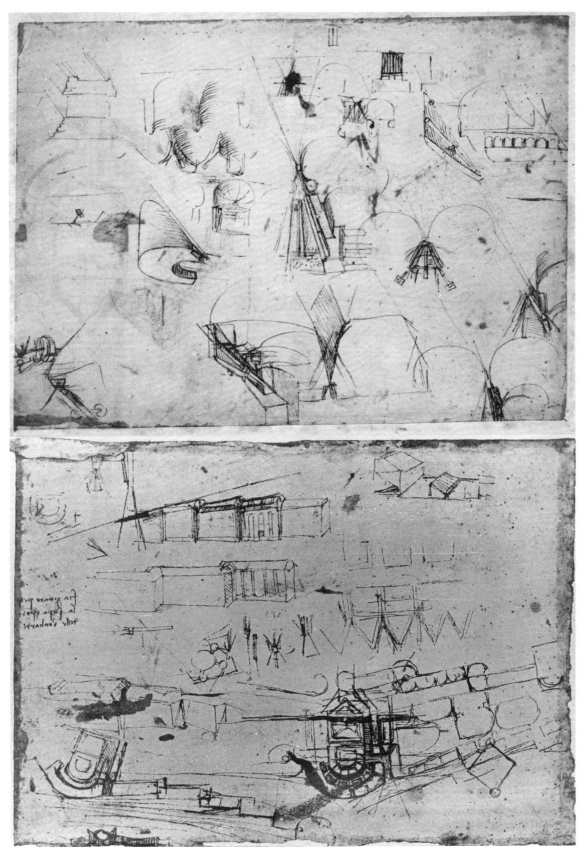

36. Verso of fig. 35. Codex Atlanticus 45 r–b (above) and 343 r–b (below).

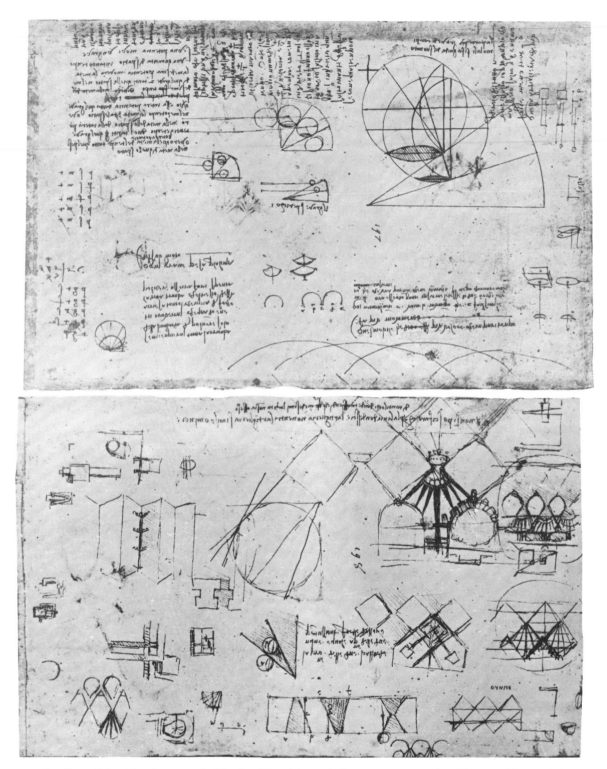

37. Studies of fortifications, probably for Piombino. A sheet recomposed with two folios of the Codex Atlanticus: 212 v-b (above) and 355 r-a (below).

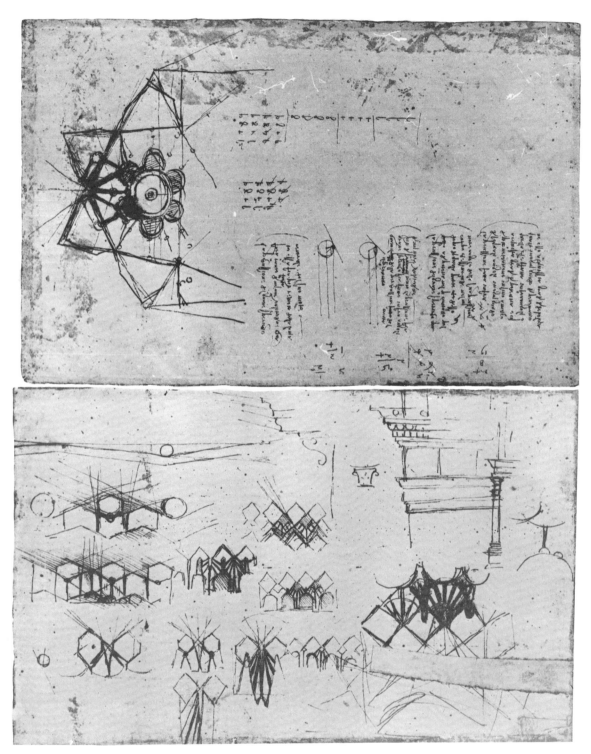

38. Verso of fig. 37. Codex Atlanticus 212 r–b (above) and 355 v–a (below).

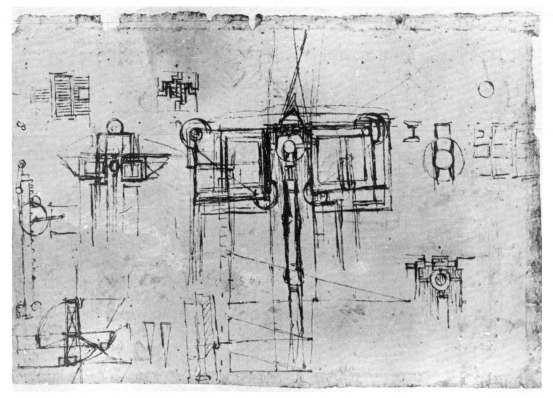

39. Studies of fortifications, probably for Piombino, ca. 1504. Codex Atlanticus 286 r–b.

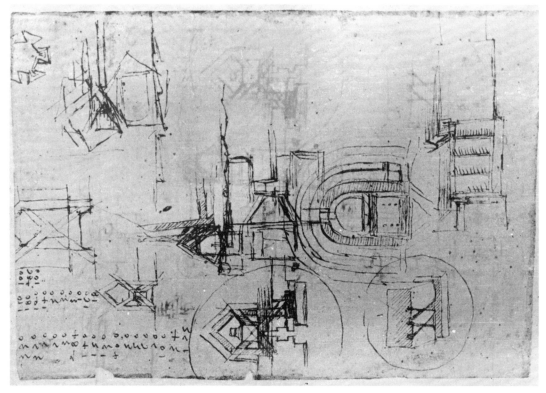

40. Studies of fortifications, probably for Piombino, ca. 1504. Codex Atlanticus 286 v–b.

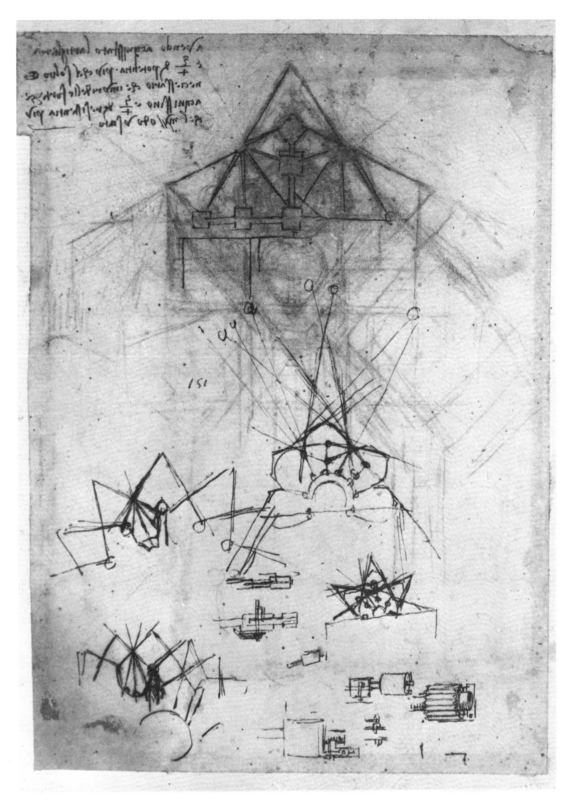

41. Studies of fortifications, probably for Piombino, ca. 1504. Codex Atlanticus 48 v-a.

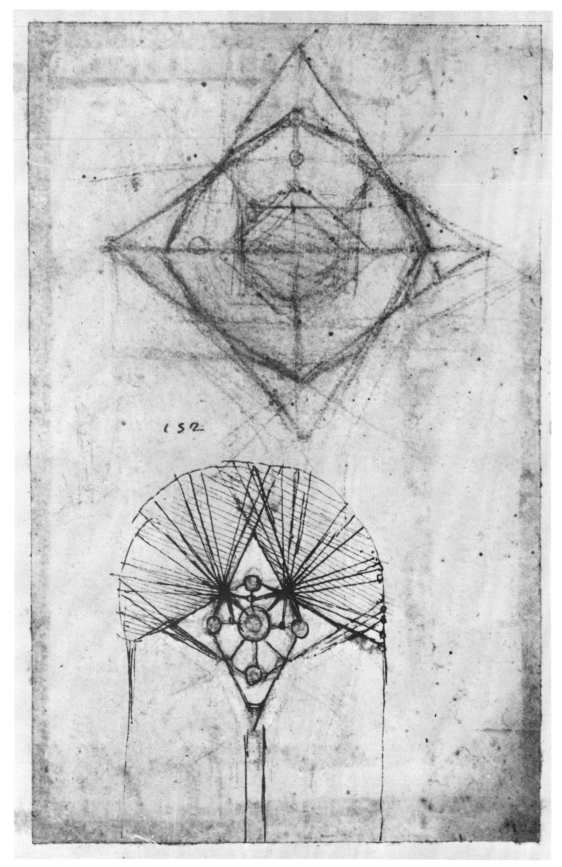

42. Studies of fortifications, probably for Piombino, ca. 1504. Codex Atlanticus 48 v-b.

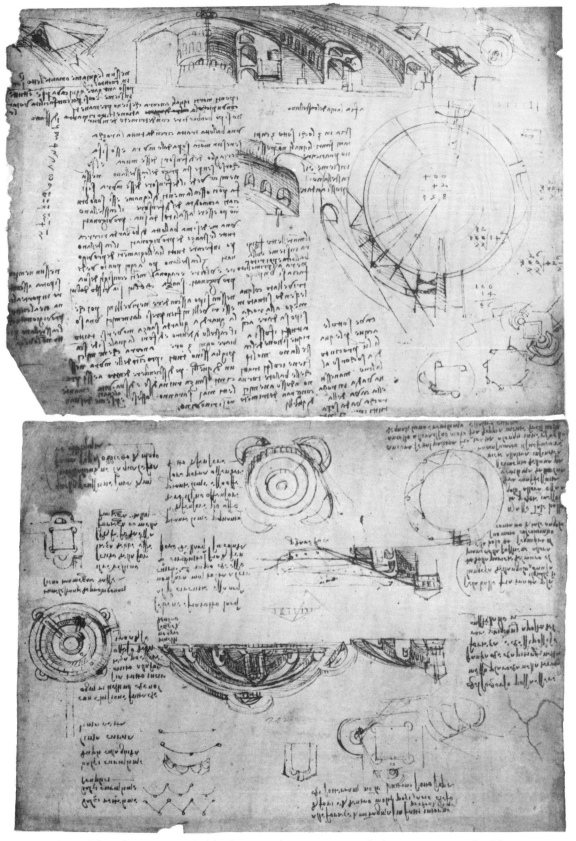

43. Studies of fortifications, probably for Piombino, ca. 1504. A sheet recomposed with two folios of the Codex Atlanticus: 48 r-a (above) and 48 r-b (below).

44. Studies of fortifications, probably for Piombino, ca. 1504. Codex Atlanticus 43 r–b.

45. Verso of fig. 44. Codex Atlanticus 43 v–b.

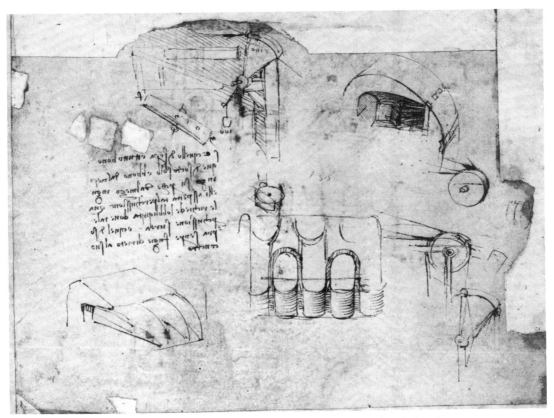

46. Studies of fortifications, probably for Piombino, ca. 1504. Codex Atlanticus 43 r-a.

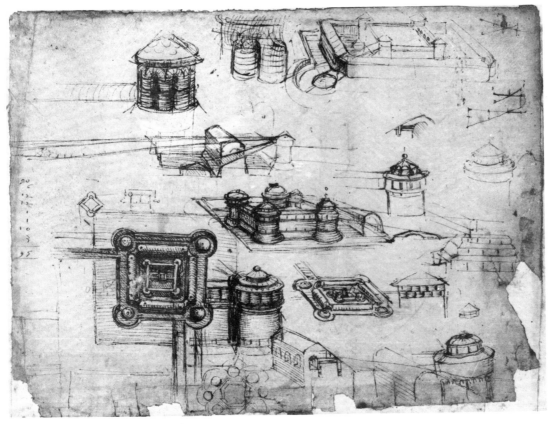

47. Verso of fig. 46. Codex Atlanticus 43 v-a.

48. Leonardo (?). Church of S. Maria alla Fontana, Milan, ca. 1507.

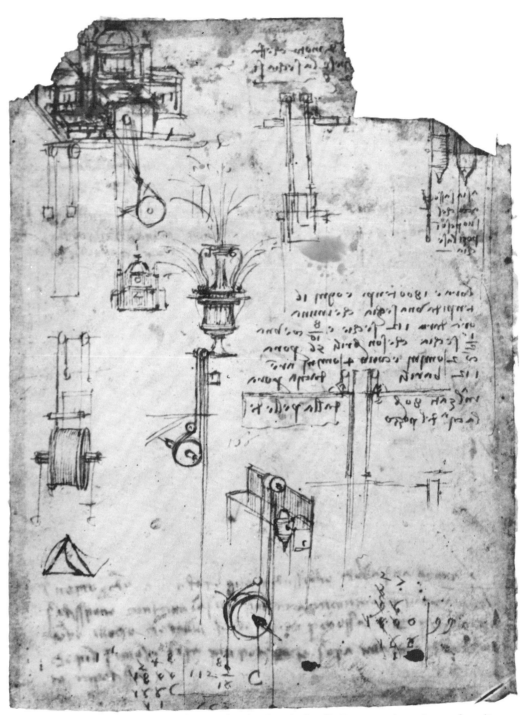

49. Sketch of a church, probably an idea for S. Maria alla Fontana, in a sheet of studies of pulleys (and, on its verso, notes on painting). Codex Atlanticus 352 r–b, ca. 1508.

50. Architectural studies for the Villa of Charles d'Amboise in Milan. Sheet recomposed with two fragments in the Codex Atlanticus: 271 v-a (description of a garden) and 231 r-b (ground plans of the house with notes to them), ca. 1506–1508.

51. Verso of fig. 50. Codex Atlanticus 231 v-a (left) and 271 r-e (right).

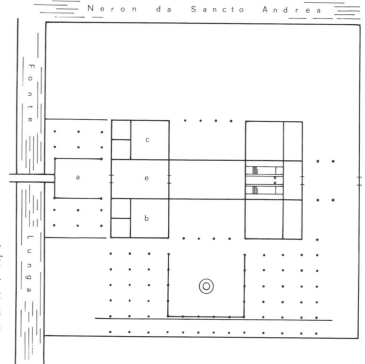

52. Detail of fig. 50.

53. Conjectural reconstruction of the general layout of the Villa of Charles d'Amboise: (a) Court of the "Great Master" (b, c) His rooms (e) His hall, which "may be wide open at its head."

Neron da Sancto Andrea

Fonte Lunga

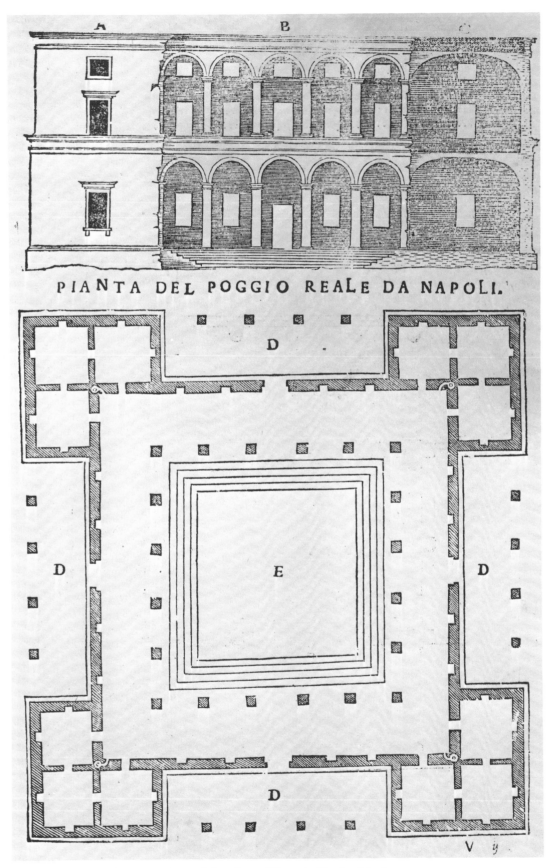

PIANTA DEL POGGIO REALE DA NAPOLI.

54. Sebastiano Serlio. Variation of the plan of Poggio Reale, Naples.

55. Sebastiano Serlio. Variation of the plan of Poggio Reale, Naples.

56. Ground plan of Poggio Reale, Naples. Rendering to scale of a drawing by Baldassare Peruzzi.

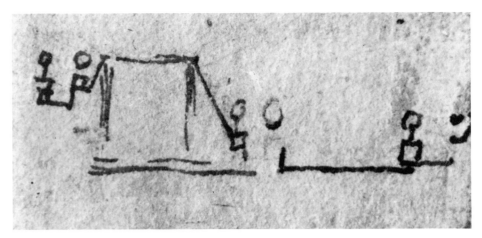

57. Detail of fig. 50.

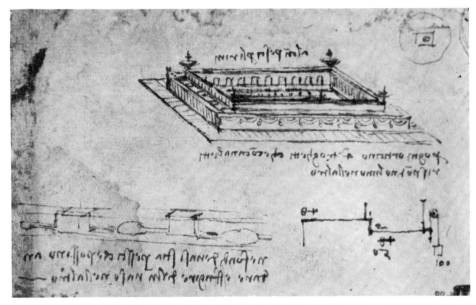

58. Drawing of a "peschiera." Codex Atlanticus 348 v-a (detail), ca. 1506–1508.

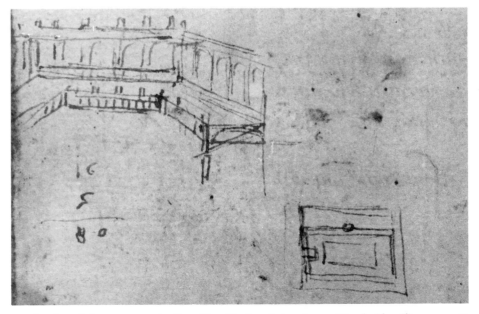

59. Study of the courtyard of a villa. Codex Atlanticus 288 r-b (detail), ca. 1508.

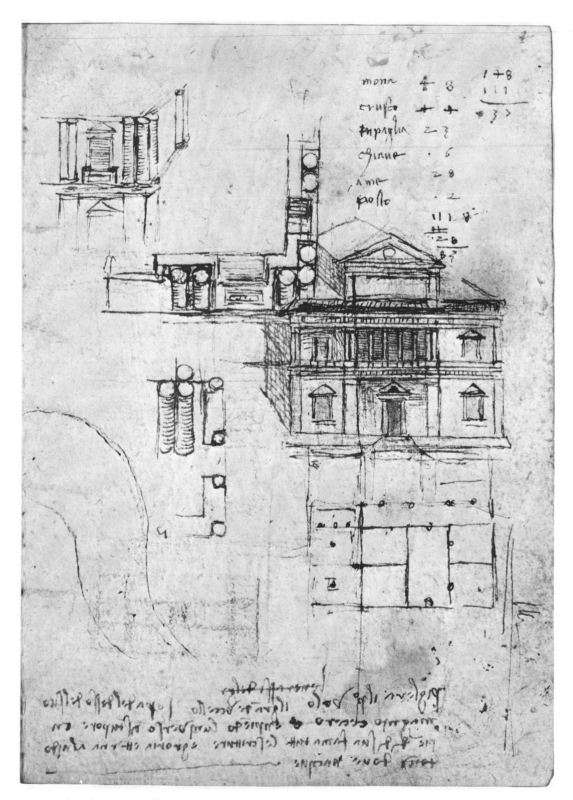

60. Study of a villa. Codex on the Flight of Birds, cover, ca. 1505–1506.

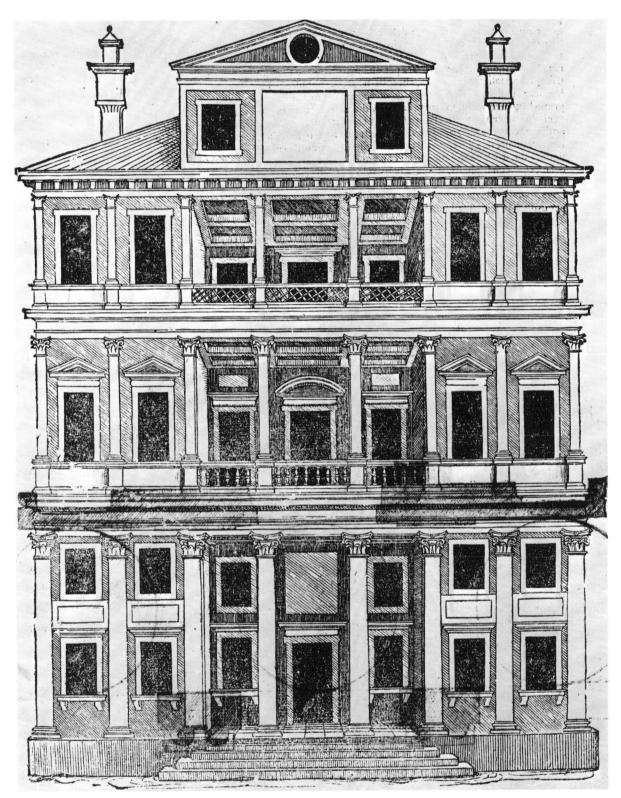

61. Sebastiano Serlio. Façade of a house "al modo di Venezia."

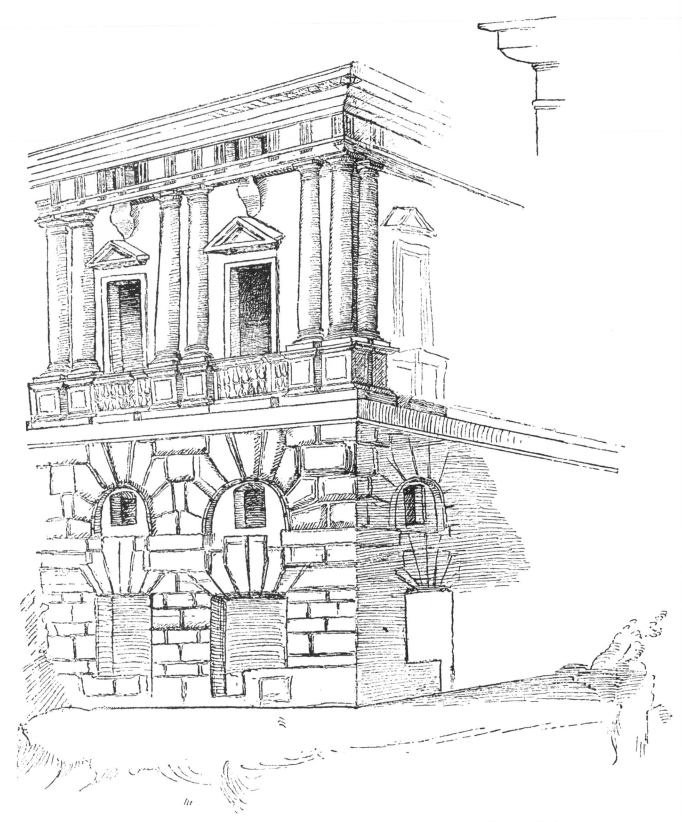

62. Palladio. Bramante's Palazzo Caprini, or "The House of Raphael" (detail). London, R.I.B.A.

63. Sketch of a palace façade. Arundel MS, fol. 160 v (detail), ca. 1506–1508.

64. Sketch of a palace façade. Codex Atlanticus 322 r-b (detail), ca. 1506.

A

E uoleuano piu presto saperlo quanti erano dheno. Ancora tutti esacerdoti po
teuano auere una donna Clli egiptij quante neuoleuano & questo faceuano psa
re assai gente & non stimauano nessuno bastardo tutti teneuano ligitimi

Et ancora dice che iloro fighuoli glinutricauano amidice derbe & aderbe & altre
cose molto uili credo cheplagrande moltitudine che erano faceuano ancora exe
ctauangli cosacerdoti & conualenti huomini amparare scientia & maxime astro
logia & arismetrica

EXPLICIT·LIBER·XX·
INCIPIT·LIBER·VIGESIMVS·PRIMVS·

INQVESTO·VIGESIMO·PIMO·LIBO

stractera daltre cose & dibagni & duna casa fatta inluo
gho pantanoso Percerto queste sono belle cose che sono i
questo libro doro & buoni ricordi & amaestramenti m
guarda unpoco seue altri edificij pche unaltra uolta in
tenderemo tutti questi hordini & modi dhedico deperto
sono boghi. Ora uediamo fece altro maisi chemipare
dhequi tutti duno casamento ilquale era muno luogho
pantanoso & aquatico malacqua era salmatra cheui
sboccaua dentro ilmare ppiu luoghi sicheplui molti ca
samenti degni insaluaticha fa mentione solo duno ilquale dice chestaua inque
sta forma era lasua misura cento braccia puno uerso & trecento pelaltro il
suo disegno & forma non hpotete uedere pcheglio disegnato qui appresso la
quale era inuno quadro dicento braccia prima doue che uenti braccia et
dicasamenti intorno intorno poi restaua uno chiostro dibraccia sessanta p
ogni uerso Perintendere bene questo casamento e mestiere chesiueggha pri
ma come staua ilcasamento ilquale secondo dequi inquesto libro e discrip
to & disegniato cosi io uinarrero & disegniato come disopra hauete inteso elle
ra trecento braccia plunghezza & cento plarghezza uno quadro dicento
braccia nera spartito inhabituri come qui sipuo uedere lemura dique
sto quadro dicento braccia erano grosse braccia due & questo pche erano
inuolta tutte ilprimo solare & dacquello insu erano uno braccio & mezzo p
fino inama. Erano questo stanze disotto & cosi disopra lerghe braccia sedici
& cosi aueuano ilmuro grosso dentro come difuori siche ueniua armanere
uno chiostro dibraccia sessanta doue che imesso sifaceua uno quadro duicti
braccia ilquale aueua lui ancora ilmuro grosso duo braccia deueniua a
rimanere disdici braccia di uacio doue cheintorno intorno acquesto gli
rimaneua spatio diuenti braccia circuncircha donde chediqueste uenti bra
ccia dispano deua intorno acquesto quadro delmezzo sonetoglie tre bra
ccia netto intorno intorno secondo ua questo spatio ditre braccia & inardi

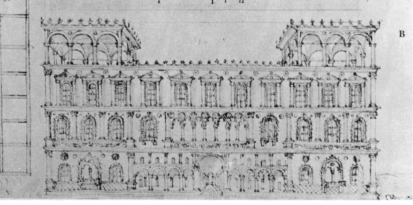

B

65. Filarete. Project for a "Palazzo in luogo palustre." Florence, Biblioteca Nazionale, Cod. Magl. K. I. 140.

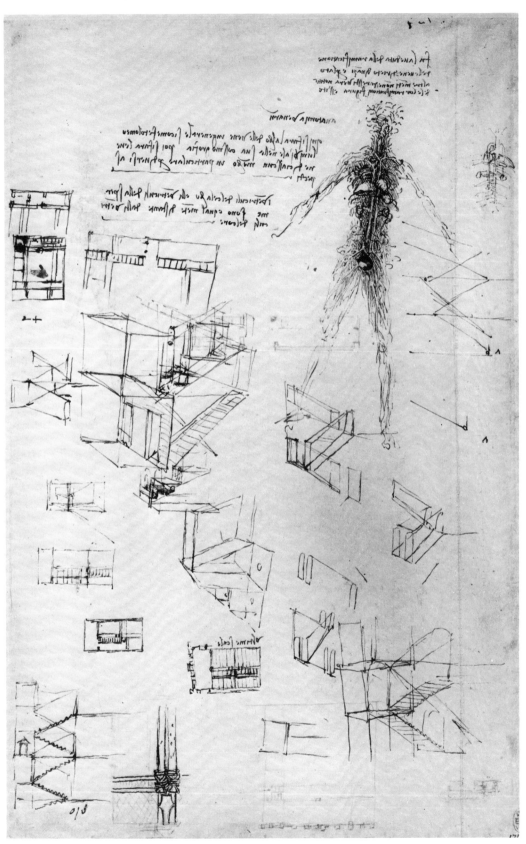

66. Studies of a system of staircases and detail of a palace façade. Windsor, Royal Library, no. 12592 r, ca. 1506–1508.

67. Studies of a drawbridge, probably for the side entrance to the Villa of Charles d'Amboise. A sheet recomposed with two folios of the Codex Atlanticus: 260 v–b (left) and 87 v–a (right), ca. 1508.

69. Sketches of ceiling decoration. Codex Atlanticus 375 r (detail), ca. 1513.

68. A masquerader. Windsor, Royal Library, no. 12576, ca. 1513–1515.

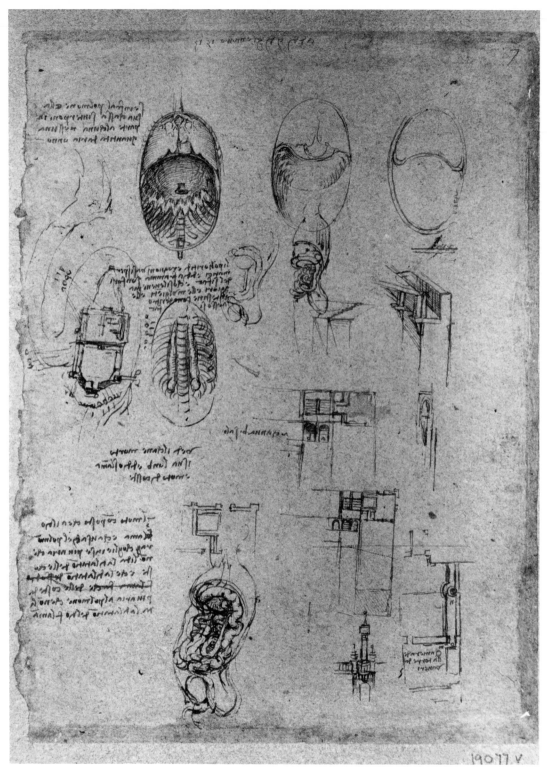

70. Studies for the enlargement of the Villa Melzi at Vaprio d'Adda. Windsor, Royal Library, no. 19077 v (C. II. 7), dated January 9, 1513.

73

71

71–73. Studies for the enlarge-
ment of the Villa Melzi at Vaprio
d'Adda, ca. 1513: (71) Codex
Atlanticus 61 r-b (72) Codex At-
lanticus 153 r-e (73) Codex At-
lanticus 153 r-d.

72

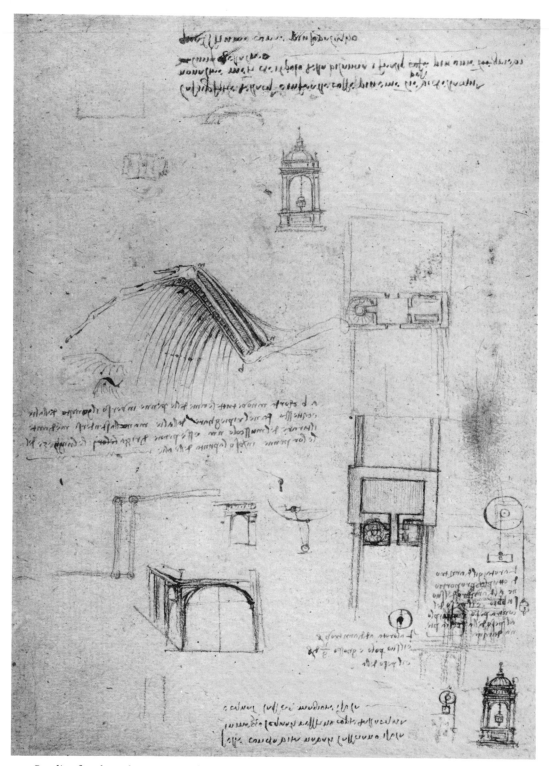

74. Studies for the enlargement of the Villa Melzi at Vaprio d'Adda, ca. 1513. Windsor, Royal Library, no. 19107 v (C. IV. 1).

76. Studies for the enlargement of the Villa Melzi at Vaprio d'Adda.
Codex Atlanticus 395 r-b, ca. 1513.

75. Detail of fig. 74 (author's
tracing).

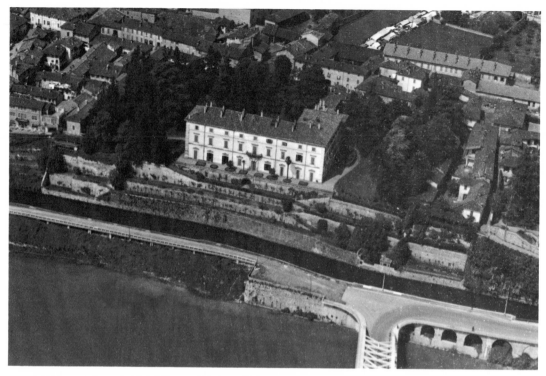

77. Air view of the Villa Melzi at Vaprio d'Adda.

78. Eighteenth-century ground plan of the Villa Melzi at Vaprio d'Adda (detail). Vaprio, Melzi Archives.

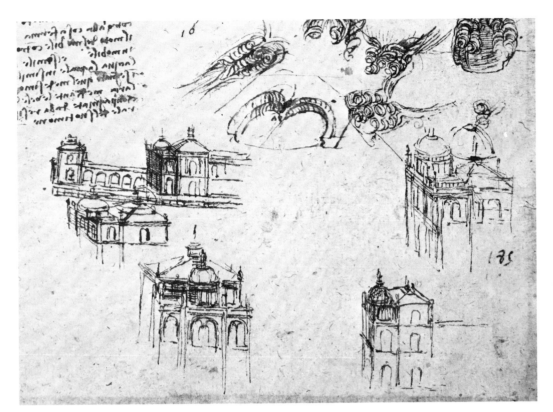

79. Detail of fig. 76.

80. Architectural studies, probably for the Villa Melzi at Vaprio d'Adda. Windsor, Royal
Library, no. 12579 v, ca. 1513.

81. Studies of scaffoldings. Codex Atlanticus 225 r-a, ca. 1514.

82. Studies of scaffoldings and other sketches. The sketches of a hand and detail of a beard are probably by Francesco Melzi. The recumbent figure after the Ariadne in the Belvedere is probably by Leonardo. Codex Atlanticus 283 r-e, ca. 1514.

83. Project for a new Medici Palace and for the replanning of the Medici quarter in Florence.
Codex Atlanticus 315 r-b, ca. 1515.

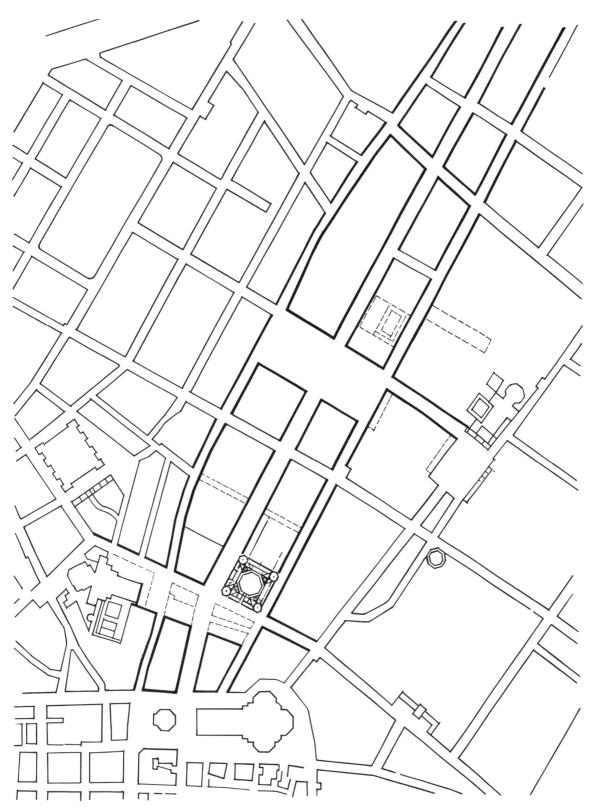

84. The Medici quarter in Florence according to Leonardo's project of replanning.

85. Sketch of the projected opening up of Piazza S. Lorenzo in a sheet of geometrical studies. Codex Atlanticus 315 r-a, ca. 1515.

86. Studies of a temporary structure for festivals. Codex Atlanticus 3 v-b, ca. 1515.

87. Studies of a wooden construction on the verso of fig. 86 (Codex Atlanticus 3 r-b).

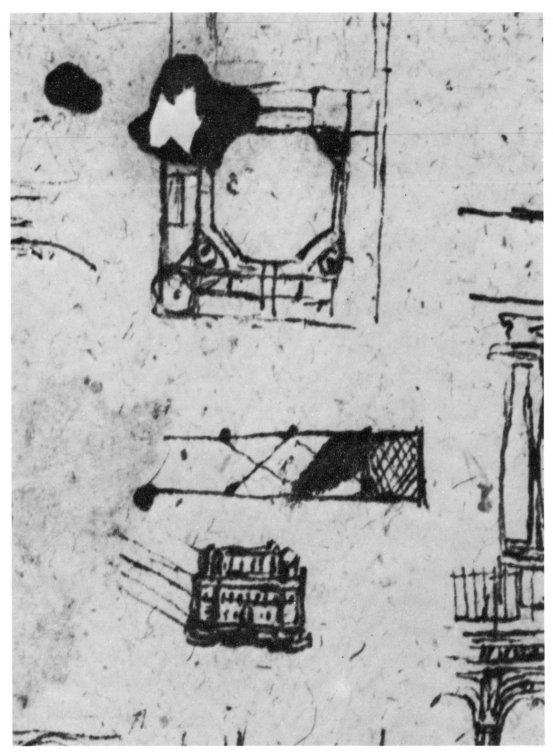

88. Detail of fig. 83.

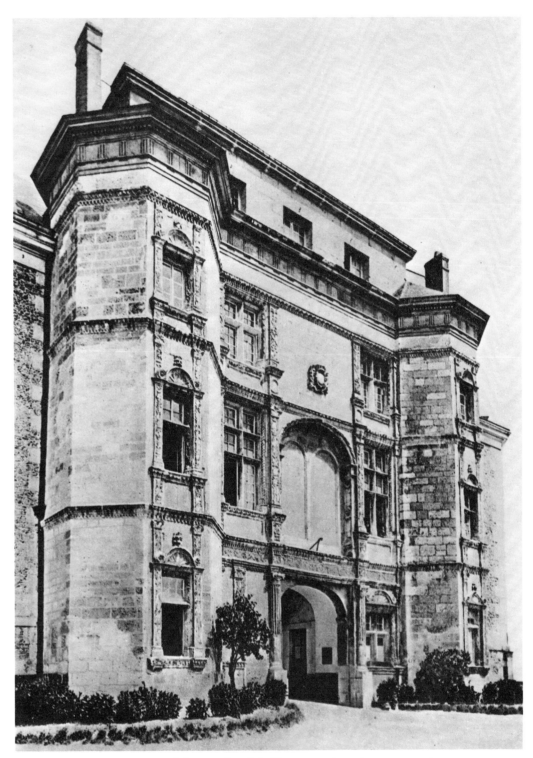

89. The entrance pavilion of the Castle of Gaillon, exterior view, ca. 1506–1510.

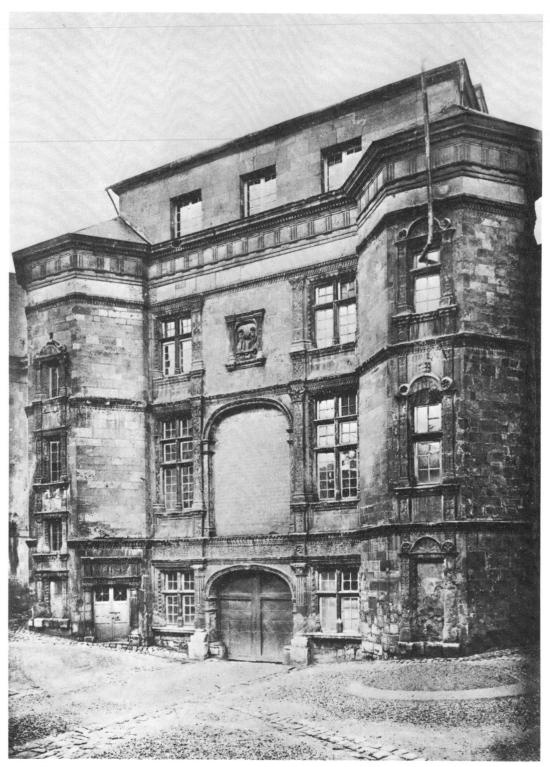

90. The entrance pavilion of the Castle of Gaillon, interior view, ca. 1506–1510.

91–92. Bramante. Portico of the Canonica of S. Ambrogio, Milan, ca. 1497.

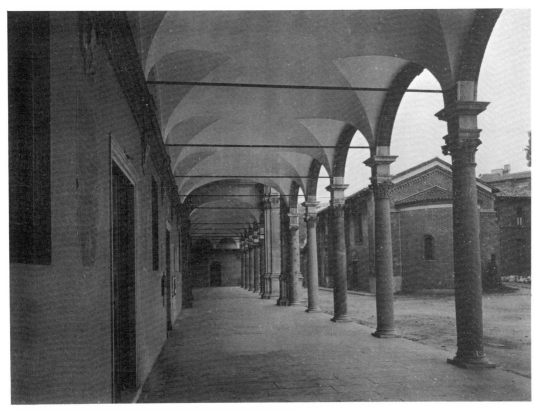

91

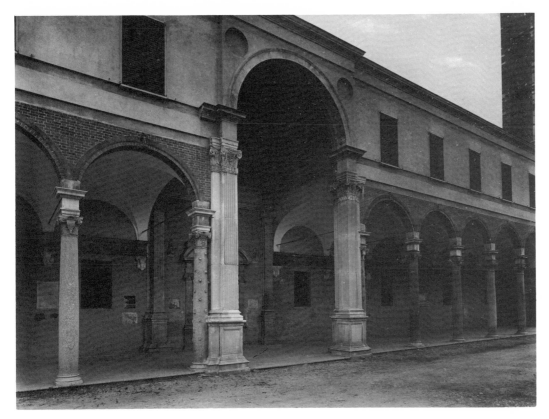

92

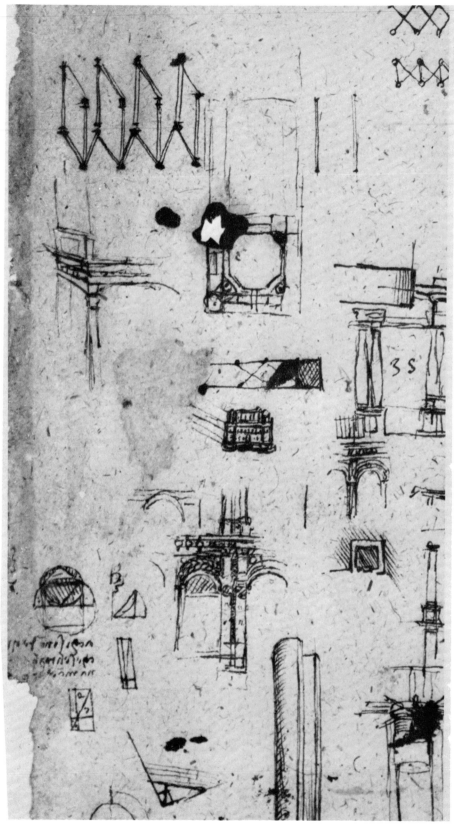

93. Detail of fig. 83.

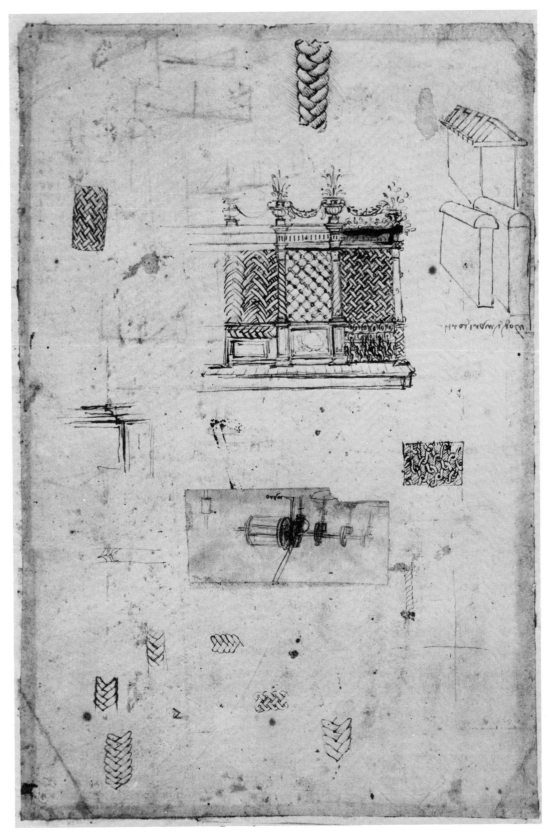

94. Studies of decoration of garden walls. Codex Atlanticus 357 v-a, ca. 1487–1490.

95. Plan and elevation of a palace with corner towers and sketch of a Neptune fountain. With notes on the project of a "Garden of Venus." Windsor, Royal Library, no. 12591 r, ca. 1506–1507.

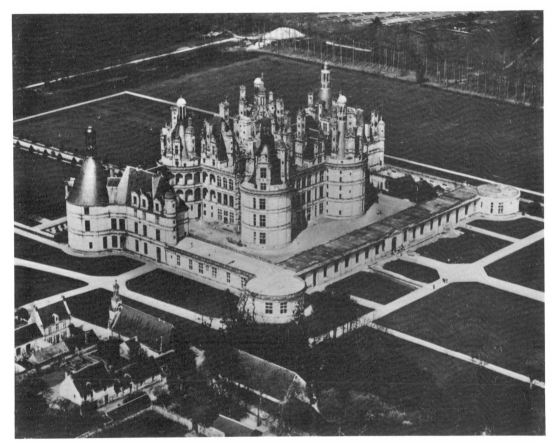

96. The Castle of Chambord.

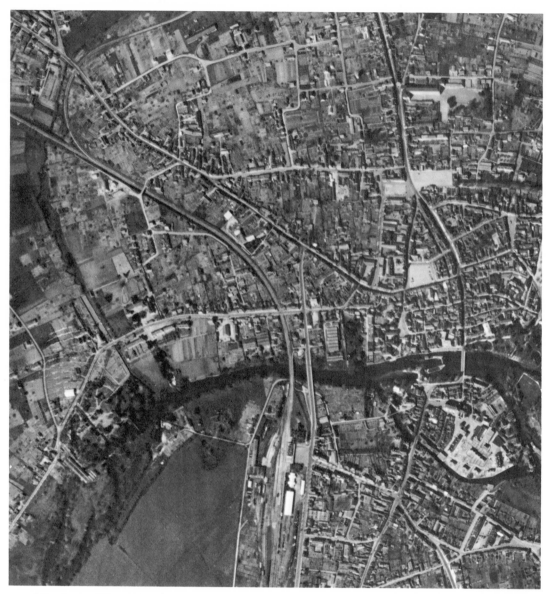

97. Air view of Romorantin.

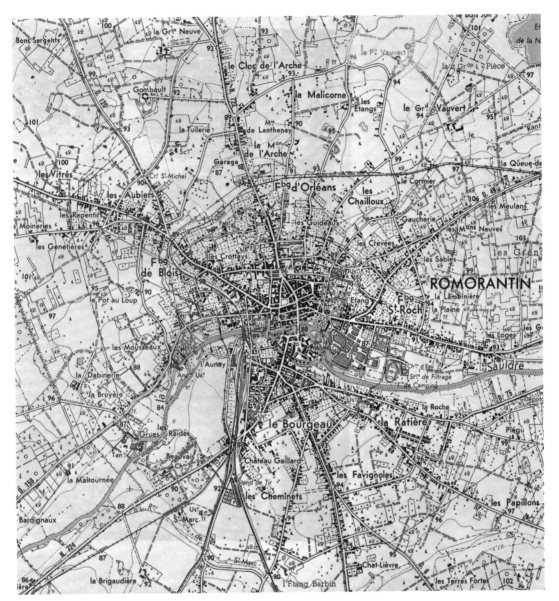

98. Topographical map of Romorantin.

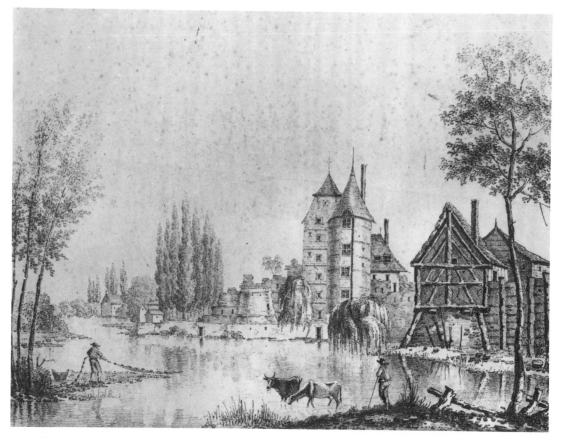

99. "Restes du Château de Romorantin." Print by Lockhart, 1822. Musée de Blois, no. 623.

100. The fifteenth-century château at Romorantin.

101. The Mousseau Manor at Romorantin.

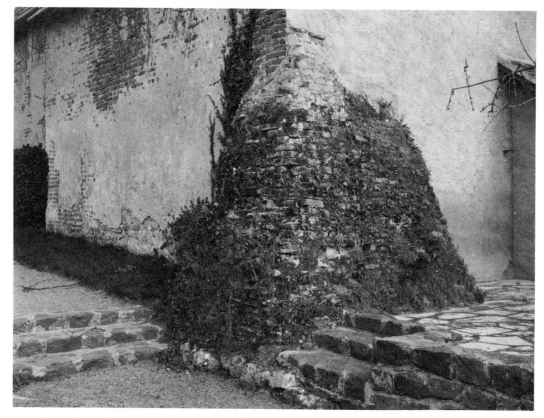

102. Remains of early sixteenth-century brickwork in the area of the Mousseau Manor. Compare fig. 110, no. 8.

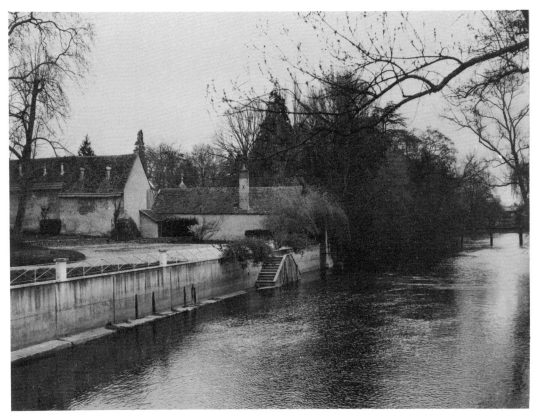

103. The Saudre River facing the Mousseau Manor.

104. The park between the Mousseau Manor and the Château of Romorantin.

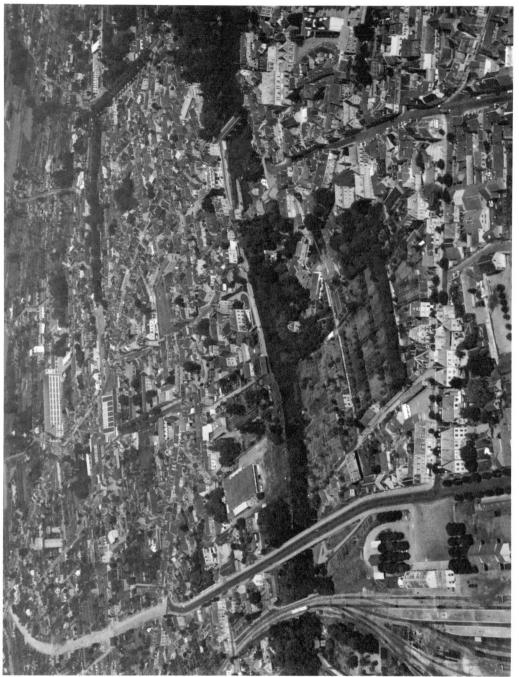

105. Air view of Romorantin: the fifteenth-century château.

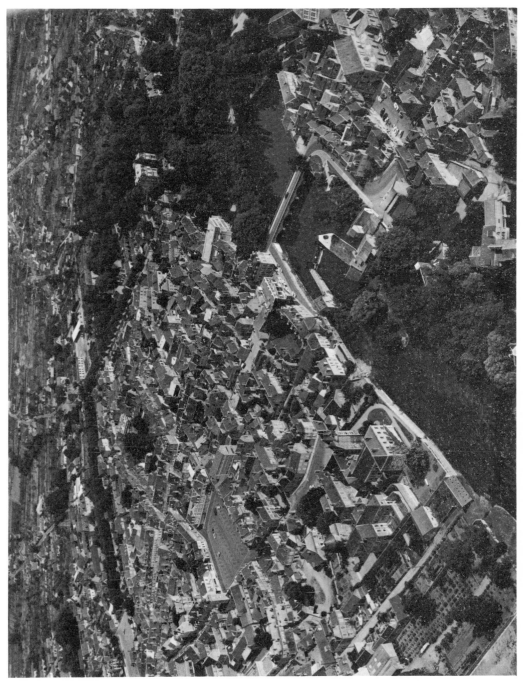

106. Air view of Romorantin : area of the "fosse aux lions" (lower left corner).

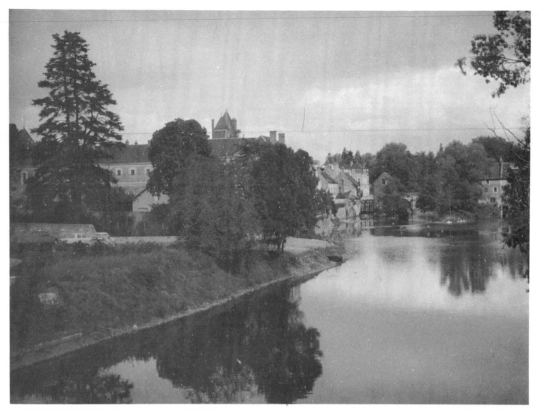

107. The right bank of the Saudre River, showing remains of the wall of the "fosse aux lions."

108. The remains of the wall of the "fosse aux lions" as seen from the château.

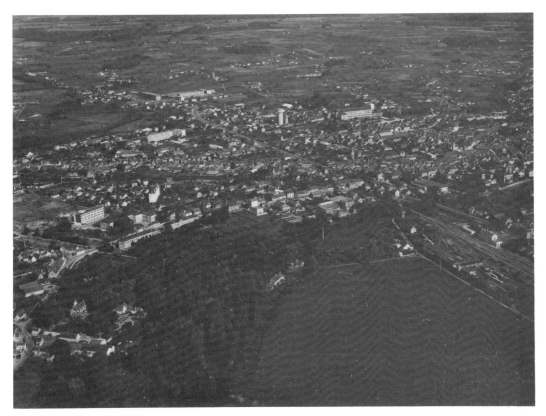

109. Air view of the fifteenth-century château at Romorantin, its park, and the Mousseau Manor.

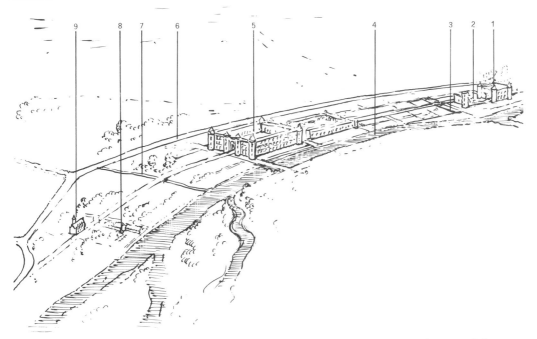

110. Author's scheme of the preceding air view, interpreted as the area of Leonardo's projected palace: (1) Château (2) Remains of its enlargement (3) "Fosse aux lions" (4) Saudre River (5) Leonardo's projected palace (6) Route to Amboise (7) Nasse Brook (8) Remains of sixteenth-century brickwork (9) Mousseau Manor.

111. Project for a royal palace at Romorantin. Codex Atlanticus 76 v-b, ca. 1517.

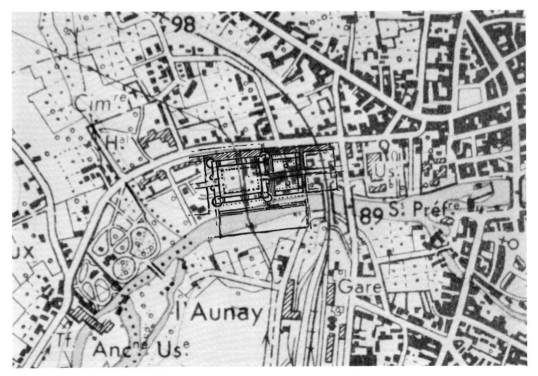

112. Detail of fig. 111.

113. Conjectural identification of the intended site for the Leonardo palace in a modern map of Romorantin.

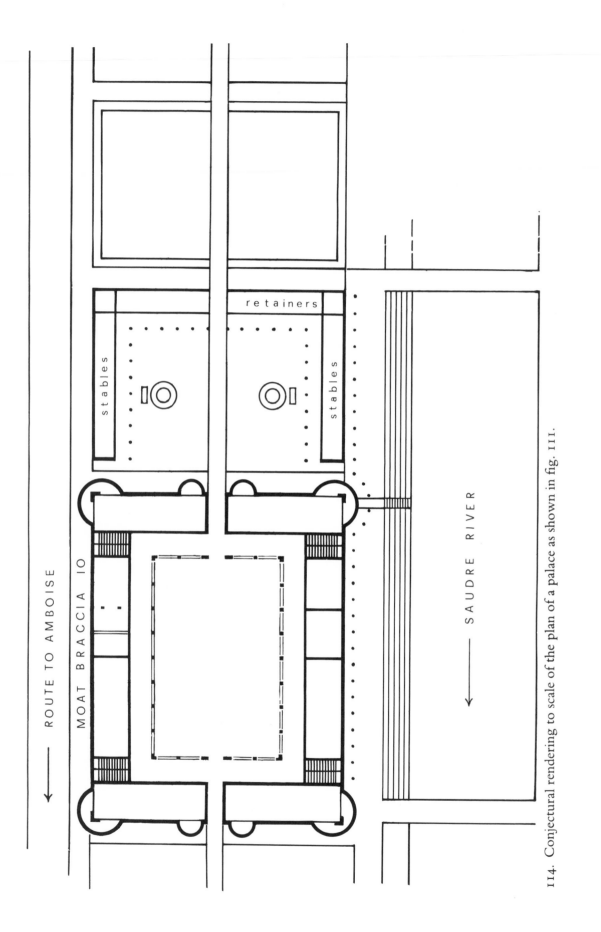

ROUTE TO AMBOISE

MOAT BRACCIA 10

stables

retainers

stables

SAUDRE RIVER

114. Conjectural rendering to scale of the plan of a palace as shown in fig. 111.

115. Studies of geometry and architectural sketches, Codex Atlanticus 106 r-b, ca. 1517.

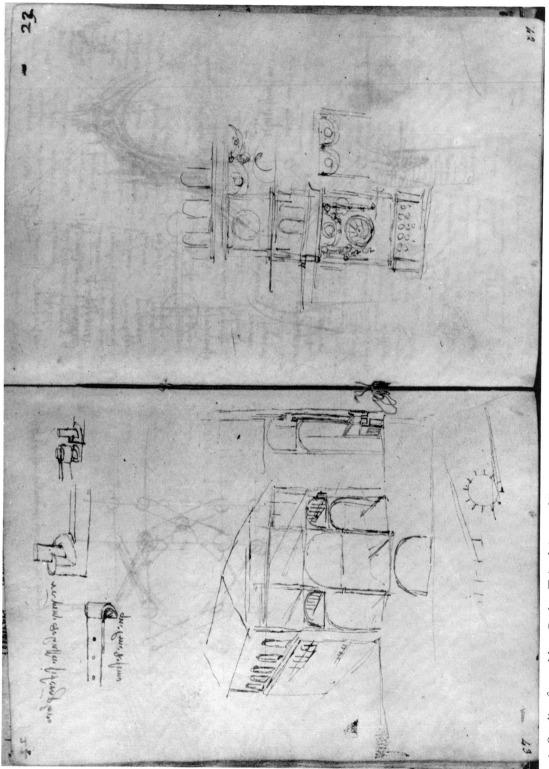

116. Studies for stables. Codex Trivulzianus, fols. 21 v–22 r, ca. 1487–1490.

117. Studies for stables. MS B, fols. 38 v–39 r, ca. 1487–1490.

118. Memoranda not by Leonardo on the "escuyerie du Roy" in a sheet of Leonardo's geometrical studies. Codex Atlanticus 174 v–c, ca. 1517–1518.

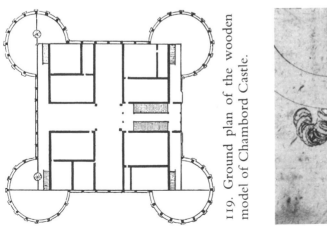

119. Ground plan of the wooden model of Chambord Castle.

120. Ground plan of a palace with corner towers. Codex Atlanticus 242 v-a (detail), ca. 1515.

121. Note not by Leonardo, "Memoria a noi mastro domenico," in a sheet of Leonardo's geometrical studies. Codex Atlanticus 174 v-a, ca. 1518.

122. Topographical studies of the Sologne region, with notes on the project of its canalization. Codex Atlanticus 336 v-b, January 1517.

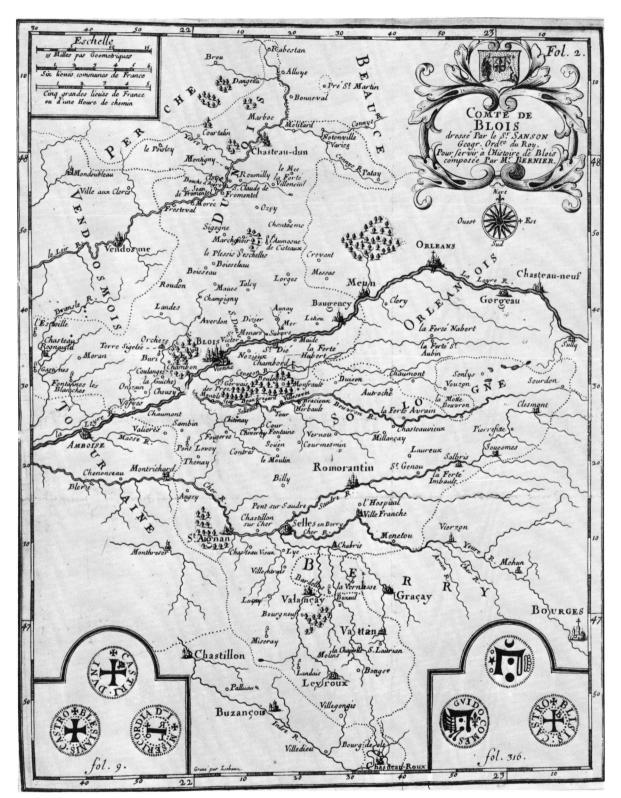

123. Map of the Sologne region from Bernier's *Histoire de Blois*, 1682.

124. Francesco Melzi. Notes on the topography of Romorantin on the verso of a sheet of Leonardo's studies for the Romorantin project (see fig. 126). Arundel MS, fols. 263 v (below) and 270 r (above), ca. 1517.

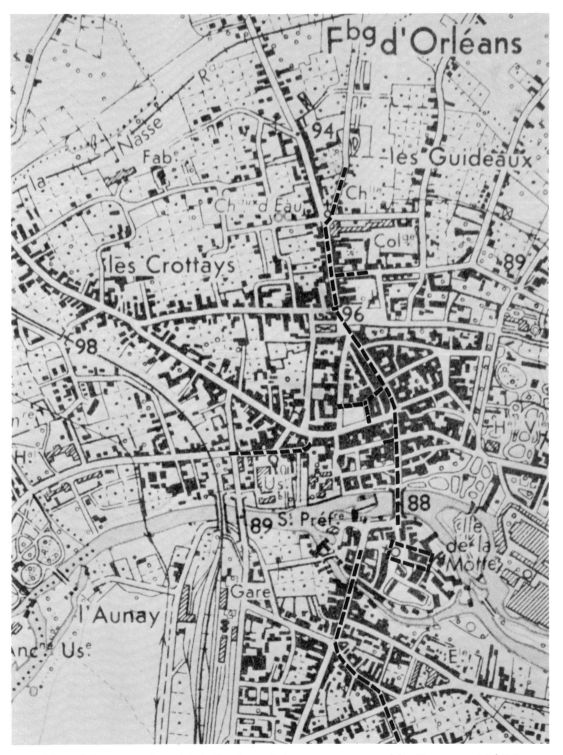

125. Map of Romorantin, with indication of the streets measured by Francesco Melzi (see fig. 124).

126. Studies for the palace at Romorantin and drawings of octagonal structures. Arundel MS, fols. 270 v (below) and 263 r (above), ca. 1517–1518.

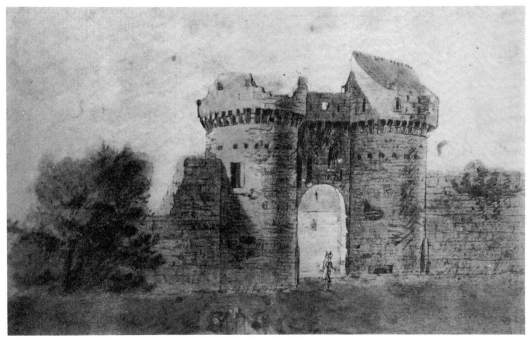

127. The "Porte d'Orléans" at Romorantin, before its demolition in 1849. Drawing in the Miscellanea Berge. Romorantin, Bibliothèque Municipale.

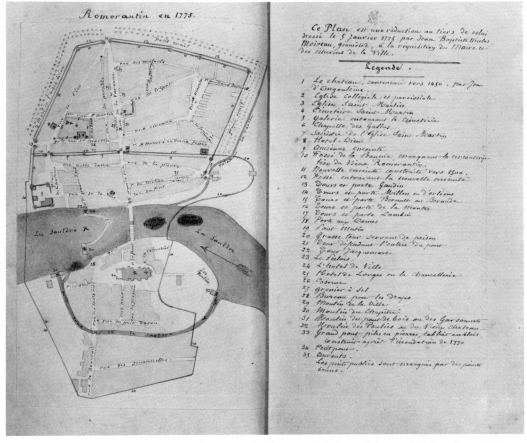

128. Map of Romorantin in 1775, showing the "Porte d'Orléans" (no. 14). Miscellanea Berge. Romorantin, Bibliothèque Municipale.

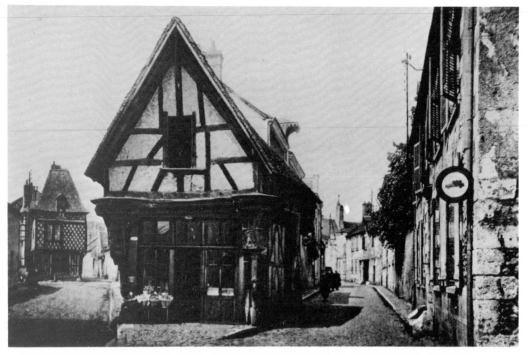

129. Wooden houses at Romorantin at the beginning of the road to Orléans (right).

130. Francesco Melzi (?). Black chalk sketch of a wooden house in a sheet of Leonardo's geometrical studies. Codex Atlanticus 163 v-a (detail), ca. 1517–1518.

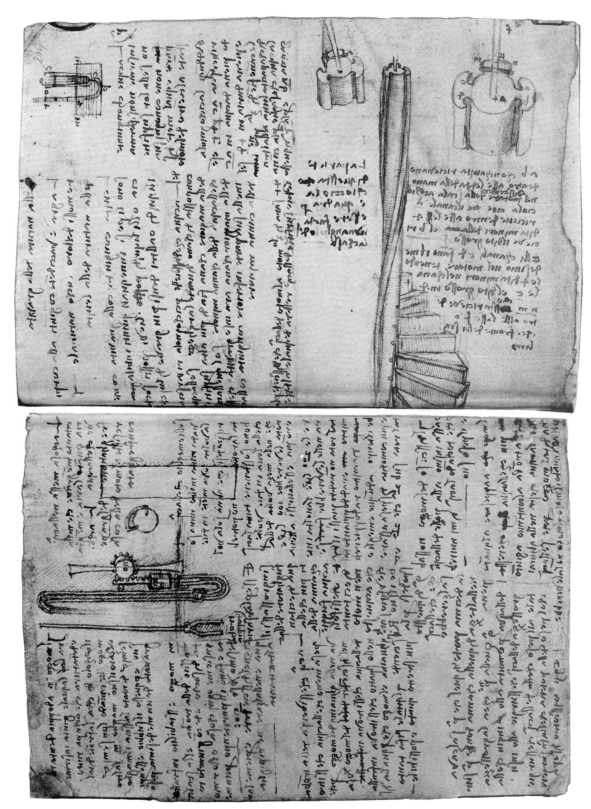

131. Studies of a wooden spiral staircase and studies for the mechanism of a fountain (compare fig. 133). Arundel MS, fols. 264 r (above) and 269 v (below), ca. 1517–1518.

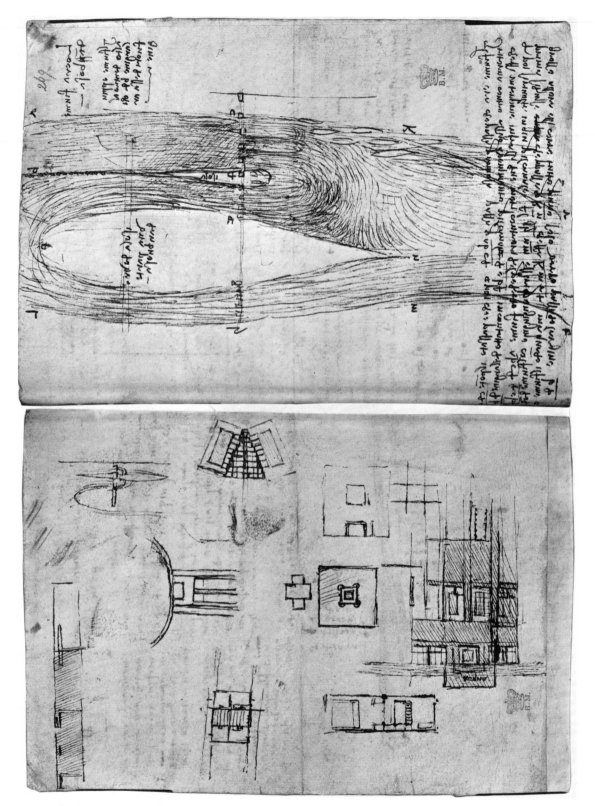

132. Architectural studies, with topographical representation of the island of Amboise. Arundel MS, fols. 269 r (above) and 264 v (below), ca. 1517–1518.

133. Studies for the mechanism of a fountain, with the note: "Amboise has a royal fountain without water." Codex Atlanticus 296 r-a, ca. 1518.

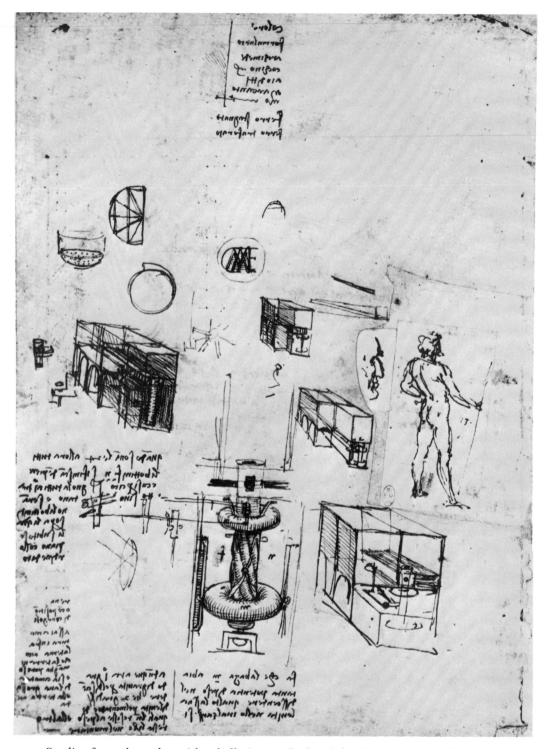

134. Studies for a clepsydra with a bell-ringer. Codex Atlanticus 20 v–b and Windsor fragments 12480 and 12718, ca. 1508–1509.

135. Studies for the mechanism of a bell-ringer in a clepsydra. Windsor, Royal Library, nos. 12688 and 12716, ca. 1508–1509.

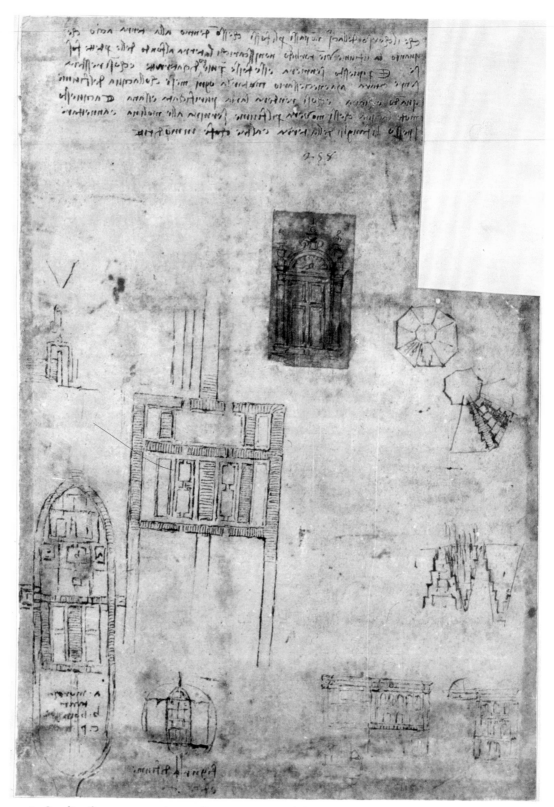

136. Studies for a new section at Romorantin and details of the elevation of the royal palace. Codex Atlanticus 217 v-b, ca. 1517–1518.

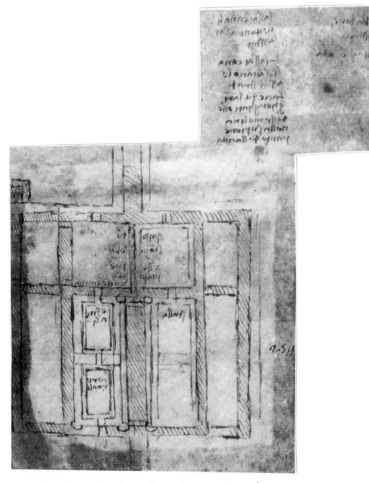

137. Studies of twin palaces in a projected new section at Romorantin. Codex Atlanticus 217 v-c, ca. 1517–1518.

138. Medal of Bramante's Palazzo dei Tribunali.

La pporhous de lati della corda os sustiene il peso nel suo angulo, nó fia equale alla proportione de pesi os sus tengono essi lati della corda.

139. Architectural studies, probably for the palace at Romorantin. Codex Atlanticus 294 v-b, ca. 1517.

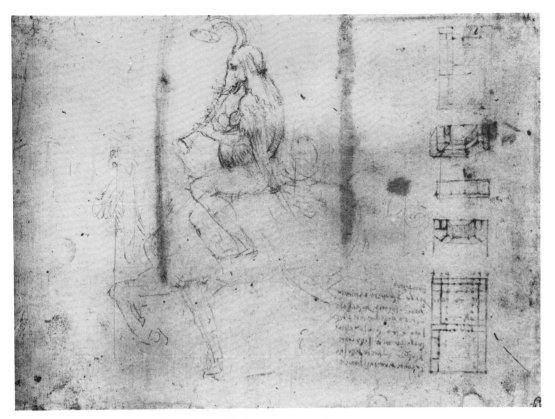

140. A masquerader. Windsor, Royal Library, no. 12585 r, ca. 1508–1510.

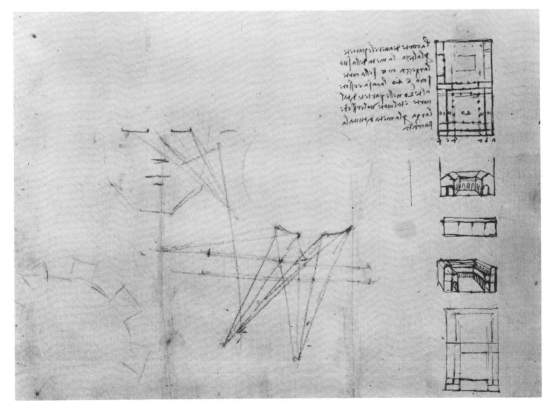

141. Studies of optics and the proportions of the court of a palace. Verso of fig. 140.

142. Study of a horse's foreleg. Windsor, Royal Library, no. 12292 r, ca. 1508–1511.

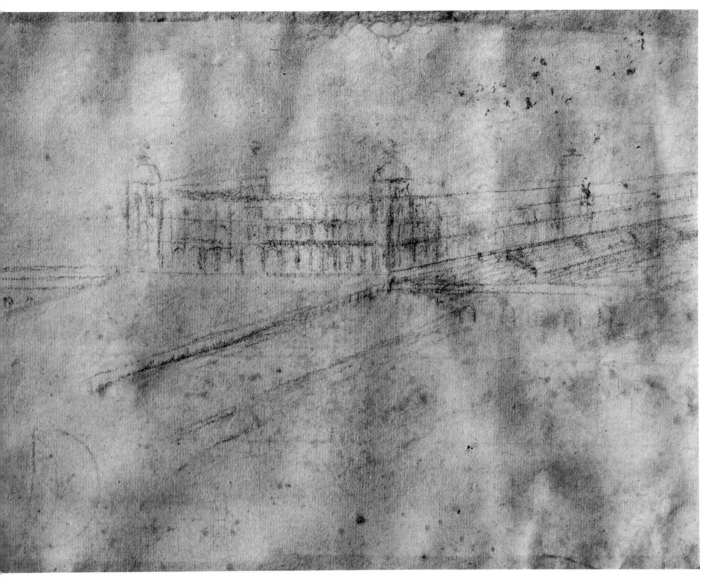

43. Bird's-eye view of a palace on an island in a river. Verso of fig. 142.

144. Geometrical studies and a topographical note on the location of the Arva River in Savoy. Codex Atlanticus 87 v-b, ca. 1508–1509.

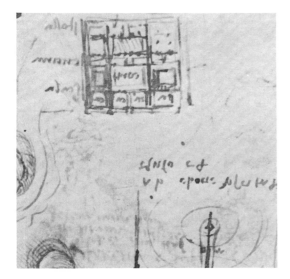

145. Study of a palace with corner towers. MS K, vol. III, fol. 116 v, ca. 1507.

146. Note to a diagram of the water conduit built by Fra Giocondo in the garden of the Castle of Blois. MS K, vol. III, fol. 20 r, ca. 1507.

147. Plan of a palace, Windsor, Royal Library, no. 19106 v (detail), ca. 1510. The ground plan is inscribed with references to the stables, kitchens, stairs, court, rooms, and hall: "stalla / cucina / scala / corte / camera [three times as 'ca'] / sala [as 'sa']."

148. Study of the system of canals in an oblong city. Windsor, Royal Library, no. 12641 v (detail), ca. 1508.

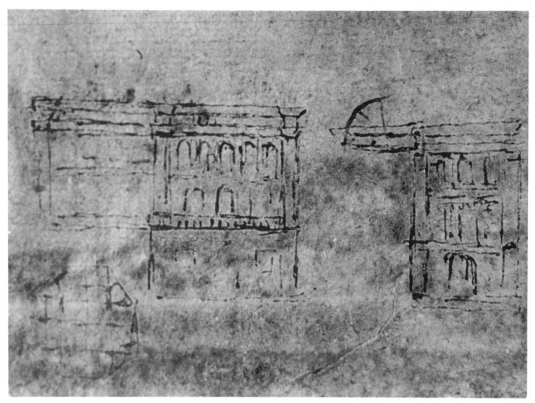

149. Study of the façade of the palace at Romorantin. Codex Atlanticus 217 v-b (detail of fig. 136).

150. Antonio da Sangallo the Elder. Palazzo Tarugi, Montepulciano, ca. 1530.

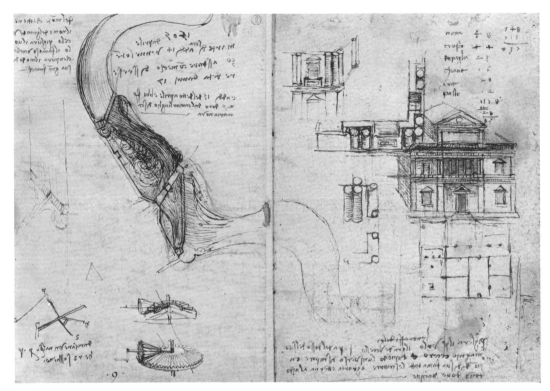

151. Study of a villa. Codex on the Flight of Birds, ca. 1505–1506.

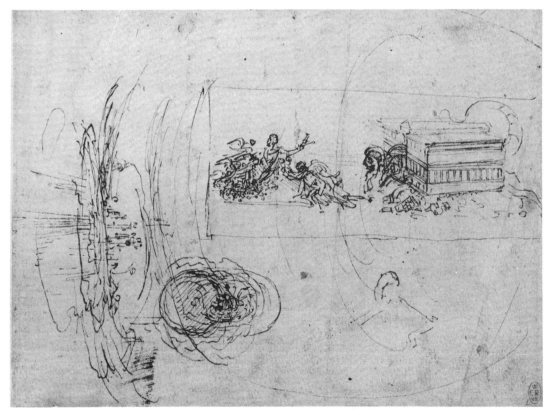

152. Allegory. Windsor, Royal Library, no. 12497, ca. 1508–1509.

153. Studies for the palace at Romorantin. Arundel MS, fol. 270 v (compare fig. 126).

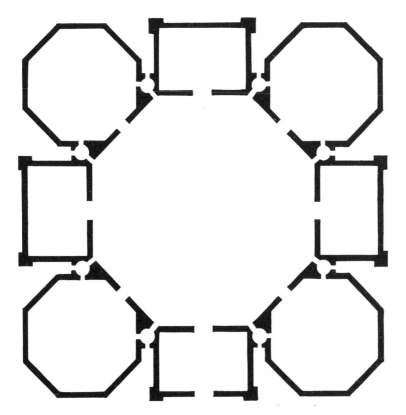

154. Author's interpretation of the ground plan of the centralized building shown in fig. 153.

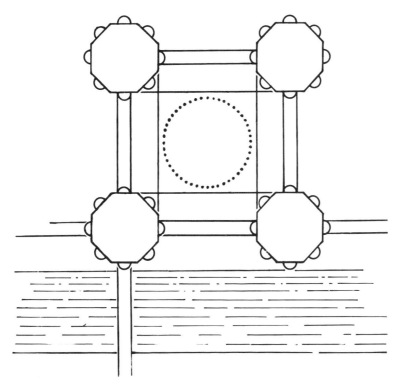

155. Author's interpretation of the ground plan of a castle sketched in Codex Atlanticus 106 r-b (fig. 115).

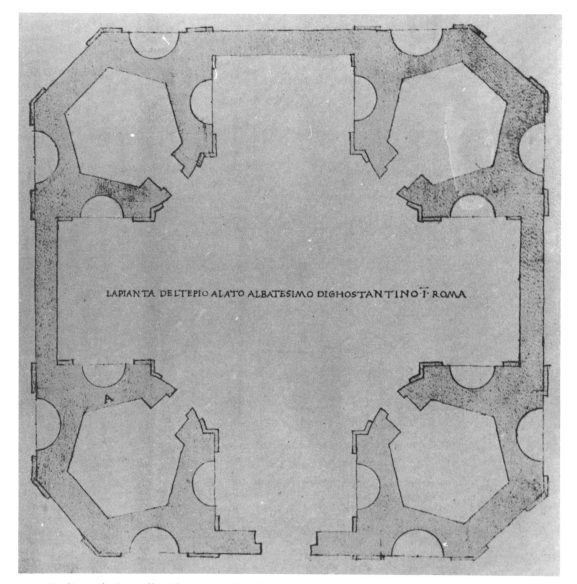

LAPIANTA DEL TEPIO ALATO ALBATESIMO DIGHOSTANTINO I ROMA

156. Giuliano da Sangallo. Plan of the Baptistery in S. Giovanni Laterano. Vatican Library, Codex Barberinus, fol. 30 v.

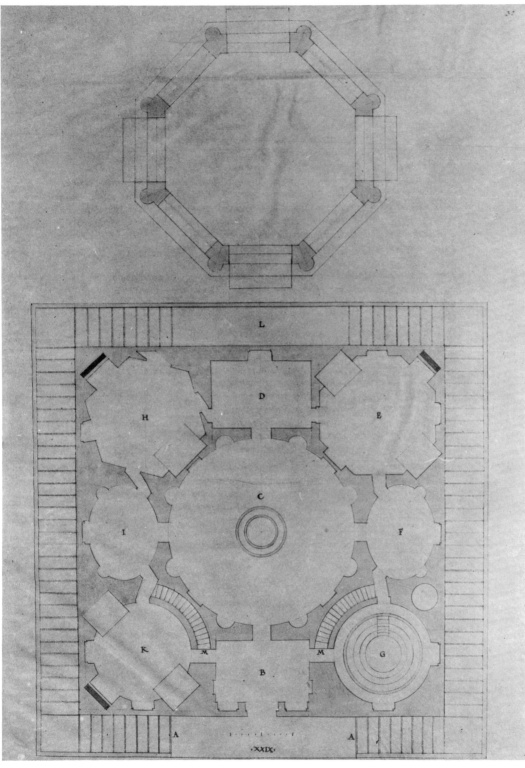

157

157–158. Sebastiano Serlio. Project for a bath pavilion in the garden of the castle at Fontaine-
bleau. *Libro sesto*, fols. 32 r and 33 r.

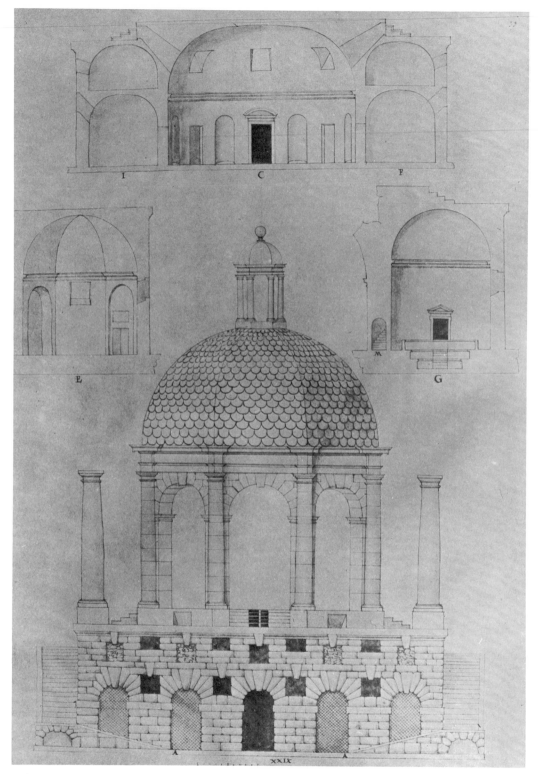

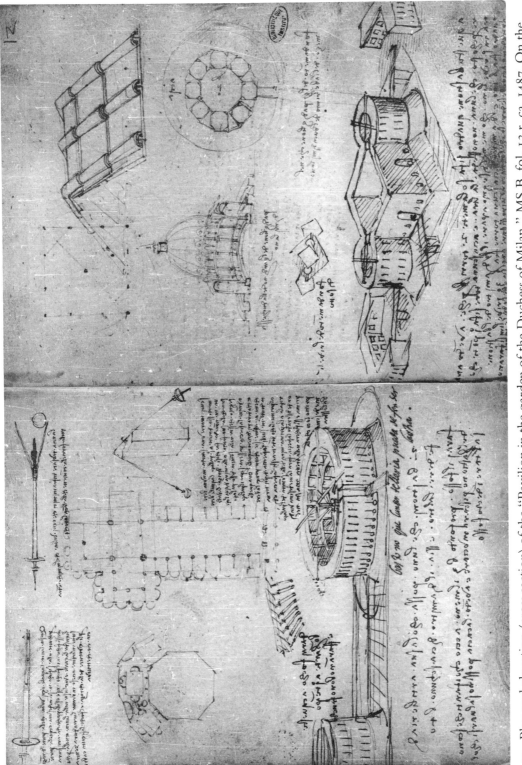

159. Plan and elevation (cross section) of the "Pavilion in the garden of the Duchess of Milan." MS B, fol. 12 r, ca. 1487. On the facing page (fol. 11 v), ground plans of S. Maria degli Angioli and S. Spirito in Florence.

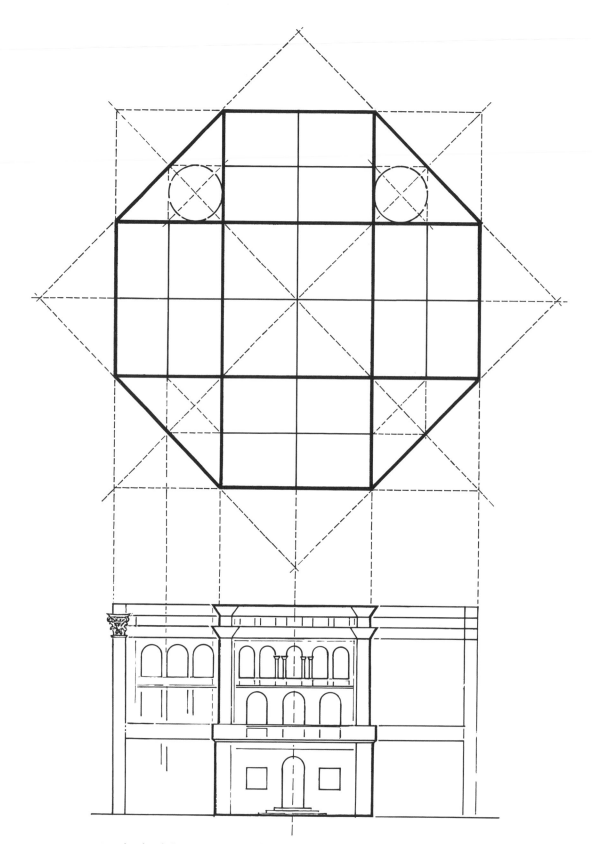

160. Author's interpretation of plan and elevation of the building shown
in fig. 149.

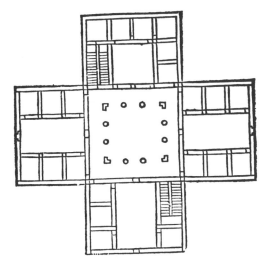

Che ne i palaʒʒi , o caʃamenti ʃi può procedere fuor delle figure rettangule ,
& come dalla pianta paʃʃata ʃi poʃʃa fare il palaʒʒo ottangulo ,
con le ʃue particolari miʃure . Cap. X I.

OTRASSI ancor procedere ne i caʃamenti, o palazzi fuor delle figure rettangule, facendo il palazzo eʃagono, ottangulo, & di piu anguli & lati, di uarie & diuerʃe maniere, ʃecondo il deʃiderio di chi edifica. ma noi per hora moʃtraremo, come dalla pianta paʃʃata ʃi poʃʃa cauʃare il palazzo di otto anguli, o lati· quantunque le ʃtanze non concordino in tutto nella diʃtributione loro con quelle della figura già moʃtra, per dimoʃtrarʃi queʃta di due ʃole entrate principali: benche queʃta ancora ʃi potria fare di quattro . Queʃta pianta dimoʃtra , l'edifitio , oltre a quel del mezzo , far quattro cortiletti triangulari, ʃegnati di croce . & dalle bande & lati diuerʃo il ʃuo ottagono ʃi potrà paʃʃar per loggia ʃopra colóne dalle ʃtanze de gli anguli delle braccia , per ʃignoreggiar meglio l'edifitio : del quale non ne darò altre miʃure, per eʃʃere maggior parte delle ʃue ʃtanze ʃimili a quelle del diʃegno paʃʃato : alle quali proportionando l'altre , ʃi trouerà facilmente il tutto .

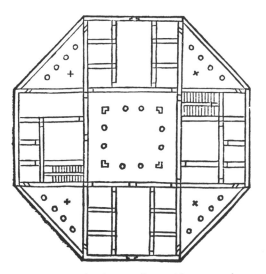

161. Pietro Cataneo. Ground plans of cruciform and octagonal palaces.
Dell'architettura di Pietro Cataneo . . . Venice, 1554.

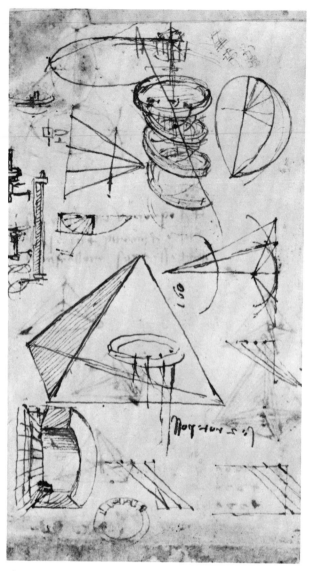

162

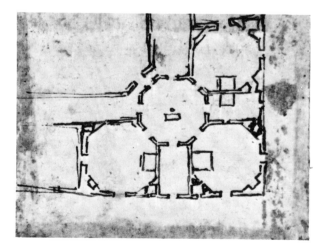

163

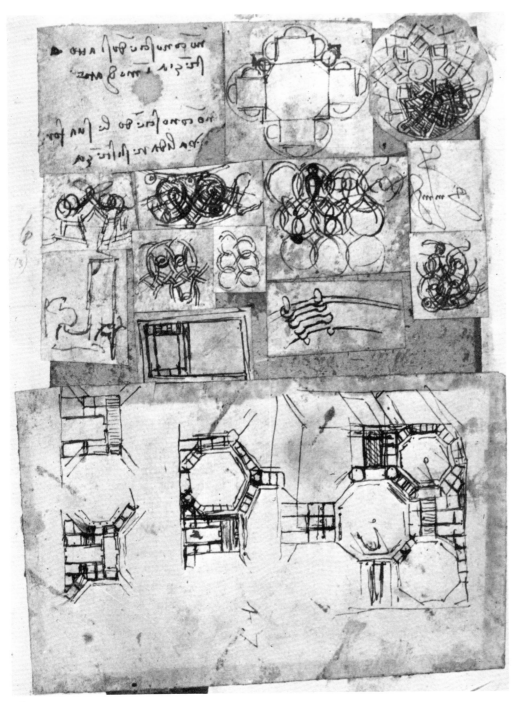

162–164. Studies of octagonal palaces and spiral staircases, ca. 1515 or later: (162) Codex Atlanticus 304 v-c (163) Codex Atlanticus 349 v-c (164) Codex Atlanticus 348 v-c.

E la pianta qui adietro del Tempio ottogono, questa è la parte de fuori. Dal piano del portico fin a la summità de la cornice, sara piedi.xxx.j.e mezo: poi sara diuisa in.vi.parti: una de lequa li sara per la cornice, fregio, ꝛ architraue: le altre.v.per l'altezza de le colonne piane, che saran grosse piedi due, e mezo, laqual gracilità per esser due insieme, e di poco rilieuo, non è uiciosa. Le misure del tutto si troueran nel'ordine Ionico, al Quarto mio libro. Sopra la cornice si metterà la Tribuna, oueramente cuppola, sopra laquale sara una Lanterna per dar luce al corpo del Tempio. La misura sua si trouerà con gli piedi piccoli ne la pianta segnati. L'altezza de le colonne tonde del portico, si fara de piedi.xij. sopra lequali sara l'architraue d'uno piede, sopra delquale posara l'arco: e sopra quello sara una cornice di tant'al tezza a quanto è grossa la colonna partita come il capitello Dorico; ma le colonne saranno Doriche. La figura qui sotto segnata A, rappresenta una di quelle capelle che usciscono fuori del muro.ij.piedi, ꝛ questa rappresenta la parte di fuori, laquale ua coperta di mezo tondo come si uede.

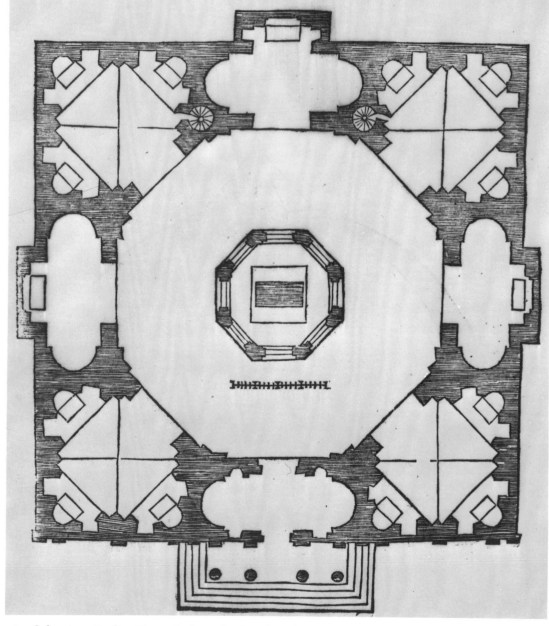

165. Sebastiano Serlio. Ground plan of a church. *Libro quinto.*

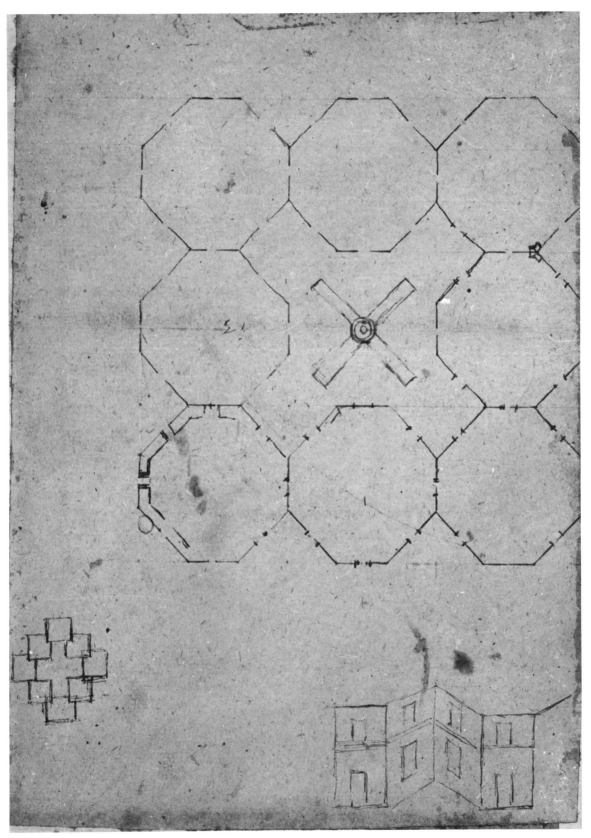

166. Geometrical study of the ground plan of a palace. Codex Atlanticus 114 v-a, 1518.

167. Study of a window. Codex Atlanticus 217 v-b (detail of fig. 136).

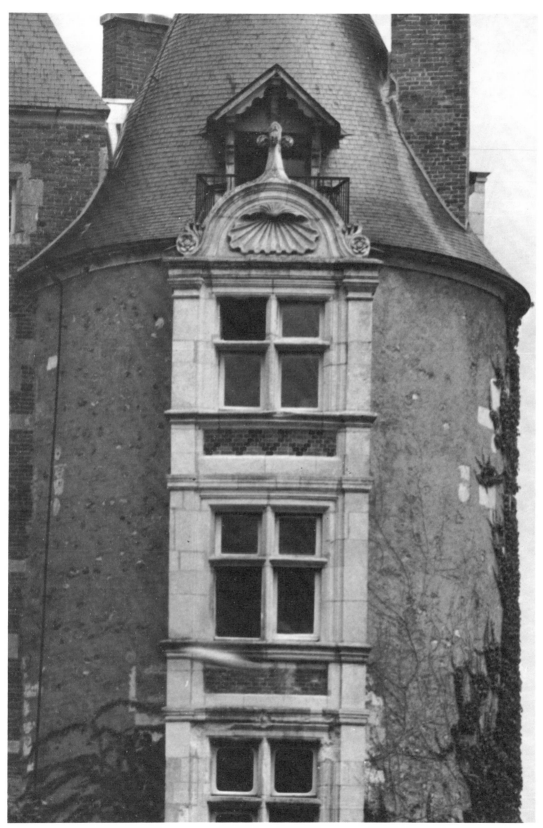

168. Sixteenth-century window in the tower of the Château of Romorantin.

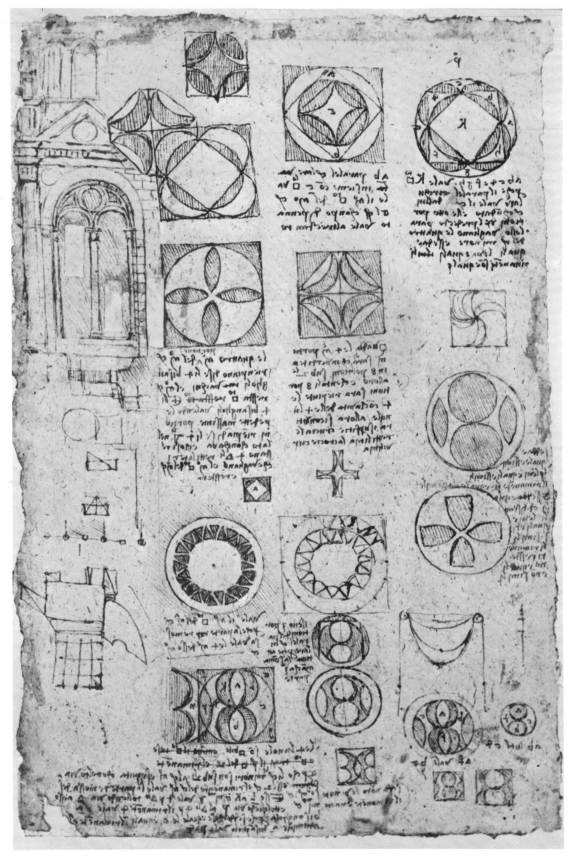

169. Studies of geometry and architecture. Codex Atlanticus 281 v-a, ca. 1513–1515.

170. Studies of geometry and architecture. Codex Atlanticus 279 v-a, ca. 1513–1515.

171. Studies of geometry and architecture. Codex Atlanticus 114 r-b, ca. 1513–1515.

172. Studies of geometry and architecture. Codex Atlanticus 184 v-c, ca. 1513–1515.

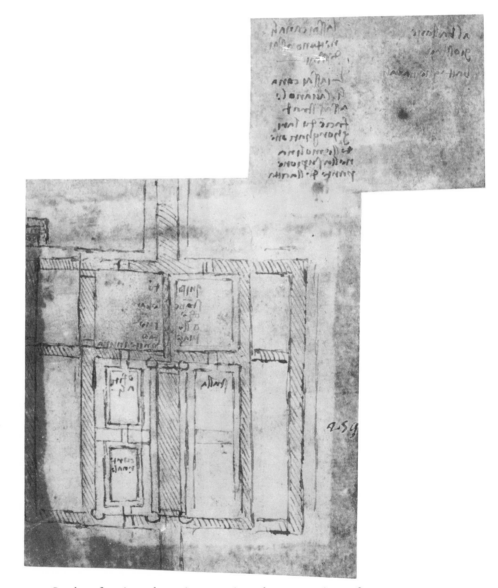

173. Study of twin palaces in a projected new section of Romorantin. Codex Atlanticus 217 v-c, ca. 1517–1518.

174. Andrea Palladio, Illustration to Julius Caesar's *De bello Gallico*, 1575.

175. The court of the Castle of La Rochefoucauld.

ABBREVIATED TITLES
NOTES
INDEXES

ABBREVIATED TITLES

Alberti	Leon Battista Alberti, *L'architettura (De re aedificatoria)*, ed. G. Orlandi and P. Portoghesi. Milan, 1966. 2 vols. English ed. by James Leoni, translated from the Italian of Cosimo Bartoli, London, 1726, 1739, and 1755. Reprint of the 1755 ed.; London, 1955 (ed. J. Rykwert).
Beltrami, *Documenti*	Luca Beltrami, *Documenti e memorie riguardanti la vita e le opere di Leonardo da Vinci in ordine cronologico*. Milan, 1919.
Calvi, *Manoscritti*	Gerolamo Calvi, *I manoscritti di Leonardo da Vinci dal punto di vista cronologico, storico e biografico*. Bologna, 1925.
Cellini	Benvenuto Cellini, "Discorso dell'architettura," in J. Morelli, *I codici manoscritti della Libreria Naniana*, Venice, 1776, pp. 155ff.
Chronology	Carlo Pedretti, *A Chronology of Leonardo da Vinci's Architectural Studies after 1500*. Geneva, 1962.
Clark	Kenneth Clark, *Leonardo da Vinci: An Account of His Development as an Artist*. Cambridge, 1939 (second ed., 1952; Penguin Books ed., 1963). See also *Windsor Catalogue*.
CU	Codex Urbinas. See *Trattato della Pittura*.
Dupré	Alexandre Dupré, "Recherches historiques sur Romorantin," *Société archéologique et historique d'Orléans*, XIV, 1875, pp. 3–64.
Filarete	Filarete, *Treatise on Architecture* . . . ed. J. R. Spencer. New Haven and London, 1965. 2 vols.
Firpo	Luigi Firpo, *Leonardo architetto e urbanista*. Turin, 1962–1963.
Francesco di Giorgio	Francesco di Giorgio Martini, *Trattati di architettura, ingegneria e arte militare*, ed. C. Maltese. Milan, 1967. 2 vols.
Heydenreich, *BM*	Ludwig H. Heydenreich, "Leonardo da Vinci, Architect of Francis I," *Burlington Magazine*, XCIV, 1952, pp. 277–285.
—— *Leonardo*	—— *Leonardo da Vinci*. London, New York, Basel, 1954.

281

—— *Lettura* —— *Leonardo architetto: II Lettura Vinciana, Vinci, 15 Aprile 1962.* Florence, 1963.

—— *Sakralbau* —— *Die Sakralbau-Studien Leonardo da Vinci's.* Leipzig, 1929.

Landucci Luca Landucci, *Diario Fiorentino dal 1450 al 1516*, ed. Iodoco del Badia. Florence, 1883. English ed. by Alice De Rosen Jervis, London, 1927.

Libro A Leonardo da Vinci, *On Painting: A Lost Book (Libro A) Reassembled from the Codex Vaticanus Urbinas 1270 and from the Codex Leicester*, ed. Carlo Pedretti. Berkeley and Los Angeles, 1964.

Lu Ludwig. See *Trattato della Pittura.*

MacCurdy *The Notebooks of Leonardo da Vinci*, ed. E. MacCurdy. London, 1938 (new ed., 1956). 2 vols. Citations are to chapters, Leonardo's texts being given in the sequence they have in the original MSS.

McM McMahon. See *Trattato della Pittura.*

Popham *The Drawings of Leonardo da Vinci*, ed. A. E. Popham. London, 1945.

Richter *The Literary Works of Leonardo da Vinci*, ed. J. P. Richter. London, 1883. 2 vols. Second ed., enlarged and revised by J. P. Richter and I. A. Richter, London, 1939. 2 vols. Third ed., London, forthcoming, with a volume of commentary by C. Pedretti.

Rosci See Serlio, *Libro sesto.*

Sangallo *Il libro di Giuliano da Sangallo* (Codex Barberinus), ed. C. Huelsen. Lipsia, 1910. 2 vols.

Sanuto *I diarii di Marino Sanuto (1496–1533)*, ed. Rinaldo Fulin et al. Venice, 1879–1903. 58 vols.

Serlio, *Libro primo, secondo, terzo, etc.* Five Books on Architecture by Sebastiano Serlio. Venice ed. of 1551.

—— *Libro sesto* Sebastiano Serlio, *Il sesto libro* . . . ed. M. Rosci. Milan, 1966. 2 vols.

Solmi, *Fonti* and *Nuovi contributi* Edmondo Solmi, "Le fonti dei manoscritti di Leonardo da Vinci," *Giornale storico della letteratura Italiana*, 1908 (suppl.).

ABBREVIATED TITLES

	Supplemented by the same author in the same journal, vol. LVIII, 1911.
Studi Vinciani	Carlo Pedretti, *Studi Vinciani. Documenti, analisi e inediti Leonardeschi. In appendice: Saggio di una cronologia dei fogli del Codice Atlantico.* Geneva, 1957.
Trattato della Pittura (Treatise on Painting)	CU = Codex Vaticanus Urbinas Lat. 1270. Lu = Ludwig ed. of the Codex Urbinas, Vienna, 1882. McM = McMahon ed. of the Codex Urbinas (with facsimile), Princeton, 1956.
Uzielli, *Ricerche* (1896, 1884)	Gustavo Uzielli, *Ricerche intorno a Leonardo da Vinci.* Serie prima, Rome, 1872 (second ed. expanded, Turin, 1896), serie seconda, Rome, 1884.
Vasari	Giorgio Vasari's *Lives.* References are to the Milanesi standard edition, unless it is specified that they are to either the first or the second edition (1550 and 1568).
Windsor Catalogue	Kenneth Clark, *A Catalogue of the Drawings of Leonardo da Vinci . . . at Windsor Castle.* Cambridge, 1935. Second ed., revised with the assistance of Carlo Pedretti, London, 1968. 3 vols.
Windsor Fragments	Leonardo da Vinci, *Fragments at Windsor Castle from the Codex Atlanticus,* ed. Carlo Pedretti. London, 1957.

For quotations of Leonardo's texts, when available in English translations, I have preferably drawn from MacCurdy's anthology and occasionally from Richter's. In either case, however, I have always checked their renderings against the originals.

NOTES

INTRODUCTION

1. E. Solmi, "Documenti inediti sulla dimora di Leonardo da Vinci in Francia nel 1517 e 1518," *Archivio storico Lombardo*, XXXI (1904), pp. 389–410.

2. *Raccolta Vinciana*, XIX (1962), p. 270, n. 15.

3. *Ibid.*, pp. 267–272.

4. Letter to Giovan Francesco Fattucci from Florence, October 1525: "Ancora m'ocorre un'altra fantasia che sarebbe molto meglio, ma bisognierebbe fare la figura assai maggiore: e potrebbesi, perchè di pezzi si fa una torre: e questa è che 'l capo suo servissi pel campanile di San Lorenzo, che n'à un gran bisognio: e cacciandovi dentro le campane, e usciendo el suono per boca, parrebbe che detto colosso gridassi misericordia, e massimo el dì delle feste, quando si suona più spesso e con più grosse campane," *Le lettere di Michelangelo Buonarroti*, ed. G. Milanesi (Florence, 1875), pp. 448–449.

5. Vasari, *Le vite . . .* (1st ed., 1550), part III, p. 574: ". . . Era sdegno / grandissimo fra Michele Agnolo Buonaruoti & lui: / per il che parti di Fiorenza Michelagnolo per la concor/renza, con la scusa del Duca Giuliano, essendo chia-/mato dal Papa per la facciata di San Lorenzo. Lionar-/do intendendo ciò si parti, & andò in Francia . . ." Cf. *Chronology*, p. 129.

6. Cf. J. S. Ackerman, *The Architecture of Michelangelo* (London, 1963), vol. I, pp. 1ff.

7. G. P. Lomazzo, *Trattato dell'arte de la pittura* (Milan, 1584), p. 430.

8. Cellini, pp. 155–159. Cf. *Bibliothèque d'Humanisme et Renaissance*, XXV (1963), pp. 69–87.

9. Codex Atlanticus 270 r-c (Richter, §1347 A).

10. *Raccolta Vinciana*, XX (1964), pp. 359–367.

11. Heydenreich, *Leonardo*, p. 78.

12. An early phase of the idea is shown in Codex Atlanticus 266 r. Compare the slightly later solutions in the Codex Trivulzianus, fols. 8 r and 22 v.

13. *Tratto della Pittura*, CU 15v–16, Lu 28, McM 34, ca. 1500.

14. *Trattato della Pittura*, CU 12v, Lu 23, McM 42, ca. 1492.

15. *Trattato della Pittura*, MS Ash. 28, CU 131v, Lu 407, McM 440, 1492.

16. S. Lang, "Leonardo's Architectural Designs and the Sforza Mausoleum," *Journal of the Warburg and Courtauld Institutes*, XXXI (1968), pp. 218–233.

PART ONE

I. EARLY STUDIES AND PROJECTS

1. Sabba da Castiglione, *Ricordi . . .* (Venice, 1555), Ricordo CIX. Cf. G. Bossi, *Del Cenacolo di Leonardo da Vinci* (Milan, 1810), pp. 24–25.

2. L. Pacioli, *Divina proportione* (Venice, 1509), part I, fol. 28v.

3. Codex Atlanticus 391 r-a (Richter, §1340).

4. Lomazzo (above, Introduction, n. 7), pp. 159–160.

5. The ball was placed on top of Brunelleschi's lantern on May 27, 1471, as recorded in the *Florentine Diary* by Luca Landucci. Leonardo himself, at a later period (ca. 1515) refers to the event in MS G, fol. 84 v: "ricordati delle salda/ture cō che si saldo la pal/la dj scā maria del fiore" (remember the soldering with which the ball of S. Maria del Fiore was soldered). A detail of a painting by "Utili" (Berenson, *Florentine School*, II, no. 1029) shows the cupola of Florence Cathedral with the wooden frame of the device used to lift the ball. The same device is known in drawings by Giuliano da Sangallo, Bonaccorso Ghiberti, and Leonardo da Vinci. See the following note.

6. Cf. L. Reti, *Tracce dei progetti perduti di Filippo Brunelleschi nel Codice Atlantico di Leonardo da Vinci, IV Lettura Vinciana* (Florence, 1965). See also G. Scaglia, "Drawings of Brunelleschi's Mechanical Inventions for the Construction of the Cupola," *Marsyas*, X (1961), pp. 45–73, and, by the same author, "Drawings of Machines for Architecture from the Early Quattrocento in Italy," *Journal of the Society of Architectural Historians*, XXV (1966), pp. 90–114. Reflections of Brunelleschi's architecture are frequent in Leonardo's studies of cupolas in the early MS B, and also in later drawings. Compare the sketch showing the herringbone arrangement of bricks in the construction of a dome, Codex Atlanticus 341 v-a, ca. 1497–1500. The sketch of a tempietto in Codex Atlanticus 202 v-a, ca. 1505, may be a recollection of the wooden model of Brunelleschi's S. Maria degli Angioli (*Chronology*, fig. 17). Even Leonardo's studies on the diverting of the Arno River may be traced back to

Brunelleschi. Cf. Reti, p. 26, and A. Parronchi, "L'allagamento di Lucca," *La Nazione*, 8 September 1963.

7. As shown in his Uffizi *Annunciation*, Leonardo had mastered Brunelleschi's system of artificial perspective as early as ca. 1475. His statement reported by Caporali in the 1536 edition of Vitruvius, p. 16, leaves no doubt that as late as ca. 1515 Leonardo was still advocating the two-point perspective employed by Brunelleschi, Masaccio, and Donatello. See P. Sanpaolesi, *Brunelleschi* (Milan, 1962), pp. 41ff. See also my article in *Bibliothèque d'Humanisme et Renaissance*, XXV (1963), pp. 69–87.

8. The evidence that Leonardo owned a copy of Alberti's *De re aedificatoria* is now given by one of the newly discovered manuscripts at Madrid (vol. II), in the list of the books in Leonardo's possession in 1504.

9. E.g. Codex Atlanticus 395 v (Richter, pl. LXXXII, no. 4), which represents a tower-shaped loggia above a fountain. See also the slightly later drawing on fol. 63 v-a, ca. 1485–1487, which belongs to a series of studies for a pump (cf. fols. 6 v-b, 401 v-a, etc.). Probably Leonardo's earliest architectural drawings are the sketches of a loggia and portico in Codex Atlanticus 28 r-b, 1479 (Calvi, *Manoscritti*, p. 44; Firpo, p. 16), but they may well be ideas for the background of a painting, perhaps an *Annunciation*.

10. Codex Atlanticus 324 r (Calvi, *Manoscritti*, pp. 53–57).

11. For the possibility that Leonardo had begun MS B as early as 1482 see my note in *Raccolta Vinciana*, XX, pp. 211–224. See also *Windsor Catalogue*, p. xxi. For an account of the architectural studies in MS B see Clark, pp. 65ff.

12. See the article by S. Lang cited above, Introduction, n. 16.

13. Studies for temporary architecture

for festivals are in MS B, fol. 28 v. Cf. Calvi, *Manoscritti*, pp. 90–91. The studies related to the project of a *città ideale* are on fols. 5v–6, 36, 37–39.

14. Codex Atlanticus 130 v-a.

15. Calvi, *Manoscritti*, p. 110, and figs. 33, 34. Firpo, p. 17.

16. Compare MS B, fols. 5v–6, 36, and 67 v.

17. Vasari, *Vita di Giuliano da Sangallo,* IV, p. 276.

18. Beltrami, *Documenti*, no. 48.

19. See G. Favaro, "Le proporzioni del corpo umano in un codice anonimo del Quattrocento postillato da Leonardo," *Reale Accademia d'Italia, Memorie della Classe di Scienze Fisiche, Matematiche e Naturali,* V (1934), pp. 577–596. See also *Chronology,* p. 23. A "libro di Francesco da Siena" is listed by Leonardo in the Madrid MS II.

20. Beltrami, *Documenti*, nos. 25–33. See also Beltrami's study cited above. Appendix B, n. 16.

21. Codex Atlanticus 65 v-b, which can be dated ca. 1493 by comparison with fol. 23v of the third volume of the Forster MS. The latter contains a topographical sketch of the same section considered in the folio of the Codex Atlanticus, and a note ("che ne canali / niente si getti / e vadino essi / canali direto / alle case") that corresponds to a paragraph of Leonardo's report to the duke. C. Maltese, "Il pensiero architettonico e urbanistico di Leonardo da Vinci," in *Leonardo: Saggi e ricerche* (Rome, 1954), p. 340, suggests identifying the "duca" to whom Leonardo addresses his report with the duke (*sic*, i.e. lord) of Chaumont, i.e. Charles d'Amboise, thus dating the project ca. 1507. This is not the case. See *Raccolta Vinciana,* XIX (1962), pp. 137–147. The recent publication by L. Bulferetti, *Leonardo l'uomo e lo scienziato* (Milan, 1966), pp. 173–174, still

follows Maltese's interpretation.

22. See Appendix B, p. 132.

23. C. Bianconi, *Nuova guida di Milano* (Milan, 1787), pp. 87–89.

24. Horst de La Croix, "Military Architecture and the Radial City Plan in Sixteenth Century Italy," *Art Bulletin*, LXIII (1960), pp. 263–290.

25. As such it is discussed by R. Bernheimer, "Gothic Survival and Revival in Bologna," *Art Bulletin*, LVII (1954), p. 271. See also J. Baltrušaitis, *Aberrations* (Paris, 1957), pp. 85–87.

26. See E. Solmi, "Leonardo da Vinci nel Castello e nella Sforzesca di Vigevano," *Viglevanum*, V (1911), reprinted in *Scritti Vinciani* (Florence, 1924), pp. 75–95.

27. Berghoef, "Les origines de la Place Ducale de Vigevano," *Palladio*, XIV (1964), pp. 165–178.

28. Bernardinus Arlunus, *Historiarum ab origine Urbis mediolanensis ad nostra usque tempora sectiones tres*, Basileae, n.d. [1530]. The original manuscript is preserved in the Ambrosian Library, Milan. It was used extensively by B. Oltrocchi in his *Memorie storiche su la vita di Leonardo da Vinci*, written ca. 1780. Cf. S. Ritter, *Baldassare Oltrocchi e le sue Memorie storiche su la vita di Leonardo da Vinci* (Rome, 1925). Oltrocchi's *Memorie* served as a basis for Amoretti's *Memorie* of 1804. See Appendix B.

29. As quoted by Oltrocchi (Ritter ed., p. 34): ". . . Leonardum pictorem mollissimum, cuius in hunc diem picturae vivunt, Pramantem architecturae magistrum, Caradoxum statuariae artis antistitem, Jacobum lapidarium, omnesque Minerva praedocente peritos optavit." The latter is probably to be identified with Jacopo Antiquario, whose importance in the circle of Leonardo's acquaintances has only recently been stressed by M. Gukovskj in *Raccolta Vinciana, XX*

(1964), p. 366 and n. 25.

30. As told by his contemporary Matteo Bandello (Beltrami, *Documenti*, no. 79).

31. See Codex Atlanticus 361 v-b, reproduced in my *Windsor Fragments*, pl. 28: "serra dasse la sala dj sopra / effa il modello grāde e alto / e arebe loco sul tetto dj sopra ede / piv al proposito che loco djtalia / per tutti i ristetti // esse stai sul tetto allato / alla torre que del ti/burio novedano" (Close the hall upstairs with wooden boards and make the model large and tall; the model should be placed on the roof above, which is more suitable than any other place in Italy. And if you stay on the roof beside the tower, the workmen at the tiburio do not see you). Cf. Calvi, *Manoscritti*, p. 118.

32. Firpo, p. 94, relates it to a drawing in MS B, fol. 12 v, which illustrates the security system of having a single entrance door. But the similarity is only apparent.

33. A. Marinoni, *I rebus di Leonardo da Vinci* (Florence, 1954), p. 130, dates the Windsor drawing ca. 1497 on the assumption that the palace should be identified with the one planned in Codex Atlanticus 158 r-a and v-a (figs. 5 and 6). But comparison with Codex Atlanticus 80 r-a and related folios (e.g. 212 r-a, v-a, 324 r, and perhaps 47 r-b) leaves no doubt that it should be dated ten years earlier. The handwriting also confirms a date around 1487–1490.

II. THE GUISCARDI HOUSE

1. Beltrami, *Documenti*, no. 90. See also the studies cited below, n. 10.

2. See L. Beltrami, *Luini* (Milan, 1912), pp. 279–297.

3. Codex Atlanticus 1 r-c: "barbera stampa." Cf. Solmi, *Fonti* (*Nuovi contributi*),

p. 356. The folio, like the Anatomical MS C II at Windsor, is in blue paper.

4. MS C, fol. 15 v (Richter, §1458), dated January 26, 1490: "essendo io in chasa dj messer galeazo da sanseuerino . . ."

5. Windsor, nos. 12294 and 12319 (Richter, §§717, 716): "ciciliano di messer galeazzo" and "gianecto . grosso . dj messer galeaz." Richter's identification of "messer galeazzo" with Sanseverino is fully justified, since Leonardo refers to Duke Gian Galeazzo Sforza as the "duca." Cf. Codex Atlanticus 177 v-b and 389 r-b.

6. Pacioli, part I, fol. 28v. Cf. Uzielli, *Ricerche* (1896), pp. 461–462.

7. Pacioli, part I, fol. 33r.

8. *Ibid.* Cf. Uzielli, *Ricerche* (1896), pp. 555–556.

9. As quoted by Oltrocchi (Ritter ed., p. 35): "Successere Sanseverini stabula pulcritudine ac decore tanto, ut in his, si dixisse par est, solis equi, Martisque bijuges constabulati esse credantur. Haec a fronte detrita, omnique decore spoliata perforataque crebris ictibus tormentorum situ computrescunt." The destruction of Sanseverino's house and stables is also related briefly by Corio (see below, n. 11) and Giovanni Andrea Prato ("Storia di Milano," *Archivio storico Italiano*, III [1842], p. 222). Stables in ruinous conditions located outside the Porta Vercellina are recorded by Vasari in his life of Piero della Francesca for their fresco decoration by Bramantino: "Fuori di porta Vercellina, vicino al castello, dipinse a certe stalle, oggi rovinate e guaste, alcuni servitori che stragliavano cavalli; fra i quali n'era uno tanto vivo e tanto ben fatto, che un altro cavallo tenendolo per vero, gli tirò molte coppie di calci."

10. G. Biscaro, "La vigna di Leonardo da Vinci fuori di Porta Vercellina," *Archivio storico Lombardo*, 4th ser., XII (1909), pp.

II. THE GUISCARDI HOUSE

363–396. L. Beltrami, *La vigna di Leonardo* (Milan, 1920).

11. B. Corio, *L'historia di Milano . . .* (Venice, 1554), fol. 49v: "Nel giorno predetto [i.e. September 7, 1499] la plebe concorse a casa di Ambrogio Curzio, et quella dilapidarono in tutto, quantunque poco di ualore gli fosse trouato, et similmente fu fatto del giardino di Brugonzio Botta Regolatore delle Ducale entrate, del pallagio et stabulo di Galeazzo Sanseuerino, et dell'habitatione di Mariolo Cameriero di Lodouico, nuouamente fondata et non ancora coperta."

12. Milan, Archivio di Stato, Fondo di Religione, Conventi, S. Maria delle Grazie, busta 563, a document excerpted by Biscaro (above, n. 10), pp. 375–376, n. 2. According to Biscaro, an indirect reference to the construction of Mariolo's palace as having been undertaken after November 1498 occurs also in a document of 1507, April 27, concerning a legal action taken by the nuns of S. Nazaro over property that they were claiming in the area (Beltrami, *Documenti*, no. 187).

13. "The street of messer Mariolo is $13\frac{1}{4}$ braccia. The house of Evangelista is 75 braccia." (MS I, fols. 118 r–119 v.) Cf. Calvi, *Manoscritti*, pp. 167ff and his fig. 42.

14. Calvi, *Manoscritti*, p. 173.

15. The identification was first suggested by Govi in his *Saggio* of 1872 (Favaro ed., Rome, 1923), pp. 116–117: "Construi per la Duchessa un bagno, pel Duca una stalla grandiosa capace di 128 cavalli, e pel Sanseverino, illustre capitano e genero del Duca, una casa, alla quale forse si riferiscono certe note e alcuni disegni che ne rimangono nel Codice Atlantico." See also *Chronology*, pp. 31, 47.

16. Forster MS III, fol. 88 r (Richter, §1384): "Morel fioretino dj messer mariolo chaval / grosso . a bel chollo e assa bella testa."

17. In this, as in Leonardo's notes, the words "famelia," "famiglia," and "famigli" derive from the Latin *familia* and retain the meaning of "retainers." MacCurdy, *Architecture*, translates these words "family," which may not apply to retainers only. Calvi, *Manoscritti*, p. 173, points out that the words and expressions "famelie," "granda," "per mi," are either Lombard or Venetian.

18. "Nota che li volemo [camera vna cum *deleted*] saloto vno de braccia 25 vna Guarda Camera per mi. / vna Camera cum camere doue [i.e. due] per mia mulier et le done sue. cum la / sua cortexela. / Item stala vna dopia per cauali 16. cum la camera da famelie da stalla / Item cuxina vna. cum la dispensa apresso. / [Item camere doue cum vna canzelaria *deleted*] / Item saroto vno de braccia 20 per manzar la famelia / Item camera vna / Item canzelaria vna."

The words "vna Guarda Camera" (a guardroom) are transcribed by Calvi, *Manoscritti*, p. 170, as "vna granda camera" (a large room). Compare Leonardo's specification "n guarda camera" in n. 20 below. The "guardacamera" is a vestibule, as shown in some of the ground plans of houses in Serlio's *Libro settimo*, ed. Jacopo Strada (Frankfurt, 1575).

A similar handwriting appears in Codex Atlanticus 172 r-b, a folio not transcribed in the edition of the codex. It is the draft of a letter headed either "Vicere Valente" or "Vicario Valente" concerning legal matters and specifying punishment to be inflicted upon some felons. This document, which has nothing to do with Leonardo, appears in the edition of the codex as an isolated leaf with a blank verso. But in the original it is the recto of folio 172 v-c, d, the larger size of which can now be explained: the recto

289

appears through a window in the mount and includes only the upper part of the folio, the remainder being blank. The verso has a flap hanging out of the window. The writing on the verso is related to Leonardo's activity as an architect in the service of the French governor of Milan in 1506–1508 (see *Raccolta Vinciana*, XVIII [1960], p. 85, fig. 11); thus Leonardo may have used a sheet discarded by the governor's office. The draft of the letter might be by a Milanese in the service of the governor. According to Prato's "Storia di Milano" (above, n. 9), Galeazzo Sanseverino remained faithful to the Sforza family, but nothing is known of Mariolo de' Guiscardi's activity after 1500. It is tempting to think that Charles d'Amboise came to know Leonardo as an architect through a person who had already known him as such.

19. "il djsegno fatto a magiore faciata dj rie/to che djnançj che debe essere per loposito." Some of the ground plans on the page show the rear façade slightly larger.

20. "a sala del padrone / d camera / b cucina / c djspesa / n guarda camera / o sala della famj/gla."

21. "la sala della famjglia dj la dalla cucina / acio il padrō nō senta loro rumore / e chella cucina sia lor comoda pel peltro / chessa allavare che nō passi / per la casa evidēte."

22. "chella famjglia nonvsi in cucina / le legnje comode alla cucina." "sala / djspēsa / cucina / ofitio dj codelle / sala della / famjglia / camera / dj famjglj / 3 came/re per fore/stierj."

23. "djspēsa legne cucina e pollaro essala e camera sarā over de/bono essere cōtingētj per la comodjta che ne resulta / ellorto . stalla letame he orto cōtingētj / la sala del padrone e della famjglia debbe mette/re imeço la cucina ennelluna enellaltra sipor/ga le viuāde

per via dj finestre large e basse over tornj." The words "legne" and "e pollaro" are inserted above the line.

24. In the ground plan (fifth from above): "sala maestra / del padroni / camera / del padro / cusina / sala dela / famiglia / camera / de famjglj / cortisella / legne." Note on the left, second paragraph: "fareno alla mogliera la sua camera essala / sança . la sala della famjglja perche si fano mā/giare a vnaltra tavola le sua dōçelle nvna me/desima sala / bisognja 2 camere ōtre alla sua vna per le dōçelle / laltra per balie . e camerinj per loro serujtj— / voglio che vnusscio serri tutta la casa."

25. In the ground plan: "credēça / cuci/na / fa/mj/glia." Note at the bottom of the sheet: "quello che sta alla credētia / de avere djreto asse lētrata della cucina per potere sollecitare e nella frōte della credēça / la finestra della / cucjna / per torre legnje."

26. "ciēto [j *deleted*] braccia dj largeça / e 294 dj lūgeça / sō 15 pertiche e $\frac{3}{4}$." Cf. Calvi, *Manoscritti*, p. 165.

27. "sio tolgo 95.braccia dj largeça / e 294 dj lūgeça io ho / 15 pertiche / sio tolgo . 100 braccia dj lar/geça he 194 [i.e. 294] dj lūgeça io ho . piv $\frac{3}{4}$ dj perti/cha piv chel bisognjo la / quale rimā djrieto." Cf. Calvi, *Manoscritti*, p. 165.

28. "a 4 soldi il quadretto / essendo la perticha 1855 / quadrettj essa perticha vie/ne achostare lire 371 / cioe duchatj 92$\frac{3}{4}$ / chelle 15 pertiche vē/gano ducati / 1391 e $\frac{1}{4}$." Cf. Calvi, *Manoscritti*, p. 166.

29. Biscaro (above, n. 10), p. 375, n. 2 (document dated January 16, 1540).

30. *Ibid.* Mariolo's property was located in the triangular area bounded by the Borgo delle Grazie and the Redefosso, opposite Leonardo's property.

31. It is, however, puzzling that none of

the calculations in Codex Atlanticus 158 r-a seems to work out to a figure of 1936 or 1944 square braccia to a pertica. According to Leonardo's specification in MS I (15 pertiche equal to 294 × 95 braccia), the number of square braccia in each pertica should be 1862.

32. Unfortunately, none of the plans in Codex Atlanticus 158 is accompanied by measurements, and the proportions change in each plan. But if we were to take the length of the "sala del padrone" (specified by the committent himself as 25 braccia) as a unit of measurement, we would find that in a plan on the verso of the sheet (the third from above) the width of the façade measures six such units, suggesting therefore a façade 150 braccia wide. Indeed, throughout his plans Leonardo seems to have been adopting the style of the tripartite wing, the wing's width being made up of three units measuring some 12.5 braccia each. Thus the width of the façade would always amount to about 150 braccia. By means of the same unit of measurement one can estimate the length of the side of the palace as being approximately 85 or 90 braccia. One of the plans on the verso (second from above) shows that the garden was meant to stretch out at the rear of the palace, its width corresponding to the width of the palace.

33. See J. Coolidge, "The Villa Giulia," *Art Bulletin*, XXV (1943), pp. 177–225.

34. The first line is difficult to interpret. The "cinta" could be the enclosing wall, but it is not clear to what part of it the 18 braccia of "vachuo" (void) refer. The other lines can be translated as follows: "The entrance 6 braccia and the study $11\frac{1}{2}$ braccia. A hall 18 braccia long and 12 braccia wide and 8 braccia high. And the height of the study $7\frac{1}{2}$ braccia. The hall and the rooms; a granary [i.e. an attic] 4 braccia high."

35. Both the Stradone di S. Vittore and the Strada alle Grazie, which were respectively 30 and 25 braccia wide, date from 1498–1499, and Biscaro has already suggested that Leonardo might have had something to do with their realization. See Beltrami (above, n. 10), p. 8. Indeed, it is surprising that so little evidence of Leonardo's involvement in the urban replanning of the area of S. Vittore should be left in his manuscripts. In the newly discovered Madrid MS I, which dates for the greater part from 1497–1498, there is not one single reference to such architectural plans. Yet Codex Atlanticus 397 r-b, the technological contents of which are related to Madrid MS I, contains the sketch of an elaborate bell tower (resembling that of the Palazzo Vecchio at

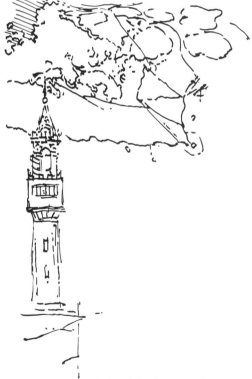

Codex Atlanticus 397 r-b

291

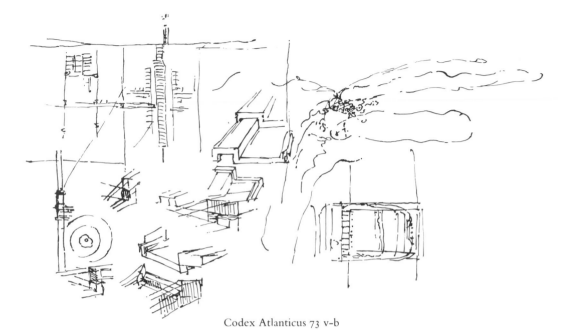

Codex Atlanticus 73 v-b

Florence), whose purpose is not clear. Just above it is sketched a map of Europe and the Near East, showing the Mediterranean route from Venice to Cyprus and to Palestine. Similar sketches (without the indication of routes) occur in MS I, fols. 46 v and 47 r, and again in Codex Atlanticus 73 v-b. (Compare also Codex Atlanticus 305 r-b, ca. 1495–1497.) Folio 73 v-b is related to fol. 194 r-a and v-a, to which it was probably joined originally, and they in turn relate to the double sheet 145 r-a-r-b and v-a-v-b, which contains the celebrated drawings and description of a feigned Eastern journey. Cf. Popham, 258–259, who dates it ca. 1497. Note the isolated inscription "profetia di lionardo da vincj" on fol. 194 v-a. The slight architectural sketches and indication of an urban area on fol. 73 v-b may therefore refer to the projects for Mariolo de' Guiscardi's house. (Note the sketches of roof tiles in each of the related folios, including 145 r-b.) The series, how-

ever, might be slightly later. In fact, the style of the drawings and the handwriting point to a period around 1498–1500, if not later, as suggested by Clark in his note to Windsor 12587.

36. The sketch is fairly accurate in representing the area of the Borgo delle Grazie, but there seems to be an alternative solution for the Stradone di S. Vittore, so as to make the new road parallel to the Borgo. Furthermore, Leonardo seems to suggest opening a new street between the Borgo and the Stradone running parallel to them along one side of his own property. He was perhaps envisaging an independent access to Mariolo's property directly from the street of the Naviglio, between the Porta Vercellina and the Pusterla de' Fabbri. Such a street would have increased considerably the value of his vineyard.

37. Heydenreich, *Leonardo*, pl. 123, dates it ca. 1505, but in his later *Lettura Vinciana*,

p. 17, fig. 39, he dates it ca. 1502. Since there is no evidence for dating MS I later than 1500, I previously suggested relating the drawing of this villa to Leonardo's design of the Villa Tovaglia at Florence (1500). Cf. *Chronology*, pp. 25–31. But the ground plan of the Villa Tovaglia (still recognizable in the present villa "La Bugia" near S. Maria a Montici) has convinced me that the drawing cannot be dissociated from the 1497 series of architectural studies for a country house in Milan, as Calvi had already suggested (*Manoscritti*, p. 173, n. 2). Firpo, p. 103, is of the same opinion. Maltese (above, sec. I, n. 21), p. 353 (and fig. 32), considers it as a study for the Villa of Charles d'Amboise in Milan, dating therefore ca. 1506–1508. He assigned to the same period even the plans in Codex Atlanticus 158 v-a, which Calvi had already shown to date from ca. 1497. M. Rosci, in his edition of Serlio's *Libro sesto*, p. 31, mentions the drawing in the context of the Bramantesque origin of the motif of the "Serlian window."

III. TUSCANY AND ROMAGNA

1. Cf. Prato, "Storia di Milano" (above, sec. II, n. 9), pp. 251–253. Pacioli in his *Divina proportione* mentions Giacomo Andrea as a friend of Leonardo: "e suo quanto fratello Iacomo Andrea da Ferrara de l'opere di Victruvio accuratissimo sectatore" (Uzielli, *Ricerche* [1896], p. 377). In a note in MS K, fol. 109 v (Richter, §1501), which dates from after his return to Milan, ca. 1507, Leonardo mentions Giacomo Andrea's Vitruvius: "Messer vīcentjo aliplādo che sta / presso allosteria dellorso a il uetru/ujo dj iacomo andrea." I have no way of identifying the source of the information given by

the Ferrarese historian Cittadella about Iacopo Andrea being active in Milan while Leonardo was planning a palace for the duke (L. N. Cittadella, *Notizie relative a Ferrara* [Ferrara, 1864], p. 341: "Un *Jacopo Andrea* era pure architetto ferrarese assai stimato al servizio appunto dei duchi di Milano circa il 1480; come architettava per essi nel 1486 un magnifico palazzo in quella città il grande *Leonardo*"). Leonardo mentions another Ferrarese at the Sforza court, Giannino Alberghetti, a founder, for his system of building the tower of Ferrara without holes for the scaffolding (Codex Atlanticus 225 r-b, Richter, §1448). There is no evidence that Leonardo had known of Biagio Rossetti's urban planning at Ferrara in the 1490s.

2. MS L, first verso of the cover (Richter, §1414).

3. The document gives the date 1499 for the minutes of the committee in charge of the problem (Beltrami, *Documenti*, no. 99). This means that the event must date between March 13, 1500 (the last time Leonardo is recorded as being in Venice) and March 25, 1500 (the beginning of the Florentine year). The committee met again in 1506. Cf. *Chronology*, pp. 23–25.

4. A. Luzio, *La Galleria Gonzaga venduta all'Inghilterra* (Milan, 1913), pp. 199–200. Cf. *Chronology*, pp. 25–31.

5. Luzio (above, n. 4), and Beltrami, *Documenti*, no. 105: "El prefato Leonardo dice che a fare una chosa perfecta bisogneria poter transportare questo sito che è qui, là dove vol fabrichare la S.a V.a" (Leonardo says that in order to make the work perfect one should move these surroundings to the place where Your Excellency wants to build).

6. G. Lensi Orlandini, *Le ville di Firenze di là d'Arno* (Florence, 1955), pp. 130–132, and pls. 71, 72. The villa dates from ca. 1470

and is the work of Lorenzo da Monte Aguto, an architect in the service of the Medici. He worked at Careggi and is mentioned by Vespasiano da Bisticci.

7. *Chronology*, p. 31.

8. The same ink is used in the studies for the House of Charles d'Amboise in Milan, ca. 1508, and in some of the studies for the Trivulzio Monument, ca. 1508–1511. Cf. *Windsor Catalogue*, pp. xxii–xxiii.

9. The notes read as follows: (to the right) "a hellentrata e volta in . o / e riesscie . in . c e volta in / b e viene dj b . in . a dirit/tamente e capita in sulla / sala per la porta . a . —— / houero in . a b c o a. ——"; (to the left) "per . a . si saglie in . r . essi uolta / in . q essiriesscie in . n a . ouero / si uolta . in . p . essiriescie in / m a . ——

"ancora si po fare in contrario / coe entrare in . a e voltare . in / n . ho in . m . e andare dj a m p / r a . ‖ houero in ‖ a n q r a ——

"maj le teste delle sale debone esse/re rotte."

(One enters in *a* and turns to *o* and goes in *c* and turns in *b*, and from *b* comes direct to *a* and arrives at the hall through the door *a*; or one goes by *a b c o a*.

One goes up to *r* through *a* and turns to *q* and goes out through *n a*; or one turns to *p* and goes out through *m a*. One can also do the opposite, that is, enter in *a* and turn to *n*, or enter in *m* and go either by *a m p r a* or *a n q r a*.

One should never have a hall wide open at its head.)

This must be the folio to which Pevsner refers in his *Outline of European Architecture* (London, 1966), p. 282, as containing the Leonardo sketches that can be taken as the pattern for the so-called Imperial staircase. This type of stairs seems to have been intro-duced in Spain for the first time at the Escorial around 1563–1584. "An Imperial staircase," explains Pevsner, "is one which runs in a large oblong cage, starting with one straight arm and then, after the landing, turning by 180 degrees and leading up to the upper floor with two arms to the left and right of, and parallel with, the first arm (or starting with two and finishing with one)." Jean Guillaume ("Léonard de Vinci, Dominique de Cortone et l'escalier du modèle en bois de Chambord," *Gazette des Beaux-Arts*, LXXI [1968], pp. 93ff) has shown that the wooden model of Chambord had this type of staircase, which can be traced back to Leonardo's studies for the House of Charles d'Amboise. The Imperial staircase is called in Italian "scala a tenaglia." It became very popular with the baroque (compare the Corsini Palace, Rome), but it already appears in Sangallo's project for a Medici Palace in the Piazza Navona, Rome. Cf. G. Giovannoni, *Antonio da Sangallo il Giovane* (Rome, 1959), p. 281, and figs. 237–239.

10. It is described in the manuscript of Benvenuto di Lorenzo della Golpaja at Venice. There are studies for it in the last folios of Leonardo's MS G, which date from ca. 1510. Cf. *Studi Vinciani*, pp. 23–42, and *Raccolta Vinciana*, XVII (1954), pp. 177–215.

11. The date ca. 1507 is also suggested by its relationship with the maps at Windsor, nos. 12675 and 12676; see the notes to these in *Windsor Catalogue*.

12. MS L, fols. 19v–20 r (Richter, §1038, and pl. CX): "scale durbino." The drawings of the Cappella del Perdono are on fols. 74 r and 73 v. See *Raccolta Vinciana*, XX (1964), pp. 263–270. See also N. De Toni, *I rilievi cartografici di Leonardo per Cesena ed Urbino contenuti nel Manoscritto "L" dell'Istituto di Francia, V Lettura Vinciana* (Florence, 1966).

13. MS L, fols. 76 v, 77 r, 82 r, 83 r, and 84 r. These references are discussed in the following section.

14. See below, sec. IV, n. 2, for the reference to Landucci's *Diary* about the return of Appiani to Piombino on August 31, 1503.

15. Madrid MS II, fol. 2 r: "del muro / La canna quadrata si fa a Roma / a sue spese per 19 carlini e per / 7 carlini si fa a spese del / signore della muraglia." In the same sheet Leonardo records that on June 6, 1505, he began painting "in palazzo," that is, on the *Battle of Anghiari*.

16. A visit by Leonardo to Rome at the beginning of the sixteenth century has already been suspected on the basis of an entry in a document of April 30, 1505, pertaining to work on the *Battle of Anghiari*: "A Lionardo di S.r Piero da Vinci, paghati per lui a Mariotto Ghalilei camerlengo in dogana, per ghabella d'uno suo fardello di sue veste fatto venire da Roma. — lire 18. s. 9. d. 8." (Beltrami, *Documenti*, no. 165). Leonardo's visit to Rome must have been brief. In Madrid MS II, fol. 1 r he wrote: "Roma lunedj mattina fiorini j°." On fol. 2 r, which contains the annotations quoted in the preceding note, he repeated the entry "lunedj mattina fiorini j°," adding "sabato mattina fiorini j° a lorenço." The reference to Lorenzo gives a *terminus a quo* for the date of Leonardo's trip to Rome. Lorenzo entered Leonardo's studio on April 14, 1505 (Codex on the Flight of Birds, fol. 18 v). Since Leonardo's clothing was returned from Rome by April 30, 1505, his sojourn there did not last longer than two weeks. It is, of course, possible that he had already gone to Rome at the time of Cesare Borgia. Either visit, however, was important, not only for the effect that it undoubtedly had on his art (see Kenneth Clark, "Leonardo and the An-tique," in *Leonardo's Legacy* [Berkeley and Los Angeles, 1969], pp. 1–34) but also because it brought him into contact with Bramante again. Significantly enough, it was about 1500 that there appeared in Rome the curious poem *Antiquarie Prospettiche Romane*, dedicated to Leonardo by an anonymous "Prospectivo Melanese Depictore." G. De Angelis d'Ossat, "Preludio Romano del Bramante," *Palladio*, XVI (1966), pp. 83–102, puts forward the theory that the anonymous author might have been Bramante himself.

17. Cf. Calvi, *Manoscritti*, pp. 34ff.

18. Windsor 12684 (Richter, pl. CXIV). For the problem of Melzi's handwriting in general and on this map in particular see *Libro A*, p. 108. See also below, sec. VII, n. 7.

19. Arundel MS, fol. 272 r. See also Codex Atlanticus 71 v-b.

20. Cf. *Chronology*, pp. 23–25.

21. Richter, §766, pl. CIII, 3. Cf. Heydenreich, *Lettura*, pp. 3ff and his fig. 1. My date ca. 1480 (*Studi Vinciani*, p. 281) was based on the belief that the sheet was the recto of folio 325 v-b. This is not true: the two sheets are placed back to back, so that recto-b is an independent sheet that can be dated ca. 1504.

22. Letter of Pier Soderini to Charles d'Amboise, October 9, 1506 (Beltrami, *Documenti*, no. 180). For the history and appearance of Leonardo's painting see C. Gould, "Leonardo's Great Battle-Piece: A Conjectural Reconstruction," *Art Bulletin*, XXXVI (1954), pp. 117–129.

23. The only study on the Council Hall is by J. Wilde, "The Hall of the Great Council of Florence," *Journal of the Warburg and Courtauld Institutes*, VII (1944), pp. 65–81. An earlier study by A. Lensi, *Palazzo Vecchio* (Rome, 1929), is well informed but inadequate.

24. Vasari, *Life of Cronaca:* "Ne' medesimi tempi dovendosi fare per consiglio di fra Ieronimo Savonarola, allora famosissimo predicatore, la gran sala del consiglio nel palazzo della signoria di Fiorenza, ne fu preso parere con Lionardo da Vinci, Michelagnolo Buonarroti ancorachè giovanetto, Giuliano da S. Gallo, Baccio d'Agnolo, e Simone del Pollaiuolo detto il Cronaca, il qual era molto amico e divoto del Savonarola." The information is repeated in the *Life of Leonardo* (p. 255): ". . . essendosi fatta di nuovo la gran sala del consiglio, l'architettura della quale fu ordinata, col. giudizio e consiglio suo [Leonardo's] . . ."

25. The note in Codex Atlanticus 230 v-c (not transliterated in the edition of the codex, but given by M. Herzfeld in *Raccolta Vinciana*, XIII [1926–1929], pp. 53ff) reads as follows: "memoria a m^{ro} Lionardo di hauere presto la nota del / stato di firēze, videlicet como a tenuto el mode et stillo / el R^{do} pad^{re} .d. frate Jero.° jnordinaire el stato di firēze / Jtem li ordini e forma espressa di ogni luj ordīatie / per cqual modo via et ordīe come sono seruati et se / seruano vsque nunc." (Letters in italics are supplied from abbreviations in the manuscript.)

Herzfeld suggests that the note was jotted down by Louis of Ligny and relates it to the so-called Ligny memorandum in Codex Atlanticus 247 r-a (Richter, §1379). This cannot be dated much earlier than 1500, although an architectural drawing on the same folio is close in style to those of MS B. Obviously the notes were added later, because they are written around it. A draft of a report to the Signoria of Venice in Codex Atlanticus 234 v-a, pertaining to a project of defense against the Turk, and therefore datable around 1500, has the identical ductus and style of the notes on the verso of the

"Ligny memorandum." They are on a project for a wine fountain, probably for festivals, and are all crossed through. There are notes on the identical subject in Codex Atlanticus 218 r-b, which was originally numbered 186, so that it may be considered as the counterpart of fol. 247 v-a (the verso of the "Ligny memorandum"), which was in fact numbered 187. Leonardo must have spent much time on the project for such a wine fountain, to which he refers later in the Leicester MS, fol. 26 v. Folio 218 r-b includes a sketch of it, reproduced by Maltese (above, sec. I, n. 21), fig. 29, as a fountain. It may be referred tentatively to the type of fountain mentioned in the chronicles of pageantries and festivals in France and Italy at the time of Charles VIII. Cf. E. M. Bancel, *Jean Perreal dit Jean de Paris* (Paris, 1885), with documents about the Lyons festivals of 1494; F. Rolle, "Jean de Paris," *Archives de l'art française.* 2nd series, I (1861); and M. Dufay, "Essai biographique sur Jehan Perreal," *Mémoires de la Société littéraire de Lyons* (1894).

26. Michele Pocianti [Luca Ferini da Prato], *Vite de sette Beati Fiotentini . . .* ' In Fiorenza, appresso Giorgio Marescotti (1589), p. 176: "Ma non meno l'accrebbe [la Nunziata] nel 1477 l'Illustrissi-/mo, & Eccellentissimo Lodouico secondo Marchese di Mantoua, che edificò la cupo-/la fabbrica molto magnifica circodata da noue Cappelle con colonne riquadrate, archi-/traui, & cornicioni di pietra viua, in mezzo / le quali è vn Choro à guisa di Teatra, & un / nobilissimo Altare in forma d'Arco trionfa-/le (disegno di Lionardo da Vinci) tutto co-/perto d'oro, oue è vn Ciborio ricchissimo per / il Santissimo Sacramento, accompagnato cō / due porte di misti, & statue di marmo, il che / se bene apporta ornamento,

non minore stu-/pore però dà la quātità incredibile dell'ima-/gini, che sopra palchi, & nel mezzo della / Chiesa sospese si veggano . . ."

27. Landucci, p. 333: ". . . la qual cosa dolse a tutto Firenze—non la mutazione dello Stato, ma quella bella opera di legniame di tanta spesa. Ed era di grande riputazione ed onore della città avere sì bella residenza. Quando veniva una ambasceria a visitare la Signoria, facieva stupire chi la vedeva quando entravano in sì magna residenza e in sì grande cospetto di consiglio de' cittadini . . ."

28. Florence, Archivio di Stato, Operai di Palazzo, Stanziamenti, no. 15, carta 4: 1513 (i.e. 1514), February 26. Cf. Beltrami, *Documenti*, no. 216 (under the date 1513, April 30, and as *filza* 25, fol. 24).

29. Vasari, IV, pp. 198ff (cf. Wilde [above, n. 23], p. 77): ". . . nella quale sono tutti e' protettori della città di Fiorenza, e que' Santi che nel giorno loro la città ha auto le sue vittorie."

30. Reproduced by Lensi (above, n. 23), p. 240. A drawing by Battista Naldini in the Scholz collection, New York, shows the same scene from a slightly different angle. Cf. G. Thiem, "Neuentdeckte Zeichnungen Vasaris und Naldinis für die Sala Grande des Palazzo Vecchio in Florenz," *Zeitschrift für Kunstgeschichte*, XXXI (1968), pp. 143–150. In my *Leonardo da Vinci inedito* (Florence, 1968), pp. 63–64, n. 24, I mention a drawing after Michelangelo's *Battle of Cascina* in the Albertina (Berenson, no. 1748) as containing some indication of the architectural decoration of the Council Hall. I must correct myself by referring to A. E. Popham's article "Sogliani and Perino del Vaga at Pisa," *Burlington Magazine*, LXXXVI (1945), pp. 85–90, in which the drawing is identified as

a work by Perino del Vaga, with studies for the decoration of the chapel of St. John and St. George in the Duomo at Pisa.

31. See Michelangelo's letter to Ammanati, January 1559 (Milanesi, *Lettere*, p. 550): "Openione che quando detta scala si facesse di legname, cioè d'un bel noce, che starebbe meglio che di macigno e più a proposito a' banchi, al palco e alla porta."

32. Casa Buonarroti 114 A. See P. Barocchi, *Michelangelo e la sua scuola: I disegni di Casa Buonarroti e degli Uffizi*, vol. I (Florence, 1962), pp. 51–52.

33. Codex Atlanticus 179 v-b (Richter, §725): ". . . e per li capitelli fatti di metallo . . ." Cf. G. Castelfranco, *Studi Vinciani* (Rome, 1966), pp. 186–198.

34. *Chronology*, p. 64, n. 67, and fig. 27.

35. In his life of Cronaca, Vasari writes that "nel mezzo poi della sala erano panche in fila ed a traverso per i cittadini" (in the middle of the hall, then, were benches laid in rows and crossways for the citizens).

IV. THE FORTIFICATIONS OF PIOMBINO

1. *Le legazioni e commissarie di Niccolò Machiavelli*, ed. L. Passerini and G. Milanesi (Florence, 1876), vol. III, pp. 91–93. Machiavelli paid a first visit to Appiani in 1499, March 24 (see vol. I, pp. 1–4). He was sent to Piombino to discuss the higher pay that Appiani was requesting as a condottiere in the service of Florence. Appiani's relations with Florence must have terminated in 1501 when the Florentine republic favored Cesare Borgia's invasion of the Piombino territory. See G. Canestrini, "Documenti per servire alla storia della Milizia Italiana," *Archivio storico Italiano*, XV (1851), pp. 269–271. Cf. R. Ridolfi, *Machiavelli*, any of the several editions.

2. The event is mentioned in Luca Landucci's *Diary*: "E a di 31 d'agosto 1503, ci fu come el signore di Piombino aveva ripreso Piombino."

3. Florence, Biblioteca Nazionale, Carte del Machiavelli, cassetta IV, no. 159. The *Deliberazione della Signoria*, dated April 2, 1504, is in the Archivio di Stato, Signori: Legazioni e commissarie, elezioni, istruzioni, lettere, no. 26, fol. 142 v. The text is given by Passerini–Milanesi (above, n. 1). The credentials, also transcribed by Passerini–Milanesi, are in the Archivio di Stato, Dieci di Balìa, Legazioni e commissarie, istruzioni e lettere missive, registro 28, fol. 14. An English translation follows: "Most Illustrious Lord, etc. The present letter will be shown to you by Nicolo Machiavelli, our citizen and secretary, who comes to Your Excellency to talk about a few things which to our judgment are of no little importance. May we ask you to trust him for all he has to say to you on our behalf; and may we assure you of our concern, now as ever, about your welfare and of our desire to please you in any way we can."

4. See my *Leonardo da Vinci inedito*, pp. 9ff, with full bibliography.

5. Beltrami, *Documenti*, no. 140.

6. See Landucci, *Diary*: "E a di 22 d'agosto 1504, si mise mano a volgere Arno a Livorno, poi si lasciò stare." See also E. Solmi, "Leonardo e Machiavelli," *Archivio storico Lombardo*, XVII (1912), pp. 209–244, reprinted in *Scritti Vinciani*, pp. 199–237.

7. See L. Reti, "The Two Unpublished Manuscripts of Leonardo da Vinci in the Biblioteca Nacional of Madrid—II," *Burlington Magazine*, CX (1968), pp. 81–89, supplemented by C. Maccagni, *ibid.*, pp. 406–410. See also my *Leonardo da Vinci inedito*, pp. 15–16.

8. On October 31, 1504, Leonardo received payments from the Signoria for his work on the *Battle of Anghiari* (Beltrami, *Documenti*, no. 153). He is mentioned again on December 31, 1504, as being back at work on the cartoon for the battle piece (Beltrami, *Documenti*, no. 154). He may have been away from Florence in November and December 1504.

9. The first reference to Michelangelo in the documents occurs under the date October 31, 1504. Cf. K. Frey, "Studien zu Michelagniolo Buonarroti . . ." *Jahrbuch der königlich Preuszischen Kunstsammlungen* (1909), p. 133. See also C. Gould, "Michelangelo: Battle of Cascina," *Charlton Lectures on Art* (University of New Castle upon Tyne, 1966).

10. Madrid MS II, fol. 2 r. Cf. my *Leonardo da Vinci inedito*, pp. 53ff, and pl. 29.

11. Madrid MS II, fol. 25 r: "Addi ultimo di novembre [?, perhaps lapsus for October] per Ognissanti, 1504, feci in Piombino al Signore tale dimostrazione." The beautiful drawings of fortifications on fol. 37 r are faced (fol. 36 v) by notes on the estimation of the cost of works on the "torre della cittadella." It is therefore a reference to the fortified place that included the residence of Iacopo IV Appiani.

12. See L. H. Heydenreich in *Kunst-Chronik*, XXI (1968), pp. 85–100.

13. Prepared in New York on February 18 and 19, 1967, and immediately published in mimeographed form. See *Life*, LXII (March 3, 1967), pp. 25–30.

14. In my chronology of the folios of the Codex Atlanticus (*Studi Vinciani*, p. 267), I date the series 1500–1505. So far the drawings have been studied by only I. Calvi, *L'architettura militare di Leonardo da Vinci* (Milan, 1943), who refers them to the Borgia period, 1502.

15. Windsor 12665 (Richter, §609). The

note in MS L reproduced by Richter, §1035. Compare also the note illustrated by two sketches of waves on the margin of a leaf of Francesco di Giorgio's treatise in the Laurentian Library (Richter, §952), a book owned and annotated by Leonardo at the time of Madrid MS II.

16. This is fully discussed in my *Leonardo da Vinci inedito*, pp. 9–51. The notes on painting on fol. 78 v face a page (fol. 79 r) containing two drawings of a fortress, probably an idea for the fortification of the citadel of Piombino. M. Rosci (*Atlante*, April 1967, pp. 82ff) reproduces the drawing as a probable "studio per il rafforzamento del Castello Sforzesco di Milano."

17. The small sketch is reproduced (together with the other references to Piombino in MS L) by M. Baratta, "La carta della Toscana di Leonardo da Vinci," *Rivista geografica Italiana* (*Memorie geografiche*), XIV (1911), pp. 66–71.

18. Compare a similar drawing in the Windsor fragment 12705, which was originally in Codex Atlanticus 366 v-b, a sheet of notes on mechanics and technology dating from ca. 1497 and relating (together with its companion, fol. 27 r-a) to the contents of Madrid MS I.

19. Francesco de' Marchi, *Dell'architettura militare* . . . (Brescia, 1599). In book IV, chap. 36, there is a reference to Leonardo's system of casting the Sforza horse, based on information published in Biringuccio's *De la pirotechnia* (1540). Cf. R. Cianchi in *Raccolta Vinciana*, XX (1964), pp. 277ff. The codex attributed to Francesco de' Marchi is the MS Magliabechiano II. I. 280 in the Biblioteca Nazionale at Florence. The map of Piombino is on fol. 21.

20. Eighteenth-century maps of Piombino are preserved in the town hall. I am grateful to Sig. Sergio Carignani, Assessore all'Urbanistica, and his colleagues for having given me access to this and other material in the Municipal Library and Archives. They introduced me to the basic sources for the history of Piombino, such as L. Cappelletti, *Storia della città e stato di Piombino* (Livorno, 1897), and the publications by R. Cardarelli, e.g., "Storia di Piombino di Agostino Dati," *Bollettino storico Livornese*, III (1939) and "Fonti per la storia medievale e moderna dei porti di Piombino e dell'Elba," in the same journal, II (1938). I should also like to thank my friend Professor Alessandro Parronchi, who constantly helped me in this research.

21. In Madrid MS II, fol. 6 r, Leonardo writes; "il fosso ellungho cāne 160 coe braccia 640," thus giving the value of each canna as 4 braccia. And yet the computations on fol. 36 v (fig. 34) are headed: "la cāna del terreno e braccia 64 ella cāna del muro e braccia 16." The drawing in the Codex Atlanticus may be tentatively ascribed to Antonio da Sangallo the Elder, who was employed by the Florentine republic during the war with Pisa. Cf. Canestrini (above, n. 1), pp. 272ff.

22. Each of the collector's numbers is written in the middle of the folio, in line with its longer sides. When the two folios are placed together, so as to read 130 above 131, they appear in Leonardo's customary "head-to-head" arrangement in filling the sides of a sheet folded in half. The collector's numbers are the only evidence, so far, that the two sheets were originally joined together (as mentioned below in n. 27, I was not permitted to see the original manuscript), but paper and style appear to be identical. Furthermore, a similar conjugation discussed later (fols. 48 r-a and r-b, see also n. 27), for which there is now indisputable evidence, shows the same "head-to-head" arrangement of the folios.

23. Other studies of the same gate are found in Codex Atlanticus 286 r-b, a folio half the size of the paper used in the other sheets of the series. On its verso the gate is transformed into a system of twin fortresses with a canal running in between. It is reminiscent of drawings in the early MS B, e.g. fol. 25 r, and anticipates the arrangement of twin palaces for Romorantin (1517). See also Codex Atlanticus 281 r-b and v-b, ca. 1487–1490. (Cf. MS B, fols. 57v–58r, etc.) Other drawings and fragments in the Codex Atlanticus may pertain to the Piombino series, e.g. fols. 221 v-c, 223 v-a, 225 r-d and 264 v. They must be taken in conjunction with preliminary studies in MS L. It is therefore possible that they date from the Borgia period, in the summer of 1502. This seems to be the case with the beautiful drawing of a citadel in Codex Atlanticus 41 v-a, which is in the identical style of the excavation machines in the first two folios of the Codex Atlanticus (originally one single, long sheet).

24. See the document (Beltrami, *Documenti*, no. 151) as given in its context by Frey (above, n. 9), p. 132:

1504 a di 30 dagosto.

A Francesco et Pulinari, spetiali, y 10, sono per libre 28 di biacha Alexandrina a sol. 6 [la] libra et per libre 36 di bianchetta soda a sol. 12 la libra et libre 2 di gesso, ebbe Lionardo da Vinci per dipignere, et per once 6 di cera bianca: el che Romolo [portò] per incerare una finestra di palagio della gelosia ——— y 10 sol. —.

.

A maestro Lucha del Borgo per piu spese, fatte in piu corpi giometrici, cioe di giometria, donati alla Signoria: in tutto ——— y 52 sol. 9.

(For the brackets see below, sec. V, n. 35.)

A sketch of an icosahedron shown structurally as in the illustrations for the *Divina proportione* is in Codex Atlanticus 190 r-a together with related studies of geometry. On the verso of the same folio is a sketch (only in part by Leonardo) of a warrior's head in left profile after the Anghiari study at Budapest (Popham, pl. 199).

25. Reproduced by Firpo, p. 12, together with similar drawings of a later date. They are similar in style to the sketches after the Cappella del Perdono in MS L, fols. 73 v and 74 r. Furthermore, fol. 212 v-b contains a note on jumping that may suggest an even earlier date, ca. 1500. Compare a similar note in MS M, fol. 55 r (Richter, §373). Yet we know that this problem of human movement occupied Leonardo around 1502 (cf. MS L, fol. 28 v and Codex Atlanticus 164 r-a, discussed in *Studi Vinciani*, pp. 162–166; see also Lu 390 and 401); and there is a note on jumping in Codex Atlanticus 373 v-b, a sheet of a much later period, ca. 1508–1510. The way a curtain wall should be shaped to receive hurtling missiles is also studied in MS M, fol. 82 v, but notes and sketches in MS L, e.g. fols. 39 v, 41 r, 45 r and v, 46 r, etc. (all reproduced by Calvi; see above, n. 14), show a closer relation to the notes on fol. 212 r-b etc. There are other hints that shortly before 1500 Leonardo had reasons to consider the same problem. Cf. MS I, fols. 19 r and 20 v, on which, however, the sketches may have been added at the time of MS L.

26. "avendo acquisstato lartiglieria / e $\frac{3}{4}$ dj potentia . piv chel solito e / neciessario che i mvri delle fortezze acquissino e $\frac{3}{4}$ dj resistentia piv / chel modo [*originally* mvodo] vsato." This and a selection of notes from the other folios of the series are given in *Leonardo da Vinci, Scritti Scelti*, ed. A. M. Brizio (Turin, 1952), pp. 480–483.

27. I owe this information to a student of mine, James E. McCabe, who was able to see the "restored" Codex Atlanticus in Au-

gust 1968. Only one month before, I was denied permission to see even the folios that were still in the library. See n. 67, p. 35 of my *Leonardo da Vinci inedito*.

28. See Machiavelli's letter to the Signoria, written from Imola on October 12, 1502: "... S'intende come un don Ugo Spagnuolo, capo di gente d'arme di questo Signore [Cesare Borgia] e Don Michele, capo di sue fanterie ... essendosi fatti avanti a soccorrere i castellani di Pergola e di Fossombrone, hanno preso l'una e l'altra terra, e messa a sacco, e morti quasi tutti gli abitanti" (Machiavelli, *Legazione al Duca Valentino* [Turin 1958], pp. 34–35). The event is mentioned by Sanuto, IV, 366: "... la zente di Valentino la notte intrò in Fossinbrun, cridando: Feltre! et ingannò li abitanti." See also Guicciardini, *Historia d'Italia* (Fribourg, 1775), book V, p. 465: "... le milizie borgiane furono introdotte in Pergola e in Fossombrone dai castellani di quelle fortezze." Finally, in a manuscript in the Vatican Library, Codex Urbinas 490, quoted by Tommasini, *Vita del Machiavelli*, I, pp. 240–241, it is specified that "Don Michele, partito dalla Pergola et intrato in Fossombrone *per via della cittadella cum spalle della Roccia*, saccheggiò quella città ..." (italics mine). Cf. A. Vernarecci, *Fossombrone dai tempi antichissimi ai nostri* (Fossombrone, 1914), II, p. 229. Machiavelli, in his report to the Signoria, makes a pun on the word "soccorso" (help, assistance), which is a technical term to indicate a secret passage in a fortress, usually known only to the "castellano." Leonardo indicates one such passage in one of his studies for the gate of Piombino in Codex Atlanticus 45 v-b (fig. 35). See also the note in Codex Atlanticus 41 v-b, which ends with a similar historical reference: "... e cquesto effatto per li / sochorsi falsi

come fu chi tradj simõ arrigonj." The reference to Simon Arrigoni has made it possible to date the fortification drawing in the sheet as not earlier than 1507. Cf. Solmi, *Fonti* (*Nuovi contributi*), p. 299, and my *Chronology*, p. 17.

29. Heydenreich, *Leonardo*, note to pl. 142 (surprisingly with reference to Popham 320, where the drawing is dated 1500–1505). See also the note to pl. 143, another drawing of the series, which is dated even earlier (about 1490).

30. Popham, p. 108, and pl. 320.

31. Clark, p. 176 (p. 156 of the Penguin Books edition).

V. THE HOUSE OF CHARLES D'AMBOISE

1. Beltrami, *Documenti*, no. 181.

2. Richter (note to §4) indicates that the date March 22, 1508, should be taken as a reference to 1509 because of the Florentine calendar, in which March 25 is the first of the year. Calvi (*Manoscritti*, p. 263, n. 1) states that Leonardo must have adopted the common style rather than the Florentine one, because "in the preceding March as well as in the following March Leonardo is assumed to be in Milan." Beltrami (*Documenti*, no. 194) also gives the date as 1508, and in fact no one except Richter has suspected that Leonardo, being in Florence, could have adopted the Florentine system of recording the year. A date of the Arundel MS folio in March 1509 would not affect our concept of the development of Leonardo's style; on the contrary, it would support the theory that the greater part of his anatomical drawings at Windsor should be dated around 1509–1510. Leonardo notes the date September 8, 1508, in Milan, in the first folio of MS F, which contains a reference to the

anatomy of the "old man." His dissection of the "old man" is fully described in the Anatomical MS B, fol. 10 r, as having been carried out in the hospital of S. Maria Nuova in Florence. The series of studies based thereon should therefore be dated not long before September 8, 1508; this means that Leonardo was in Florence for the greater part of 1508, and in fact since September 18, 1507, when we know he had just arrived there from Milan (letter to Cardinal d'Este, Beltrami, *Documenti*, no. 193). One of the drafts of letters addressed to his Milanese patrons contains an indirect reference to more than one stay in Milan during his second Milanese period: "alla partita mia di costà" is in fact corrected "a l'ultima partita" (cf. Calvi, *Manoscritti*, p. 266, n. 1). According to the evidence given in the list of dates in the new edition of the Windsor catalogue, his movements between Florence and Milan and vice versa can be charted as follows:

1506, May 30, goes to Milan
1507, March 5, is in Florence
1507, May-July, is probably in Milan
1507, July 26, is certainly in Milan
1507, September 18, is back in Florence
[1508?, March 22, is in Florence. Note in the Arundel MS]
1508, September 8, is in Milan. Note in MS F
1508, October, still in Milan. Note in MS F
[1509?, March 22, is in Florence. Note in the Arundel MS]
1509, May 3, in Milan. Drawing of the "Navilio dj Sancto Crisstofano"

Thus Leonardo may have left Milan the first time in 1507 before March 5, the second time again in 1507 before September 18, and the third time (if we take the date in the Arundel MS as a reference to 1509) after October 1508 and before March 22, 1509. If he wrote the letters to his Milanese patrons

at the time of the Arundel MS, as the handwriting suggests, his mentioning the "forthcoming Easter" as the time of his projected return to Milan would be a reference to April 8, 1509, which was in fact Easter Day (cf. Sanuto, VIII, p. 71). Calvi (*Manoscritti*, pp. 270–271) points out that Leonardo's reference to dry weather in an immediately preceding period may apply to either the second part of 1507 or to 1509. So there is really no serious objection to Richter's interpretation of the date in the Arundel MS as being a reference to 1509.

3. Beltrami, *Documenti*, no. 189.

4. A. Annoni, *Dell'edificio "Bramantesco" di S. Maria alla Fontana in Milano* (Milan, 1914). See also F. Reggiori, "Il Santuario di Santa Maria alla Fontana alla luce di recentissime scoperte," *Arte Lombarda*, II (1956), pp. 51–64, and my *Chronology*, pp. 53–58.

5. MS B, fol. 15 r and Codex Atlanticus 184 v-c (fig. 172), reproduced by Firpo, pp. 33 and 50.

6. See my article "Dessins d'une scène, exécutés par Léonard de Vinci pour Charles d'Amboise (1506–1507)," in *Le lieu théatrale à la Renaissance* (Paris, 1964), pp. 25–34.

It has been suggested recently (K. T. Steinitz, *Leonardo architetto teatrale e organizzatore di feste: IX Lettura Vinciana*, Vinci, 15 Aprile 1969, Florence, 1969) that my identification of the stage designs in the Arundel MS as pertaining to the d'Amboise period should be dismissed and that the folios should be dated as early as 1490. This statement, which disregards the evidence of style and handwriting, is based on the assumption that a note on mechanics in one of the folios is transcribed (according to information originating from Dr. Reti) in Madrid MS I. This is not the case. Not only are the notes in the Madrid MS unrelated to the one in

the Arundel MS folio, but Leonardo would have crossed through the note in the Arundel MS had he transcribed it somewhere else. A. Uccelli (Leonardo da Vinci, *I Libri di Meccanica* [Milan, 1940], p. 228, n. 1) indicates a related note in black chalk (almost faded away) on fol. 225 r of the same manuscript—a folio dated about 1510 because of a drawing of water vortexes related to the Windsor series 12659 etc. and because of two emblems related to the Windsor nos. 12700, 12701 (again drawings of about 1508–1510, not 1498 or 1592 as dated by Brizio, Reti, etc.). Finally, a drawing of the structure of a stage with the outline of a mountain is in Codex Atlanticus 131 v-a, a folio that Calvi, *Manoscritti*, p. 245, had already dated later than 1505.

7. ".a. ella corte del grāma/esstro .b.c. son sue came/re e ella sua sale—/ e po essere tutta aperta djnāçi."

8. Peruzzi, Uffizi, A. 15 verso. Serlio, *Libro terzo*, p. CLII. Rosci (ed. Serlio's *Libro sesto*, p. 22) traces Serlio's derivations from Poggio Reale through Leonardo and Peruzzi and points out the example of a realization of the architectural idea in Tibaldi's Palazzo delle Quattro Torri at Gravedona (Como), ca. 1586. On Poggio Reale see C. L. Frommel, *Die Farnesina und Peruzzis Architektonisches Frühwerk* (Berlin, 1961), pp. 90–98, and pl. XIII, P. G. Hamberg, "The Villa of Lorenzo il Magnifico at Poggio a Caiano and the Origin of Palladianism," in *Idea and Form: Studies in the History of Art* (Stockholm, 1959), p. 84. See also F. Schreiber, *Die französische Renaissance-Architektur und die Poggio Reale-Variationen des Sebastiano Serlio* (Halle [Saale], 1938).

9. One such aviary is mentioned in a contemporary description of the Castle of Gaillon in France, which was being built at that time by the uncle of Charles d'Amboise, the Cardinal George d'Amboise. See Robert Weiss in the *Journal of the Warburg and Courtauld Institutes*, XVI (1953), pp. 1–12 and 351.

10. It may be objected that the Codex on the Flight of Birds was compiled in Florence and has notes dated March 14, and April 14, 1505. However, the date March 14 on fol. 18 (17) v may be a reference to 1506, if Leonardo had adopted the Florentine calendar (see above, n. 2). Firpo, pp. 110–111, suggests that the architectural drawing may have been added later and considers it as a study for the House of Charles d'Amboise.

11. See Guillaume (above, sec. III, n. 9), pp. 97–101. Triple-ramped staircases are also shown on fol. 220 v-b of the Codex Atlanticus (fig. 16), discussed above, sec. III, n. 9.

12. Given in my *Chronology*, p. 39, fig. 8.

13. It is interesting, in this connection, that he uses a term ("rivolta") later used in the contracts concerning the stairs in Michelangelo's vestibule of the Laurentian Library and sometimes interpreted as referring to decorative turns, while it is used here to designate the platform connecting one ramp with the other. Cf. R. Wittkower, "Michelangelo's Biblioteca Laurenziana," *Art Bulletin*, XVI (1934), pp. 167ff, and Ackerman (above, Introduction, n. 6), vol. II, p. 35.

14. The words "ed è inginochiata" cannot be translated "and is bent like a knee" as MacCurdy, *Architecture*, has it. Leonardo speaks of the staircase as composed of two ramps that come together to a landing, thus suggesting the image of a leg that bends at the knee. The terms "inginocchiato" and "inginocchiatura" were widely used in architecture and technology from Alberti to Vasari. Compare also Michelangelo's "finestre inginocchiate" in the Medici Palace.

15. "Lasscala ellargha vn braccio e $\frac{3}{4}$ ede

inginochiata ettutta insieme / gunta e braccia 16 cō 32 scalinj larghi vn meço braccio e alti $\frac{1}{4}$ el pi/ano della rivolta ellargho braccia 2 ellūgho braccia 4 el muro che diuj/de luna scalla dallaltra e $\frac{1}{2}$ braccio ma fara lla largheça dessa sca/la largha 2 braccia tenēdo piu largha la scala $\frac{1}{2}$ braccio che verra essa / sala a essere lūgha braccia 21 ellargha braccia 10 e $\frac{1}{2}$ e cosi stara / bene effarēla alta braccia 8 bēchella sua ragō sia [alta *deleted*] lessere al/ta quāto larga. Ma ame pare quelle essere malinchonj-che perchere/stano osscure intāta alteça elle scale vēgano poi aessere trop/pe erte coe djritte —— "

16. Transliteration in the preceding note.

17. Palladio's similar departure from Alberti's postulate is discussed by P. H. Scholfield, *The Theory of Proportion in Architecture* (London, 1958), p. 61.

18. In Codex Atlanticus 145 v-c, one of the sheets pertaining to a series of geometrical studies dating from ca. 1508, is a sketch of the ground plan of a house, which seems

Codex Atlanticus 145 v-c

Codex Atlanticus 192 v-b

Codex Atlanticus 235 v-a

to consist of two building blocks placed at either end of a long rectangular court. One is reminded of house projects by Serlio and de L'Orme discussed by Rosci in his edition of Serlio's *Libro sesto*, p. 54. The narrow façade has indications of detached columns flanking the central bay. In two other folios of the same series are other slight architectural drawings: on fol. 192 v-b, sketches of some rustic construction made of tree trunks; and on fol. 235 v-a, the sketch of a basilica (Firpo, p. 55), somewhat resembling Peruzzi's cathedral at Carpi, 1515 (R. Wittkower, *Architectural Principles in the Age of Humanism* [London, 1952], pl. 32c).

19. Attributed to Brunelleschi himself by R. Longhi, "Fatti di Masolino e di Masaccio," *La critica d'arte*, V (1940), pp. 161–162, and figs. 22, 23. Cf. P. Sanpaolesi, *La Sacristia Vecchia di S. Lorenzo* (Pisa, 1950), pp. 6–7, in which it is dated ca. 1427–1435, and H. W. Janson, *The Sculpture of Donatello* (Princeton, 1957), II, p. 131, n. 5, in which it is dated from the second half of the century. See also M. Meiss, "Masaccio and the Early Renais-

V. CHARLES D'AMBOISE

sance,.. in *Acts of the Twentieth International Congress of the History of Art*, II (1963), p. 139, pl. xxxv, 21, and A. Parronchi, *Studi su la dolce prospettiva* (Milan, 1964), pl. 92b.

20. Codex Atlanticus 83 r-a, in a memorandum of ca. 1515: "el peruzo ghōfiatoio," and 97 r-a: "nudo del peruzzo" (not "A nude by Perugino," as given by MacCurdy, II, *Miscellaneous*).

21. The problem, which I touch in my *Chronology*, p. 45, is fully discussed by P. M. Wolf in *Marsyas*, XII (1964–1965), pp. 16–21.

22. Alberti, IX, iv (Leoni ed., p. 193).

23. Alberti, I, x (Leoni ed., p. 14). Cf. Wittkower (above, n. 18), p. 34.

24. It can be argued that the Vendramin-Calergi Palace was not yet built in 1500 and that Leonardo could hardly have seen projects of it during his brief visit to Venice in that year. A nineteenth-century historian, G. Selva, who had access to the Vendramin archives, states that the palace was begun in 1481, but Jacopo de' Barbari's view of Venice of 1500 does not include it. Cf. M. Luxoro, *Il Palazzo Vendramin-Calergi* (Florence, 1957), p. 5. Of course, Barbari's omission is not to be taken as indisputable evidence that the construction of the palace had not yet been begun in 1500. The large woodcut was begun in 1497, and it is reasonable to suspect that the preliminary design dates even earlier. See L. Servolini, *Jacopo de' Barbari* (Padua, 1944), p. 51.

25. Cf. B. M. Apollonj, "Il prospetto del Palazzo Romano del Primo Cinquecento: Saggio sulla sua origine e su i suoi sviluppi," in *Atti del Primo Congresso Nazionale di Storia dell'Architettura* (Florence, 1938), pp. 237–243. In the Colosseum there is also the "bottega type" of opening in the cella for the elevator of the wild beast cage. See G. Cozzo, *Ingegneria Romana* (Rome, 1928),

pp. 231–235, and figs. 171–174.

26. Serlio, *Libro quarto*, fols. 54v–55: ". . . tutte quelle cose dentro alle quali la uista si puo dilatare, sono sempre di più satisfattione." Serlio's concluding remark is also revealing in that it stresses the idea underlying the principle of emphasizing structure rather than surface: "Qui sotto non dimostrerò pianta alcuna di questa seguente faccia, perchè la prospettiua delle loggie dimostra il tutto chiaramente." Serlio's reference in this connection to Venetian architecture is also significant: "E questa fabrica non pur seruiria per una al costume di Venetia; ma alla villa saria molto al proposito." The woodcut in fact includes the representation of water as in the plates on fols. 33 and 34.

27. In the same sheet are sketches of a pump, one of which is inscribed: "tronba . da imola." This suggests a reference to Leonardo's sojourn in Imola in 1502 (*Studi Vinciani*, p. 220), but the style of the drawings points to a later date, probably around 1505. Furthermore, the architectural sketch is done with a different pen and in a paler ink.

28. Compare the sixteenth-century drawing reproduced by E. di Geymüller, *Raffaello Sanzio studiato come architetto* (Milan, 1884), p. 25.

29. Codex Magliabechianus K. I. 140 (Spencer ed.). Cf. M. Salmi, "Antonio Averlino detto il Filarete e l'architettura Lombarda," in *Atti del Primo Congresso Nazionale di Storia dell'Architettura* (Florence, 1938), p. 190, n. 1, for the suggestion that Filarete's "Palazzo in luogo palustre" may represent a project for the Ca' del Duca at S. Michele on the Grand Canal at Venice, in the area of a house of the Corner family bought by Francesco Sforza in 1461.

30. *Raccolta Vinciana*, XIX (1962), p. 273.

31. Cf. MS M, fols. 55 v and 56 r, ca. 1498–1500. See also the reference to Bramante on fol. 53 v: "modo del pōte leuatoi° che mj mostro donnjno."

32. P. Giovio, *Dialogo dell'imprese militari e amorose* (Lyons, 1574), pp. 102–103. Cf. *Chronology*, p. 42, n. 16.

33. As told by Serlio in his description of Poggio Reale. J. Shearman, *Mannerism* (London, 1967), pp. 126–127, points out that the tedious conceit of the "wetting sports" was current at the Burgundian court early in the fifteenth century and that it appears all over Italy around 1500.

34. It may be surmised that the mechanical bird was meant to be the partridge in a representation of Poliziano's *Orfeo*, as suggested in my article quoted in n. 6 above.

35. A tear in the paper makes the last eight lines fragmentary. The following transliteration includes a tentative restoration of the missing section, which differs considerably from that given by Beltrami, *Documenti*, no. 42 (under the wrong date ca. 1490): "la sala della festa / vole avere la sua colle/tione inmodo chepri/ma passi djnāti al si/gnjore epoj a chōujtatj / essia il camjno imodo / che hessa possa venjre / insala imodo nōpassj / djnāçi al popolo piv / chellomo si voglia he / sia dalloposita parte / situata aris-scōtro al / signjore la entrata de/lla sala elle scale como/de imodo. che sieno ā/plie imodo che le giē/te per quelle nonabino / vrtando linmascera/tj aguastare le loro / [f]oggie quā vsscissi / [grande] turba domjnj / [insieme] cō tali imassche/[rati] vole tale sala a/[vere] due camere per testa / [cō] sua destrj doppj / [. . .]adj queste vn vscio / [per la col]letione e v̄ per li ma/[scher]atj ——"

In the transcription of Leonardo's manuscripts I have used square brackets to enclose words or letters missing because of damage

to the paper and angle brackets ⟨ ⟩ to supply words or letters that Leonardo neglected to write.

36. Windsor 12591 (Richter, §§1103, 1104). Leonardo might have known the long description of the garden of Venus in the *Hypnerotomachia Poliphili* (1499), but his own description was more probably inspired by Poliziano, *Stanze*, I, 70, or even by a passage in the *Paradiso degli Alberti* (ed. A. Wesselofsky [Bologna, 1867], II, p. 29). Cf. A. Marinoni, "Il regno e il sito di Venere," *Atti del IV Congresso Internazionale di Studi sul Rinascimento* (*Il Poliziano e il suo tempo*) (Florence, 1954), pp. 273–287. For the Neptune fountain considered as a possible project for the garden of the Castle of Bury see *Chronology*, pp. 49–52. There is still much to be investigated about the revived classicism in Milan in the first decade of the sixteenth century and its reflection in the works of Leonardo and his followers. It is enough to mention that one of Leonardo's patrons and a close collaborator of Charles d'Amboise, the vicechancellor Japhredus Karoli (or Charles), edited Horace (Venice, Aldus, 1509), and Gaffurio dedicated his treatise *De harmonia musicorum instrumentorum* to him in 1508. The *Storia di Milano*, VIII (1957), pp. 65–68 (chapter by G. P. Bognetti), presents a somewhat fanciful theory about the symbolism of Charles d'Amboise's architectural programs in Milan and proposes to establish a parallel between Giampietrino's *Nympha Egeria* (Milan, Marchese Brivio collection) and the building of S. Maria alla Fontana.

37. On *Leda* as symbol of the female aspect of creation see Clark, p. 117: "Even those elaborate coils of hair seem appropriate to the intricacy of conception. All round this passive figure, nature is bursting with new life, thick grasses writhe out of the

earth . . ." An excellent analysis of the two versions of the *Virgin of the Rocks* is given by J. Shearman in *Zeitschrift für Kunstgeschichte*, XXV (1962), pp. 13–47.

VI. THE VILLA MELZI

1. Notes by Venanzio de Pagave in the della Valle edition of Vasari, vol. V (Siena, 1791), p. 65. Cf. *Raccolta Vinciana*, XX (1964), pp. 220ff. See also above, Appendix B.

2. No. 12400. For the revised date of such drawings see the new edition of the Windsor catalogue, *sub numero*.

3. Windsor 19077 v (C. II. 7). Other references to Vaprio are on 19092 v (C. II. 22) and 12667 r.

4. Cf. Beltrami, *L'espugnazione del Castello di Trezzo nel gennaio 1513 in uno schizzo di Leonardo* (Milan, 1923).

5. The note reads as follows: "nella parte terrena il trā/sito a b andra nellorto overo per il transito c d / essevoi entrare nel/lorto per _a_ _b_ tu puoj fa/re lasscala della canova / socto ilcha della scala n m / cioe sotto m edjsscien/dere inchanoa [s *deleted*] conis/scala chessi faccj choperchio / della scala n m malluscio / dellorto fia basso ——" (On the ground floor the passage _a b_ will lead to the garden through the passage _c d_, and if you wish to go into the garden through _a b_ you can make the staircase of the cellar underneath the slope of the staircase _n m_, namely underneath _m_. In this way you will come down into the cellar through a staircase, which is roofed by the staircase _n m_, but let the door of the garden be low).

6. No. 19107 v (C. IV. 1), anatomy of bird's wing and studies for the Villa Melzi (fig. 74). Compare no. 12662, studies of water vortexes, and no. 12356, study for the Trivulzio Monument.

7. Nos. 12656 and 12657.

8. The Windsor anatomical fragment 19110 (C. IV. 4) is of the same paper and might originally have been part of this sheet.

9. See my article "Leonardo da Vinci e la Villa Melzi a Vaprio," *L'arte*, XVIII (1963), pp. 229–239.

10. Heydenreich, *Leonardo*, note to pl. 126.

11. Windsor 12579 verso. Cf. Frommel (above, sec. V, n. 8), p. 133, pl. ixf. Firpo, p. 136, interprets the vegetable motif as "figure di belve in corsa."

12. Popham, pl. 282. Richter, §389, and pl. xxv. Cf. *Libro A*, p. 13, and pl. i.

VII. THE NEW MEDICI PALACE

1. A sketch of the villa seen from the northeast is found in Codex Atlanticus 78 v-b (*Chronology*, p. 82). It is done with the right hand, probably not by Leonardo. It could be by Melzi, who has written at the top of the sheet "Teodorus Rex" and "Semper Augustus bono resp . . ." (Richter, §1556). On the same sheet, upside down, Leonardo wrote the well-known sonnet of precepts of hygiene (Richter, §855, MacCurdy, *Miscellaneous*); a fragment of a line from this ("non star . essta coper[to ben di notte]") is on fol. 159 r-c, which contains a sketch of the ground plan of a church, reflecting Bramante's project for St. Peter's, and a sketch of the ground plan of the wing of a palace, probably representing Leonardo's quarters in the Belvedere (*Chronology*, pp. 83–84). The sonnet is by a fourteenth-century anonymous author, known in a manuscript in the Municipal Library at Udine. Cf. Solmi,

Fonti, pp. 211–212. It is printed by A. Venusti, *Discorso generale intorno alla generatione* . . . (Venice, 1562), p. 22, as coming from a Milanese physician. Venusti's chapter on human proportions (pp. 107–108), based on Girolamo Figino's, reflects Leonardo's theories very closely. Cf. Bossi (above, sec. I, n. 1), p. 260, n. 20.

2. See C. Ricci, "Leonardo in Vaticano," *Raccolta Vinciana*, X (1919), pp. 113–116. See also Beltrami, *Documenti*, no. 218.

3. Codex Atlanticus 90 v-a (Richter, §1376 B).

4. Cf. O. H. Förster, *Bramante* (Vienna-Munich, 1956), p. 261. One such scaffolding is shown in place in a view of St. Peter's in Vasari's Cancelleria fresco "Paul III visiting the work in St. Peter's," reproduced by Ackerman, (above, Introduction, n. 6), vol. I, pl. 52b. Such a scaffolding might have been used to vault the Medici stables in Florence, 1515–1516. See n. 8 below.

5. Codex Atlanticus 283 r-e (originally numbered 27), reproduced together with fol. 225 r-a (originally numbered 28). The statue of Ariadne was placed in the niche at the northeast corner of the court of the Belvedere Villa, as shown in the Hollanda sketchbook. See J. S. Ackerman, *The Cortile del Belvedere* (Vatican City, 1954), p. 37. See also H. H. Brummer, *The Statue Court in the Vatican Belvedere* (Stockholm, 1970). A bronze cast of it commissioned by Francis I from Primaticcio and Vignola was sent to Fontainebleau in 1541–1543 and is now in the Louvre. The fragment with the sketch of Ariadne is used as a "patch" to fill a lacuna produced by the extraction of a drawing. The late folios in the Codex Atlanticus are almost systematically mutilated in this way, and the loss of what might have been an enormous amount of drawings seriously affects our concept of Leonardo's latest de-

velopment as an artist. A discovery of the missing material would reveal entirely new aspects of Leonardo's life and work, at which the remains in the Codex Atlanticus cannot even hint. It is much to be hoped, at least, that a search may be undertaken in the Roman archives to find new information to supplement the little we know about Leonardo's Roman period. (A note by Frommel in *Raccolta Vinciana*, XX [1964], pp. 369ff, shows that the field is most promising.) I must mention in this connection that in Rome Leonardo must again have met Atalante Migliorotti, his former associate at the time of his first trip to Milan. Milanesi, in his last note to Vasari's life of Leonardo, gives the important information that Migliorotti was a superintendent architect at the Vatican between 1513 and 1516 and that he was last recorded in 1535 as an architect. Unfortunately, Milanesi does not give the source of this information. Nothing else is known of Migliorotti, who started his career as a musician in association with Leonardo.

6. On September 25, 1514, Leonardo was in Parma, and two days later he was at S. Angelo near the Po, probably on his way to Milan (Beltrami, *Documenti*, nos. 220, 221). And yet on the following October 10 he is recorded back in Rome (*Raccolta Vinciana*, XX [1964], p. 370). Leonardo's patron, Giuliano de' Medici, was the military governor of Parma and Piacenza. In Codex Atlanticus 44 r-b and v-b there are sketches of the ground plan of a large building, the purpose of which is still unknown. Cf. *Chronology*, pp. 99–102, for my reconstruction in scale of the building and for the suggestion that the drawing may date from around 1514–1515. The structure seems to be fortified and may have had something to do with Leonardo's sojourn in Parma in Sep-

tember 1514, but this cannot be ascertained yet, since the available studies on castles and fortifications in the area of Parma and Piacenza do not include ground plans (e.g. A. Ghidiglia Quintavalle, *I castelli del Parmense*, Parma, 1955). The folio is in a group of studies for the fortifications of Piombino (see above, sec. IV), but I have reasons to believe that it has nothing to do with Piombino.

7. Between 1514 and 1515 Leonardo prepared a project for the drainage of the Pontine marshes, as shown by the famous map at Windsor, no. 12684. E. Solmi, "Leonardo da Vinci e i lavori di prosciugamento delle paludi Pontine ai tempi di Leone X (1514–1516)," *Archivio storico Lombardo*, XXXVIII (1911), has published the documents pertaining to the scheme initiated under Leo X for draining the Pontine marshes. The project was actually undertaken. On January 9, 1515, Giuliano de' Medici, who had obtained from his brother the pope "totum et omne territorium quod putridis stagnatur aquis et Palus Pontina inundat," entrusted part of his property to a Messer Domenico de Juvenibus with the task of draining it, and in the ensuing months the owners of the neighboring properties joined in the enterprise. Finally, on May 19, 1515, a new contract was drawn up, and Fra Giovanni Scotti of Como took charge of the project, successfully carrying out a scheme that is reflected in Leonardo's map. The event is recorded by Cesariano in his commentary to Vitruvius (Como, 1521), fol. 20 r: "Queste pontine paludi per un frate di Como nostra aetate sono sta purgate et evacuate, cosa che mai Romani il poteno fare." The project was abandoned soon after Giuliano's death in 1516.

8. Codex Atlanticus 96 v-a. *Chronology*, pp. 125–128, and Firpo, p. 93. The comple-

tion of the vaulting of the Medici stables is recorded in Landucci's *Diary* under the date January 17, 1516.

9. B. Varchi, *Oratione funerale fatta e recitata pubblicamente nell'esequie di Michelagnolo Buonarroti in Firenze nella Chiesa di S. Lorenzo* . . . (Florence, 1564), pp. 54ff.

10. See Introduction, p. 4.

11. See sec. III above.

12. See Introduction, n. 5.

13. See n. 6 above.

14. See my article "An arcus quadrifrons for Leo X," *Raccolta Vinciana*, XX (1964), pp. 225–261.

15. Cf. *Chronology*, pp. 107–128.

16. Richter (1st ed., 1883), II, p. 32; (2nd ed., 1939), p. 24, and pl. LXXXII.

17. The mills of the Castel Sant' Angelo are described in a codex of one of Leonardo's contemporaries, Benvenuto di Lorenzo della Golpaja (MS 5363 in the Biblioteca S. Marco, Venice, fol. 81 r). Cf. *Chronology*, p. 113. The same codex, fol. 64 v, contains a list of data on the surveying of Florence. It is known that during the siege of Florence in 1529 Benvenuto della Golpaja and Il Tribolo secretly prepared a model of the city and sent it to Pope Clement VII. In his life of Tribolo Vasari explains that Golpaja's surveying work was carried out during the night with a magnetic compass. Such a system, which is described by Raphael in a letter to Leo X, had already been adopted by Leonardo in preparing the map of Imola.

18. An edifice somewhat like Palladio's Villa Rotonda appears in a drawing attributed to Leonardo and reproduced by C. Amoretti, *Memorie storiche su la vita, gli studi e le opere di Leonardo da Vinci* (Milan, 1804), pl. II B, fig. 7. Since the original drawing, which was in the Ambrosiana, cannot be located, its attribution to Leonardo remains uncertain.

19. The problem is fully discussed in my article in *Raccolta Vinciana*, XX (1964), pp. 225ff.

20. Cf. fig. 4, *ibid*.

21. Cf. C. de Tolnay, *Michelangelo*, vol. III: *The Medici Chapel* (Princeton, 1948), pp. 33–37, and pls. 84, 86, 88.

22. In my *Chronology*, pp. 124–125, I suggested that Leonardo's plan might have been intended as a development of Landucci's earlier idea that Il Cronaca was asked to study, that is, to raze the block in front of S. Lorenzo in order to have a new freestanding church built in honor of S. Giovanni the Evangelist. Such an idea, as well as Leonardo's plan, may stem from an earlier prototype, a Medici Palace planned by Brunelleschi as an imposing free-standing structure in front of S. Lorenzo. Cosimo de' Medici reverted to a more restrained project, but the Medici must always have visualized the possibility of relating the family church of S. Lorenzo to their palace by means of a piazza. A. Parronchi ("Una Piazza Medicea," *La Nazione* [24 August 1967], p. 3) has even suggested that the famous perspective panel in the Ducal Palace at Urbino may reflect such an idea. The same idea is even better expressed in the background of a Visitation scene in a *Book of Hours* of Loadamia de' Medici, British Museum, Yates Thompson MS 30, fol. 20 v (C. H. Krinsky, "A View of the Palazzo Medici and the Church of San Lorenzo," *Journal of the Society of Architectural Historians*, XXVIII [1969], pp. 133–135, and fig. 1). Since the Medici Palace is shown with the corner still open in a loggia, this miniature must date before 1517. The front of S. Lorenzo is completed with a façade somewhat inaccurately rendered, yet suggesting a combination of traditional Florentine forms (Alberti) and High Renaissance ideas (Sangallo, Michelangelo) in a way that recalls Leonardo's late drawing at Venice (*Chronology*, fig. 69). I am tempted to date the miniature about 1515 and to consider it as a reflection of Leonardo's plan. Leonardo's relationship with miniaturists is known: in 1513–1514 he refers to the "scriptoio di Gherardo miniatore" in S. Marco at Florence (Windsor 19076 r); a "Francesco miniatore" is mentioned in Windsor 19027 r, about 1508; and Melzi himself was a miniaturist. Thus his ideas were directly available to such a category of artists. The *Book of Hours*, which has been attributed to Attavante (1452–1517), was produced for Laodamia de' Medici, daughter of Pier Francesco de' Medici (1463–1503) and of his wife Semiramide di Giacomo Appiani of Piombino (d. 1523). Leonardo was well acquainted with both Pier Francesco de' Medici and Giacomo (or Iacopo) Appiani. Furthermore, he was on friendly terms with Attavante himself, to whom in 1503 he lent four gold ducats (Arundel MS, fol. 229 v, Richter, §1525: "Ricordo chome addj 8 daprile 1503 io lionardo daujcj prestai a uãte mj/njatore ducati 4. doro . . ."). Attavante, like Leonardo, was one of the committee of artists who, in 1504, considered the installation of Michelangelo's *David*.

23. G. Marchini, *Giuliano da Sangallo* (Florence, 1942), pls. x*a* and *b*.

24. Alberti, IX, i (Leoni's ed., p. 188): "We may observe with what a beautiful effect some of the more lively architects used . . . to make columns, especially in the porticoes of their gardens, with knots in the shafts, in imitation of trees that had their branches cut off, or girded round with a cinture of boughs." Compare the remarks that Francisco de Hollanda attributes to Michelangelo (*Dialoghi Michelangioleschi*, ed.

VII. THE NEW MEDICI PALACE

A. M. Bessone Aureli [Rome, 1953], p. 133): "From this [i.e. the artistic conception of a chimeric creature] originates man's insatiable desire of preferring to a building with its columns and doors and windows a chimeric one, grotesque, the columns of which may be made of reeds or other things which appear impossible and irrational, but which may turn out to be very beautiful if executed by someone who has a great knowledge of them." A sketch by Leonardo in Codex Atlanticus 98 r–b, ca. 1490, which was engraved as early as 1784 in the Gerli edition of Leonardo's drawings, shows another aspect of "bizarre architecture" that would have been well suited to a mannerist building: the motif of "The Lovers," perhaps derived from an antique group of Eros and Psyche, appears to be used as a caryatid, although the

Bayonne, Musée Bonnat

Codex Atlanticus 98 r–b

group may have been intended to stand in front of a column with an elaborate shell, as are the figures in an earlier drawing for the *Adoration of the Magi* at Bayonne (Popham, pl. 45). Such motifs may be studied in the context of the origins of the Netherland Grotesque, as suggested by H. H. Brummer in his review of Schéle's book on Cornelis Bos, *Renaissance Quarterly*, XX (1967), pp. 477–480.

311

25. Windsor 12591 r. Cf. A. Marinoni (above, sec. V, n. 36), pp. 273–287. Recently, J. Shearman ("Raphael . . . 'fa il Bramante,' " in *Studies in Renaissance and Baroque Art presented to Anthony Blunt* [London, 1967], p. 16) has pointed out that Leonardo's design is connected with the earliest surviving Villa Madama ground plan (Uffizi A. 1054; cf. the *torrioni*), and with a Raphael drawing at Oxford for the same villa.

PART TWO

I. THE OLD CHATEAU

1. Archives du Loiret, A 698–699, 703, as quoted by Stein (see n. 4 below).

2. Dupré, p. 12. The manuscript of Dupré's *mémoire* preserved in the Municipal Library at Blois (MS 297) contains (pp. 177–180) a more detailed account of the Château of Romorantin, its origin and alterations, but there is no additional observation about the project for enlargement.

3. Dupré (MS), p. 178, n. 3.

4. H. Stein, "L'architecte du Château de Romorantin," *Bulletin monumental*, LXIII (1898), pp. 335–340.

5. E. Paty, "Notice sur la Ville de Romorantin," *Bulletin monumental*, IX (1843), p. 125: "François Ier affectionait Romorantin, comme on aime toujours les lieux où s'écoulèrent les suaves journées de l'enfance. Il fit au château des embellissements qu'il est facile de reconnaître; l'on peut même voir encore, à plusieurs pieds hors de terre, les fondations d'un corps de bâtiment, commencé par son ordre, pour prolonger le château existant. Mais il abandonna presque aussitôt ce projet d'agrandissement et porta ses plans à Chambord. Peut-être faut-il attribuer ce changement à une peste qui sévit dans le pays, vers l'an 1520, par suite du dessêchement d'un étang qui existait long des murs, à l'est de la ville." The anonymous author in the Miscellanea Berge (see note 11 below), p. 19, writing at the beginning of the nineteenth century says: "Il y a peu de temps qu'on reconnaissait encore les fondations de ce château." But the *Notice* by Goberville of 1879 (Berge, no. 2), p. 36, does not mention the foundations: "On avait entrepris pas ses ordres [Francis I's] les travaux d'une royale et magnifique résidence lorsque la peste le força de se retirer à Chambord où il fit construire en 1520 le Château qui existe encore."

6. *Bulletin monumental*, XXXIV (1868), p. 206.

7. Paris, Archives Nationales, R⁴ 496, no. 2. Reproduced in Appendix A, document 1.

8. J. Bernier, *Histoire de Blois* (Paris, 1682), p. 237.

9. Cf. Dupré (MS), p. 179. The information is taken from an eighteenth-century manuscript by M. De Froberville, *Mémoires de la Sologne*, p. 115. Dupré (p. 18 of the publication) refers to the Froberville MS as containing the information that the château planned by Francis I was to have an immense park that would have included the Braudan forest (ten kilometers from Romorantin), and concludes: "Ce plan gigantesque aurait peut-être produit un plus magnifique résultat que Chambord lui-même." The Froberville MS was donated to the Bibliothèque de Romorantin by the family in 1941, but it has not been located yet.

10. Heydenreich, *BM*, p. 278.

11. They are: (1) *Notes sur Romorantin par un anonyme. Notice* (pp. 1–26); (2) *Notice sur Romorantin. Régime féudale par M. Goberville, 31 Mai 1879* (pp. 27–63); (3) *Notice sur la ville de Romorantin par Nicolas Millot* (pp. 65–93); (4) *Recherches Historiques sur Romorantin par M. Dupré* (pp. 95–139; pp. 140–210, *Additions*, i.e. the section that was not published; pp. 211–230, *Pièces justificatives*; pp. 231–243, *Table*); (5) *Charte de franchise accordée aux habitants de Romorantin par Louis, Comte de Blois le 25 octobre 1196* (pp. 245–256); (6) *Notice sur les monnaies frappées a Romorantin* par M. Cartier (pp. 257–262); (7) *Antiquités de la Ville de Romorantin* (Anonymous), *I^er Mai 1790* (pp. 263–289).

12. Paris, Archives Nationales, cat. 1322, N III, *Loire et Cher* 2: "Plan du Château Roïal de Romorantin appartenent a S. A. S. le Duc d'Orléans." No reference to such an enlargement or "vestiges d'anciens bâtiments," as specified in the map, is to be found in Bernier's report of 1682 (see n. 8 above), unless the reference to the château as being "presque encore tout entier" implies that there was some part of it in ruinous condition. The scale of the map is specified as representing "10 Perches de 24 pieds," which means that a "perche" is 24 feet. A map in the Miscellanea Berge, which represents the "moulins" of the Saudre River (but without indication of the château), has a scale of 25 "perches" with the specification that a "perche" equals 4 toises.

13. Compare the plan in Du Cerceau's *Livre d'architecture*, pl. XXX.

14. The Anonymous Gaddiano, the earliest biographer of Leonardo, states that he went to France sometime after having been in the service of Cesare Borgia: "Et dipoi stette col duca Valentino et anchora poi in Francia in piu luoghi. Et tornossene in Milano" (*Il Codice Magliabechiano . . .* ed. C. Frey [Berlin, 1892], p. 110; Beltrami, *Documenti*, no. 254). The information is not confirmed by any document, but there are a few references in the Leonardo MSS showing that around 1508–1510 Leonardo was in two places in Switzerland that mark a route to France. See below, sec. IV, n. 6. Furthermore, in MS K, vol. III (ca. 1507–1508), fol. 20 r, the water conduit built by Fra Giocondo in the garden of the Blois Castle is referred to. Finally, it is possible that Leonardo went to Lyons in 1515 and met Francis I there. This is suggested by a reference by Michelangelo Buonarroti the Younger mentioned in the Introduction above, and by a note in Codex Atlanticus 79 r-c, a sheet with notes on the *Deluge*, ca. 1515: "bonbarde dalliō a vinegia chol modo cheio / detti a gradisca inel frigholi e in avn . . ." (cf. *Raccolta Vinciana*, XIX [1962], pp. 267ff).

15. About Pierre Nepveu in general see C. Bauchal, *Nouveau dictionnaire biographique et critique des architectes français* (Paris, 1887), p. 443. About his activity at Chambord after 1522, see F. Lesueur, "Un nouveau document sur la construction du Château de Chambord," *Bulletin de la Société de l'histoire de l'art française* (1931), p. 218, and, by the same author, "Les dernières étapes de la construction de Chambord," *Bulletin monumental*, CIX (1951), pp. 7ff and n. 3, p. 11. See also R. Blomfield, *A History of French Architecture* (London, 1911), vol. I, pp. 22, 29–30.

II. THE PLANS OF A NEW PALACE

1. Firpo, p. 120, follows the reading given in the edition of the codex: "strada da basso" (lower street). The correct reading "strada

dābosa" (road to Amboise) had been given already by Richter (1883 edition, vol. II, p. 33, note to §748). See also Heydenreich, *BM*, p. 281.

2. In rendering the measurements of the court we assume that a braccio is about two feet. However, a more precise equivalent can be suggested by a circle in Leonardo's MS G, fol. 52 v, specified as having the diameter of one "oncia," i.e. the twelfth part of a braccio. The diameter of the circle is 51 mm. Thus the braccio adopted by Leonardo around 1510–1515 measures exactly 0.6120 m. Assuming that this was the type of braccio used in his Romorantin project, we would have the following figures: 48.96 m. for the width and 73.44 m. for the length of the court. The façade (160 braccia) would therefore be 97.92 m., excluding the projection of the towers.

3. "Jl palaço del principe de auere djnāti vna piaçça." Firpo, p. 120, states that this axiomatic sentence echoes the one that Leonardo himself had written as one of his marginalia in the Ashburnham MS of Francesco di Giorgio's treatise: "I palazzi dei signori ovvero principi devono avere un'ampia piazza, intorno libera ed espedita" (The palaces of lords or princes must have a wide and free piazza in front of them). No such note by Leonardo is found there, but a very similar sentence occurs in the text of the treatise itself (see Maltese's ed., vol. II, p. 351).

4. "Le abitationenj doue sabbia abballare offare diuersi / salti e vari movimēti chomoltitudjne dj gente sieno ter/rrene perche gia no vedute ruinare [ov *deleted*] cholla morte dj / moltj Essopra tucto fa che ognj muro per sottile che / sia abbia fondamēta interra ossopra archi bene / fondati."

5. "Sieno li meçanelli delli abitacholi /

djujsi da muri fatti dj stretti mac/tono [s *deleted*] essança legnjamj perriss/spetto del fuocho ——

"Tucti li neciessarj abbino esalatio/ne per le [m *deleted*] grasseçe de muri e in / modo chesspirino perli tectj ——

"lj meçanellj sieno in volta le qualj / sarā tanto piu forti quāto esarā mi/nori ——

"Le chatene dj quercie siē rinchi/vse perli muri accio nō siē offese / dal focho ——

"Lesstāçe dandare adesstri sieno / molte [de *deleted*] chēentrino luna nellal/tra accioche il fetore nonjsspiri per / leabitationj ettutti lj loro vsscj / siserrino chollj chōtrappesi."

6. See sec. V, below.

7. The word "famigli" inscribed in the right end section of the second court next to the stables has not been transcribed before. Cf. Heydenreich, *BM*, p. 281, and Firpo, p. 120. (See also above, Part One, sec. II, n. 17.) Richter, §748, transliterates and translates all the notes in the folio, with the exception of the word "famigli," and mistakenly refers the measurements of the court to the stables. Cf. MacCurdy, *Architecture*.

8. Alberti, IX, vi (Leoni ed., p. 198). Cf. Wittkower (above, Part One, sec. V, n. 18), part IV. See also Scholfield (above, Part One, sec. V, n. 17), p. 56

9. Vasari, *Introduction to the Lives* (*Architecture*, chap. VII), refers to both in his description of an ideal palace: "Il cortile figurato per il corpo sia quadro ed uguale, ovvero un quadro e mezzo, come tutte le parti del corpo." (The courtyard, representing the trunk, should be square and equal, or else a square and a half, like all the parts of the body).

10. Codex Atlanticus 107 r-b, dated May 1517, to be compared with fol. 106 r-b (fig. 115), which contains studies for the Romorantin project.

11. Codex Atlanticus 118 v-b: "La massima perfectione della diuisione del circhulo in parte equali e il numero senario." This folio as well as fol. 111 r-a and v-a, and Windsor 12670, can be dated to 1518 by comparison wtih Codex Atlanticus 249 r-a and r-b (joined together in the original), which is dated at Amboise June 24, 1518. On the significance of the number six see Vitruvius III. ii, 6–7. The source of Leonardo's studies on lunulae was Georgio Valla's *De expetendis et fugiendis rebus*, a celebrated scientific encyclopedia published at Venice in 1501 and the first publication to include a discussion of Hippocrates' lunulae. Cf. R. Marcolongo, *Studi Vinciani* (Naples, 1937), pp. 50–64. The principle of the first lunula of Hippocrates is simple: a semicircle is traced on each side of a square inscribed in a circle; the resulting area between the arcs of the four semicircles and the circle equals the area of the square. Leonardo applied the principle to an endless number of variations, achieving at times the most intricate decorative patterns. A drawing in one of his studies for the Trivulzio Monument (Windsor 12359), which resembles the plan of an architectural member, is in fact the diagram of a lunula. See *Windsor Catalogue*, Appendix D.

12. Serlio, *Libro primo*, p. 14.

13. *Trattato della Pittura*, first chapter.

14. His instructions would have been obvious to any builder of the time, as his theoretical writings of an earlier date would also have been, e.g. Arundel MS, fol. 157 v (Richter, §771): "What is the law by which buildings have stability . . . The walls must be all built up equally, and by degrees, to equal heights all round the building, and the whole thickness at once, whatever kind of walls they may be." See also Arundel MS, fol. 138 r (Richter, §789): "As to foundations of the component parts of temples and other public buildings, the depth of the foundation must be in the same proportions to each other as the weight of the material which is to be placed upon them. Every part of the depth of earth in a given space is composed of layers, and each layer is composed of heavier or lighter materials, the lowest being the heaviest." These notes date from ca. 1508. Leonardo must have had access to sources unknown to us. In the so-called Ligny memorandum in Codex Atlanticus 247 r-a, ca. 1498–1500 (Richter, §1379), he has such entries as "le misure delli edifiti publici" and "il teatro di Verona" (to be obtained from a Giovanni Lombardo) that are still unexplained. See also some of the entries in Codex Atlanticus 225 r-b, ca. 1492 (Richter, §1448), e.g. "Libro che tratta di Milano e sue chiese," "misure della corte vecchia," "misure del castello," "della misura di Sco Lorenzo." We know now that he owned a copy of Alberti's *De re aedificatoria* (see above, Part One, sec. I, n. 8) and probably a copy of Vitruvius.

15. Codex Atlanticus 335 r-a. Cf. Calvi, *Manoscritti*, pp. 300–301.

16. Quoted above, Part One, sec. II, n. 9.

17. A. de Beatis, *Die Reise des Cardinals Luigi d'Aragona*, ed. L. Pastor (Vienna, 1905), pp. 144–145, describes the stables at Blois as "una stalla del roy Francesco, dove sono XXXVIII cavalli, tra quali ne son circha XVI corsieri," and refers to "monsignor il Gran Cudiero Galeazzo Sanseverino, quale per essere cavallarizzo magiore de la predicta Maestà ne ha cura."

18. Geymüller, in Richter, II, p. 52. Firpo, p. 16.

19. A list of all of them would probably amount to over a hundred folios in the

Codex Atlanticus. I mention only fol. 97 r-b, which contains a sketch of the harbor of Civitavecchia (*Chronology*, p. 85, fig. 46) and is therefore datable around 1514, and fol. 95 r-a, which might be the earliest of the series because it is the parent sheet of two anatomical fragments at Windsor, ca. 1513–1514 cf. *Windsor Fragments*, pl. 7; *Chronology*, pp. 92–93). But I must mention also fol. 230 v-a, b, because one of its lunulae is inscribed with the date March 3, 1516, and contains a sketch (covered by a note) of a Hercules and the Hydra, which might be

Codex Atlanticus 230 v-a

related to some collection of antiques in Rome. Finally, the slightly more untidy fol. 170 r-b, c, which contains the same type of lunulae, appears even closer to the format of the Romorantin folio. (Notice also the water stain at the margin.) Its interest is in-

Codex Atlanticus 170 r-a / Codex Atlanticus 170 r-b

creased by a few architectural sketches of corner towers and the beautiful sketch of a lion's head on its verso (i.e. recto-a). Windsor drawings on the same kind of paper are 12388, 12665, and 12670. Compare also 12391; and finally 12329, with a drawing of an elaborate helmet (probably for a masquerader) that might explain the purpose of the sketch of the lion's head.

20. Codex Atlanticus 79 r-c (Richter, I, pl. XXXVIII). Cf. *Raccolta Vinciana*, XIX (1962), pp. 265–272. See also *Libro A*, pl. 11.

21. E.g. 19076 r (C. II. 6), in which a note refers to the "figure che apariano nello scriptoio di Gherardo miniatore in San Marco a Firenze." Cf. *Libro A*, p. 19.

22. Folio 95 r-a, quoted above in n. 19. For a possible date ca. 1514–1515 see below, sec. IV, n. 1.

23. There is no historical ground for assuming that Leonardo had met Francis I in Bologna, when the king and the pope met there in December 1515. In *Raccolta Vinciana*, XIX (1962), p. 270, I show that a document often mentioned as evidence of Leonardo's presence in Bologna in 1515 may be interpreted differently, that is, as referring to the journey of Lorenzo di Piero de' Medici to Boulogne in France, where he went to marry Madeleine de La Tour d'Auvergne in 1518. The document proves only that Leonardo was in his pay. The note identifying a drawing in the Ambrosian Library as a portrait of the king's chamberlain Artus de Boissy made by Leonardo in Bologna in 1515 is without documentary value: the note was written by the seventeenth-century collector P. Sebastiano Resta, and the drawing is not by Leonardo. (W. Suida, *Bramante pittore e il Bramantino* [Milan, 1953], pl. 84, attributes it to Bramantino.) Nevertheless, there are reasons to believe

II. THE NEW PALACE

that in 1515 Leonardo had already come in touch with Francis I, one occasion being the construction of a mechanical lion for the king's entrance into Lyons in 1515; it is also known that a letter by Leonardo dated in that year (whereabouts unknown) was written from Milan (Beltrami, *Documenti*, no. 232). Francis I entered Milan on October 11, 1515, and in January 1516 he financed the project of the Adda canal. See below, sec. III, n. 11.

24. Codex Atlanticus 247 v-b (Mac-Curdy, *Letters*; Richter, §1351).

25. Cf. Labord, *Les comptes des batiments du roi*, Paris, 1880, II, p. 204. See also P. Lesueur, *Dominique de Cortone dit le Boccador* (Paris, 1928), and an article by the same author in the *Bulletin de la Société de l'histoire de l'art française* (1936), p. 30, Guillaume (above, Part One, sec. III, n. 9), p. 101, states that the wooden model of Chambord was prepared by Domenico under Leonardo's direct instructions. This is quite possible, although it cannot be proven. In April 1518 Domenico was in Amboise to organize the festivals for the baptism of the "duphin." Leonardo may have advised him, as can be inferred from a letter of Galeazzo Visconti published by Solmi in the *Archivio storico Lombardo*, XXXI (1904), pp. 389–410. The greatest attraction of the festival was the besieging of a fortress, with a mock battle in which the king himself took part. The fortress was built of wood and canvas. There is a reference to the event in the *Mémoires de Fleurange* (vol. V of the *Nouvelle collection des mémoires pour servir à l'histoire de France* ... [Paris, 1838], p. 69), under the date 1520, in the chapter about Francis I's meeting with the king of England at Ardres: "Et fist le roy de France faire à Ardres trois maisons, l'une dedans ladicte ville ... Et en fist faire ledict

seigneur Roy une autre, hors de la ville, couverte de toile, *comme le festin de la Bastille avoit été faict*: et estoit de la façon comme du temps passé les Romains faisoient leur théâtre, tout en rond, à ouvrage de bois, chambres, salles, galleries: drois estanges l'ung sur l'autre, et tous les fondemens de pierres" (italics mine). Guillaume, p. 108, n. 22, points out the significance of the presence of Domenico da Cortona at Ardres on that occasion and quotes *Lordonnance et Ordre du Tournay* ... (Paris, 1520) and *La description et ordre du camp* ... (Paris, 1520) as containing more detailed descriptions of the temporary palace built at Ardres. Another festival was organized at Cognac for the visit of Louise of Savoy and Claude de France on February 19, 1519. The event is recorded by the king's mother in her *Journal*. C. Cippolla, *Una festa per Claudia di Francia* (Verona, 1880), publishes a contemporary description of the festival and puts forward the theory that Leonardo was the author of the apparatus. The "show" was an adaptation of some mythological fable, with nymphs and fancy boats, and especially swans, the emblems of Claude de France. Windsor fragment 12711, which contains a sketch of a swan, is on a type of paper (lightly prepared with black chalk) that Leonardo used in 1518.

III. THE PLANS OF A NEW CITY

1. Dupré, p. 18.
2. *Oeuvres de Clément Marot*, vol. II, p. 485, ed. of 1731, as quoted by Dupré, p. 18.
3. Heydenreich, *BM*, p. 282, and *Leonardo*, p. 83.
4. Romorantin-Lanthenay, Archives Communales, C. C. 70, fol. 90, as quoted by A. Dezarrois, "La vie française de Léonard," *Études d'art*, 8–10 (1953–1954), p. 129.

5. This is the official title given to Leonardo in the act of inhumation, August 12, 1519 (Beltrami, *Documenti*, no. 246). Leonardo's canal project was made known in the eighteenth century by J. B. Venturi, *Essai sur les ouvrages physico-mathématiques de Léonard de Vinci* (Paris, 1797), pp. 38–40. See also E. Delécluze, "Essai sur Léonard de Vinci," *L'artiste*, VIII (1841), p. 408. Dupré, p. 19, refers to a "mémoire raisonné" of Leonardo in a "manuscrit de la Bibliothèque National, en vieil italien, et d'une écriture presque illisible." Such a manuscript can only be the Codex Atlanticus, more precisely fol. 336 v-b (fig. 122), but Dupré could not have seen it in the Bibliothèque Nationale: it was returned to the Ambrosian Library in 1815, the year he was born. His source must have been either Venturi or Delécluze, although neither of them describes the manuscript in detail.

6. "vigilia dj scō anto/njo tornaj daromo/rōtino inābuosa / el re [dj fra *deleted*] si parti due / dj innantj da romorō/tino ——"

7. Cf. V.-L. Bourilly, *Le journal d'un bourgeois de Paris sous le règne de François Ier* (1515–1536) (Paris, 1910), p. 41. See also *Chronology*, p. 141. Heydenreich, *BM*, p. 278, n. 1, states that the date January 17, 1518, may be the correct one because the royal order for financing Leonardo's canal was issued in 1518 (Appendix A, document 5). But the financing order pertains to the project of making the river navigable from Romorantin to the Saudre bridge rather than to the canal project. Furthermore, the king was not at Romorantin at that time, and the project must have gone through a reasonable period of studies and discussions before reaching the final stage. In August 1516 Leonardo was still in Rome, since he recorded the measurements of the Basilica

of S. Paolo fuori le Mura, Codex Atlanticus 172 v-b (Richter, §757 A). He must have left Italy soon afterward.

8. "Jl dj dellasēsione inābosa / 1517 dj maggio nel clu."

9. The sketches are so rough and slight that it is impossible to understand what they represent. One shows a pyramid of balls and is inscribed "ognj palla / si posa sopra / altre palle," but it may illustrate just a principle of mechanics. Below is the note "ecciesso decciesso." The other sketches show the framework of a round platform, with a system of pulleys and cables. One may suspect that they refer to some stage apparatus because of the diagram of steps, which can be interpreted as the structure for the spectators' seats (one such structure is clearly shown in Codex Atlanticus 286 r-a, 1497–1500).

Codex Atlanticus 286 r-a

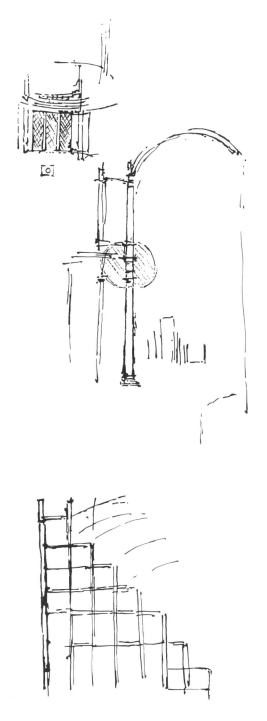

Codex Atlanticus 286 r-a

The drawings do not necessarily refer to the mechanical device for the *Paradiso* play that Leonardo may have organized in Amboise in 1518, but they can be considered as at least his latest known technological studies.

10. "faraj saggio del / liuello dj quel cha/nale chessa achōdur/rre dallera aremo/ lontino convncha/nale largho vn braccio e / profondo vn .braccio."

11. In the projected Villefranche canal Leonardo could have employed the lock system hinted at in the Arundel MS, fol. 264 v (fig. 132), which is exactly the system shown in his earlier project for the canalization of the Adda River (Codex Atlanticus 41 v-b, Calvi, *Manoscritti*, pp. 295 ff and fig. 59). Compare also Codex Atlanticus 33 v-a, in which the same type of canal with locks is represented in a bird's-eye view recalling the Du Cerceau drawings mentioned above in the Introduction. It is amazing that this drawing, which can be dated from Leonardo's first Florentine period, ca. 1480, anticipates his landscape and architectural drawings of thirty years later (Calvi, *Manoscritti*, pp. 34, 41). Leonardo was probably recording a lock system of the kind mentioned by Alberti, X, xii (Leoni ed., p. 233), which may have been well known in Lombardy when he arrived there around 1482 and was soon to be brought to France. M. Gauchery, "Le Livre d'heures de Jehan Lallement le jeune, Seigneur de Marmagne," *Mémoires de la Société des antiquaires du Centre*, XXXIII (1910), pp. 342–346, publishes a document of 1510 in which it is stated that locks were to be constructed at Vierzon "de la façon que l'ingénieulx de Milan a baillé." In 1923 one such lock was discovered at Vierzon during the replanning of the public park. (Cf. *Raccolta Vinciana*, XII [1923–1925], pp. 177–180.) As shown in Leonardo's

sketch in Codex Atlanticus 336 v-b (fig. 122), the projected canal from Lyons to Amboise was to pass through Vierzon and Romorantin. The "Milanese engineer" mentioned in the document cannot be Leonardo because other documents record the "ingénieulx de Milan" as having visited Vierzon in 1505 accompanied by his son (payments to Bienaimé George, architect of Bourge for having escorted "l'ingénieulx de Milan et son fils pour la navigation des rivières d'Yèvre et du Cher"). G. Nicodemi, "Initiation aux recherches sur les activités de Léonard de Vinci en France," *Études d'art*, 8–10 (1953–1954), p. 281, surmises that the "fils" could have been just a pupil of Leonardo; Francesco Melzi, writing to the brothers of Leonardo to inform them of Leonardo's death, refers to him as "mio quanto ottimo padre" (Beltrami, *Documenti*, no. 245). The question is far from being settled one way or the other. Indeed, there were Milanese engineers contemporary with Leonardo who could have had the skill necessary to carry out the Vierzon project. (Compare Codex Atlanticus 236 v-b, ca. 1513, a fragment of blue paper with notes on the Adda canal: "Questo anno lingegneri li quali dicano alloro modo per essere loro padroni.") Much would probably be learned from research on the activities of Bartolomeo della Valle (1439–1524), architect and engineer in charge of the canal system in the Milanese region. Albuzzi in his *Memorie* (*L'arte*, LV [1956], p. 86) records him as the author of a codex dated 1509 with extensive notes and detailed maps pertaining to all the Milanese canals that had been the object of Leonardo's studies. The della Valle codex was in the Library of the Padri Teatini in Milan, but I have not yet been able to locate it. Bartolomeo della Valle and Benedetto Missaglia were in charge of the project of the Adda canal soon after Leonardo had left for France. Significantly enough, the project as described by C. Pagnano, *Decretum super flumine Abdue* (Milan, 1520), can be identified with the one studied by Leonardo around 1510–1513 and sponsored by Francis I in January 1516 with a donation of ten thousand ducats a year "ad constructionem navilii." Francis I had entered Milan on October 11, 1515, and there is indirect evidence that Leonardo was there in December of the same year (Beltrami, *Documenti*, no. 232; see also above, sec. II, n. 23). Cf. L. Beltrami, "Leonardo da Vinci negli studi per rendere navigabile l'Adda," *Rendiconti del R. Istituto Lombardo di Scienze e Lettere*, ser. II, vol. XXXV (1902), pp. 1–15, who suggests that Leonardo instigated the king to finance the Adda project and that the king invited Leonardo to France to carry out the Romorantin canal. Finally, Leonardo might have been consulted for the project of the harbor of Le Havre, the construction of which was undertaken in January 1517. Francis I had entrusted with the task his "grand amiral" Guillaume Goüffier, Seigneur de Bonnivet, who was in Amboise on the occasion of the festivals of 1518. The harbor of Le Havre is based on the same principles shown in Leonardo's sketch for the harbor of Cesenatico, MS L, fol. 66 v, dated September 6, 1502. See A. d'Arrigo, *Leonardo da Vinci e il regime della spiaggia di Cesenatico* (Rome, 1940), pp. 48–61. See also Nicodemi, p. 283. A convenient and accurate survey of the construction of harbors and canals in Italy and France in Leonardo's time is given by W. B. Parson, *Engineers and Engineering in the Renaissance* (New York, 1939; 2nd ed. M.I.T. Press, 1968), Parts IV, V.

12. Heydenreich, *BM*, p. 281, n. 9, points

out that Richter's reading "pancho" (sand bank) is wrong. Francesco di Giorgio's Ashburnham MS 361, fol. 25 r, contains a drawing of an octagonal park inscribed "barcho." Cf. R. Papini, *Francesco di Giorgio architetto* (Florence, 1946), pl. 290 (detail of fol. 25 r, which does not show the upper part with Leonardo's note given by Richter, §952). See also Leonardo's sketch of a map of Milan, Codex Atlanticus 73 v-a, ca. 1508 (Richter, pl. CIX), in which the park of the Sforza Castle is indicated as "barcho."

13. "vntrabocho e quattro braccia . e j° mjglio e tremjla desse braccia El braccio [s *deleted*] sidjujde in 12 õcie [cie *deleted*] / ellacqua de canalj addj chalo inognj cēto trabochi 2 delle dette oncie adūque 14 õ dj / dj chalo son neciessarie aduimjla otto cēto braccia dj moto [dede *deleted*] ne detti canalj segujta che 15 õ dj / dj chalo danno debito moto allj corsi [dedetti ca *deleted*] dellacque dj predettj canali cioe j° braccio e ½ / permjglio E per quessto cõcludereno chellacqua chessitoglie dalfiume dj villa francha essi / pressta alfiume dj remolontino vole Dove lūfiume medjante [la ba *deleted*] la sua bassecça nõ / puo entrare nellaltro e neciessario ringhorgharlo intale alteça che possa djsscićedere [nel *deleted*] / inquel che prima era piv alto."

14. Cf. *Libro A*, pp. 97–98.

15. "Da Romorentino insino al / põte a sodro, si chiama soudro / [Po *deleted*] e da esso põte insino a Tours / si chiama schier." This note is transcribed and translated by Richter, §1078, as a paragraph by Leonardo. It had already been identified as Melzi's by Calvi, *Manoscritti*, p. 258.

16. "libro xvi° c. 6° de Ciui^te Dei / nõ esse Antipodes" (" c. 6°" is inserted above the line). The reference is to chap. 9 (not 6) of Book 16 of the *De civitate Dei*. St. Augus-tine's *De civitate Dei* is the eleventh item in Leonardo's list of books in Madrid MS II.

17. The surveying system adopted by Leonardo in preparing his map of Imola is the same as the one described by Raphael in his letter to Leo X. Cf. d'Arrigo (above, n. 11), pp. 62–65, and my *Chronology*, pp. 157–171.

18. Windsor 12470. Cf. my note in *Italian Quarterly*, III (1959), pp. 42–57.

19. "Le chase sieno trassmutate emesse perordjne / ecquessto cõfa[s *deleted*]cilita sifara / perche talj case son prima fatte / dj peççi sopra le piaçce eppoj / sicõmettano insieme colli lor / legnjamj nelsito dove sidebbono / stabilire ——"

20. "facciasi fonti / [che m *deleted*] incias/ scuna piaça."

21. "liomjnj del pae/se abitino le nuo/ve chase in parte / Quando non ve lacor/te."

22. Heydenreich, *BM*, p. 281. See also L. Hautecoeur, *Histoire de l'architecture classique en France* (Paris, 1963), vol. I, pp. 188–189: "Il propose de bâtir en dehors de la ville une sorte de camp de loges octagonales en bois qui, en temps ordinaire, pourraient recevoir des habitants et, en cas de présence de la cour, des employés des services."

23. Dante, *Inferno*, XXIX, 67–69:

Qual sovra 'l ventre, e qual sovra le spalle
l'un dell'altro giacea, e qual carpone
si trasmutava per lo tristo calle.

Boccaccio, *Decameron*, Nov. 2, giorn. 4: "A Vinegia, d'ogni bruttura ricevitrice, si trasmutò . . ." Compare also Leonardo's note in Codex Atlanticus 144 r-a: "Perchè il colpo è una indivisibile parte del moto e del tempo fatto, ovvero usato da esso moto, i corpi, *trasmutati per il moto*, obbediscano prima alla natura del colpo . . ." (italics mine).

24. Codex Atlanticus 163 v-a (fig. 130), a folio of geometrical studies dating from ca. 1518. It is in black chalk and is probably by Francesco Melzi. A similar, impressionistic sketch of a village in Codex Atlanticus 90 v-b has been dated ca. 1513–1514 by Popp and Goldscheider; A. E. Popp, *Leonardo da Vinci Zeichnungen* (Munich, 1928), pl. 72, and L. Goldscheider, *Leonardo da Vinci Landscapes and Plants* (London, 1952), p. 9. But the geometrical studies of lunulae on the same sheet are characteristic of Leonardo's French period, ca. 1518. The sketch may therefore show a portion of Amboise (cf. the Windsor drawing 12727) or even the village of Romorantin seen across the river, as suggested by the vegetation in the foreground.

25. "Lacqua siarin/ghorghata sopra / iltermjne dj ro/molontino intā/ta alteça chelle / faccino poi nel / suo djsscièso mol/te molina ——

"Jl fiume dj uilla/francha sia cōdocto aromolō/tino el simj/le siafatto del su[o] / po polo ellilegni/amj che conpō/ghano lelorcase / siè per bar che cō/dotte aremolō/tino elfiume / sia ringhorgha/to intāta alteç/ça chella cqua / si possa cō co/modo djssciè/so riduciere / aromolōtino."

26. "el fiume djmeço / nō ricieva acqua / torbida Mattale ac/qua vada perli fossi / dj fori della terra / con 4 moljna nellē/trata e 4 nella vs/scita e cquessto sifa/ra col ringhorghare lacqua / djsopra aromolontino."

27. "sel fiume m n ramo del fiume [Era *deleted*] Era | si manda nel / fiume dj romolontino colle sua acque torbide esso ī/grassera lecanpagnje sopra le quali essesso adacque/ra erēdera il paese fertile [so *deleted*] da nutrire [il *deleted*] lia/bitatori effara chanale navichabile emerchātile."

28. "modo chelfiume / col suo corso / netti il fondo del / fiume ——

"per la nona del 3°/Quella chepiu velo/cie piu cōsumail / suo fondo e perlacō/versa lacqua cheppiu / sitarda piv lasscia / dj quel chella intorbj/da ——

"addunque nellj djluuj defiumj sidebbe apr[ire le cate]/ratte de molinj accioche tutto il corso del fiume si [netti Le ca]/teratte inciasscū molino sieno molte accio che [ognuna] / sapra effacci magiore īpeto ecosi nettera tutto il f[ondo].

"effaciasi [la *deleted*] ilserraglio mobile cheio or/djnaj nel frigholj del quale aperto vna caterat/ta lacqᵃ che dj quella vssciva cav[a]va ilfond[o].

"einfralle due posste de molj/nj sia vno delle dette caterac/te sia vna desse posste djtalcate/rate mobilj infralluno ellal/tro molino ——"

29. Beltrami, *Documenti*, no. 103.

30. Cf. F. Savorgnan di Brazzà, *Leonardo da Vinci ed il suo progretto di fortificazione dell'Isonzo* (Udine, 1935). In one of the newly discovered MSS at Madrid Leonardo has a reference to occurrences in Venice, but this may date from an earlier period, ca. 1497. Madrid MS I, fol. 1 r: ". . . Jo mi richordo . avere veduti . molti e dj vari paesi essere per loro puerile . credulita essersi condottj alla citta dj ujnegia cō grāde speràça dj provisionj efferere . mvilina inacqua . morta . / che nō potēdo dopo molta spesa movere tal machina erā costretti a mouere cō grā fu⟨g⟩a . se medesimj / dj tal cit⟨ta⟩."

31. "Loera fiume / dā[n *deleted*]bosa ——/ Jlfiume eppiu / alto dentro al/largine b d che / fuori dessa ar/gine ——"

32. "Jl fiume era che passa per anbosa passa per a̱ ḇ c̱ ḏ e̱ poi che e passato il pōte c̱ ḏ e̱ / ritorna contro alsuo avenjmento per il canale d e b f in contatto dellargine d b / chessi interpone infrallj due motj contrarj del predecto fiume a̱ ḇ c̱ ḏ ḏ e̱ ḇ [f̱] / dj poj

322

siriuolta ingiu per il canale f̱ l g̱ ẖ ṉ m̱ essi-richongiugnje col fiume dode / prima sidjujse [epp *deleted*] cheppassa per Ḵ ṉ cheffa Ḵ m̱ ṟ ṯ ma quãdo il fiume e / grosso allora ellj corre tutto peruno solo verso passãdo largine b d."

Like Dante, Leonardo refers to the Loire as "Era." Cf. E. Solmi, "Il fiume Era: Nota al Paradiso, VI, 56, desunta dai manoscritti di Leonardo da Vinci," *Giornale Dantesco,* XIX (1909), pp. 47–49.

33. "a b chonchaujta ricievano / dentro asse ledjta della mano / nel djsscendere [*replacing* montare] della scala achio/ciola cioe [ae *deleted*] ilcanale a / ricieue dentro asse le [. *deleted*] 4 / djta mjnori [della ma *deleted*] el ḇ ri/cieve ildjto grosso—— / Ellj chanalj c d fãno ilme/desimo nel mõtare tenendo / le 4 djta mjnori nel chana/le c̱ el djto grosso in .ḏ/ ṉ m̱ cho [*replacing* co]ssta ricieve dē/tro asse lasse f o / che e fronte delli sca/lini.

"La pariete / dj quessta [cho *deleted*] / chiocciola / e quadra per / essere facta / nvnangholo del/la chasa ——"

34. F. Gebelin, *Les Châteaux de la Renaissance* (Paris, 1927), fig. 149. See also T. A. Cook, *Spirals in Nature and Art* (New York, 1910), fig. 55.

35. Vitruvius IX, viii and X, viii.

36. The problem of the chronology of Windsor fragments 12688 and 12716 (fig. 135) is discussed in the new edition of Kenneth Clark's *Catalogue.* Fragments 12480 and 12718, which were cut out of Codex Atlanticus 20 v-b (fig. 134), may be studies for the bell-ringer. Leonardo may have had in mind such figures as Rizzo's bell-ringers on the clock tower at Venice. There might be a relation between these studies for a water clock and what Leonardo says in the concluding paragraph of his letter to Charles d'Amboise (?, or Pallavicini) from Florence,

Codex Atlanticus 317 r-b, ca. 1508 (Richter, §1349): ". . . on my return I hope to make there [i.e. in the water of the canal] instruments and other things which will greatly please our most Christian King."

37. It is enough to mention Dondi's famous Astrarium in the Library at Pavia dating from the fourteenth century and the "orologio dei pianeti" by Leonardo's contemporary Lorenzo della Golpaja. Cf. *Studi Vinciani,* pp. 23–25.

38. *Di Herone Alessandrino De gli Avtomati ouero Machine se moventi, Libri due . . .* ed. Bernardino Baldi (Venice, 1589). For Leonardo's references to Heron see Solmi, *Fonti,* pp. 143–146. (Windsor fragments 12690 and 12691, ca. 1513, represent table fountains, i.e. the so-called Heron's fountains, as described by Alberti, *Ludi matematici,* ix.) For the general problem of automata and their relation to architecture in the sixteenth century see E. Battisti, *L'Antirinascimento* (Milan, 1962), pp. 220–253. Leonardo's architectural plans foreshadow much of the later development of garden architecture. Cf. V. Scamozzi, *L'idea della architettura universale* (Venice, 1595), p. 344: "Oltre alle fontane ordinarie, per maggior delitie, e piacere si possono far'altre cose; come sono bellissime decadute d'acque, e spruzzi di varie maniere, far suoni di stromenti da fiato: mouimenti di figure, d'animaletti, d'uccelli, e simiglianti cose, delle quali se ne dilettarono gli Antichi, come habbiamo in Vitruvio & Herone, e come si può vedere a Tivoli, a Caprarola, a Bagnaia, a Pratolino, & altroue" (Besides the usual fountains, other things can be done to one's greater delight and pleasure, such as very beautiful waterfalls, various systems of sprinkling water, sounds produced by water from wind instruments, movements of figures, little

animals, birds, and suchlike things, of which the Ancients were exceedingly fond, as we have it from Vitruvius and Heron, and as one can see at Tivoli, Caprarola, Bagnaia, Pratolino, and elsewhere).

39. Alberti, X, vii (Leoni's ed., p. 223).

40. "Col mulino faro continui sonj dj uari strumēti li quali [a *deleted*] tāto sonerā / quāto durera il moto dj tal molino ——"; the device referred to as "molino" (mill) is the same as the ones mentioned several times in the Romorantin project, i.e., a device to raise water.

41. "che il chorso dellacqᵃ nō passi per li fossi chessō dentro alla terra accio che / quando [la *deleted*] il fiume viē torbido nonjs-scarichi la terra al fondo delle predette fos/se E per quessto senpiera esse fosse per meçodj [ço *is an insertion*] chateratte e chōsi resstera / senpre chiara ma eneciessario mvtarla ognj mese chollacqua del fiume / quādo e chiara e chosi rendera laria purifichata essana E acquesto / modo lacqua chessimovera per il fiume serujra alle moljna eannettare / spesso li fanghj della terra e altre [chose *deleted*] in-mōdjtie."

42. Appendix A, document 5. The document of the tax exemption on wine (document 2), clearly states the king's intention to make Romorantin his residence, just as it was already the residence of his mother, and stresses his wife's attachment to it as her hometown. The king's determination to make the city's inhabitants "deffensables contre les ennemis de nostre royaulme, si besoing en estoit," may account for a certain military aspect of Leonardo's project.

43. Heydenreich, *BM*, p. 282, n. 16.

44. "lassaj canalj / nettano assaj / desstrj —— / Ljassaj cana/lj lauano le / assaj strade / faciēdo lari/ghorghatione / delle moljna / nella superiore / parte della città."

45. In a fresco attributed to Perino del Vaga, the Cortile del Belvedere is represented as having a pond for naval battles. See J. S. Ackerman (above, Part One, sec. VII, n. 5), pp. 126–129 and pl. 19. Boat races were customary in Florence on the Day of S. Jacopo; cf. Landucci's *Diary:* "E a dì 25 di luglio 1507, non si potè correre el palio delle navi perchè non era quasi punto d'acqua in Arno."

IV. THE ELEVATION OF THE NEW PALACE

1. Folio 95 r-a, the parent sheet of the Windsor anatomical fragments 19125 and 19126, has been dated ca. 1513 on the basis of a sketch of the ground plan of the Castle of Milan, and the itinerary Fiorenzuola-Bologna on the verso, which has been assumed to refer to Leonardo's trip to Rome in September 1513. (Cf. *Windsor Fragments*, pl. 7.) However, there are similar anatomical doodles in folios of archaeological studies at Civitavecchia, 1514 (*Chronology*, fig. 48); and, since Leonardo was in Parma in September 1514 and probably in Milan in December 1515 (Beltrami, *Documenti*, no. 232), his reference to cities in Emilia may have something to do with his activity in the service of Giuliano de' Medici, who was governor of Parma, Piacenza, Reggio, and Modena. Both Giuliano and Lorenzo di Piero de' Medici were in Emilia in 1515. Finally, the geometrical studies on fol. 95 r-a are identical to those on fols. 83 and 96, two sheets originally joined together and datable to ca. 1515 on account of references to Sansovino, Peruzzi, and the Medici stables at Florence. In my *Chronology*, p. 108, I dated fol. 83 r-a ca. 1513, but a later date would account for the presence of the ground plan

of a castle on fol. 99 v-b, which contains geometrical studies of ca. 1515–1516. The castle is identified as the Castello Sforzesco by Calvi (above, Part One, sec. IV, n. 14), p. 104 and fig. 37, but this is not completely convincing. An accurate ground plan of the Castello Sforzesco occurs on fol. 385 v-c, a sheet of blue paper dating, like the Anatomical MS C II at Windsor, from about 1513. Folio 385 r-a (also a blue sheet), contains an anatomical sketch and a topographical sketch (reproduced in *Chronology*, p. 91), which is probably a representation of the area around the Sforza Castle. An earlier

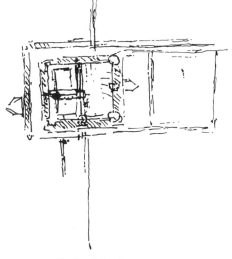

Codex Atlanticus 385 v-c

sketch of the ground plan of the Sforza Castle is in MS H, vol. III, fol. 111 (32 v) r, ca. 1493–1494.

2. Compare the "letto da campo" in MS L, fol. 70 r.

3. "la corte de auere le pariete / per lalteça la meta della sua / largeçça coe sella corte / sara braccia 40 la casa e essere / alte 20 nelle pariete dj tal / corte e tal corte vole essere / larga per la meta dj tutta la / faccata."

4. Heydenreich, *BM*, p. 281, and his re-

view of my *Chronology* in *Raccolta Vinciana*, XX (1964), pp. 408–412.

5. The paper is also of a kind used by Leonardo in other studies for the Trivulzio Monument. Compare nos. 12291 and 12293.

6. Codex Atlanticus 87 v-b (fig. 144) contains the note: "riujera [dor *deleted*] darua presso aginevra / $\frac{1}{4}$ dj mjglo in sauoia doue si fa la fiera / batte in sangovannj neluilago dj sancervagio" (Richter, §1059: "The river Arve, a quarter of a mile from Geneva in Savoy, where the fair is held on mid-summer day in the village of Saint Gervais"). Another reference to a locality in Switzerland on the way to France, Arosa, is found in Windsor 12660 r, again a folio dating from ca. 1508–1509. Finally, there is a reference to France in the third part (ca. 1507–1508) of MS K, i.e. fol. 20 r (fig. 146), which contains a diagram of Fra Giocondo's conduit in the garden of the Blois Castle.

7. Cf. Sanuto, *Diarii*, VII, 631, September 3, 1508: "Come a dì 3 partì monsignor di Chiamon per Franza, acompagnato da molti primarij da Milan assa' fuora, versso Aste . . ."; VII, 674, November 1508: ". . . essendo ditti Palavicini favoriti da questo regio governador e dil gran maistro, con el qual se atrova al presente in Franza el signor Antonio Maria Palavesin . . ."; VII, 715, January 1509: ". . . monsignor di Chiamon andato in Amboys, a uno suo loco." At the end of February 1509 Antonio Maria Pallavicino was already back in Milan; Charles d'Amboise had left Blois on February 4 and arrived incognito in Milan on February 21: "*Item*, aver letere di Milan, di 21, dil zonzer a dì 20 il gran maistro, venuto di Franza incognito, e stravestito introe, et cussì star a piacer fino a dì 25, ch'è il suo carlevar, et va a feste *etc.*" (Sanuto, VII, 715, 738, 739, and 762). Sanuto's reference to festivals in Milan attended

by Charles d'Amboise may have some relation with Leonardo's activity as a stage designer at that time. Antonio Maria Pallavicino, governor of Bergamo, was also a patron of Leonardo (cf. Calvi, *Manoscritti*, pp. 267 and 273). His brother Ottaviano is mentioned by Leonardo in the context of a copy of Vitruvius (Richter, §1421).

8. A similar system of attic windows is clearly shown in the early drawing of a palace in MS B, fol. 36 r (Richter, plate LXXIX-2). The same system appears again in the projects of a house for Charles d'Amboise in Codex Atlanticus 231 r-b (fig. 50), lower right-hand corner.

9. See *Windsor Catalogue*, sub numero.

10. Leonardo might have had direct information about the work on the Castle of Gaillon, and it is even possible that he had seen the frescoes representing that castle in the Castello di Gaglianico in Piedmont in 1510. See M. Rosci and A. Chastel, "Un château français en Italie: Un portrait de Gaillon à Gaglianico," *Art de France* (1963), pp. 103–112.

V. THE OCTAGONAL BUILDINGS

1. Heydenreich, *BM*, pp. 281–282.

2. E.g. MS B, fols. 25 v and 39 v (Firpo, pp. 41–42). Compare Filarete, Book XIV, fol. 10 r, and Francesco di Giorgio, vol. I, pl. 169, and vol. II, pl. 200. But the pattern is so common in Renaissance architectural theory that it is impossible to trace its origin and derivations. See Peruzzi's drawing, Uffizi A. 529, reproduced by H. Wurm, *Der Palazzo Massimo alle Colonne* (Berlin, 1965), pl. 50a, and Sangallo's drawing, Uffizi A. 1254 (Giovannoni [above, Part One, sec. III, n. 9], figs. 211, 214).

3. Sangallo, p. 46, and fol. 30 v. See also Bramantino, *Le rovine di Roma*, ed. G. Mongeri (Milan, 1873), plate XXX. Cf. C. Baroni, "Elementi stilistici fiorentini negli studi vinciani di architettura a cupola," *Atti del I Congresso Nazionale di Storia dell'Architettura* (Florence, 1938), p. 77. On the debated question of Sansovino's project for the Fiorentini and the possibility of its having affected Serlio's ideas, see Rosci, p. 13, n. 5, and pp. 77–79 (with full bibliography).

4. Rosci, pp. 75–76.

5. *Libro sesto*, project XXIX, fols. 31v–33. See also P. Du Colombier–P. d'Espezel, "L'habitation au XVI siècle d'après le sixième livre de Serlio," *Bibliothèque d'Humanisme et Renaissance* (1934), and "Le sixième livre retrouvé de Serlio et l'architecture française de la Renaissance," *Gazette des Beaux-Arts*, 6th ser., XII (1934), pp. 42–59.

6. Cf. Codex Atlanticus 349 v-c (fig. 163), and v-k, Firpo, p. 112.

7. Florence, Casa Buonarroti, 88 A r. Cf. *Raccolta Vinciana*, XX (1964), p. 261 and fig. 16.

8. Pietro Cataneo, *Quattro libri di architettura* (Venice, 1554), Book IV, chaps. x and xi.

9. Their schemes are conveniently gathered in Rosci's edition of Serlio's *Libro sesto*, p. 38, fig. 94. Compare the next to last, which is in fact reminiscent of the ground plan in Codex Atlanticus 76 v-b. A derivation reproduced by Rosci on p. 33, fig. 68 (Villa XIII), is most interesting because it can be interpreted as a variation of the ground plan in Codex Atlanticus 217 v-b, that is, a Greek cross inscribed in an octagon.

10. Rosci, figs. 69 and 70.

11. Dupré, p. 17, states that Françoise de Foix, the first "favorite" of Francis I, "habitait, à Romorantin, le pavillon du Mouceau,

VI. THE WINDOWS

maison de plaisance bâtie sur le bord de la Sauldre, à l'extrémité des jardins du château, *et dont il ne subsiste aucune trace*" (italics mine). I have found no other evidence for a pavilion, so the reference must be to the Mousseau Manor that still exists.

12. Rosci, p. 79; Guillaume (above, Part One, sec. III, n. 9), pp. 103–104.

13. See the reproduction in W. H. Ward, *French Châteaux and Gardens in the XVIth Century by Jacques Androuet Du Cerceau* (London, 1909), pl. VIII.

14. Cf. Rosci's comment to Serlio's project XXXIV, p. 77.

15. On the subject of architectural drawings in the Renaissance see W. Lotz, "Das Raumbild in der italienischen Architekturzeichnung der Renaissance," *Mitteilungen des Kunsthistorischen Institutes in Florenz*, VII (1956), pp. 193–226.

16. Cf. Codex Atlanticus 249 r-b, dated June 24, 1518 (Richter, §1378), Windsor 12391, etc., discussed in *Libro A*, pp. 157–158. See also *Chronology*, p. 111, n. 12.

VI. THE WINDOWS

1. As pointed out by Heydenreich, *BM*, pp. 282–285, the type of arcade that encroaches on the zone of the superimposed architrave at Chambord is prefigured in Leonardo's earlier drawing in Codex Atlanticus 136 v-a, ca. 1507–1508. This appears also in the projects for the Medici Palace, Codex Atlanticus 315 r-b (fig. 93). Cf. *Chronology*, pp. 120–121

2. See above, Introduction, p. 5.

3. Cf. *Chronology*, p. 90, n. 24.

4. According to Landucci's *Diary*, the Medici stables "si finirono di voltare" on January 17, 1516.

5. Quoted above, Part One, sec. III, n. 26. The drawing on the left looks like a portico, but it may be a detail of a ballatoio, a combined gallery and cornice. As such it may be related to the ballatoio that Baccio d'Agnolo began to put up in 1515 at the top of one of the eight sides of the drum of Florence Cathedral. Michelangelo on returning from Rome in 1516 objected so vigorously to Baccio's work (he called it "a cricket cage") that the project was suspended, and he was able to produce his own model, which was to be more in harmony with Brunelleschi's intentions, but which was not carried out either. See G. de Angelis d'Ossat, "Uno sconosciuto modello di Michelangelo per S. Maria del Fiore," in *Scritti di storia dell'arte in onore di Edoardo Arslan* (Milan, 1966), pp. 501–504 (with full bibliography). Baccio's solution is anticipated by Leonardo's drawings in Manuscript B, fol. 95 v (Ash. 2037, fol. 5 v) and Windsor no. 19134 v.

6. Firpo, p. 18, considers them as probable studies for the Medici Palace. See also C. de Tolnay, "La Bibliothèque Laurentienne de Michel-Ange," *Gazette des Beaux-Arts*, 6th ser., XIV (1935), p. 95, fig. 1.

VII. CONCLUSION

1. Serlio, *Libro terzo*, p. iii: ". . . et essendo uostra Maestà non solo dotata di tante altre scientie e per theorica, e per pratica; ma tanto intendente, et amatore de l'Architettura, quanto ne fan fede tante bellissime, e stupende fabriche da quella ordinate in più parti del suo gran regno"; and the note *A li Lettori* at the end of the book (p. CLV): ". . . e sopra tutti del gran Re loro . . . la cui ombra sola metterà spauento a chi uolesse contrariare a le uere dottrine del gran Vitruvio."

327

2. Dupré, pp. 3–4. The etymology of Romorantin as "Roma minor" can be traced as far back as 1682, in Bernier's history of Blois, pp. 234–236: ". . . si l'on en croit ses habitans, elle s'appelloit anciennement *Roma minor*, parce, disent-ils, qu'une tradition confirmée par divers Titres (que nous ne voyons point) assure que Jule Cesar s'estant trouvé pendant le sejour qu'il fit dans les Gaules, à extremité de la Forêt de Braudam joignant la riviere de Saudre, où cette Ville est située; il y fit construire quelques Forts & quelques maisons pour rafraichir son armée, & pour y camper, leur donnant le nom de *Roma minor*; soit parce que le lieu & les Forts avoient quelques rapports aux éminences & aux Forts de Rome, soit parce que ce lieu est coupé de la riviere de Saudre, comme Rome l'est de celle du Tibre." Bernier also reports the belief that Caesar had named his lieutenant Titus Labienus governor of the place, and concludes: "Je sçay que Cesar n'a pas écrit en ses Commentaires tout ce qu'il a fait, & qu'on peut mesme avoir perdu une partie de ce qu'il nous a laissé, mais ces traditions ne meritent pas toute nostre creance quand l'autorité de l'Histoire leur manque."

3. Andrea Palladio, *I Commentari di C. Givlio Cesare, con le figure in rame de gli alloggiamenti, de' fatti d'arme, delle circonuallationi delle città, et di molte altre cose notabili descritte da essi* (Venice, 1575). In the *Journal* of Louise of Savoy, in which domestic incidents are recorded in a simple, almost naïve, way, there is a reference to Julius Caesar's *Commentaries*, which shows that the book was indeed well known in the family: "Le dernier jour de mai 1520, mon fils arriva à Ardres qui s'appelle en latin *Ardea*, et ledit jour le roi d'Angleterre, second de sa race, arriva à Calez, qui s'appelle en latin *Caletum*,

ou *Portus Itius*, selon César, au cinquième livre de ses Commentaires" (*Mémoires pour servir à l'histoire de France . . .* vol. V [Paris, 1838], p. 91; as seen above, sec. II, n. 25, it was at Ardres that Francis I had a temporary edifice built, "da la façon comme du temps passé les Romains faisoient leur théâtre"). Francis I's copy of Caesar's *Commentaries* in the Venice edition of 1517 was sold recently in New York. Cf. Catalogue 39 of the William H. Schab Gallery, New York, no. 34.

4. Cellini, p. 158. See Introduction, p. 4 above.

5. *Gaglianico-Gaglione-Gaillon.* Cf. Rosci-Chastel (above, sec. IV, n. 10), p. 111. See also the description of the "palazzo del reverendissimo cardinale di Ambosa nel loco ditto *Gaglione* in la provincia di Normandia" by Jacopo d'Atri published by Weiss (above, Part One, sec. V, n. 9).

6. Alberti, V, iii (Leoni's ed., p. 86). See also IX, iv (Leoni's ed., p. 194): "I cannot be pleased with those who make towers and battlements to a private house, which belong of right entirely to a fortification or to the castle of a tyrant, and are altogether inconsistent with the peaceable aspect of a well-governed city or commonwealth, as they show either a distrust of our countrymen, or a design to use violence against them."

7. R. Borghini, *Il Riposo* (Florence, 1584), p. 169, refers to a treatise on architecture, manuscript, by Bartolomeo Ammanati, "nel quale egli figura un'ampia e perfetta città, facendo vedere i disegni (e sopra essi discorrendo), il palagio reale con tutte le sue appartenenze, gli uffizj, i tempi, l'arti, le case de' gentiluomini e quelle degli artieri, le piazze, le strade, le botteghe, le fontane, e tutte l'altre cose appartenenti a una bene intesa città; e poscia descrive ancora il palagio regio della villa con giardini, e con tutte le

VII. CONCLUSION

comodità che si ricercano, e gli abitari de' gentiluomini, e de' contadini, con tutti gli avvertimenti necessari e belli, che si posson nelle ville desiderare, e ha già il tutto disegnato e descritto, talchè non gli manca se non rivederlo, e farlo stampare" (in which he represents in drawings, with notes to them, a large and perfect city, showing the royal palace with all its services, offices, temples, the guilds, the houses of the gentlemen and those of the artisans, the piazzas, the streets, the shops, the fountains, and all the other things that belong to a well-organized city. Furthermore, he describes the king's summer residence, with gardens, and all pertinent commodities, including the housing for the gentlemen and the farmers, with all the beautiful and convenient arrangements that one may wish to find in the countryside; and he has already designed and explained everything, so that he has only to edit it and have it printed.) Ammanati's *Dell'arte edificatoria*, long believed lost, has been located recently in the Biblioteca Riccardiana, Florence. Cf. *Mostra documentaria e iconografica dell'Accademia delle Arti del Disegno* (Florence, 1963), no. 69. Unfortunately, the manuscript is incomplete, and most of the drawings are missing. See M. Fossi, "Di un trattato di architettura di Bartolomeo Ammannati," *Rinascimento*, IV (1964), pp. 93–100, and *Bartolomeo Ammannati Architetto* (Florence, 1967), pp. 9–21. A thorough study of Ammanati's "città ideale" from the viewpoint of late sixteenth-century theory is in M. Tafuri, *L'architettura del Manierismo nel Cinquecento Europeo* (Rome, 1966), pp. 235ff.

8. The lost *Madonna with the Yarn Winder*, mentioned in a letter from Pietro da Novellara to Isabella d'Este, April 4, 1501 (Beltrami, *Documenti*, no. 108). For the castles of Bury and Verger see P. Lesueur, "Le Château de Bury et l'architecte Fra Giocondo," *Gazette des Beaux-Arts*, 5th ser., XII (1925), pp. 337–357, and B. Lowry, "High Renaissance Architecture," *College Art Journal*, XVII (1958), pp. 123–126. See also *Chronology*, pp. 52–53.

9. A possible representation of Alberti's castle of the tyrant is in one of Leonardo's early drawings in MS B, fol. 60 r, which Firpo, p. 117, considers as a forerunner of the Romorantin Palace.

10. This is a time-honored opinion (cf. Gurlitt, *Geschichte des Barockstiles* [Stuttgart, 1887], chap. III), accepted by M. Walcher Casotti, *Il Vignola* (Trieste, 1960), pp. 79, 125, but rejected by Giovannoni (above, Part One, sec. III, n. 9), p. 267, on the evidence of Sangallo's early design of the Villa Farnese at Caprarola (ca. 1524).

11. Vignola's activity in France must have brought him into contact with the same remains or records of Leonardo's theoretical writings that were known to Serlio. His system of painted columns at the corners of rooms, as seen in the Palazzo Farnese at Caprarola (a trick that might have originated with Paolo Uccello), is described by Leonardo in MS A, fol. 42 r, ca. 1492. Compare also Leonardo's diagram in MS A, fol. 40 r, with Vignola's perspective construction with four distance points (Walter Casotti [above, n. 10], figs. 53 and 296). It is worth noting that Egnatio Danti's preface to Vignola's *Le due regole della prospettiva pratica* (Rome, 1583) contains what is probably the first reference in print to Leonardo's writings on perspective: "Habbiamo inoltre queste regole ordinate in compendio da Leonbattista Alberti, da Leonardo da Vinci, da Alberto Duro, etc." Nothing has been done yet to complement the pioneering study by J.

Strzygowski, "Leonardo, Bramante, Vignola im Rahmen vergleichender Kunstforschung," *Mitteilungen des Kunsthistorischen Institutes in Florenz*, III (1919).

12. F. Gebelin, *Les châteaux de France* (Paris, 1962), pp. 93–95. See also, by the same author, *Les châteaux de la Renaissance* (above, sec. III, n. 34), pp. 125–127, and pl. XLIX (fig. 74).

13. *Profugiorum ab aerumna libri III*, Libro I, in L. B. Alberti, *Opere volgari*, ed. C. Grayson (Bari, 1966), vol. II, p. 107: "È certo questo tempio ha in sé grazia e maiestà: e,

quello ch'io spesso considerai, mi diletta ch'io veggo in questo tempio iunta insieme una gracilità vezzosa con una sodezza robusta e piena, tale che da una parte ogni suo membro pare posto ad amenità, e dall'altra parte compreendo che ogni cosa qui è fatta e offirmata a perpetuità."

14. Cf. J. S. Ackerman, "Sources of the Renaissance Villa," *Acts of the Twentieth International Congress of the History of Art*, vol. III: *Renaissance and Mannerism* (Princeton, 1963), pp. 6–18 (with full bibliography).

Postscript

Just before the printing of this book was completed I was able to locate the Leonardo fragment formerly in the Geigy-Hagenbach collection, Basel, which is now preserved in the University Library at Basel, and which is the last item listed by Richter in his inventory of Leonardo's manuscripts (1939 ed., vol. II, p. 418). The fragment (cm. 29.1 × 9.8) was reproduced, without transcription of the text, in the catalogue of the collection (Basel, 1929, p. 281). A small reproduction of the recto (sketches of a basilica, spiral staircase, etc.) was given in the volume of the Leonardo exhibition at Milan (Novara, 1939, p. 241).

The Geigy-Hagenbach fragment is the missing "flap" of Codex Atlanticus 13 r-a, v-a. (For similar "flaps" see p. 142 above.) The sheet thus recomposed shows geometrical studies and architectural details pertaining

to the period of Leonardo's activity in France, ca. 1517–1518, and is related to the Romorantin project in that it may be taken to explain the basilica included in the plan in Codex Atlanticus 294 v-b (fig. 139). Furthermore, the sketches of Gothic arches on the upper right-hand corner of Codex Atlanticus 106 r-b (fig. 115) are now explained by the sketch on Codex Atlanticus 13 r-a, which used to be related to the façade of Milan Cathedral (*Chronology*, fig. 29). Finally, the geometrical studies in the sheet show the familiar problem of the "stelliform lunulae"—or, as Leonardo calls it, "curvilateral star"—which is found throughout the Romorantin series. A full illustration of this and related material is given in my forthcoming paper "Leonardo da Vinci: Manuscripts and Drawings of the French Period, 1517–1518."

FINIVNT PARITER
RENOVANTQVE LABORES

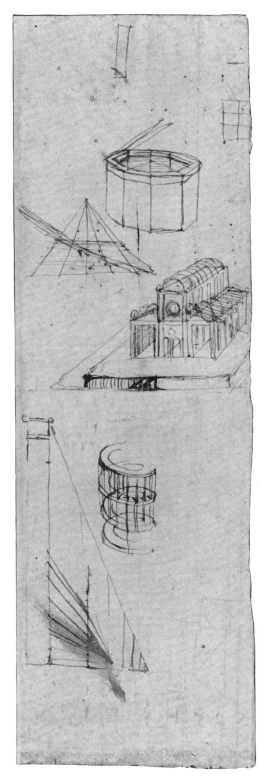

INDEX OF LEONARDO'S
MANUSCRIPTS AND DRAWINGS

For a chronological list of the material indexed below see pp. 138–147 above.

III. INDIVIDUAL SHEETS AND DRAWINGS

IV. TREATISE ON PAINTING AND SIXTEENTH-CENTURY RECORDS

337

GENERAL INDEX

339

Foyal, Nycollas, seigneur de Herbault, 68, 123

Fra Bartolomeo: altarpiece for Council Hall, Florence, 29, 297

Fra Giocondo, 113; water conduit at Blois, 104, 146, 313, 325

France: Leonardo's visit, 57, 59, 78, 104, 313

Francesco di Giorgio: treatise on architecture, 4, 12, 138; as source of Leonardo's theoretical writings, 5, 34; with Leonardo at Pavia, 13; as source of Leonardo's architectural style, 26, 49, 103, 107; octagonal building plans, 108, 326; at Milan, 119; treatise on architecture owned by Leonardo (Ashburnham MS 361), 287, 299, 314, 321; project of an octagonal park, 321

Francesco et Pulinari, spetiali: in document pertaining to *Battle of Anghiari*, 300

Francis I de La Rochefoucauld, 118–119

Francis II de La Rochefoucauld, 118–119

Francis I, king of France: decision to build Chambord Castle, 1, 69, 87; architectural program at Romorantin, 1–2, 72, 73; entrance into Lyons, 2, 317; with Leo X at Bologna, 59, 316; accident at Romorantin, 69; Italian campaign, 85; first meeting with Leonardo, 85, 316–317; at Romorantin with Leonardo, 88; financing canal project at Romorantin, 98–99, 130; order concerning tax on wine at Romorantin, 98, 124–125; bath in Fontainebleau garden, 109; on Leonardo's knowledge of Latin and Greek literature, 117; stables at Blois, 315; financing Adda canal, 317, 320; knowledge of Vitruvius, 327; copy of Caesar's *Commentaries*, 328

Francis II, king of France, 72, 74, 126–130 *passim*

Francisco de Hollanda, 310–311

Frey, K., 298, 300, 313

Friuli, Italy: Leonardo's sojourn, 95–96, 313, 322. *See also* Isonzo River

Froberville, *see* Huet de Froberville

Frommel, C. L., 303, 307, 308

Gaffurio, Franchino, 306

Gaglianico, Italy: castle dedicated to Charles d'Amboise, 117, 326, 328

Gaillon Castle, 63, 107, 117, 326, 328; aviary, 303

Galbiati, G., 132, 140n

Galen, 6

Galilei, Mariotto, 295

Gallus, Jean, 68, 123

Garden: as extension of house, 44–45; wetting sports, 50–51; wall decoration, 63; of Venus at Cyprus, 63, 306; in Leonardo's architectural plannings, 94, 97–98; pavilion, 109. *See also* Music

Gauchery, M., 319

Gebelin, F., 118, 137n, 323, 330

Geneva: mentioned by Leonardo, 325

Geometry: as a continuous quantity, 83; Leonardo's late studies of lunulae, 83, 85, 86, 89, 315–316, 322, 324, 330; Leonardo's researches on equation of curved surfaces, 104; geometrical bodies, 300

Gerli, Carlo Giuseppe, 131, 311

German craftsmen: Leonardo's assistants in Rome, 86

Geymüller, H. von, 60, 133–134, 305, 315

Gherardo Miniatore, 310, 316

Ghiberti, Bonaccorso: drawings after Brunelleschi's inventions, 286

Ghidiglia Quintavalle, A., 309

Giacomo Andrea da Ferrara, *see* Ferrara

Giampietrino: *Nympha Egeria*, 306

Giorgione, Il, 95

Giovannoni, G., 294, 326, 329

Giovio, Paolo, 306

Giuliano da Maiano, 44. *See also* Naples, Poggio Reale

Giulio Romano, 63; "Cavallerizza" at Mantua, 84

Goberville, 312, 313

Goldscheider, L., 322

Golpaja, Benvenuto di Lorenzo della, 138n, 309

Golpaja, Lorenzo della: planetarium, 323

Gonzaga family, 95

Gonzaga, Francesco, 24

Gonzaga, Lodovico II, 296

Gothic: effect on Leonardo's architectural designs, 107; arches, in Leonardo's sketches, 330

Gouffier, Artus, seigneur de Boissy, 316

Gouffier, Guillaume, seigneur de Bonnivet, 320

Gould, C., 295, 298

Govi, G., 134, 289

Gradisca, Italy, 313

Graffiti, 84

"Gran Maestro" (Charles d'Amboise): mentioned by Leonardo, 43, 44, 45

Grasserreille, L., 68, 123

GENERAL INDEX

Gravedona (Como), Italy: Palazzo delle Quattro Torri, 303
Grayson, C., 330
Grez, France, 87
"Guardacamera" (vestibule), 289
Guarna da Salerno, Andrea: *Simia*, 132
Guicciardini, Francesco, 301
Guillaume, J., 137n, 294, 303, 317, 327
Guiscardi, Mariolo de': Leonardo's project for his house, 16–23 *passim*, 25, 105, 136n, 145, 289, 292; stables for his house, 83
Gukovskj, M. A., 5, 287
Gurlitt, C., 329
Gusnasco da Pavia, 95

Hamberg, P. G., 303
Heart: in Leonardo's drawings, 34, 37
Henry II, king of France, 74
Henry IV, king of France, 129
Hercules and the Hydra: in Leonardo's sketch, 316
Heron of Alexandria, 97, 323
Heron's Fountain, 323
Herzfeld, M., 28, 296
Heydenreich, L. H., 40, 56, 72, 73, 87, 93, 99, 103, 117, 125, 130, 131n, 134, 136, 285, 292, 295, 298, 301, 307, 313, 314, 317, 318, 320, 321, 324, 325, 326, 327
Hippocrates of Chios, 315
Horace, 306
Houses: prefabricated, 93; to be moved in pieces from Villefranche to Romorantin, 93–94
Huet de Froberville, Claude Jean-Baptiste, 312
Hunting: in Leonardo's project for Romorantin, 83
Hypnerotomachia Poliphili, see Colonna, Francesco

Icosahedron, 300
Ideal city, 98, 116, 329
Imola, Italy: Leonardo's sojourn, 39, 305; Leonardo's map, 90, 309, 321
Ink: greenish, used by Leonardo in architectural drawings, 25, 43, 294
Innocent VIII, pope: villa in Vatican, 58, 307
Isonzo River, 24, 95

Jacopo Antiquario, 287
Jacopo d'Atri, 328
Jacopo de' Barbari: view of Venice, 305

Janson, H. W., 304
Jousting in boats: in Leonardo's project for Romorantin, 81, 83, 99
Julius II, pope: Michelangelo's first project for his tomb, 30

Karoli, Japhredus, 306
Kitchens: in Leonardo's architectural plans, 18–20, 81, 109, 290
Krinsky, C. H., 310

Labienus, Titus, 116, 328
Labord, L. de, 317
La Muette Castle, France, 111
Landucci, Luca: on destruction of furnishing of Council Hall, Florence, 29, 297; on Sangallo's "arcus quadrifrons," 62; on copper ball of Florence Cathedral, 286; on Piombino, 295, 298; on diverting Arno River, 298; on Medici stables alla Sapienza, Florence, 309, 327; on Piazza S. Lorenzo, Florence, 310; on boat races, 324
Lang, S., 7, 136n, 285, 286
Lanthenay, France, 74
La Rochefoucauld Castle, France, 118
Last Supper by Leonardo, 101, 131–132
Laurana, Luciano, 101, 103
Le Clerc, Michel, 124
Leda by Leonardo, 52, 306–307
Leghorn, Italy, 298
Le Havre, France: its harbor, 320
Leno, Giuliano, 58
Lensi, A., 295, 297
Lensi Orlandini, G., 293
Leonardo: on canalization of Sologne region, 1, 2, 84, 88–90, 92, 95–96, 98–99; his death, 1, 88; in service of Lorenzo di Piero de' Medici, 2, 3, 58, 59; motivation for going to France, 2, 59, 285; organizer of festivals at Amboise, 2, 84, 317, 319; mechanical lion, 2, 313, 317; decoration of *Sala delle Asse*, 3, 14, 50, 63; *Battle of Anghiari*, 3, 27, 33, 38, 40, 139, 145, 295, 298, 300; project for a new Medici Palace at Florence, 3, 49, 58–63 *passim*, 84, 89, 102, 107, 111, 114, 327; rivalry with Michelangelo, 3, 59, 285; stipends in France, 4; visited in Amboise, 4; last will, 4; praised by Francis I, 4, 59; title in act of inhumation, 4, 65; style of late drawings, 5; drawing of mausoleum, 5; Adda